Simultaneous Worlds

Simultaneous Worlds

Global Science Fiction Cinema

JENNIFER L. FEELEY AND SARAH ANN WELLS, EDITORS

University of Minnesota Press

Minneapolis • London

The University of Minnesota Press gratefully acknowledges financial assistance provided for the publication of this book by the Institute for Scholarship in the Liberal Arts, College of Arts and Letters, University of Notre Dame.

Published by the University of Minnesota Press
111 Third Avenue South, Suite 290
Minneapolis, MN 55401–2520
http://www.upress.umn.edu

Library of Congress Cataloging-in-Publication Data
Simultaneous worlds : global science fiction cinema / [editors] Jennifer L. Feeley and Sarah Ann Wells.
 Includes bibliographical references, filmography, and index.
 ISBN 978-0-8166-9317-7 (hc)
 ISBN 978-0-8166-9318-4 (pb)
1. Science fiction films—History and criticism.
I. Feeley, Jennifer L., editor. II. Wells, Sarah Ann, editor.
 PN1995.9.S26S55 2015
 791.43'615—dc23

 2014032699

Printed in the United States of America on acid-free paper

The University of Minnesota is an equal-opportunity educator and employer.

21 20 19 18 17 16 15 10 9 8 7 6 5 4 3 2 1

Contents

Acknowledgments

As with all collaborations, this book is the result of various forms of labor and various demonstrations of friendship and solidarity. Its publication is made possible in part by support from the Institute for Scholarship in the Liberal Arts, College of Arts and Letters, University of Notre Dame.

We thank those involved in the book's embryonic form, the conference "Visions of the Future: Global Science Fiction Cinema," which took place in Iowa City across a three-day period in April 2012. Russell Ganim, Corey Creekmur, Teresa Mangum, and especially Brian Gollnick deserve thanks for their support for the conference and for encouraging our collaboration across disciplines and area studies lines. During its execution, Rick Altman, Diana Cates, Melissa Curley, Rob Latham, Jon Winet, and Dave Wittenberg contributed valuable feedback as respondents. For their sponsorship of the conference, we acknowledge the generous support given by the Japan Foundation New York Japan Studies Grant, the Arts and Humanities Initiative of the Office of the Vice President for Research at the University of Iowa, and multiple other units at the University of Iowa. In addition to those whose chapters are featured in this collection, our conference significantly benefited from the contributions of other participants and respondents; the ideas exchanged across three days of panels, keynotes, and screenings informed this collection. Finally, we are grateful to the students in our Global Science Fiction Cinema class at the University of Iowa during Spring 2012, who kept us on our toes as we navigated the joys and challenges of collaborative work.

Both Tom Lamarre and Kate Hayles delivered thought-provoking keynote addresses during the conference. Tom transformed his lecture into the chapter included here, and Kate has been generous in her support of the book. We thank Tom and Kate for their encouragement and for their scholarship, which has taught us much over the years.

For valuable feedback on the editing of the Introduction and on the structure of the collection, we thank the two anonymous reviewers, as well as Ayelet Ben-Yishai and Beth Baker. Many thanks go to our editors Danielle Kasprzak and Doug Armato, along with the editorial board and the staff of the University of Minnesota Press, for their enthusiasm and professionalism. We are honored to be a part of this impressive network of scholars and writers.

This book would not be possible without the work of our contributors; each brought his or her own "world" to the table and worked hard to meet the deadlines we set. We learned a lot from you in the process.

A few people have seen us through from the very beginning of this project, from the inception of the conference to drafting our book proposal and editing the final manuscript. Melissa Curley, Nataša Ďurovičová, and Víctor Goldgel-Carballo deserve our highest gratitude for their support, feedback, and honesty at various moments during the past few years.

Introduction

JENNIFER L. FEELEY AND SARAH ANN WELLS

In Fritz Lang's *Metropolis* (1927), the robot Maria crystallizes the seductive and debilitating dreams of science in a futuristic world. Lang's verticalized city—apparently inspired by a trip to New York—set a precedent, or perhaps an invitation, for feature-length films about possible worlds. This invitation has been taken up by filmmakers across disparate contexts: the pleasure models inhabiting the "third world" Los Angeles of Ridley Scott's *Blade Runner* (U.S., 1982); the girl robot Tima created to reign from the towering Ziggurat skyscraper in Rintaro's animated *Metropolis* (Japan, 2001); the cyborg ontology of a female mental patient whose mechanized interior illuminates when she eats a spoonful of rice in Park Chan-wook's *I'm a Cyborg, but That's OK* (South Korea, 2006); and the faceless voice that bewitches a depoliticized populace in Argentine filmmaker Esteban Sapir's retrofuturist *The Aerial* (2007). Each reiteration of Maria and her divided city articulates a new take on the complex nexus of space and time amid rapid modernization throughout the world.

With the 2008 discovery in Sapir's Buenos Aires of a longer version of Lang's masterpiece, the film's global reach came full circle. The itinerant *Metropolis* demonstrates science fiction (hereafter SF) and cinema's dual pact with networks of globalization and utopias of spatial-temporal travel. Such images constitute fragments of a global exchange, one in which *Simultaneous Worlds: Global Science Fiction Cinema* both participates and facilitates.

The Global Iterations of SF Cinema

Simultaneous Worlds maps an uncharted quadrant in the field of SF cinema, namely its global ubiquity. Engaging with broader conversations

increasingly taking place across disciplines, this collection emerged from a conference held in Iowa City in April 2012 entitled "Visions of the Future: Global Science Fiction Cinema." As scholars and teachers of Asian and Latin American cinemas, we were eager to explore how our shared interest in SF might be refracted differently through encounters with other theories and traditions of the genre's production. The enthusiasm that the conference generated, and the sense among participants that we were entering into a timely discussion around increasingly fraught questions, became the impetus for this book.

The years immediately preceding and following our conference witnessed a burgeoning interest in global SF, including Indian, indigenous, and postcolonial SF, among others.[1] Although undeniably important, many of these studies focus solely on literature or consider cinema only in piecemeal fashion. This book, meanwhile, aims at something more precise: a transnational, interdisciplinary contribution that probes the specificity of global SF *cinema* as a medium and cultural practice. While arguing for its specificity, several chapters also investigate its interface with other media and paratexts—the "making of" DVDs that, as Hye Jean Chung demonstrates, alter the way that viewers experience SF film, or the increasing presence of "small-screen" culture noted in Thomas Lamarre's chapter. Moreover, although most of the chapters focus on contemporary productions—as exemplified by our title, *Simultaneous Worlds*—this book also shows how thinking about global cinema allows scholars to reread earlier moments crucial in cinematic history, as in the case of contributions by J. P. Telotte and Jillian Porter.

Although SF cinema has generated scholarly attention, critical writings have focused largely on American and, to a lesser extent, European and Japanese SF. Even SF studies dealing explicitly with the global have tended to concentrate on economic and political centers (such as late nineteenth-century England, or the United States during the Cold War). In contrast, this book fosters a dialogue among cinemas (such as North Korea, Cuba, and India) not traditionally associated with the major tenets of SF cinema production—technological modernity, high production values, and the conventions and codes of classical film narrative—and those that are (for example, Japan and the United States). The chapters included here range from topics such as the relationship between televisual and filmic screens in Japanese anime,

biometric technologies of surveillance on the U.S.–Mexico border, the creation of otherworldly spaces through analogic and digital environment composites, the status of the human in the political economy of a divided nation in North and South Korean SF, and the boom in the global production of SF shorts as an alternative to big-budget film industries. In this way, we challenge the notion of SF film as a primarily Hollywood, or even Western, genre.[2]

Simultaneous Worlds thus operates at the intersection of three fields, one long-standing, the other two relatively recent: SF cinema scholarship; global, transnational, and world cinema studies; and global SF (not limited to cinema). Expanding on classic anthologies of SF cinema criticism that have shaped us as scholars, fans, and educators,[3] we nevertheless see this volume as more than just an addendum, a "global plus." Framing SF as a global phenomenon shifts the understanding of the genre. Through this frame, new ways of reading the world emerge, demonstrating the simultaneity of contemporary world-making projects.

A central premise of the book is that any investigation of the global must elucidate how this term shifts according to the positionality of artists, intellectuals, and cultural artifacts. The postcolonial (and Benjaminian) critique of linear, homogenous modernity, for example, finds a special resonance in the Argentine films analyzed by Joanna Page, which, against the grain of Jameson's argument about modernity's allegorization, posit the temporalities of modernity as multiple and heterogeneous.[4] Page reveals how in their diegesis these films depict modernity as a coproduction between first and third worlds. Along with others in the volume, her chapter questions the notion that centers of economic and technological modernity have the sole privilege of producing SF. Though certainly it is true that some Global South SF depicts technology as an invasive Other coming from the North, several of the chapters in this book challenge these and other implicitly diffusionist accounts of modernity, whereby SF arrives in an area once it has achieved a significant level of technological "advancement." Although it may be tempting to map the emergence of SF along a continuum of capitalist modernity, we suggest that this kind of developmentalism cannot account for the scope of the genre's production, because it tends to presume a capitalist teleology that does not take into consideration the errant and strategic use that SF can provide to

filmmakers working within nation-states in vastly different positions of power with respect to global capital. Read as a whole, these chapters reveal the inadequacy of models that implicitly uphold the nation-state as the fulcrum by which a culture becomes "SF-ready." Both Page and Swarnavel Eswaran Pillai, for example, highlight Argentine and Tamil SF cinema's relative dearth, suggesting that this scarcity serves a strategic function in underscoring the global circulation of scientific technologies and capital.

In this light, we might rethink how one of SF cinema's most pronounced features—special effects—shifts when we traverse borders. Because many film industries exist in more precarious conditions than their Hollywood counterparts, filmmakers often invent imaginative, strategic solutions to these material limitations, as Page, Everett Hamner, and Emily A. Maguire suggest in their chapters in this collection. The association of SF cinema with technological spectacle and a cinema of attractions therefore might be rethought through a consideration of strategic "minor" practices in poorer film industries, often with compelling results. One of the films that Page examines, *Stars* (Federico León, Argentina, 2007), documents the production of an SF movie made in a shantytown, calling into question who has the right to make an SF film. Like the working-class city dwellers of the alien action movie *Attack the Block!* (Joe Cornish, U.K., 2011), the protagonist of *Stars* explicitly wonders why aliens never land in the slums, thereby emphasizing how planetary imaginings often are conditioned by the monologue of capitalist strongholds. Global SF therefore can illustrate the consolidation of U.S. economic and political hegemony, but it also can serve as a harbinger of its waning, the flip side of the anxiety found in dystopic SF from the United States, with its third worlds within the first.[5]

At the same time, new media technologies have spearheaded additional types of filmmaking, distribution, and cinephilia.[6] Consequently, both filmmakers and spectators are participants in the production, dissemination, and discussion of knowledge. Through divergent readings of science and technology, they employ the genre to appropriate and coin new grammars and idioms of technology.[7] Looking back to a technological development in film history, Telotte's chapter situates the development of the SF film genre within the emergence of the multiple language version films that came onto the scene immediately following

the arrival of sound film, demonstrating how early SF cinema aided in the attempted creation of a global visual language. Thus, despite the asymmetrical access to resources that characterize globalization, calling attention to the global production of SF allows us to emphasize that no particular film industry, national cinema, or set of cinematic conventions has the monopoly on imagining the possibilities and perils of globalization and technological modernity.

SF as a Global Film Genre

Our collection examines multiple global permutations of SF film, accommodating the specificity of varying sociocultural conventions, cinematic traditions, and production conditions.[8] Accordingly, although *Simultaneous Worlds* considers SF cinema as part of a global network, the chapters in this book also contexualize the films under discussion. Though the Indian film *Enthiran* cites Isaac Asimov's theories of robotics, Pillai's chapter demonstrates how it is also in conversation with author Sujatha's short fiction and the trope of doubling in Tamil cinema more broadly. Though North Korea's *Pulgasari* may call to mind the Japanese cult classic *Godzilla* (Honda Ishirō, 1954), Travis Workman's contribution illuminates how the film also follows specific codes of representing national history stipulated by the state. Or as Paweł Frelik remarks, although some SF short films are heavily influenced by Hollywood and Western SF, others such as *Pumzi* (Wanuri Kahiu, Kenya, 2009) or *Doll No. 639* (András Dési and Gábor Móray, Hungary, 2005), "are uniquely inflected with local patterns of the fantastic." Given both the hybridity of the genre and the different historical and production contexts of these films, this book showcases the range of the unique ways in which the genre is inflected in its global iterations, reflecting on the problem of the genre itself. Rather than positioning SF from places like China, Kenya, and Argentina as derivative, or as passive recipients of an imported model, we ask instead what we can gain by seeing these sites as simultaneous *generators* of the genre.

But how does the genre change if we venture beyond the Hollywood canon of SF cinema? Perhaps more than any other film genre, SF is notorious for its porousness.[9] As Rick Altman has argued, SF supplies its own loose set of semantic elements but relies on the syntactic frameworks of contiguous genres, such as horror, the western,

martial arts, noir, and fantasy.[10] In this book, for example, Workman's chapter examines how two films from a divided Korea appropriate SF elements in order to parody realist cinema. Even the semantics of SF do not remain stable as the genre travels. For example, certain semantic hallmarks of Hollywood SF film, such as space exploration, doomsday scenarios, environmental crises, and alien invasions, rarely appear in Chinese-language SF cinema, and those that are featured, such as cyborgs, robots, and mad scientists, are not icons exclusive to SF in their local contexts.[11] And though time-travel scenarios in popular television dramas have frustrated Mainland China's State Administration for Radio, Film and Television (SARFT), leading to sensational headlines such as "China Bans Time Travel," time travel holds a special resonance for a national cinema like Argentina, where the promises and disappointments of a certain understanding of modernity, coupled with the hefty legacy of Borges, have secured the trope's centrality.[12] Thus, the hybrid nature of the genre becomes particularly pronounced when examining SF produced outside of the Anglo-American tradition: we might encounter a pair of sorceress-prostitutes on a mission to rid a futuristic society of corrupt and sex-crazed politicians (*Les Saignantes*, Jean-Pierre Bekolo, Cameroon, 2005); a love-struck kung-fu-fighting cyborg cop with the face of Hong Kong heartthrob Andy Lau and the hairstyle of Elvis Presley (*Metal Attraction: Kung Fu Cyborg*, Jeffrey Lau, Hong Kong and China, 2009); or a desert planet where matchsticks are more valuable than money and the color of one's trousers designates social status (*Kin-dza-dza!*, Georgii Daneliaa, Soviet Union, 1986).

At first glance, then, some of the works under discussion in this book may not seem to qualify as SF films. The protagonist in Hirokazu Koreeda's *Air Doll* (Japan, 2009) is an inflatable sex doll, not a cyborg, android, or robot, and the so-called cyborg in *I'm a Cyborg, but That's OK* (Chan-Wook Park, 2006) is actually a mental patient who believes she is a cyborg. Yet in his chapter on the latter, Steve Choe contends that the South Korean film "critiques the conventions of the SF film and romantic comedy," "bring[ing] the generic forms of sci-fi and the rom-com to aporia, not only in order to reveal its contradictions, but also to rethink its very origins." At the same time, Choe cautions that viewers should be wary of interpreting the film "as simply a localization of global Hollywood conventions," arguing that its exploration of genre

facilitates both global and local exchanges, a claim that could be made for other films analyzed in the book. Michelle Cho, in turn, posits that the doll who gains sentience in *Air Doll* destabilizes divisions among human, nonhuman, and posthuman; by choosing a *doll* as its central figure, the film thereby challenges the "binary understanding of the social and the biological that affects discourses of the posthuman and the cyborg." Meanwhile, Maguire's chapter on the Cuban zombie spoof *Juan of the Dead* (2011) argues that George Romero's particular take on the zombie film qualifies as a subset of SF on the basis of the zombie's association with contagion, tracing this subgenre's iterations and return, as it were, to its home in the Caribbean.

Despite an increasing awareness of the global, for fans and critics of a popular genre like SF it still is tempting to focus on a preexisting canon largely made up of Hollywood blockbusters. While acknowledging Hollywood's global reach, this volume avoids making it the default location for SF cinema. One likely reason that many film scholars and critics have not given rigorous study to non-U.S. SF films could be attributed to a bias against non-U.S. genre cinema.[13] In this sense, and, as with cinema studies more broadly, global SF also has to contend with the centrality of English-language productions, above all those from the United States. (Riffing on Robert Stam and Ella Shohat, we could say that in Hollywood not only God but also science and technology speak English.[14]) Consequently, if and when scholarship on non-U.S. SF cinema is published, it is usually in venues that target audiences familiar with one discrete national cinema or culture, which does little to facilitate conversations across national, cultural, and linguistic divisions or among film scholars in general.[15] As such, one of the goals of our book is to bring together SF from multiple national cinemas, adopting a comparative, interdisciplinary, and transnational perspective. We have organized *Simultaneous Worlds* accordingly, privileging critical concerns rather than national or regional categories. Thus, while both Lamarre and Sharalyn Orbaugh offer new readings of Oshii Mamoru's films, given their different theoretical emphases we have placed their chapters in separate parts to foster an exchange of ideas among scholars working on media theory and revisionist readings of the cyborg, respectively. Moreover, in an effort to avoid perpetuating the binary of art house cinema versus popular cinema—a dichotomy often replicated in volumes of world cinema—this book as a whole

weaves together analyses of works by contemporary avant-garde artists such as Dominique Gonzalez-Foerster with analyses of blockbusters by Ridley Scott, and treatments of independent crossover hits like Alex Rivera's *Sleep Dealer* (2008) with treatments of films from auteurs such as Tarkovsky and Park.

SF Cinema as a Global Commodity

Cinema studies has moved increasingly toward transnational and world cinema (with planetary undoubtedly close behind) both to define the state of the field and to reread earlier moments of film history.[16] In this context, our choice of the term *global* as a frame for SF cinema studies is an admittedly polemical one. Because of SF's close-knit relationship to processes of uneven exchange and traffic, we argue that the global allows us to reference the geopolitical in a way that other terms cannot. Both together and individually, the essays in this volume probe not only the possibilities for interconnection but also its limits, including asymmetrical access to resources, for in Frederick Cooper's words, "Attempts to posit a transition from multiple worlds to a single world system with a core and a periphery have been mechanistic and inadequate to understand the unevenness and the dynamics of such a spatial system."[17] At the same time, chapters by Nathaniel Isaacson, Porter, and Workman provide revisionist readings of the equation of capitalism and globalism through the grid of different world-making architectures: the politics, film histories, and cinematic styles of Communist and Socialist states.[18] As Porter notes in her triptych of Soviet SF, "These films offer fascinating counterexamples to SF narratives of commodification and consumption in capitalist societies," whereas for Isaacson, "The coral island, caught between the first and second worlds, serves as a theater for the examination of the relationship among capital, science, technology and political intrigue." Different locations in the world system produce different kinds of worlding, along with different frames from which to view globalization, its grand narrative both produced and undermined by the plurality of representational regimes described in this volume. Thus, our choice of *global* also is a way of illuminating SF's world-making strategies, with their implicitly totalizing gestures, as well as the utopic and dystopic visions of globalization that the genre addresses.

Indeed, perhaps more than any other genre, SF is deeply inter-

twined with globalization. This interconnected relationship presents particular challenges and opportunities for cinema. In this sense, too, globalization is both the process that produces these films and the concepts with which they grapple and depict in their diegesis and mise-en-scène. Scholars have frequently expressed the difficulty of representing globalization's seemingly totalizing grid; in the words of Jameson, globalization is "an untotalizable totality."[19] In reading these multiple investigations into SF cinema, we argue that the genre constitutes precisely that imaginative work, that impossible possibility of mapping our chaotic and frightening world from necessarily linked but incommensurable vantage points. We see the genre's potential for different kinds of resistance in chapters by Hamner, Choe, Cho, and Orbaugh, and even the "generalized, hybridized global city in East Asia" that Lamarre finds in Oshii's *The Ghost in the Shell* (1995) represents a negotiation between the abstract global and the phenomenologically concrete site of networked perception. The composite worlds that emerge in the SF films analyzed here by Chung are another prominent example of this effort; Chung examines how digitally composited ecosystems in recent SF blockbusters such as *Oblivion* (Joseph Kosinski, U.S., 2013) and *Prometheus* (Ridley Scott, U.S.-U.K., 2012) "embody and construct a shared visual imaginary or vernacular of 'Other' spaces—whether on this Earth or beyond—for global consumption." Although these otherworldly spaces are foregrounded on-screen, the real location (in this case, Iceland) is rendered invisible, a stand-in for another planet or for a post-apocalyptic United States. In his analysis of different intermedial visual installations, Jihoon Kim examines how their multiple platforms similarly depict Antarctica—often figured as the limits of the globe—as "less a stable geographical location than a site whose meaning, territory, and map are constructed by discursive and representational practices." These cinematic practices therefore emerge as the visible, aural, and tactile realization of how both implications of and alternatives to processes of globalization may be imagined, at times leading to a meditation on the medium of cinema itself, as both Choe and Kim suggest. Meanwhile, per Orbaugh's reading of the changing trajectory of Japanese anime creator Oshii's filmography, embodied SF—in particular Oshii's "cautious and fleshy vision"—offers us specific features, including narrative investment, embodiment, and the sensory—that theory alone does not.[20]

With the turn toward the transnational and the world in cinema studies, it has become something of a truism that cinema always has been globalized. At the same time, SF also has had pretentions to the same: to speak the apparently universal language of science, as Telotte demonstrates in his chapter. He observes how both SF and the cinema were lauded as "common languages," as ways to "successfully address a modern global audience"; and yet ultimately, these films reveal that "the 'language' of science and technology" is "less universal than was hoped." In this sense, SF culture—including but not limited to film—is, like Hollywood cinema in Miriam Hansen's seminal analysis, a global vernacular, as SF magazines from different parts of the world can attest.[21] Isaacson's chapter addresses the issue of loan terms (or *calques*) from scientific discourse in the case of mainland Chinese SF; along with other chapters in this volume, we might think of how SF itself operates as a "loan genre" in specific locales and traditions. For its part, the *rasquache* (defiantly, self-consciously gaudy or precarious) aesthetic that Hamner locates in the border SF of Alex Rivera offers a different example of SF's vernacularization.

Several chapters in this collection remind us that SF films are themselves global commodities, circulating on different scales as part of the increasingly more networked markets, media, and forms of transport that characterize globalization. For example, as Istvan Csicsery-Ronay Jr.'s chapter recounts, non-U.S. animation initially sprung up around the world unhindered by the material and aesthetic constraints often part of SF cinema production; more recently, however, we are witnessing the emergence of a global network of anime, less readily identifiable as national or regional. Lamarre's chapter, meanwhile, aptly juxtaposes the experience of the scan line in Oshii's films with recent Hollywood SF films. Rather than celebrating the global as a shorthand—or euphemism—for neo-liberalism's ostensibly unfettered circulation of goods (including films), contributions by Csicsery-Ronay Jr., Chung, Lamarre, Page, and Frelik probe both the possibilities and limitations encoded in the new mediascapes opened up by contemporary globalization, not only in terms of circulation but also regulation. The globalization of labor (for example, of animators and special effects artists), is one aspect of this broader process; Chung explains how contemporary nonlinear production processes shape the view-

er's awareness of the labor embodied in transnational SF locales from the very center of Hollywood film production.[22] On the other end of the budget spectrum, Frelik shows how the digital turn has led to more accessible forms of technology to inaugurate "a new paradigm of thinking about the character and role of the genre in contemporary culture" that differs from long SF films on the scales of production and distribution. Along with other chapters in the volume, these chapters suggest a shared concern with what Hansen has termed "provincializing Hollywood."[23]

Certain theoretical concepts, tropes, and figures feature implicitly and explicitly throughout the volume. No account of SF cinema would be complete without recognizing the ways in which works by Jameson, Donna Haraway, N. Katherine Hayles, Darko Suvin, and Annette Kuhn, as well as earlier scholarship by some of our contributors, have opened up new lines of inquiry.[24] In several instances, the chapters in *Simultaneous Worlds* directly engage these precursors, as well as the ways in which global SF asks us to reread their ideas. For example, Csicsery-Ronay Jr. shows how global SF anime helps us reconsider the attachment to realism that undergirds theories of SF from Suvin to Jameson; Workman also revisits Suvin's accounts through the elasticity of SF from North and South Korea. Meanwhile, Lamarre departs from Haraway and Hayles in his suggestion that we read the cyborg as a media platform that speaks to the "co-emergence of self and infrastructure."[25]

Finally, a caveat: Our emphasis on the global should not foreclose the importance of the nation-state as a theme and the residual importance of the national in cinema studies. As Abé Mark Nornes reminds, the national persists as a fundamental organizing category for cinema at the level of production, distribution, and reception.[26] In this collection, Pillai, Isaacson, Workman, and others suggest that nationalism in its distinct guises may in fact be the "logical" outcome of SF's pretenses to a universal language. Just as cosmopolitan cannot be unhooked from the nation, neither can the global, which stems from local attachments. Indeed, in many instances, transnational flows can be said to reinforce, rather than undermine, the authority of the nation-state.[27] Likewise, in other cases, the nation also could be regarded as a site of potential resistance vis-à-vis globalization.

Structure of the Volume

Although several chapters emphasize the residual centrality of the national for SF cinema, the volume overall facilitates new exchanges across disciplinary and area study divides and establishes itineraries that trace cinema's role in imagining global communities and global power struggles. *Simultaneous Worlds* is divided into five parts organized around shared theoretical issues. If, as Jameson argued early on, globalization "has no firm disciplinary home or privileged context," it likewise demands an interdisciplinary perspective, and accordingly, the collection moves freely among media theory, film studies, literary analysis, historiography, and sociology.[28]

The chapters that follow explore popular cinemas as well as independent, precarious, or alternative circuits. Some focus on readings of individual films, embedding them within a theoretical frame that interrogates the problem of the global. Others look beyond reading single works and toward broader problems of networks. In this way, the volume underscores the dialectic of global and local (or transnational and national) that characterizes contemporary filmmaking and viewing practices.

The collection begins by approaching SF through its location in media ecologies that are rapidly transforming very different sites, including screen cultures, Internet distribution of computer-generated shorts, special effects industries, and the contemporary art market. Part I, "Intermediality and New Media Economies," encompasses four interpretive angles on the evolving relationship between SF and various media formats in terms of technological (re)production, distribution, and consumption. Thomas Lamarre's "Scan Lines: How Cyborgs Feel" analyzes the concept of expanded television and the deployment of the scan line as a deliberate formal choice in *The Ghost in the Shell* franchise, demonstrating how it confronts the media problematic of cyborg perception by rendering visible the temporal disjuncture that results when media moves between platforms, transforming the relation between self and technologies as well as larger media infrastructures. Istvan Csicsery-Ronay Jr.'s "What Is Estranged in Science Fiction Animation?" analyzes what makes SF animation distinctive, demonstrating how specific cultures and subcultures of SF animation construct alternate regimes of physics. Paweł Frelik's "Famous for Fifteen Minutes: Permutations of

Science Fiction Short Film" charts the emergence of the SF short as
a multifaceted global phenomenon across media platforms, arguing
that its departure from the traditional narrative-centric focus offers a
new paradigm for thinking about SF in popular culture and cinema
in general. The fourth chapter in part 1, Jihoon Kim's "Forms of Jour-
ney and Archive: Remaking Science Fiction in Contemporary Artist-
Filmmakers' Projects," focuses on two recent projects, Pierre Huyghe's
video *A Journey That Wasn't* (2005) and Dominique Gonzalez-Foerster's
large-scale installation *TH.2058* (2008), examining how moving image
art's reflection on the cinema can be mapped into SF's imagining of
past futures. Kim details the various ways that these intermedial works
integrate the settings, spatiotemporal elements, and narrative tropes of
SF film, probing the fluidity of the medium of cinema.

Part II, "Traveling Science Fiction: Translation, Adaptation, and In-
terpretation," features three chapters that investigate various iterations
of SF as it crosses media and national contexts. In this sense, the part
functions as a miniature for the volume as a whole. In "Media Hetero-
topias and Science Fiction: Transnational Workflows and Transgalac-
tic Spaces in Digitally Composited Ecosystems," Hye Jean Chung illus-
trates how hybrid environments are composited out of transnational,
real-world locations and CGI effects in order to create otherworldly
spaces in two recent SF blockbusters, *Prometheus* and *Oblivion*. Like
Kim's chapter in part I, Chung's also draws upon Foucault's concept
of heterotopia, though in a very different context. As Hollywood be-
comes increasingly transnational in its production and distribution
(as it has long been in its reception), bringing so-called mainstream
and peripheral texts into conversation offers a unique take on these
processes. Additionally, Chung demonstrates how the global always
has been present in Hollywood SF, and not merely the commonplace
inverse: concealed in material landscapes and the international labor
that transforms them into fictional spaces. J. P. Telotte's "*F. P. 1* and
the Language of a Global Science Fiction Cinema" examines *F. P. 1
Doesn't Answer* (1932), a German-made film with versions in English
and French, from the perspective of a developing global SF in the early
sound period, focusing on how it addresses the challenge of crafting a
common cinematic language for a modern global audience. Swarna-
vel Eswaran Pillai's "*Enthiran, the Robot*: Sujatha, Science Fiction, and
Tamil Cinema" enacts a dialectical negotiation between Tamil culture

and the technological theories of Isaac Asimov, illuminating the transnational contexts of Tamil SF.

"Spatial and Temporal Alternative Modernities in the Global South," the third part of the volume, most explicitly engages the intersection between SF and postcolonial theory to probe the problem of modernity outside of its ostensible centers. Joanna Page's "Polytemporality in Argentine Science Fiction Film: A Critique of the Homogenous Time of Historicism and Modernity" sets the agenda to reread the historicist and diffusionist accounts of modernity associated with SF criticism through the alternative temporalities put forth by contemporary Argentine SF, in both live-action and 3D animation. Everett Hamner's "Virtual Immigrants: Transfigured Bodies and Transnational Spaces in Science Fiction Cinema" situates Alex Rivera's *Sleep Dealer* in the context of a broader turn in SF cinema toward a critique of bio-surveillance on a global scale, revealing how Rivera's film illustrates the rising propensity of SF cinema to turn techno-capitalism inside out, building social networks that redefine national boundaries and creating alternative stories of the dispossessed. His reading of *Star Wars* as an immigration narrative resonates with Chung's chapter, suggesting approaches to globalizing (or provincializing) Hollywood. The final chapter in part III, Emily A. Maguire's "Walking Dead in Havana: *Juan of the Dead* and the Zombie Film Genre," interprets the Cuban zombie film *Juan of the Dead* (2011) as a response to conditions in post-Soviet Cuba and as an ironic, specifically Caribbean, recasting of the nexus between the SF and zombie genres.

Part IV, "Techno-Capitalism and Techno-Desires: The Gendered Affect of Post-Cyborgs," presents three perspectives on how the machine–human interface may be rethought in the context of the global twenty-first century along the twinned axes of affect and desire. This part considers alternative amalgamations of the cyborg, insisting on its continued relevance for cinema at a moment when the cyborg may be considered to have gone out of fashion in critical theory. In "Who Does the Feeling When There's No Body There? Critical Feminism Meets Cyborg Affect in Oshii Mamoru's *Innocence*," Sharalyn Orbaugh uses Haraway's *The Companion Species Manifesto* to show how Oshii's films *Avalon* and *Innocence* deploy animals to theorize emotion and affect in a posthuman context, contending that these works constitute both extensions of and deviations from Haraway, in

particular her turn toward companion species and the relationship to the residual figure of the cyborg. Steve Choe's "The Invention of Romance: Park Chan-wook's *I'm a Cyborg, but That's OK*" draws on Kierkegaard and psychoanalysis to examine how this South Korean film presents the spectator with an extreme instantiation of love, revealing how this most intimate of relations also may be understood as a form of technics and SF that is specifically cyborgian in nature. Though both Choe and Orbaugh locate the cyborg at the center of their respective analyses, Choe challenges the humanism that is central to Orbaugh's piece. Michelle Cho's "A Disenchanted Fantastic: The Pathos of Objects in Hirokazu Kore-eda's *Air Doll*" reads the 2009 film about a sex doll who comes to life in two ways: first, as an example of a genre innovation that Cho terms the "disenchanted fantastic," and second, as a fantasized survival strategy against the depersonalized social relations in the lived spaces of late capital. The protagonists described in these essays are "not-quite" cyborgs who reveal alternative modes of pressing upon the human in late capitalism. As such, this part offers a vantage point for exploring the cyborg's residual influence as a cinematic figure—if the cyborg is theoretically "dead," then why is it continually resuscitated in twenty-first-century films around the world (for example, in Kise Kazuchika's 2013 *The Ghost in the Shell* prequel)? What kinds of deviations do we find in the cyborg's revival, and what alternatives emerge in its wake? In her "Unfinished Work: From Cyborg to Cognisphere" (2005), Hayles states that the cyborg "is not *networked* enough," arguing instead for what she terms "the cognisphere."[29] In his chapter in the first part of this volume, Lamarre ventures further, arguing that the cognisphere itself is "not enough." Although it certainly is true that the cyborg may no longer function as the heady metaphor it once did in theoretical discussions of SF and media/technology studies, as it migrates, its potential to be tricked up, distorted, or errant increases. Ultimately, for SF cinema, the figure of the cyborg as a point of departure continues to index and visually translate contemporary experience in a way that other material metaphors have not.[30] Indeed, Haraway's continual interrogation and revision of her own works constitutes her continuing importance for scholars, as Orbaugh's essay in particular suggests.

The three chapters in our collection's final part, "National, International, Intergalactic: Socialist and Post-Socialist Science Fiction

Cinema," traverse numerous national cinemas, mobilizing SF to offer unique visions of globalization from outside its capitalist frame. In "Alien Commodities in Soviet Science Fiction Cinema: *Aelita, Solaris,* and *Kin-dza-dza!,*" Jillian Porter compares three Soviet SF films from radically different periods—*Aelita, Queen of Mars* (1924), *Solaris* (1972), and *Kin-dza-dza!* (1986)—in an exploration of the paradox of the Soviet commodity, an object at once alien and integral to the project of socialist world building. Travis Workman's "Parodies of Realism at the Margins of Science Fiction: Jang Jun-hwan's *Save the Green Planet* and Sin Sang-ok's *Pulgasari*" analyzes how SF and fantasy elements in the South Korean film *Save the Green Planet* (2004) and the North Korean film *Pulgasari* (1985) are deployed to parody dominant realist modes of representation and narration in their respective film industries, in the process troubling the divide between SF and realism in cinema. Finally, Nathaniel Isaacson's "Media and Messages: Blurred Visions of Nation and Science in *Death Ray on a Coral Island*" concludes the volume with an examination of the multimedia phenomenon of the first mainland Chinese SF film as an expression of China's unsteady relationship both with the world and its own history, investigating the country's apprehensions toward global capital, scientific inquiry, and empire during the cultural ferment of the 1980s. Isaacson's exploration of a narrative (and scientific discourse) across different platforms also returns us to the intermedial investigations that open the volume.

In 1932, Universum Film AG (UFA) fashioned slightly different versions of the same futuristic flight in three different languages. In 1985, North Korea imagined a metal-eating monster descending upon its feudal past, while one year later, Soviet screens envisioned an alternate present in which Russian and Georgian strangers would become stranded on a desert planet. The title of our collection, *Simultaneous Worlds*, draws attention to the concomitant spaces and times produced within and through SF cinema and film criticism. As exemplified by the various on-screen incarnations of Fritz Lang's 1927 Maria and her vertically segregated metropolis, each film inaugurates its own worlds and temporalities, yet in terms of technologies, production, diegesis, consumption, and afterlives, these films also intersect.[31] In this sense, they encompass the shared worlds and shared moments of our globalized present.

Notes

1. See, for example, *Science Fiction Studies* 39, no. 3 (November 2012) and 40, no. 1 (March 2013) ("Special Issue on Chinese Science Fiction"); *Revista Iberoamericana* LXXVIII, nos. 238–39 (January–June 2012), a special issue on science fiction; Eric D. Smith, *Globalization, Utopia, and Postcolonial Science Fiction* (New York: Palgrave, 2012); Rachel Hayward-Ferreira, *The Emergence of Latin American Science Fiction* (Middletown, Conn.: Wesleyan University Press, 2010); Jessica Langer, *Postcolonialism and Science Fiction* (London: Palgrave, 2012); "Chinese Science Fiction: Late Qing and the Contemporary," *Renditions*, nos. 77 and 78 (Spring and Autumn 2012), special issues; Bodhisattva Chattopadhyay, "Recentering Science Fiction and the Fantastic: What Would a Non-Anglocentric Understanding of Science Fiction and Fantasy Look Like?" *Strange Horizons* (September 2013). The 2011 Eaton Conference held in Riverside, California, was titled, "What Is Global Science Fiction?" Other earlier, relevant texts include Wong Kin Yuen, ed., *World Weavers: Globalization, Science Fiction, and the Cybernetic Revolution* (Hong Kong: Hong Kong University Press, 2005); M. Elizabeth Ginway, "A Working Model for Analyzing Third World Science Fiction: The Case of Brazil," *Science Fiction Studies* 32, no. 3 (November 2005): 467–94; Ericka Hoagland and Reema Sarwal, eds., *Science Fiction, Imperialism, and the Third World: Essays on Postcolonial Literature and Film* (Jefferson, N.C.: McFarland, 2010).

2. Even volumes taking on global problems often confine these to the United States and its sphere of influence, reasserting the paradigm of its centrality to the world, reproduced in much of its SF film (with no signs of abating). In other instances where non-U.S. SF is brought to the table, center/ periphery binaries typically are reaffirmed rather than challenged, as in the case of *World Weavers: Globalization, Science Fiction, and the Cybernetic Revolution*, which tends to fall into the trap of the East versus West dichotomy (with "West" usually referring to the United States or Britain).

3. See, for example, Sean Redmond, ed., *Liquid Metal: the Science Fiction Film Reader* (London and New York: Wallflower, 2005); Annette Kuhn, ed., *Alien Zone: Cultural Theory and Contemporary Science Fiction Cinema* (London: Verso, 1990) and *Alien Zone II: the Spaces of Science Fiction Cinema* (London: Verso, 1999); Brooks Landon, *The Aesthetics of Ambivalence: Rethinking Science Fiction Film in the Age of Electronic (Re)Production* (Westport, Conn.: Greenwood, 1992).

4. Eric D. Smith's *Globalization, Utopia, and Postcolonial Science Fiction* argues that works of postcolonial SF (novels and film) can help us to reread postcolonial theory, rather than simply applying the latter to the former.

Smith argues that postcolonial SF is "the literary and cultural expression of the habitus of globalization" (16).

5. See Guiliana Bruno, "Ramble City: Postmodernism and 'Blade Runner,'" *October* 41 (Summer 1987): 65–66.

6. See Dina Iordanova, "Rise of the Fringe: Global Cinema's Long Tail," in *Cinema at the Periphery,* ed. Dina Iordanova, David Martin-Jones, and Belen Vidal, 36–37 (Detroit: Wayne State University Press, 2010). Iordanova includes video sites such as YouTube, online discussion forums, blogs, and social media among her examples of ways in which technology has diminished the foreignness of "foreign" cinema.

7. See Ron English, "Introduction," *Appropriating Technology: Vernacular Science and Social Power* (Minneapolis: University of Minnesota Press, 2004).

8. As Iordanova points out, the power of Hollywood often is overestimated: one-fourth of the world's most successful films are not Hollywood productions, and 25–30 percent of the forty internationally top-grossing films are not from the United States or the United Kingdom ("Rise of the Fringe," 28).

9. On SF genre as an increasingly porous category see, for example, Sherryl Vint and Mark Bould, "There Is No Such Thing as Science Fiction," in *Reading Science Fiction,* ed. James Gunn, Marleen S. Barr, and Matthew Candelaria, 43–51 (London: Palgrave, 2008); Carl Freedman, *Critical Theory and Science Fiction* (Middletown, Conn.: Wesleyan University Press, 2000).

10. Rick Altman, *Film/Genre* (London: British Film Institute, 1999).

11. See Wei Yang, "Voyage into an Unknown Future: A Genre Analysis of Chinese SF Film in the New Millennium," *Science Fiction Studies* 40, no. 119 (March 2013): 139, 134.

12. Contrary to Western media reports, time travel was not banned in Chinese media, but rather, in March 2011, SARFT instituted guidelines discouraging new TV programs from employing the popular trope of "supernatural time travel" (*shengguai chuanyue*) in favor of "improving the ideological and artistic quality of TV dramas." See the official SARFT statement here: www.sarft.gov.cn/articles/2011/03/31/20110331140820680073.html. See also John Berra, "The SF Cinema of Mainland China: Politics, Production and Market Potential," *Science Fiction Film and Television* 6, no. 2 (2013): 177–201.

13. There are, of course, exceptions, particularly in the case of martial arts and horror cinema from East and Southeast Asia.

14. As quoted in Abé Markus Nornes, *Cinema Babel: Translating Global Cinema* (Minneapolis: University of Minnesota Press, 2007), 20–21.

15. As Corey K. Creekmur and Linda Y. Mokdad observe, in the case of the international film musical, such ghettoization impedes "a comparative understanding of the musical as an international film genre." The same could be said

for SF as an international film genre. See "Introduction," in *The International Film Musical*, ed. Corey K. Creekmur and Linda Y. Mokdad (Edinburgh: Edinburgh University Press, 2012), 3.

16. On debates surrounding world cinema, see Nataša Ďurovičová and Kathleen Newman, eds., *World Cinemas, Transnational Perspectives* (London: AFI, 2010); Dudley Andrew, "An Atlas of World Cinema," *Framework* 45, no. 2 (Fall 2004): 9–23; Lucia Nagib et al., *Theorizing World Cinema* (New York: Tauris, 2012). Elsewhere, Dudley Andrew also argues that the term *global* is more totalizing than *world*, which implies transnational negotiations: Google would be an example of the former, while anime would be an example of the latter. See "Time Zones and Jet Lag: The Flows and Phases of World Cinema," in Ďurovičová and Newman, *World Cinemas*, 80.

17. Frederick Cooper, *Colonialism in Question: Theory, Knowledge, History* (Berkeley: University of California Press, 2005), 101. See also Ďurovičová, "Vector, Flow, Zone: Towards a History of Cinematic Translation," in Ďurovičová and Newman, *World Cinemas*, 96.

18. As Mark Bould and China Miéville point out in *Red Planets: Marxism and Science Fiction* (Middletown, Conn.: Wesleyan University Press, 2009), "SF world-building is typically distinguished from other fictional world-building, whether fantastic or not, by the manner in which it offers, however unintentionally, a snapshot of the structure of capitalism," not as a merely reflexive document of contemporary experience but as a kind of negative space, the imprint left after the work is completed (4).

19. Fredric Jameson and Masao Miyoshi, eds., "Preface," *The Cultures of Globalization* (Durham, N.C.: Duke University Press, 1998), xii; Carl Freedman, "Symposium on Science Fiction and Globalization," *Science Fiction Studies* 30, no. 3 (November 2012): 374–84. On films as cognitive maps and collective identities, see Andrew, "An Atlas of World Cinema," 17.

20. Gerry Canavan notes that the visual representation of worlds, for example, in *Pumzi*, "perform in miniature the cognitive work of sf in a time of globalization: to register, interrogate, and reconcile" different world histories of different worlds." Quoted in Freedman, "Symposium on Science Fiction and Globalization," 376.

21. See Miriam Hansen, "The Mass Production of the Senses: Classical Cinema as Vernacular Modernism," *Modernism/Modernity* 6, no. 2 (April 1999): 59–77.

22. See, for example, Toby Miller et al., *Global Hollywood* (London: British Film Institute, 2001), 44–82; *Global Hollywood. No. 2* (London: British Film Institute, 2008), 111–72.

23. Hansen, "The Mass Production of the Senses," 65.

24. See Donna Haraway, *Simians, Cyborgs, and Women: The Reinvention*

of Nature (New York: Routledge, 2013) and *When Species Meet* (Minneapolis: University of Minnesota Press, 2007); N. Katherine Hayles, *How We Became Posthuman: Virtual Bodies in Cybernetics, Literature, and Informatics* (Chicago: University of Chicago Press, 1999), "Unfinished Work: From Cyborg to Cognisphere," *Theory Culture Society* (2006): 23/59, and *Writing Machines* (Cambridge: MIT Press, 2002); Rob Latham, *Consuming Youth: Vampires, Cyborgs, and the Culture of Consumption* (Chicago: University of Chicago Press, 2002); Fredric Jameson, *Archaeologies of the Future: The Desire Called Utopia and Other Science Fictions* (London: Verso, 2007); J. P. Telotte, *A Distant Technology: Science Fiction Film in the Machine Age* (Middletown, Conn.: Wesleyan University Press, 1999); Thomas Lamarre, *The Anime Machine: A Media Theory of Animation* (Minneapolis: University of Minnesota Press; 2009); Istvan Csicsery-Ronay and Takayuki Tatsumi, eds., *Robot Ghosts and Wired Dreams: Japanese Science Fiction from Origins to Anime* (Minneapolis: University of Minnesota Press, 2007).

25. Similarly, SF studies of the Global South have questioned Haraway's earlier paradigms and their limitations, something that Haraway herself acknowledged in the wake of the publication of "Manifesto for Cyborgs: Science, Technology, and Socialist Feminism in the 1980s," in which she notes the difficulties inherent in appropriating figures like the trickster or coyote from African and Native American cultures or immigrant women like the Malay laborers in her "Manifesto" as a white, first world woman through the pronoun *we*. "Manifesto for Cyborgs: Science, Technology, and Socialist Feminism in the 1980s," *Socialist Review,* no. 80 (1985): 65–108. See also Constance Penley and Andrew Ross, "Cyborgs at Large: Interview with Donna Haraway," *Social Text* 25/26 (1990): 10, 17.

26. See Nornes, *Cinema Babel,* 6–7.

27. See Cooper, *Colonialism in Question;* and Aihwa Ong, *Flexible Citizenship: The Cultural Logics of Transnationality* (Durham, N.C.: Duke University Press, 1999).

28. See Jameson, *Archaeologies of the Future,* xii.

29. See Hayles, "Unfinished Work," 159.

30. On material metaphors, see Hayles, *Writing Machines.*

31. See Andrew, "Time Zones and Jet Lag," 59.

Part I Intermediality and
New Media Economies

1 Scan Lines

How Cyborgs Feel

So often cyborg perception in cinema and animation appears in the form of a mechanized or technologized eye moving through the world, as if looking through the viewfinder of massively enhanced monocular apparatus, that also offers a broad range of sensory measurement of the environment, from infrared night vision and zooms to facial recognition and pattern matches.[1] Such a presentation gives the impression that there is a seer behind the seeing. You are invited to see with cyborg eyes (rather, eye), as if perception were primarily a matter of a seer sitting inside someone's head. Thus it is possible for you to look through their eyes—and to hear through their ears. In fact, cyborg hearing typically gravitates toward voices in the head, that is, hearing messages from other cyberized entities without their actually speaking, without emitting sound into their surroundings. Rather, speech is (one supposes) formulated and transmitted electronically or digitally (without any initial production of sound waves), yet is received through an activation of the human sensory apparatus for hearing, and then heard as if in the head.

Cyberized transmission and reception of speech is commonly distinguished perceptually from noncyberized modalities (people talking to one another without prostheses) by adding reverberation to cyber-transmitted voices, as if they were being heard within something. With both cyborg seeing and hearing, the effect is that of a perceiver behind the perceiving, a disembodied subject that may readily move from body to body, while bodies begin to figure as nothing more than apparatuses for the transmission and reception of images and sounds, as disposable and exchangeable as cameras or mobile phones. These examples of cyborg perception are drawn primarily from

3

animations in the *Kōkaku kidōtai: The Ghost in the Shell* series, which includes Oshii Mamoru's two animated films, *The Ghost in the Shell* (1995) and *The Ghost in the Shell: Innocence* (2004), and Kamiyama Kenji's two animated television series, *The Ghost in the Shell: Stand Alone Complex* 1st Gig (2002–3) and 2nd Gig (2004–5), which was followed by his television movie *The Ghost in the Shell: Stand Alone Complex: Solid State Society* (2006), and more recently four entries in a series of animated prequel films, *The Ghost in the Shell: Arise* (2013–14), directed by Kise Kazuchika. But cyborg perception is so consistently staged in this manner across a range of films and animations produced in various locations around the world, that it is surely a familiar trope for viewers of other cyborg films and animations.

What is striking about such a staging of cyborg perception is that it seems to confirm the dualism of mind and body, a divide between the perceiver-subject and the perceptual machine-organ. As such, it runs counter to claims made for how cyborgs signal a rupture with Cartesian dualism, for what is staged in such instances is the very possibility of a disembodied subject. Of course, this sort of perception is not all that happens in films and animations dealing with cyborgs. Moving images do not and probably cannot remain fixated on one sort of perceptual experience. There is, for instance, a relation between seeing and hearing, which adds a twist. Still, this twist may be construed in terms of a disjunction of voice and image and thus as an instance of the existence of a disembodied networked self, as Christopher Bolton does in his account of Oshii's *The Ghost in the Shell*.[2] In contrast, Hyewon Shin, dealing with the same animated film, finds that the correlation of voice and body (image) results neither in synchronization nor voice-off, which paves the way for a new understanding of our connection with nonhuman entities in general, one not based in Cartesian optics and thus subjective mastery.[3]

As the contrast between Bolton and Shin indicates, even when persuasive arguments are made for how cyborgs go beyond the Cartesian ego, it nonetheless reappears, in the paradigmatic form of disembodied perception. If Cartesianesque forms of cyborg perception—seeing through the massively mechanized eye and hearing voices in the head—remain a major source of attraction, it is not only because they offer a futuristic or high-tech feel but also because they offer a "media problematic," a site of perceptual focus where technologies seem at

once to be holding things together and to be pulling them apart. This is the lure of cyborg perception.

At the same time, if cyborgs today arouse less theoretical enthusiasm and controversy than they did in the 1990s, it is because the cyborg problematic came to an impasse in its reliance on a certain way of contesting the disembodied subject or Cartesian ego. Katherine Hayles explains, for instance, the importance of Donna Haraway's seminal article, "A Manifesto for Cyborgs," published in 1985: "Deeply connected to the military, bound to high technology for its very existence and a virtual icon for capitalism, the cyborg was contaminated to the core, making it exquisitely appropriate as a provocation."[4] Yet she also adds, "The cyborg no longer offers the same heady brew of resistance and co-option. Quite simply, it is not *networked* enough. . . . The individual person—or for that matter, the individual cyborg—is no longer the appropriate unit of analysis, if indeed it ever was."[5] Hayles offers instead the paradigm of the "cognisphere," or computationally distributed cognition, to overcome what she sees as the impasse of cyborg theory: taking *the individual* as *the unit* of analysis. Still, she finds a potential solution in Haraway's work, in its general commitment to *thinking relation.*

Although I fully agree that thinking relation presents a powerful alternative, I tend to think that the impasse of the cyborg problematic lies not so much in its emphasis on the individual as in its recourse to a disembodied subject. Feminist critics exploring new materialisms called attention to this problem. Vicki Kirby, for instance, questioned the assumption that net avatars, for instance, had no materiality, reminding us that their immateriality meant neither "an absence of materiality" nor "pure subjectivity."[6] Ian Hacking approached the cyborg impasse from a different direction, and cited this passage from Haraway to signal a troublesome proximity to Descartes in her take on the relation between humans and machines: "Late twentieth century machines have made thoroughly ambiguous the difference between natural and artificial . . . and many other distinctions that apply to organisms and machines."[7] Both Kirby and Hacking suggest that the impasse of cyborg theory comes of a methodology that posits distinctions and then blurs them. The alternative (thinking relation) is not, however, merely a matter of turning away from individual terms to look at the relationship between them, thereby shifting attention from

the individual to collections of individuals or interactions between individuals. Such a move merely displaces the disembodied subject onto a networked or distributed subjectivity or cognition. Such a move reaches an impasse not only because an emphasis on cognitive or logical structures discourages an account of material practices; it also becomes difficult to account for the relation between materiality and immateriality, which is precisely where the media problematic of the cyborg—"cyborg mediality"—happens.

The challenge of thinking relation lies in attending to relation prior to the emergence of the two terms (human and machine in Haraway; consciousness and computation in Hayle) that at once grounds their distinction and is produced and changed by their interaction. As such, it is not a question of looking at how computation distributes consciousness but of considering *what relation distributes experience into computation and consciousness* (or into human and machine), and how their interaction potentially transforms that relation. This is what William James refers to as an instance of "pure experience," which operates as a "little absolute." It is the primary stuff from which both subjective and objective are differentiated and integrated within this specific universe, our cyborg universe.[8] This is how cyborg mediality operates. Films and animations are good to think with in this context because they work with and through experience.

Returning to our initial problematic of cyborg perception, we see that an impasse arises when we accept the distinction between perceiver and perceived, only to argue that the distinction then becomes blurred or ambiguous. For we then accept the idea of a disembodied transcendent subject that undergoes a crisis of identity. Challenging the disembodied subject thus demands working to some extent against the grain of some of received stories about cyborgs, which often stage such a crisis of identity on the part of cyborg, reinforcing the idea of a preexisting subject that is thrown into crisis by technology. Oshii Mamoru's first *The Ghost in the Shell* animation, for instance, stages a general crisis of identity in which anyone with a cyberized brain can have his or her or their brain hacked, and thus actions controlled, and memories altered or wiped. Yet, thinking the relation requires that we complicate this paradigm of a preexisting identity that is threatened by technical alteration. Fortunately, *The Ghost in the Shell* also offers another cyborg problematic, that of "ghost," which is sometimes glossed as soul.

The ghost is matter of embodied experience and intuition of the world rather than disembodied subjectivity. It entails, in effect, *feeling* rather than perceiving. Where the perceiver seems to reside in the shell (or in the head) and to stand outside the world, the ghost feels the world and the self at the same time, prior to the perceiver being conscious of either. Sharalyn Orbaugh builds on Teresa Brennan's work to highlight this aspect of Oshii's film: "Affect does not arise solely or even primarily from within a self-contained, autonomous body. . . . Affect moves between (and into and out of) bodies in a literal, physical sense."[9] Raymond Ruyer's take on consciousness also comes to mind: "The elementary acts of consciousness of which our wakening state is made, are micro-dreams, from which we are at every instant awakening in order to get back to our story."[10]

Such a ghost offers a speculative counterpart to the techno-scientific pragmatics of *The Ghost in the Shell* world: the pragmatics, for instance, of producing a cyborg body, cyberizing a brain, transferring a consciousness into a new prosthetic body, dubbing a ghost. It also hints at a definition of science fiction as a mode of reading: reading the speculative not in opposition to the pragmatic but in terms of the contingencies of the speculative-pragmatic relation. After all, the speculative may well prove pragmatic if it affords a productive reading of science.[11]

The Ghost in the Shell animations offer an experiential analog to the ghost, in the form of the scan line, which dramatizes the relation between materiality and immateriality, in the register of infrastructure and self. Beginning with Oshii's *The Ghost in the Shell* animated film, cyborgs not only stand apart from the world as disembodied subjects perceiving the objective world through technologically enhanced organs. They also feel the world in scan lines, which are, in effect, material residues or artifacts of communication and transmission, which usually tend to escape notice. Yet with the scan line, the world and other entities in it are in turn feeling the (individual) cyborg: the relation between individual and collective is at once being produced and becoming productive in a mode of affective communication. This is communication in the concrete sense of "building with."[12]

Before discussing the specific affective and speculative functions of the scan line in Oshii's *The Ghost in the Shell*, I first consider it more generally.

Disjunctive Synthesis

When a television screen makes an appearance within a movie, rows of fine lines often appear on the screen, dark narrow bands traversing the bright image. These scan lines commonly result from a disjuncture between two media platforms. For instance, the movie camera is capturing images at a frame rate different from the frame rate or refresh rate of the image on the television screen. The movie camera thus picks up what the human eye does not perceive on the television screen: cathode rays fire half the image at a time in alternating rows at a rate faster than the human eye can detect. The movie camera, however, shooting at a faster rate, catches the interlacing of the two images, and the result is a striping effect of darker and lighter bands across the image. In effect, we are seeing an encounter of two different media rates or media temporalities: if we see the underlying temporality of the television screen's refresh rate, it is only because we perceive the television screen via the temporality of the movie camera.[13]

The scan line is thus an almost paradigmatic example of what Gilles Deleuze called "disjunctive synthesis," a notion that Deleuze and Guattari, in their reworking of Marx and Lacan in *Anti-Oepidus*, retooled to characterize the "production of distribution."[14] Indeed, scan lines make perceptible the underlying experience of how distribution across media is produced: the interface between two media platforms—movie camera and television screen, for instance—does not entail a blurring of distinctions but rather a mode of simultaneously holding together and holding apart differences between media, which occur in this case in the register of frequencies or temporalities.

Scan lines also can appear when something recorded at one rate is replayed at a different rate, which we generally associate with video playback when the frequency of the screen does not match that of the video. Footage shot with surveillance cameras commonly is presented with scan lines to indicate a discrepancy in resolution between two platforms. Moreover, the first game systems used a non-interlaced signal and introduced frames with 240 lines for compatibility with television screens, yet the resulting difference in frequency produced scan lines on the image, which today are associated with "classic" video games.

In sum, scan lines appear for different reasons in different contexts (and there is the related "roll bar" effect), but the basic operation is

one of *disjuncture between media platforms at the level of temporality,* as rate or frequency. Because scan lines appeared historically in media practices associated with television screens that used cathode ray tubes and interlaced images, in the context of such processes as adapting video games, playing back camcorder footage, and filming television screens, scan lines have gradually become associated with the experience of television screens in general. As such, even in recent films, when television screens make an appearance on screen it is common to present them with scan lines.

For instance, in recent high-profile American movies such as *Bourne Legacy, Total Recall, Warm Bodies, The Call,* and *World War Z,* scan lines are prominent on television screens. Such a use of scan lines is rather surprising, particularly in light of the emphasis in many such films on high-tech media or futuristic technologies. After all, the use of cathode ray tubes or CRT screens is a thing of the past: production of cathode ray tubes ceased in 2012, and current television screen technologies (liquid crystal and plasma displays) do not interlace images. When filmed, liquid crystal displays tend to generate a moiré effect rather than scan lines. Indeed, in Kamiyama's *The Ghost in the Shell: Stand Alone Complex* television series, produced in the early 2000s, the effect of filming screens gradually becomes rendered as geometric crosshatching on the image rather than scan lines. In the recent anime reboot of the "Space Battleship Yamato" series, *Ūchū senkan Yamato 2199* (2013), the media technology of technologically advanced aliens, the Garmillas, is characterized by forms of crosshatching on screens, in contrast to the scan lines appearing on screens used by humans, who are presented as less advanced technologically. In other words, there are some signs of a conscious shift away from the scan line in some Japanese animations, with deliberate characterizations of the scan line as belonging to a prior, lower tech moment. Nonetheless, scan lines remain the most common way to stage effects of transmission in films and animations. When crosshatching appears as an alternative, it is usually in oscillation with scan lines, which suggests a lack of certainty about whether a transition is indeed under way, and whether it is or can be complete.

Because scan lines today usually are added to the image as special effect, rather than appearing spontaneously as an artifact of filming, their continued usage is all the more striking. In cinema, it is possible

today to eliminate scan lines when filming television screens. In *Argo*, for instance, in keeping with the general mission of the film to create the sense of a direct seamless relation to the past, television screens do not show scan lines and do not produce an experience of disjuncture.

In sum, as these brief examples indicate, the appearance of scan lines entails something more than a simple and direct artifact of filming. Conventions have developed around the presentation of television screens within moving images, and in recent films such as *Total Recall*, *Bourne Identity*, *Warm Bodies*, *The Call*, and many others, scan lines apparently were added to television screens in post-production, as special effects, rather than arising in the process of filming with a movie camera operating at a different frame rate than the television screen. In this respect, cinema is hand in glove with animation.

When scan lines are added as effects to certain images, it is in order to mark them as *scanned-transmitted images*, that is, images operating across a disjuncture between what is shown-recorded and what is transmitted-received. In the films mentioned previously, a contrast between television and cinema arises, in the form of a contrast between scanned-transmitted images (television) and filmed-projected images (cinema). Cinema does not pretend to provide an invisible or transparent mediation of television: when scan lines appear, we know we're watching cinema and television at the same time. Nonetheless, there are a variety of ways of negotiating this effect.

In *Total Recall*, for instance, marking screens with scan lines plays into the movie's central concern—how to distinguish genuine memory from implanted memory—by establishing a firm distinction between the media world and the real world. Such a distinction thus actually serves to stabilize at the level of media forms the very distinctions that the film proposes to destabilize at the level of plot and action. Marking television screens with scan lines reassures viewers that at some level there is the possibility of keeping things straight or, to evoke Thomas Elsaesser's notion, of solving the puzzle upon repeated viewing.[15] Similarly, in *Bourne Legacy*, scan lines remind us of the continuous presence of information surveillance by indicating that what is seen is being seen by someone and potentially recorded and transmitted. In such instances, the moment of disjunctive synthesis underscores an oscillation between two realities that takes on the form of a puzzle, which holds out the possibility of an answer or resolution,

that is, a determination of which reality is genuine. How you respond to the film depends a great deal on whether you feel that the film needs to provide a conclusive answer or whether puzzlement itself is sufficient entertainment. As already mentioned, *Argo* goes in the opposite direction: television screens do not show scan lines nor an experience of disjuncture, which is in keeping with the film's concern for capturing the year 1980 accurately: there is no disjuncture between the movie camera and television media. In sum, scan lines may be evoked in a variety of ways. They may even be utilized nostalgically, for instance, as signs of the good old days of television or the classic era of video games.

As their prevalence in *Total Recall* and *Bourne Legacy* indicate, scan lines are frequently used today to impart an aura of high-tech telecommunication and information networks. In fact, scan lines have even become a sign of the digital. To impart an aura of high-tech digital media events, trailers for films frequently increase the number of images showing screens with scan lines. *The Call* is a good example, because it not only shows television footage with scan lines but also imbues its graphics and its look with scan lines in order to give the sense of proliferating humming networks of information, weaving together cell phones, cameras, and screens. Similarly, books on digital media in Japan from the late 1990s and early 2000s feature images with scan lines.[16]

It may seem odd that the scan line, associated with now outdated CRT technology and low-resolution video, has forged such a dominant association with cutting-edge digital and multimedia effects rather than functioning primarily as cause for nostalgia. Yet if we look at what is happening in scan lines, this association makes perfect sense. At work in the scan line is disjunctive synthesis, which builds together different media operations of capturing, sending, and receiving. The disjunctive synthesis might even be said to entail a communicating communication, recalling Niklas Luhmann's dictum, "Only communication communicates."[17] Or, put otherwise, only building with builds with.

At the same time, insofar as the experience of the scan line derives from the media world of CRT television screens with consoles or plug-ins (VCR, game consoles, and camcorders), it reminds us that contemporary media infrastructures have a deeper history, a history that is not a simple succession of forms but the transformative prolongation

of a diagram or *dispositif*. Recall that the refresh rate for computer screens for many years was modeled on that of the television screen, building an analogy between computer and television screens that was not in any way technologically necessary. Although today neither television nor computer screens employ interlaced images, the ease with which computer screens are used for viewing television is surely due at least in part to this initial analogy constructed between them.

The critical question with scan lines, then, is not that of whether they appear or not. It is one of how and how much the effect of disjunctive synthesis is deactivated (enclosed or contained within a stable semiotic system) or activated (amplified and prolonged in experience). Reproducing scan lines for nostalgic effect, mobilizing them as general indicators of media interfaces, or using them to stabilize an underlying distinction between real world and media world—these practices tend to deactivate the scan line. Films with media puzzle effects such as *Total Recall*, *Bourne Legacy*, and *Inception* are difficult to gauge, because such films studiously, even laboriously hover at the tipping point, vacillating between activation and deactivation. If films with puzzle effects based on staging disjunctive synthesis via scan lines are becoming more common, it is surely because there is an increased awareness of scan lines as an actual effect, as an active force, rather than an artifact to be tolerated or ignored. Significantly, it is for the same reason—because it does not generate scan lines as an "artifact" of the production process—that animation tends to show a greater awareness of them and a tendency to use them actively, forcefully. In addition, because so much animation is produced for television or for release on video, DVD, or Internet, it frequently shows increased awareness of effects that were initially associated with the experience of "small screens," that is, televisions and computer monitors. The use of scan line effects in animation, then, should not be considered to be secondary to or merely derivative of cinematic effects. In this instance, the idea that animation is operating at a remove from the indexical capture associated with live action filming does not imply a diminishment of an original but rather a sustained engagement with and prolongation of an effect.

This is precisely what happens in Oshii's *The Ghost in the Shell*: the scan line is activated to address the media problematic associated with cyborg perception: the moments of cyborg perception in which there

seems to be a perceiver behind the perceiving, a disembodied subject, presents an experience in which new technologies (information and telecommunication networks) seem at once to be holding together mind and body, human and machine, and to be tearing them apart. In response, Oshii's animation highlights and expands the effect of the scan line. It thus invites us to consider how a disjunctive synthesis between media platforms is the site of a "pure experience" or "little absolute" that at once generates and grounds distinctions between human and machine, and between mind and body, while being prolonged and transformed by their interaction. In this respect, Oshii's animation feels more in touch with the implications of building with media platforms than do many of the recent films cited here.

Expanded Television

Serialized in Kōdansha's weekly manga magazine, *Young Magazine*, between April 1989 and November 1990, and released in book format in Japanese in 1991, and in English in 1995, Shirow Masamune's manga *Kōkaku kidōtai: The Ghost in the Shell* presents a series of eleven story-chapters set between 2029 and 2030. Stories center on section 9, a highly secret special ops unit led by Aramaki Daisuke, initially set up as an antiterrorism squad under the Ministry of Internal Affairs, but reconfigured by the end of the second chapter, "Super Spartan," into an international hostage rescue unit reporting directly to the prime minister.[18] Section 9 is characterized as an offensive assault unit deploying high-tech power suits or tactical armors, hence the Japanese title *Kōkaku kidōtai* or "armored mobile troops." The central characters, members of section 9, range from humans with very minimal prosthetics and cyberization such as Togusa, to humans with entirely prosthetic bodies and highly cyberized brains such as Major Kusanagi Motoko and Batou as well as gynoid robot operatives referred to as speakers, and spiderlike intelligent mobile tanks called Fuchikoma.

Chapters consist largely of stand-alone stories, but in the first volume, a larger storyline emerges across chapters 3, 9, 10, and 11, in which the Major, the female cyborg Kusanagi Motoko who is ace squad leader of section 9, encounters a criminal called the Puppet Master who is hacking into human cyberbrain ghosts to control their actions like a puppeteer. He (the manga presents this AI as male) turns out to be a

new form of intelligence, accidentally generated through governmental experiments with AI, which is now seeking a way to prolong its life. Realizing that self-replication will not result in genuine reproduction (temporal stability across fluctuations), the Puppet Master develops a plan to fuse with the Major to produce new entities that will inhabit the Net. This mode of fusion is presented in terms reminiscent of disjunctive synthesis: fusion does not result in a blurring of distinctions insofar as both entities are said to retain their distinctive identities within their fusion or unification.

Oshii's 1995 animated film follows this storyline fairly closely, but transforms it into a media problematic by working with different kinds of images that present distinct media types. Especially salient is the contrast between computer images and images of the everyday urban world, that is, between cyberscapes and cityscapes. Cyberscapes are images resembling what would appear on a computer screen, which are transmitted directly from computers to cyberized brains (Figure 1.1). For instance, computer graphics track the location of a car upon a grid, allowing section 9 cyberpolice to pursue their quarry. Such images are accompanied by voice-overs that do not function in the manner of voice-over but as "voice-across," indicating transmission across network channels. Such imagery may appear crude in design by contemporary standards, consisting of a black screen with simple geometric layouts in glowing green, but the idea is contemporary enough: there is a direct digital transmission of GPS tracking information into the cyberized brain. Such cyberscapes, with their simplicity of design, color, and illumination, contrast sharply with the cityscapes.

Oshii's animation was renowned for its use of techniques of rotoscoping in creating the urban world of *The Ghost in the Shell*. Particularly famous is the sequence in which the Major travels through the city by boat on canal, which, like many other sequences in the film, was based on camcorder footage shot by Oshii in Hong Kong (Figure 1.2). Animators did not digitally paint the footage in the manner of films like *Waking Life* (2001) and *A Scanner Darkly* (2006), but rather the footage provided a point of reference for the creation of what might be called "video realism." If Oshii's animation is said to entail greater realism, it is because, on the one hand, its future world feels lived in, that is, grimy and seamy rather than clean and glossy, for which the noir-like aesthetics of *Blade Runner* were a source of inspiration. On

Figure 1.1. An image of tracking information transmitted directly into a cyber-ized brain from *The Ghost in the Shell,* which contrasts sharply with the film's cityscapes.

the other hand, realism entails a sense of accuracy in depicting pocked and pitted surfaces as well as detailed painting to impart depth to the image. The result is a world of muted tones, full of depth and detail yet without sharp corners and boundaries, as if in lower resolution than high-speed cinematography. Even when brilliantly colored, fully illu-minated advertisements and street signs appear on screen, their hues are somewhat less saturated than expected, which imparts a tinge of warmth and intimacy, in keeping with the feel of camcorder footage. This video realism, with its combination of high detail with some-what low-resolution depth and lesser saturation, contrasts sharply with the geometric simplicity and bold black-green illumination of cyberscapes.

What is the relation between these two distinct perceptual experi-ences, between these cyberscapes and cityscapes that feel like different worlds?

The story opens a potentially antagonistic relation between them. The film follows the manga and opens with a statement about the ten-sion between computerization (corporate networks and flows of infor-mation without physical boundaries) and the persistence of bound-aries in the form of nations and ethnic groups. Put another way, there

Figure 1.2. The sequence in which the Major travels on a boat on the canals winding through the city provides a prime example of the tendency toward "video realism" in *The Ghost in the Shell*.

are two sorts of infrastructure implying different kinds of experience: the almost oceanic experience of unbounded flows of information in corporate computer networks, and the experience of persistent or residual boundedness related to geopolitical frameworks and legal institutions. *The Ghost in the Shell* thus seems to flirt with the notion, dubious yet popular in the 1990s, that globalization tended to eliminate national boundaries and ethnic affiliations.[19] Significantly, while Shirow's manga situates the action within Japan, Oshii's animation does not emphasize its location, thus implying a generalized, hybridized global city in East Asia. As such, the scale already seems to be tipping in Oshii's version toward a vision of the global city as a site that is neither globalization nor nation, neither infinite network nor finite enclave, but some amalgamation of them.

At the same time, in keeping with Shirow's manga, Oshii's animated film displaces the geopolitical question (crisis of national sovereignty) onto questions of identity and selfhood (crisis in personal sovereignty). It displaces them especially onto the Japanese female cyborg, the Major, who is particularly prone to doubt her identity. The geopolitical problematic is thus displaced onto a crisis of the Cartesian ego or disembodied subject, which is mobilized and called into question at

the same time: if one's self is infinitely transferable from one prosthetic body to another, how does it remain the same self? Such doubts assail the Major, especially in the wake of two incidents in which the Puppet Master has hacked into the human cyberbrain, implanted a fake memory, and taken control of a conscious person. The sovereignty of consciousness, of a self-identical conscious self, appears at once highly desirable and unsustainable. How to know if you are a puppet or not?

It is possible to tease a conceptual answer to this cyborg conundrum out of philosophical discourses running through the film, and Oshii's films are famous for their protracted discussions of conceptual and geopolitical issues, often accompanied by direct quotation of an array of major thinkers.[20] Yet the genius of Oshii lies in the transformation of such questions, crises, and paradoxes into media problematics. Indeed, protracted discussions and extended citation always occur in conjunction with sequences that highlight media and technology. Clearly, conceptual questions and discourses are not autonomous of media through which they appear. Moreover, even in conceptual terms, the direction taken by the Major in Oshii's *The Ghost in the Shell* hinges on a media problematic related to perceiving and feeling: she soon realizes that, if the continuity of the conscious self cannot be guaranteed, then continuity must be sought at another, nonconscious, and even "nonsensuous" or "nonappearing" level, namely, that of the ghost, which entails an experience of something on the fringes of consciousness, never quite appearing as such but decidedly present nonetheless.[21]

The challenge of shifting attention to the media problematic is that it is no longer possible to look at the identity crisis in terms of a problem with an answer or a contest with a victor. Taking a discursive side—for instance, siding with the nation or ethnicity against corporate information globalization, or vice versa—resolves nothing. Oshii instead situates us within a media experience of the problematic, which becomes salient in the contrast between cyberscapes and cityscapes.

Cyberscapes offer a tentative experience of disembodiment: you see what the cyborg sees (computerized imagery) and hear what the cyborg hears (voices in the head reverberating) as if you could occupy that body, as if a body were but a center of perception. A pattern of "shot and reverse shot" may step in to remind you that this is what Batou or the Major is experiencing. Yet, even with shots that connect

perceptual experience to a particular body, you don't know what to feel because these cyborg faces are entirely impassive, without the slightest display of emotion. Cyborg faces are thus like the cityscapes: fleshed out in detail, modeled in depth, implying possibilities for warmth and intimacy, but somehow floating and dreamlike in their low-res clarity. The low rhythmic pulse of the music over the longer sequences increases the detached quality of the scenery. In one sequence in which the Major ponders the reality of her self, as the viewing position gradually comes closer to her face, the layers of background cityscape appear to separate, as if the city had become unmoored, and a voice that does not seem to be hers speaks, laden with reverberation to signal that its source is cyber.[22] In other words, as you shift back and forth between experiences of the disembodied subject and images of the actual world, the video realism of the actual world does not provide as strong a sense of embodiment as you might expect or desire. The crisis of the Cartesian subject, then, is not merely in cyberscapes or cityscapes but in their relation. Within and across cyberscapes and cityscapes, there are continual desynchronization and resynchronization of seeing and hearing, reminiscent of Michel Chion's notion of cinema as audiovision, which Massumi describes as "a singular kind of relational effect that takes off from both vision and audio but is irreducible to either."[23] Like the Major, you may well wonder, What is it that allows these two aspects to stand apart and to hold together? What is their relation?

If you pay attention only to the action of the film, there is an accelerating pattern of alternation between the two audiovisual types that does afford a certain degree of blurring, as if the two terms were gradually merging, as the spokes of the wheel appear to blur when the wheel turns rapidly. Things will somehow cohere, you feel, provided everything continues to accelerate until the end. In addition, there are moments in which the cyber-images are layered into the images of the actual world, usually in the form of computer displays that appear in luminous translucent green, projected from who knows where. Yet, at the same time, the languid pacing of some sequences in *The Ghost in the Shell* reminds you that at any moment the distinct terms may precipitate out of the mix as soon as the stirring slows: the terms are in colloidal suspension instead of dissolving into a solution. The experience of the film is as much one of incipient precipitation as one of action accelerating to an end. The pockmarks ripped into the wall by

bullets recall the ripples caused in a puddle as raindrops start to fall. Events are precipitating. . . .

It is precisely at this point that you might notice something unusual about the staging of cyborg perception: scan lines. Horizontal bright and dark bands stripe the screen when you move into the cyborg's field of perception. The first instance almost escapes notice: in the opening sequence, the Major sits on the rooftop of a skyscraper, gathering information about an illegal meeting, establishing the coordinates and timing for her "intervention" (she dives from the building in thermo-optic camouflage, crashes the meeting from the outside window to kill her target, momentarily becomes visible, and then fades into her camouflage again as she falls toward the city streets). As she sits and gathers data, the sequence alternates between green screen computer images and video-real cityscapes, but for a moment, when she looks down into the streets, the screen is striped with scan lines. It is easy to miss this fleeting instance of perception that is neither cyberscape nor cityscape, and both. Later, however, the film suddenly brings this mode of perception to the fore. Section 9 learns the whereabouts of the Puppet Master (he is in the body of a cyborized man who is in turn taking control of a cyborized man, a garbage collector), and the garbage man rushes to warn him. As the cyberized man looks at the approaching garbage truck, he perceives the world in scan lines (Figure 1.3). And in the subsequent sequence in which Batou and the Major chase him through backstreets and a marketplace, Batou's perception is also characterized by scan lines. Finally, in the penultimate scene in which the Puppet Master and the Major fuse, perception is consistently, even insistently, rendered with scan lines. The scan line becomes impossible to ignore. Similarly, Oshii's *The Ghost in the Shell* does not so much build toward a resolution of conflicts as it stages a disjunctive synthesis: two entities merge without losing their distinctiveness. Because such a synthesis was always already present in the scan line, the merging or fusing of the two entities is less a break with the existing order of things than its defining moment. But how does such a disjunctive synthesis work, concretely and specifically, in *The Ghost in the Shell*?

First, because the scan lines characterizing cyborg perception are identical to the scan lines that arise when shooting video footage, the cyborg is situated as a sort of media platform. The analogy to the

Figure 1.3. In this sequence from *The Ghost in the Shell* in which a cyberized man under the control of the Puppet Master looks toward his partner driving frantically toward him, his perception is rendered with scan lines.

camcorder is especially strong, and in addition, the continuous use of cables to connect cyborgs to the central computer or to other cyborgs (the plug features prominently when a cyborg "dives" into the brain of another) recalls the act of plugging consoles or peripheral devices into the television or into computer monitors. As such, the cyborg appears as one media platform in a network of platforms, but this is a specific network infrastructure. This network is a sort of "expanded television," not only because it highlights the emergence of a new, largely tele-visual world, but also because the operative paradigm is that of hook-ing peripherals into a television screen, and even the computer moni-tor functions like the television screen. In one key sequence in the film, Aramaki covertly sets up video surveillance around a house: he uses what looks like a laptop computer into which cables are plugged, connecting his computer to others and the network, reminding us that this is not an era of wireless connection but one of wires, cables, and diverse modalities of hooking up and jacking in.

Second, the surveillance footage appearing on Aramaki's computer screen shows scan lines, recalling another dimension of disjunctive synthesis: when you see the world in scan lines, whatever you see is being transmitted to someone somewhere, and thus potentially to any-

one anywhere. What you see may be intercepted, overheard, whether deliberately or accidentally. As such, when you perceive in scan lines, your perceptual world is open or exposed to other media platforms. The response to this situation of disjunctive synthesis can go in one of two directions. On the one hand, it can lead to paranoid defensive formation in which you are caught up in a unending game of building new forms of protection, to assure that your shell is not breached, your brain not hacked, your memories not stolen or damaged. This is where personal and national sovereignty are forced into collusion in a paranoid escalation of preemptive measures in a world where security is simply more insecurity. On the other hand, a world in which everything and everyone becomes a disembodied ego sealed within layer upon layer of protective barriers is ultimately unsustainable, for it effectively eliminates the self that it is allegedly designed to preserve. In response, at some point, like the Major and Puppet Master, you will have to run the risk of exposure to the network and of losing yourself to survive. Here a distinction between the conscious subject and the experiential self becomes critical, and the experience of the scan line potentially affords a different orientation. Rather than being construed as an invasion of your consciousness by another consciousness, the scan line implies feeling the world, and the world feeling toward you.

This experience of the scan lines brings us to the third point: the scan line is not contained within any media platform. It is the material residue of platforms building with each other. In this respect, the scan line is important precisely because it does not lead toward the blur or stain, which tends to sustain an idealist or psychologistic relationship of the self to media, which claims that media touch the subject there where its perception becomes blurred and troubled.[24] On the contrary, the scan line is visible, even tangible, and it has a sonic analog (reverberation, not distortion). The scan line is not in the brain or in the object, but in the world, of the media world. A recurring feature of Oshii's style is the staging of sequences in which characters engage in a lengthy discussion of one of the key issues in the film, and sequences in which they do so while driving along a highway at night are Oshii's signature style. Bands of light wash over the car's interior and their faces as they pass under the evenly spaced rows of lights illuminating the highway (Figure 1.4). The sensation of forward motion is lost, and it seems that the car stands still as the city's lights sweep over them. The

Figure 1.4. Bands of light wash over the car's interior as it passes under the evenly spaced rows of lights illuminating the highway, as if the city itself had become a scanning machine. From *The Ghost in the Shell*.

city itself is now scanning them, the city feels them. The scan line is not confined to the screen, to cyborg perception, or cyberscapes. In effect, the city has become cyberized and cyberizing.

This is what the "coupling" of the Puppet Master and the Major stages as the culmination of the story. Cables are plugged into the remnants of their cyborg bodies and connected to Batou as well, making him the witness and guardian of this "marriage." Although there are mismatches and new matches between body and voice (the Puppet Master speaks from the Major's body, for instance) that flirt with disembodiment, the insistent use of scan lines highlights that this coupling brings together different media platforms that perceive, record, and transmit at different frequencies. The experience is one of building a specific infrastructure and a specific self simultaneously. The human now appears as one media platform among others, as a mode of temporality that is only experienced when interlaced with another.

This coupling also tries to produce an interlacing of gender identities: after coupling, the Major in Oshii's animation regains consciousness in a girl's body. (In Shirow's manga, she winds up in the body of a youth so beautiful that Batou mistakes it for a girl's body.) Commentators on *The Ghost in the Shell* have questioned its vision of gender, calling

attention to how women's bodies stand in for matter, and as such, don't really seem to matter, existing only to be dismembered and discarded.[25] It is true that *The Ghost in the Shell* is so intent on reconfiguring ethics and politics in terms of "media others" (robots, AI, cyborgs) that it tends to avoid sustained treatment of received forms of alterity (gender, class, ethnicity) that are posited as residual formations. Consequently, gender trouble, for instance, feels at once displaced onto and displaced by cyborg trouble. Yet there may also be a challenge here: the logic of the scan line invites us to look at the implications of disjunctive synthesis, which builds received forms of alterity together with electronic or digital information entities. The female cyborg would not entail the blurring of distinctions between woman and machine but exists as the specific rate or frequency of an interlacing. In the Major's instance, this interlacing also takes the form of a meeting with her self: as she slowly cruises through the city, she encounters other cyborgs with the same prosthetic body. The interlacing of perception and cityscape takes on the temporal rhythm of encounter, which is, in fact, her.

The final image of the animation is of the Major overlooking the "wired city," into which she will release the progeny of her coupling. It is a city of towering buildings laced with cable-like connections that promise to hold together two kinds of infrastructure—city structures and wired networks (Figure 1.5). This is a highly specific vision of infrastructures in which city and net appear literally plugged into one another. It is worth recalling that Oshii's *The Ghost in the Shell* appeared in 1995, the year associated with the emergence of DVDs, the ascendency of the Internet, and the rise of digital television. Its cyborg world implies an infrastructure that today rarely attracts attention despite its persistence alongside wireless networks, an infrastructure of cables and camcorders, of consoles plugged into televisions and computers. Indeed, Oshii's animation might be seen as the culmination of the video revolution of the 1980s that generated both expanded television and a new aesthetic, that of the Original Video Animation or OVA.

From the early 1980s, production of animation in Japan at once boomed and became more differentiated in terms of its markets, formats, and genres. With the advent of VHS, a range of new animations appeared for home video, ushering in the OVA. At the same time, discourses on information society, prevalent from the late 1960s, spurred interest in emerging technologies of television reception, transmission,

Figure 1.5. *The Ghost in the Shell* culminates in an image of the "wired city," in which towering buildings are laced with cable-like connections that promise to hold together two kinds of infrastructure.

and of display and interaction (such as satellite and cable, and VHR and console games) that inspired "teletopia" initiatives and made "new media" the buzzword in discussions of television in the 1980s in Japan.[26] Not surprisingly, as a consequence, Japanese television animation, loosely dubbed "anime," often focused attention on the impact of new computer and television technologies, exploring their effects in different registers, at the levels of story and art, and distribution and reception. In fact, such anime might well be considered the new media form par excellence of 1980s Japan, anticipating its surge to global popularity in the 1990s. OVAs in particular played an important role in expanding the media purvey of animation. They not only created a relay between animated films for theatrical release and animated television series but also generated new circuits of distribution and new modes of watching.

Significantly, Oshii is credited with creating the first OVA series, *Dallos* (1983). More important, it was in the context of such animation that the scan line came to the fore. As animators found new markets and new budgets for release directly to video, they began using video or camcorder footage to enhance both the realism of effects and the media quality of animation, to produce darker, more conceptual, and more sexually explicit fare. Thus the scan lines that appear on tele-

vision or computer screens when filming with camcorders found their way into animation: the flickering scan-lined screen in a dark room became something of a signature feature of OVAs.

Oshii's *The Ghost in the Shell* is the apotheosis of this world of expanded television infrastructures and OVA aesthetics. Bringing that infrastructure to the surface in the form of the scan line, Oshii's animation shows how media networks are not simply about the reproduction of the disembodied subject, networked selves, or the distribution of cognition. It explores the coemergence of self and infrastructure, the distribution that generates the distinction of self and network and is prolonged by it. In the form of a media problematic, it tries to formulate an experience of a self-in-disjunction that might be capable of responding to the capacity of media platforms to work together.

NOTES

1. In "The Scene of the Screen: Cinematic and Electronic Presence," in *Materialities of Communication,* ed. Hans Ulrich Gumbrechts and K. Ludwig Pfeiffer, 83–106 (Stanford, Calif.: Stanford University Press, 1994), Vivian Sobchack looks closely at such effects in terms of technologically mediated experience, exploring how such effects prove alienating. My argument is not entirely different from hers in that I initially emphasize how such effects seem to generate a disembodied subject, and yet, because I am not treating natural perception as a baseline, I tend to think in terms of historical configurations of media infrastructure and their potentiality. Although I do not stress alienation of natural or human-scaled perception, I tend to see in the production of disembodied subjectivity a form of perceptual disabling that is ultimately not at odds with her analysis.

2. Christopher Bolton, "From Wooden Cyborgs to Celluloid Souls: Mechanical Bodies in Anime and Japanese Puppet Theater," *positions* 10, no. 3 (2002): 748–49.

3. Hyewon Shin, "Voice and Vision in Oshii Mamoru's *Ghost in the Shell*: Beyond Cartesian Optics," *Animation* 6, no. 7 (2011): 13, 21.

4. Katherine Hayles, "Unfinished Work: From Cyborg to Cognisphere," *Theory, Culture, Society* (2006): 159.

5. Ibid., 159–60.

6. See chapter 5, "Reality Bytes," in Vicki Kirby, *Telling Flesh: The Substance of the Corporeal* (London: Routledge, 1997).

7. Ian Hacking, "Canguilhem amid the Cyborgs," *Economy and Society*

27, no. 2 (1998): 202–16; Donna Haraway, "A Cyborg Manifesto: Science, Technology and Socialist-Feminism in the Late Twentieth Century," in *Simians, Cyborgs and Women* (New York: Routledge, 1991), 152.

8. James writes, "The pure experiences of our philosophy are, in themselves considered, so many little absolutes. . . ." See William James, "How Two Minds Can Know One Thing," in *Essays in Radical Empiricism* (Mineola, N.Y.: Dover Publications, 2003), 71.

9. Sharalyn Orbaugh, "Emotional Infectivity: Cyborg Affect and the Limits of the Human," *Mechademia* 3 (2008): 165, drawing on Teresa Brennan, *The Transmission of Affect* (Ithaca, N.Y.: Cornell University Press, 2004), 1–2. My argument differs primarily in that I see affect less as a blurring or obscuring of the boundary between subject and object or inside and outside. Rather I see affect as related to a disjunctive synthesis that at once distinguishes inside and outside and holds them together, and because affect is related to a material continuum, it tends to act with and through a holding together of self and infrastructure, making for a specific kind of self and a specific infrastructure.

10. Raymond Ruyer, *Dieu des religions, Dieu de la Science* [God of religions, God of science] (Paris: Flammarion, 1970), 175.

11. I am drawing on Brian Massumi's discussion of the speculative and pragmatic in *Semblance and Event: Activist Philosophy and the Occurrent Arts* (Cambridge: MIT Press, 2011).

12. There is resonance here with Orbaugh's notion of "infectivity," but I wish to place emphasis on a form of communicability that is specific to a network infrastructure of expanded television.

13. The filmed television screen may also appear brighter. Because of space limitations, I do not here address this aspect of disjunctive synthesis, although it is important in Oshii's film. Suffice it to say here, this brightening of the screen signals the intensity of disjunctive synthesis, serving to activate the scan line.

14. Gilles Deleuze first addresses what he later calls "disjunctive synthesis" in the context of the second synthesis or determination (neither passive nor active) in *Difference and Repetition* (New York: Columbia University Press, 1994), 82–83; Gilles Deleuze and Felix Guattari, *Anti-Oedipus* (Minneapolis: University of Minnesota Press, 1983), 4.

15. Thomas Elsaesser, "The Mind-Game Film," in *Puzzle Films: Complex Storytelling in Contemporary Cinema*, ed. Warren Buckland, 13–41 (Oxford: Blackwell, 2010).

16. A good example is the cover for Funamoto Susumu's *Anime no mirai o shiru: Posuto-japanimēshon; kīwādo wa sekaikan + dejitaru* [To know the future of anime: The key word for post-Japanimation is "worldview + digital"] (Tokyo: Ten bukkusu, 1998).

17. Niklas Luhmann, "How Can the Mind Participate in Communication," in *Materialities of Communication*, ed. Hans Ulrich et al. (Stanford, Calif.: Stanford University Press, 1994), 371.

18. The Japanese edition is Shirō Masamune, *Kōkaku kidōtai: The Ghost in the Shell* (Tokyo: Kōdansha, 1991), and the English edition is Shirow Masamune, *The Ghost in the Shell*, trans. Frederic L. Schodt and Toren Smith (Milwaukie, Ore.: Darkhorse Comics, 1995).

19. Eric Cazdyn, *The Flash of Capital: Film and Geopolitics in Japan* (Durham, N.C.: Duke University Press, 2002), 252–54.

20. Livia Monnet provides an extensive interpretation of the impact of Oshii's combination of staging philosophical debates while remediating a variety of media forms in her three-part article on his film *Innocence*. See especially "Anatomy of Permutational Desire, Part II: Bellmer's Dolls and Oshii's Gynoids," *Mechademia* 6 (2011): 153–69.

21. I am drawing here on Brian Massumi's discussion of semblance as nonsensuous similarity in *Semblance and Event*.

22. For an account of the use of mobile background, see Stefan Riekeles and Thomas Lamarre, "Mobile Worldviews," *Mechademia* 7 (2012): 174–88.

23. Massumi, *Semblance and Event*, 81–82.

24. Lucas Hilderbrand, in *Inherent Vice: Bootleg Histories of Videotape and Copyright* (Durham, N.C.: Duke University Press, 2009), shows how artifacts of copying videotapes became associated with transgression and illicit pleasure, in a manner reminiscent of the Lacanian stain. The logic of the scan line, however, is very different from the blur or stain. Its prevalence in OVA speaks to a very different relationship with videotape and piracy.

25. See, for instance, Livia Monnet, "Toward the Feminine Sublime, or the Story of a 'Twinkling Monad, Shape-Shifting across Dimension': Intermediality, Fantasy and Special Effects in Cyberpunk Film and Animation," *Japan Forum* 14, no. 2 (2002): 225–68; and Kumiko Sato, "How Technology Has (Not) Changed Feminism and Japanism: Cyberpunk in the Japanese Context," *Comparative Literature Studies* 41, no. 3 (2004): 335–55.

26. In the mid-1980s new research initiatives explored possibilities for developing integrated telecommunications systems, largely planned for new regional communities, which included a range of services such as CATV security, computer access, televisual entertainment, all of which were put under the rubric of *teretopia*, that is, tele-utopia. See Chiiki Jōhō Tsūshin Kenkyūkai, *Teletopia senryaku: Nyū media ga egaku shin jōhō rettō kaizōron* [Teletopia strategies: Modeling the new information archipelago presented by new media] (Tokyo: Shuppan Kaihatsusha, 1984) and Miraigata Komyunikēshon Moderu Toshi Kōsō Kondankai, ed., *Teretopia keikaku: Chihō no jiritsu to jōhō kakusa no kaishō o mezashite* [Teletopia planning: Envisioning regional

autonomy and the elimination of information disparity] (Tokyo: Kōdansha, 1985). At the same time, in the course of the 1980s, histories of television and broadcasting began to anticipate a great transformation called "new media," that referred largely to changes in television broadcasting and reception because of satellites as well as the rise of cable systems, which implied new affinities between computers and televisions. See, for instance, Shiga Nobuo, *Shōwa terebi hōsōshi* [A history of broadcast television, 1926–1989] (Tokyo: Hayakawa Shobō, 1990).

2 What Is Estranged in Science Fiction Animation?

ISTVAN CSICSERY-RONAY JR.

Histories of science fiction (SF) animation have yet to be written. Whatever approaches they may take, they will have to account for a formidable corpus of works from many national and craft cultures. They will have to decide what fits within the boundaries of SF, that is, which thematic, iconic, cinematic, and graphic qualities are specific to SF. They will have to negotiate with numerous texts that play with science fictional elements but reject confinement to generic protocols. They also will have to make decisions about whether to draw boundary lines between animation as a mode of expression and animated special effects that constitute an increasing proportion of ostensibly live action films. They will have to explore how and why animation artists are attracted to SF as a universe of discourse in which to develop animation as an artistic medium. In this space I suggest some ideas that future historians might find useful in that project.

Generically specific SF animation is a relatively recent art form. Although Meliès's *Voyage dans la lune* (*A Trip to the Moon*, 1902) is a founding text of both the cinema of spectacle and of SF cinema specifically, there are not many other examples before the second half of the 20th century. Like *Voyage*, movies such as *Interplanetary Revolution* (1924) in the Soviet Union and the Fleischer brothers'/Famous Studios's *Superman* serials in the 1940s proved to be isolated projects, and were viewed less as science-fictional than as elaborations of other media—Constructivist poster art in the case of *Interplanetary Revolutions*, newspaper comics in the case of *Superman*. Although this phenomenon may seem surprising, given the popularity of SF or hybrids with strong SF elements in U.S. comics, such as *Buck Rogers, Flash Gordon, The Phantom, Mandrake the Magician, The Flash*, and *The Justice League of America* (none of which was adapted to animation), there

are good explanations for this lacuna. Animation was slow to develop as a culturally supported form outside the U.S. until the post–World War II period.[1] In the United States itself, where the technical possibilities of animation were being shaped in the heady atmosphere of artistic and technological experimentation in the studios of the Fleischer brothers and Walt Disney, the art form was not particularly attracted to SF's generic strengths. The dominant model was the print cartoon, whose basic line-shapes were subjected to more and more inventive and humorous metamorphoses. The emphasis on high-energy transformations of the image led early animators naturally to grotesque and fantastic scenarios. These animations often were overtly parodistic of other, more settled genres—fairy tales, ghost tales, adventure stories, cabaret performances, and dramatic movies. The high humor of Golden Age cartoons lay in their irreverent and anarchic violation of generic protocols and of stable, contemplation-worthy images. Animation's entire raison d'être appeared to be to mock realism in narrative, in image, and in ontology. The art of uninhibited transformation established an aesthetic zone in which "anything can happen." Even the integrity of a cartoon's graphic world was continually upended, as line drawings shared space with rotoscoped images, stop-action photography, and photorealistic cinema.

When animated film became popular enough to attract large-scale financial and cultural investment, the dominant aesthetic shifted from the zany fantasy of early newspaper comics (which remained popular for shorts) toward the imitation of illustrations for children, especially of fairy tales. This trend, dominated by the Disney studios but followed even by the Fleischer brothers in their version of *Gulliver's Travels* (1939), normalized industrial entertainment animation as essentially an art oriented toward children. The fantastic elements became less surrealistic and disorienting, and more traditionally marvelous and consoling.

Among fantastic genres, SF is in general closely tied to realism. As Darko Suvin has argued persuasively, an SF narrative usually features the disruption of a familiar reality by the intrusion of *novums,* new events, objects, or information that are plausible, or rather, that are rationalizable within contemporary ideas about the existing material world.[2] Much of the action of SF scenarios revolves around the ability of humanlike characters to manipulate physical reality in techno-scientific ways in response to these novums. The huge archive of

"sci-fi" spectacles in which novums and their manipulation are barely disguised magical or supernatural devices shows that this generic norm of fantastic realism is very fuzzy and flexible. Yet even in the zaniest parodistic versions of SF novums are given pseudo-scientific rationalizations. Pseudo-science still stipulates the power of scientific reasoning. The core pseudo-mimetic ontology of SF is at odds both with metamorphic anarchy and the sensibility of the fairy tale pervaded by supernatural marvels. A case in point: the eight episodes of *Superman* produced by the Fleischer brothers were the first sustained experiment in SF animation. They included many familiar SF tropes of the time—robots, threatening comets, dinosaurs and giant apes on the loose—but with important counter–science fictional compromises. It is in the Fleischer series that Superman first acquires the power to fly (which in the earlier comics would have been considered magical), and the buildings that he occasionally has to prop up are noticeably bendy (a Fleischer trademark).[3] It was not until the rupture of World War II and the subsequent global technological urban renewal that conditions became favorable for the development of SF animation. As SF itself became a barometer for social anxieties about future shock, and technologies for the production of animation were more widely disseminated, and indeed as cinema and video became dominant as media, both SF and animation attracted global interest.

My title alludes to Darko Suvin's influential notion that SF as a mode of art is characterized by a mental operation he terms "cognitive estrangement."[4] For Suvin, SF is an "estranged genre," one of several in a class we more often call the fantastic, the marvelous, or *fantastika*, which includes all counter-mimetic genres.[5] Suvin's use of the term estrangement implies that there is a baseline of empirically and socially accurate (or at least consensually accepted) understanding about the real world, and that some genres make their livings by *not* representing it. Of these genres, only SF is, for Suvin, *cognitively* estranged—that is, only SF employs its estranging techniques to create a constructive alienation that will lead the readership to greater awareness of actual conditions. SF uses the techniques of both mimetic representation and also quasi-mimetic but counterfactual deviations from the established ideological world-picture to create a critical distance from it.

Suvin's notion is quite useful, but also quite vague—more a suggestion than a description. Neither of its terms—*cognition* nor

estrangement—are clearly defined by Suvin, or used consistently. Suvin's use of estrangement differs from its previous uses by Viktor Shklovsky and Bertholt Brecht, from whom Suvin's concept is derived. Shklovsky and the Russian Formalists intended estrangement to signify devices employed by artists to disrupt artistic techniques and forms that had become habitual and deadened. Brecht used the German term *Verfremdung* for similar purposes, but with the more ambitious goal of breaking up the audience's enchantment by ideological illusions. V-effects were to orient audiences toward the clear scientific understanding of reality, which Brecht considered to be naturally accessible to Marxist analysis.[6]

Cognitive is a word that has many meanings in contemporary discourse, but they all seem to share a strong Enlightenment quality of distinguishing true, useful knowledge about the world from delusion. We often hear of cognitive dysfunction or cognitive dissonance, but rarely of cognitive assonance or cognitive accuracy; the term seems by itself to imply that it is doing what it is supposed to do. Cognition implies a correct, healthy apprehension of things—something akin to *understanding.* Cognitive estrangement then seems to imply that a certain mental operation of dehabituation or defamiliarization is required for us to see the world correctly because the pragmatic, empirical reality we have become habituated to is a collective illusion reinforced by ruling-class ideology that masks true apprehension. Suvin grants SF high status among genres because this operation of making the world strange in order to reveal its illusory, ideological character is in his view the genre's guiding purpose. In sum, the thing that is made strange in the operation in Suvin's usage is not artifice, but reality, which has been enchanted and naturalized by ideology.[7]

Suvin's version of cognitive estrangement requires a prior commitment to the notion that one can, and should, have a true perception of reality consonant with scientific-materialist rationality. In narrative, it privileges realistic style—as if to say that realism would be the default style of true description if people's understanding of the real world weren't so distorted by irrational, consciousness-manipulating power. This is why the Suvinian notion of SF has been opposed constantly to fantasy—so that even as sophisticated a critic as Fredric Jameson sees the opposition as one between a genre that opens its public's minds and one that lulls them into infantile dreams.[8] Hence also the anxiety

by many followers of SF that the genre is continually being infiltrated by putatively irrationalist elements and corrupted by the blending of the two supposedly fundamentally opposed genres by booksellers and undiscriminating fans.

The notion of estrangement in this context may be fuzzy and tendentious, but it is nonetheless on to something: specifically, why SF has elective affinities with satirical indirection. More generally, it calls attention to the way critical discourse can contest the ideological illusion of scientism, namely that empirical science delivers a total world-explanation appearing to be politically neutral, while in fact legitimating a capitalist world system—all without calling into question the privileged role of materialist rationalism. There are certainly many texts that work in this way, with the purpose of making their audiences see the world at a critical distance by imagining alternatives to it and yet retaining a realist world picture. As long as we recognize that estrangement tactics always work in dialectical tandem with naturalization, that is, the re-emplacement of disruptive novums into a realist world picture, estrangement can be one of the most powerful of the genre's psychological and aesthetic effects-engines. One of its great drawbacks, however, is that it guides critics toward essentially realistic interpretive values: we identify the real, material social phenomena that are estranged and then measure the distance between the two termini. What happens then when we apply this notion to animation, where empirically identifiable referents, no matter how displaced they may be, simply are not required? Where is the core stratum of real empirical experience for a medium that in its essence rejects the norm of representation of a consolidated, totalized objective reality?

Since the 1950s, a great many SF animation texts have been produced for many different occasions in enormously varied styles and via many different technologies. Many are made because they are relatively inexpensive and the market has a continual demand for combinations of catchy things: cartoons and SF being a natural pair. At the other end of the spectrum, SF has been the pretext for ambitious artistic and philosophical experiments in animation. Given such variety, no definition even of the medium of SF animation can ever be more than a provocative heuristic tool.

SF cartooning became popular especially when television created an insatiable demand for programs in every country that introduced

TV after World War II. In Central and Eastern Europe, the already well-established culture of animation was harnessed for many kinds of fantasy in a great variety of animation modes—stop motion, Claymation, paper cutouts, and diverse graphic styles. The story of Japanese animation is one of the best known in our time.[9] In the United States, cartoons aimed at children became one of the mainstays of the new television regime. These shorts and series were sold transnationally. Where U.S. programs were too costly to import, non-U.S. animation became an important television resource. Eastern European cartoon series were played in Japan, Western Europe, and even China. Japanese anime series were sold to Europe, the United States, and throughout Asia. These series tended toward fantastic genres, and were among the main vehicles for the nonmimetic popular imagination in the otherwise realism-obsessed media of postwar cinema and television. In part, this tendency occurred because the medium of animation was inclined to fantasy (because animation is essentially an art of stylized metamorphic transformation), but animation artists were also discouraged from developing realistic styles and subject matter. Animation was viewed as manifestly inferior to photorealism by the cultural elites. (This differed from culture to culture. In Japan, cartooning had an established educational tradition, and in Eastern Europe television animation was considered a rich new creative medium for visual artists.) In this climate, SF's particular kind of fantasy was favored. The advent of the techno-scientific age after the war, with its nuclear fears, the rise of the Security State and its ideological organs, the penetration of high technology into everyday life, and pulp SF's historical association with popular techno-science gave SF animation an influential place in the media landscape. Since then, thousands of television cartoon series have been produced throughout the world, and many feature-length animated films with SF-inflected themes have been shown in theaters. Computer graphic imaging (CGI) techniques are in our time supplanting most of the earlier techniques of animation, and with the dominant hyper-realistic aesthetic of contemporary CGI, the line between animation and photorealism is increasingly blurred—a development that favors SF's generic interest in the technologically induced breakdowns of previously hard-and-fast ontological distinctions. The great diversity of styles and techniques that characterized different regional and national attitudes toward SF is evidently thinning out,

as CGI techniques, especially mimetic 3D modeling, and globalized entertainment industries consolidate popular animation's universe of discourse. At the same, new combinations of old and new techniques are inspiring stunningly original new kinds of SF animation in films such as Don Bluth and Gary Goldman's *Titan AE*, Mamoru Oshii's *Kōkaku Kidōtai* (*The Ghost in the Shell*), Rintaro's *Metoroporisu* (*Metropolis*), and Richard Linklater's *A Scanner Darkly*.

With these developments, the question becomes even more topical: What, if anything, do the texts in SF animation's archive have in common? What is it that lets us speak of SF animation as a distinctive mode of art? If we limit what we mean by SF animation to animated versions of literary narratives with SF themes, or to the adoption of SF iconography, we have a fairly unambiguous set to work with, but it provides little information about why animation artists find SF particularly illuminating and inspiring for their art. We are still left with the question: What does SF offer animators as a way not only to tell stories, but to develop animation as a distinctive medium?

There are doubtless many answers to this question. It is also legitimate to question whether it is a purely academic concern; should one ask a popular entertainment genre to reflect on its own conditions of aesthetic possibility? However, I believe these are questions that all artists, whatever their media, ask themselves in the languages of those media. Whatever the broader social functions of a medium like animation are, it "answers to itself," an answer embodied in the relationship—congruent or dissonant—between a given work's themes and its artistic design. The sudden and swift ascendance of CGI over traditional animation techniques has marked those earlier techniques as "others," which can be made intelligible by exploring their embedded, and embodied, aesthetic and intellectual values.

In *The Seven Beauties of Science Fiction*, I proposed that the putative science in SF texts is always to a greater or lesser degree imaginary and counterfactual because it is placed in the context of fiction, a context that necessarily transforms all the signs it manipulates into nonassertive, ludic displays.[10] Indeed, the creative freedom of SF's ontology of fiction always trumps the deterministic ontology of the science that it ostensibly describes in its (fictional) worlds. Thus, pace Suvin, one of the main things that SF may indeed estrange is science itself, or rather the view that scientific rationality is adequate for understanding

the (real) world. In a similar way, I contend that SF animations—at least as evidenced by the texts that explore their media with artistic commitment—dislodge their publics' rigid habits of thought in at least one way, by estranging the "physics engine" of the world. A genre medium that is intimately enmeshed with technologies of representation, that works with organized shape-shifting and metamorphoses from one imaginary ontology to another, and that plays with conceptions of counterfactual but plausible alterity is necessarily fascinated by physics and its role in world construction.

A physics engine in contemporary parlance is a cluster of algorithms that regulates the simulated physical constraints of digital games and CGI effects. The algorithms determine the parameters of all the quasi-physical aspects that the game masters consider relevant—how the characters move, how they manipulate space, the resistances of bodies, the norms of space and time. Ultimately it is all about gravity. A physics engine is the gravity driver of a given digital world's construction.

In computer games and CGI-crafted artifacts we have seen a trend toward more and more "realistic" physics and bodies. One can legitimately infer that full hyper-realism is the ultimate goal, if only to establish a baseline against which to set creative deviations. But many things are devilishly difficult to simulate realistically. Often several physics engines need to be coordinated, each independently governing things like the movement of hair in the wind, the reflection of light on flowing water or human skin, the Brownian motion of dust specks in moving air, the slipstream of a speeding vehicle. The difficulty of representing a physical world visually tends to bring the problem into consciousness *as a problem*—especially if the narrative involves machines that articulate or manipulate imaginary matter. Even if earlier animators did not have physics engines per se, they were certainly aware that the world does have one—and that it is one of many in the universe. From its earliest works of SF, animation has constructed sublime and grotesque gags of wonder out of playful violations of the physics of bodies and mechanical devices. Think of the rocket poking in the eye of Meliès's Moon. Think of Koko and Bimbo in the Fleischer brothers' *Koko's Earth Control* (1928) striding along the rim of the Earth on their way to the Center for Earth Control, and the lunatic mayhem caused when Bimbo pulls the lever to end the Earth—which is of course what the Fleischer brothers wanted to do all along. (In-

deed, the Fleischer corpus is filled with jokes on physics—basically saying that the animator-as-trickster can undo what that Great Overdisciplined Killjoy of a God has made.)

Although it may seem counterintuitive that animation artists would be concerned with a constraint they are almost entirely free of, in that no animated universe needs to adhere to mundane gravity, all animators who depict imaginary worlds in which embodied characters interact with other bodies according to an overarching design are concerned with the rules that govern those interactions. So the physics in question here we might call a *lyrical physics*, in which affect and imagination determine the parameters of what can and cannot happen in a quasi-mimetic world, where the design limits the possibilities of metamorphosis. In SF animation, this design is dialectically bound to real mundane physics, which it simultaneously respects (knowing that the audience has a base in experience against which all deviations are measured) and defies. In abstract form, this is the appeal of Wile E. Coyote's relationship with abysses, Sylvester the Cat's tendency to be sliced into slivers, and Tex Avery's falling anvils. In SF animation, these abstractions tend to be consolidated into rich and varied, but also systematic, worlds.

So what happens when we consider this lyrical play with physics, this creation of a selectively altered imaginary universe with different rules of time, space, and motion, as a core motive of SF animation? I suggest that animators are drawn to the possibility of depicting fictive worlds operating by different physical rules, and indeed worlds operating by several different kinds of physics. Each of these worlds is appropriate for a distinct style of animation, and each such style appropriate for an aspect of the constructed world, and each style and world is equivalent to an ontology. Thus, I propose, different cultures and subcultures of SF animation begin with different orientations toward physics. Their differing interests and traditions of physics uncover different problems for our exploration of SF animation

It would be foolish to generalize too emphatically about such differences. Animation has been the freest form of filmmaking. Its freedom from the mechanical and social constraints of photographic realism encourages artists to vary their styles of metamorphosis within individual works, so that most artistically ambitious works of animation represent more than one distinct ontology in the same world. Indeed,

this creative tension between the possibility of infinite flexibility and the order of a creative design in which all elements are interrelated is one of the guiding energies of the art form. Similarly, animation's relative freedom from many other cultural constraints—most notably national language and social-realistic specificity—allows works to travel from one culture to another more freely than photorealism, and consequently to have greater cross-cultural influence. That said, animation artists, like artists in all media, work from within certain traditions of craft and production, which they elaborate, de-form, and resist in culturally determinate ways.

René Laloux, the director of *La Planète Sauvage* (*Fantastic Planet*) (1973) and one of the most influential SF animators, drew a sharp distinction between American and Continental styles of cartooning.

> In animated cartoons, contrary to what one may think, the needs of graphics do not necessarily correspond to the needs of movement. Faced with this dichotomy, the artist must find a balance between these two "enemies," in order not to prejudice the rights of both: a difficult task easily prone to failure. The easiest way out then, obviously, is to favor one of the two contenders. Consequently, the American School ties drawings to animation; the European School (tied to its cultural heritage) generally tried to do the opposite, basing itself upon graphic imagery. What resulted is very interesting. The total freedom of movement (with its implied association with the Anglo-Saxon taste for nonsense) led Americans to a taste for curved lines, quick movement and comedy, as well as an emphasis on character. In Europe, the emphasis on graphics favored the straight line, slow movement, fantasy and a lesser emphasis on psychology of individual characters.[11]

The distinction is schematic, but it has some validity at least for the period preceding the industrial culture of serial animation produced for television. With little change we can alter Laloux's craft terms into quasi-physical ones: the American school exploring a kinetic flexibility of form that seems to defy any settled physics, European animation emphasizing contemplation of more static visual design linked to the traditional reception of graphic arts and the acknowledgment of a con-

structed world. The advent of computer graphics represents, in this sense, a major historical rupture that reconfigures these local cultures of lyrical physics, just as the digital revolution reconfigured national cultures across the globe.

Laloux intended his contrast to cover all kinds of animation, not just SF. Arguably the estrangement of physics is something that happens in animation of all kinds as a matter of course; even highly mimetic cartooning like Isao Takahata's *Hotaru no haka* (*Grave of the Fireflies*) (1988) calls attention to this worldly physics by eschewing variants and alternatives that audiences of animation come to expect. Mimetic animation also draws attention to the artistry of depicting natural phenomena that may be taken for granted in everyday experience, which become objects of wonder when they are made visible as artifacts, such as the flight of butterflies and birds in films like *Bambi* (1942) or the fireflies themselves in *Grave*. I suggest that animation intended to be seen as specifically science fictional builds on the tension between SF's inherent tendency toward pseudo-mimesis and animation's inherent tendency toward metamorphic abstraction. In other words, the quasi-realistic gravity that distinguishes SF from other kinds of fantastic imagining—oneiric, metaphysical, marvellous, magical, visionary, uncanny, psychotic, and so on—works to contain the shape-shifting energies of the medium, while it simultaneously enjoys the freedom to depict more flexible worlds than mundane physical mimesis allows.

In European, and especially Central and East European animation, for instance—which has produced more SF animations than other kinds of SF film—I suggest that there has been a particular interest in making worlds that operate according to a set of physics that is entirely different, esoteric, ostentatiously stylized, yet just as internally consistent as the mundane. Perhaps because of the close linking of animation to avant-garde and experimental graphic arts in Central and Eastern Europe, Czech/Slovak, Polish, Hungarian, and Russian animation artists have tended toward vividly grotesque and decidedly nonrealistic world frames. Laloux, perhaps the most famous European SF animator, was drawn to make *La Planète Sauvage* in the Prague studios of the great Czech animator Jiří Trnka because of what he felt was the deep aesthetic affinity of the French style developing around Moebius's and Philippe Druillet's *Métal Hurlant* and the Czech tradition of linking puppetry and found objects with surrealism. Laloux's

films demonstrate quite clearly the principle of subordinating flexibility of movement and character psychology to striking visual design and narrative symbolism. In our context, Laloux's three SF films—*La Planète Sauvage, Maîtres du temps* (*Time Masters*) (1982), and *Gandahar* (1988)—each presents its alien SF world in the somewhat static form of illustration. Although some of the stasis of the later films is attributable to Laloux having to use increasingly cheaper studios (moving from Prague to Budapest to Pyongyang), in *Fantastic Planet* one can see that the painterly qualities of the two-dimensional paper cutout animation intentionally removed any sense of a naturalistic physical world. This flat aesthetic was shared by Jean-François Laguionie's *Gwen, ou le livre de sable* (*Gwen, or The Book of Sand*, 1985), which used the explicit juxtaposition of flat paper surfaces and highly stylized movement to emphasize the two-dimensionality linking the film to the tradition of artistic illustration.

The highly experimental feature-length *Chronopolis* (1982) by the Polish director Piotr Kamler working in France—a half-SF/half-metaphysical fantasy about a race of immortals who keep from being bored by manipulating time-space modules that appear to them as floating balls—is concerned with imagining how time out of time might look. Following in this tradition, the prize-winning short film *Katedra* (*Cathedral*) (2002) by another Pole, Thomas Baginski, based on a story by the acclaimed SF writer Jacek Dukaj, depicts the grotesque transformations of human beings (probably explorers) into tree-form architectural components of a vegetable cathedral-like structure on an alien world, a transformation depicted as physical effects of their exposure to the light of a mysterious sun. In the comic Hungarian cartoon series, *A Mézga család* (*The Mézga Family*), which was a regular feature on Hungarian television before the evening news during most of the 1970s, a petit bourgeois Budapest family acquires a time machine that lets them communicate with one of their descendants in the far future. Among the many jokes about time travel and its psychic consequences, in one episode they travel to an ancient Mayanesque civilization that is essentially a two-dimensional flatland based on Mayan hieroglyphics. Complementing the extended visual joking about how to be effective in a flat world, the civilization speaks a stylized Hungarian that employs only one vowel—an amazingly possible thing to do, given the remarkable preponderance of the vowel *e* in the language. Similarly,

in the brilliant 2004 Hungarian film *Nyócker!* (*The District*) directed by Áron Gauder, a group of Magyar and Roma friends from the most infamous lumpen district of Budapest invent a time machine that takes them to primeval Hungary to complete a plan to kill and store all the mammoths in ancient Hungary, thereby creating a reservoir of oil in central Budapest when they return. The episode is jammed with jokes about impossible time, impossible space, and impossible bodies.

The dominant Japanese style of SF anime has developed different attitudes toward lyrical physics. Before digital production technologies, the need to produce animated films on low budgets for television encouraged a minimalist visual style that had a long pedigree in Japanese visual arts, a style of abstract representationalism in which quasi-realistic settings and figures were evoked through a few marked and stylized details. At the same time, Disney's influence on postwar Japanese animators and cartoonists was enormous.[12] A dialectic between a suggested environment and overtly cartoonish figures led to a distinctive hybridity of the drawn universe in each manga and anime. Figures that appeared to be drawn from different comics inhabited the same frames, and mood changes in characters were often represented in new graphic styles. Hybrid visual ontologies based on different graphic styles became the norm in Japanese cartooning. Such hybridity was common in other comic/animation styles—the Fleischers' use of rotoscoped Gulliver in a world of hand-drawn Lilliputians, the occasional overlay of photography and cartoons in Porky Pig and Daffy Duck cartoons, the racy romance between Betty Boop and Bimbo the dog, the strange Disney universe in which some animal forms can speak and others cannot (for example, Goofy versus Pluto). But the Japanese manga/anime style of fantasy normalized the coexistence of different graphic worlds, eschewing both the anarchic malleability of the Fleischer universe and the smoothing of incongruities of the Disney universe. This ontological hybridity was carried over from manga into anime, where the hybridity of graphic styles was applied to styles of movement and became a source of Japanese SF anime's distinctive culture of lyrical physics.

Early generations of SF anime emphasized lyrical physics in a number of inventive ways. Often still flat frames will feature a single physical effect, which might suggest mimesis, as in a gusting wind in *Macross Plus* (1994), but sometimes it might be a purely fantastic evocation,

as in the distinctive flowing clouds of steam in outer space generated
by the interstellar railroad engine in Rintaro's *Ginga tetsudô Three-Nine*
(*Galaxy Express 999*) (1979). The technical constraints surrounding
Hideaki Anno's twenty-six-episode television anime *Shin seiki evan-
gerion* (*Neon Genesis Evangelion*) (1995–96) led to a number of stun-
ningly sophisticated variations on the depiction of space, time, and
bodies in a two-dimensional universe—a mundane world continually
penetrated by beings from a mysterious continuum whose physical
features are never explained. The intricate architecture of effects rang-
ing from sequences consisting of minutes of stillness to the balletic
coordination of giant mecha bodies moving at high speed make *Neon
Genesis* a veritable textbook of SF anime's two-dimensional physics.

The strong cultural support for anime—and specifically SF anime—
in Japan provided it with the encouragement to develop new anima-
tion techniques while retaining the emphasis on hybrid ontologies
and lyrical physics. The most artistically ambitious projects—Otomo's
Akira (1988), Oshii's *The Ghost in the Shell* (1995), Rintaro's *Metropo-
lis* (2001)—depict futuristic metropolitan settings dense with quasi-
mimetic details side by side with spectacular novums. These two conti-
nua are simultaneously distinguished and blended in virtuoso physical
episodes of bodies moving and moving things in space, explosions,
complex rigid objects flying at great speed against hard limits, and
bodies being agonizingly transformed from one continuum to an-
other. In *Metropolis,* for example, the figures and compositions based
on Tezuka Osamu's original manga are often depicted as static, along-
side precipitous Moebius-inspired abysses, fantastic yet hyper-realistic
environmental effects (such as a gigantic carp in a gigantic aquarium),
complex steampunk machines moving with dreamlike slowness, the
coordinated movements of crowds in space, elevators, escalators, and a
fantastically mobile virtual camera—combining to create a symphoni-
cally coordinated fantasia of physical rhythms.

The application of computer graphics has opened several paths,
among them the hyper-realistic simulation of the cinematic camera,
adoption of computer game aesthetics, the coordination of all physi-
cal movements, and a myriad of remediations of diverse earlier tech-
niques. Although the elements of animation were constructed by hand,
a certain hybridity was inevitable simply because not every element
of the animated universe was done by the same hand. Laloux writes

of the tension between the artists responsible for the backgrounds versus those responsible for characters in Golden Age industrial cartoons.[13] The contrasts between the static graphic worlds and the relatively thin but dynamic forms of characters can create a sense of two worlds superimposed on each other. Similarly, two-dimensional figures and three-dimensional ones inhabiting the same frame can create a dissonance that animation artists will sometimes work to smooth, and other times to emphasize.[14] Some of the most ambitious artistic projects of recent SF animation—*Akira, Titan A. E.*, Oshii's *Ghost in the Shell* and *Ghost in the Shell II: Innocence* (2004), *Metropolis*, Otomo's *Steamboy* (2004), *A Scanner Darkly*—have explored the combination of digitally composed realistic effects and backgrounds with traditional hand drawing, hand coloring, and cel-animation techniques to create worlds in which the hybrid physics of the visual styles play out virtuoso dialectics of digital hyperrealism and manual fantasy.[15] Other artists have set out to explore the possibilities of abandoning traditional techniques altogether and to represent the physical hybridity entirely in terms of computer graphics. Hironobu Sakaguchi's *Final Fantasy: Spirits Within* (2001) and Dreamworks' *Monsters vs. Aliens* (2009), for all their many differences in mood and technique, set out to create SF worlds in which all elements are coordinated through a metaphysics engine that calibrates even the alien into a fully naturalized, even if "alternative," pseudo-three-dimensional physical world. *Final Fantasy*'s experiment proved to be a heroic failure. The attempt to create hyper-realistic simulations, especially of human bodies, in the film drove it straight into the uncanny valley. Dreamworks' more commercially savvy *Monsters vs. Aliens* brings the playful diversity of character forms under an overarching visual ontology—a physics in which each object, no matter how weird its properties, behaves in ways that manifest the same overarching physical rules of 3D simulation— the play of light off surfaces, the repertoire of speeds and angles available to all objects, their appropriate physical tolerances.

Digital techniques have transformed animation. For many viewers they are as disorienting as rotoscoping must have been in the old days, yet also just as much a natural dimension of animation. But the career of CGI has markedly affected the dominant visual regimes of animation. Because it can supply ever more sophisticated physics engines, it has encouraged a drift toward hyper-realism and richly detailed yet

fully consolidated quasi-phenomenal worlds not only in SF, where it has a natural place, but in other forms of fantasy as well. (Gore Verbinski's *Rango* [2011] and Andrew Stanton's *Finding Nemo* [2003], for instance, are replete with physics wonders, as are many Pixar productions.) My suspicion is that we will see increasing hybridization and multi-ontologies in future SF animation—here too on a spectrum: from a variety of regimes of being collected in a single overarching quasi-mundane physics (as in *Monsters vs. Aliens* and Stanton's *Wall-E* [2008]) to the overlay of incongruous graphic ontologies in flat layering that Thomas Lamarre considers the great contribution of anime to animation (as in the South Korean film *Sky Blue* [2003]).[16]

The popularity of digital effects and their relative inexpensiveness has reconfigured the cultures of SF animation as well. The marked national or regional character of animation styles has given way to international networks based less on craft and narrative traditions, than on shared production regimes and commercial aims. *Final Fantasy* in game form was, for example, a flagship of the Japanese game industry in its first incarnation, although the film was produced by an international crew, in English, in Honolulu Studios. (Even its original title is English.) *Monsters vs. Aliens* includes many elements drawn from Japanese monster movies, renormalized for a global, "pixarized" audience.

What then is estranged in SF animation? Many things, certainly, but one thing for sure: the illusion that there is a physics independent of the imagination.

NOTES

1. Cf. René Laloux, *Ces Dessins Qui Bougent: 1892–1992 Cents Ans de Cinéma d'Animation* (Paris: Dreamland editeur, 1996), 27–37.

2. Cf. Darko Suvin, *Metamorphoses of Science Fiction* (New Haven: Yale University Press, 1979), 63–84; Istvan Csicsery-Ronay Jr., *The Seven Beauties of Science Fiction* (Middletown, Conn.: Wesleyan University Press, 2008), 47–75.

3. Cf. J. P. Telotte, "Man and Superman: The Fleischer Studio Negotiates the Real," *Quarterly Review of Film and Video* 27, no. 4 (2010): 290–98.

4. Suvin, *Metamorphoses of Science Fiction*, 3–15.

5. Cf. "Fantastika in the World's Storm," in *Pardon This Intrusion: Fantastika in the World Storm*, ed. John Clute (London: Beccon, 2011).

6. See Simon Spiegel, "Things Made Strange: On the Concept of Estrangement in Science Fiction Theory," *Science Fiction Studies* 35, no. 3 (November 2008): 369–85.

7. Simon Spiegel argues that exactly the opposite is the case, at least on the formal and narrative level, which is where the term *estrangement* has been generally applied in criticism. SF does not, according to Spiegel, estrange the real; it naturalizes the marvelous. The realistic gravity of SF's universe of discourse transforms heteronormative wonders into natural-material phenomena that fit into the modern world picture dominated by rational cause and effect. Suvin and Spiegel, in my view, each articulate one aspect of SF's dialectic, in which the marvelous is set up against the plausible, and then this is made to fit into a plausible-seeming new world picture. The naturalization of the marvelous is the first step toward placing it into a new rationality, and shuttling back to a re-vision of the real. Spiegel contends that SF requires a stabilization of the world, a calming down of metamorphic energy and discipline, a suppression of estrangement. This isn't just a question of internal formal development. In the early years there was a fascination with technology by modernizing artists as a means to transform a world that they viewed as inertial and antitechnological; by World War II it became apparent that technological transformations had occurred on a global scale affecting most areas of social life. At this point SF becomes a form of realism even more than a form of fantasy.

8. Cf. Fredric Jameson, "Radical Fantasy," *Historical Materialism* 10, no. 4 (2002): 273–80.

9. See Mark Wheeler Macwilliams, ed., *Japanese Visual Culture: Explorations in the World of Manga and Anime* (Armonk, N.Y.: M. E. Sharpe, 2008); Marc Steinberg, "Immobile Sections and Trans-Series Movement: Astroboy and the Emergence of Anime," *Animation* 1, no. 2 (November 2006): 190–206; Koichi Iwabuchi, " 'Soft' Nationalism and Narcissism: Japanese Popular Culture Goes Global," *Asian Studies Review* 26, no. 4 (December 2002): 447–69.

10. Cf. Csicsery-Ronay, *The Seven Beauties of Science Fiction*, 111–16.

11. Laloux, *Ces Dessins Qui Bougent*, 121. The translation, unacknowledged but presumably by Giannalberto Bendazzi, appears in Giannalberto Bendazzi, "Book Review: Rene Laloux," *Animation World Network* (October 10, 2013).

12. Cf. Fredrik L Schodt, *Dreamland Japan: Writings on Modern Manga* (Berkeley: Stone Bridge Press, 1996).

13. Laloux, *Ces Dessins Qui Bougent*, 124.

14. In the directors' commentary included on the DVD of *Titan A.E.*, Bluth and Goldman declare that they would have worked to smooth the friction between the two-dimensional drawn cartoon figures and the three-dimensional digital graphics of the backgrounds if they had had access to the appropriate

technology when the film was made; Rintaro and his crew state the opposite on the commentary track of the DVD of *Metropolis*: that the contrast between 2D hand-drawn figures and 3D backgrounds was a desired effect.

15. Shane Acker's *9* (2009) occupies a special transitional space, in that it was conceived with traditional methods in mind at all times, especially Svankmajerian stop motion, which were then digitally modified and enhanced into 3D.

16. Thomas Lamarre, "From Animation to Anime: Drawing Movements and Moving Drawings," *Japan Forum* 14, no. 2 (2002): 329–67.

3 Famous for Fifteen Minutes
Permutations of Science Fiction Short Film

PAWEŁ FRELIK

Science fiction short film may well be the genre's most enigmatic medium. Undertheorized but represented by thousands of texts, it both inherits many of science fiction's customary preoccupations and challenges its most vital commitments. It also reflects a number of new transformations in science fiction and, together with digital graphics and video games, offers a new paradigm of thinking about the character and role of the genre in contemporary culture. These are all tall orders for the medium, which makes the status of shorts in science fiction ever more complicated.

The history of science fiction short film is as old as that of SF cinema. Like most productions of the time, Georges Méliès's *Le Voyage dans la Lune* (*A Trip to the Moon*, 1902, 13 mins.), often considered the cornerstone of SF cinema, and Walter R. Booth's trilogy of *The Airship Destroyer* (1909, 20 mins.), *The Aerial Submarine* (1910, 12 mins.), and *The Aerial Anarchists* (1911, 15 mins.) ran at lengths nowadays qualifying them as "shorts." At the same time, the lure of extended storytelling registered very early in genre cinema. Even before 1920, other early SF films ran at what would be considered full-length nowadays: among them are August Blom's *Verdens Undergang* (*The End of the World*, 1916, 77 mins.), Stuart Paton's *20,000 Leagues under the Sea* (1916, 105 mins.), Holger-Madsen's *Himmelskibet* (*A Trip to Mars*, 1918, 81 mins.), and Richard Oswald's *Die Arche* (*The Ark*, 1919, 70 mins.). From its inception, science fiction cinema has clearly favored full-length narratives—the trend that in the early period culminated in Fritz Lang's lost "director's version" of *Metropolis* (1927), which ran almost three and a half hours. This commitment to long narrative by no means, however, eliminated short filmic forms entirely. *The Time Monsters* (1959), *La Jetée* (1962), *Electronic Labyrinth THX 1138 4EB* (1967), *Game Over* (1978), *Le bunker de la dernière rafale* (*The Bunker of the Last Gunshots*,

1981), and *Betaville* (1986) are only some examples, but their presence in SF cinema was, until the turn of the century, nominal. Among 7,275 titles tagged on IMDb (Internet Movie Database) as "Sci-Fi" and "Short," only 542 were produced before 2000, including 268 produced before 1990. The millennial watershed is thus not purely numerative, but it symbolically marks the advent of digitality, the year in which the first fully broadcast-quality program was produced using the Final Cut Pro software. SF shorts were certainly produced before the current digital turn, but it is also clear that the booming of the medium is intimately connected with the rise of new technologies of production and distribution. By the second decade of the twenty-first century, short film has become a major, if critically neglected, SF medium: in 2010 alone 855 titles were released, and this tally is only approximate.[1]

Addressing the critical lacunae surrounding SF shorts and relying on a broad selection of texts, this chapter has three distinct goals. First, it discusses how SF shorts reflect contemporary transformations of both cinema in general and SF cinema in particular. Second, it demarcates the medium's complex territory in which the boundaries between fiction short film and other short forms become complicated and blurred. Finally, it considers the ways in which science fiction shorts depart from the traditional narrative-centric focus of much SF and exemplify the spectacular nature of digital texts, a shift reflective of their materiality.

The proliferation of SF shorts is a consequence of a number of transformations. Writing in 2002 about the renaissance of shorts, Elsey and Kelly identified such factors as the development of the music video, which provides an opportunity for aspiring directors to hone their skills; the prohibitive cost of feature production and the need for a reasonably risk-free demonstration of talent for young directors; the break with celluloid and the digital turn; the financial and creative advantage of smaller projects; and increased sponsoring by varying structures of exhibition.[2] A decade later, all of these readily apply to SF shorts, but the digital turn seems to have had the most decisive impact, particularly in the form of a dramatic drop in the cost of production and post-production hardware and software; novel channels of marketing and distribution; and crowdsourcing capacity of online communities. The shape of many shorts is thus determined as much by individual creativity as by the affordances and limitations of digi-

tal tools, major among them programs. In *Software Takes Command* (2013), Lev Manovich boldly, and—to my mind—correctly, suggests that "there is no such thing as 'digital media.' There is only software. . . . For users who only interact with media content through application software, the 'properties' of digital media are defined by the particular software."[3] The degree to which the look and feel of digital shorts is shaped by nonlinear editing suites such as Final Cut Pro, Sony Vegas Pro, or Adobe Premiere may be debated, but comprehensive analyses of such filmic texts cannot afford to disregard the material circumstances of their production.

The nature of many SF shorts embeds them in the flows of digital media, in which talent and assets circulate among various media. Though few long-form productions utilize elements from their short progenitors, the medium of machinima, heavily dominated by science fiction and science fictional themes and very friendly toward short forms, perfectly exemplifies such circulation. Skills and practices from other digital media are also more than likely to be carried over into shorts. Hasraf Dulull, the director of *Project Kronos* (2013), which is slated to be made into a full-length film, has also worked as a VFX (visual effects) specialist on Hollywood productions such as *The Dark Knight* (2008) and *Hellboy 2* (2008) as well as video games such as *Enemy Territory: Quake Wars* (2007). Sam Nicholson, the author of *Xxit,* has contributed visual effects to more than a hundred TV shows and movies and also worked on video games. Attracted to SF formulas by their openness to spectacularity, these creators actively reshape— often unknowingly—the very contours of the genre as it circulates outside its traditional communities.

The medium's materiality has also imprinted itself on the narrative patterns recurrent in SF shorts. On the one hand, they demonstrate some interesting analogies with literary science fiction. Brooks Landon suggests that "digital technology gives the kind of creative control to the science-fiction filmmaker previously enjoyed by science-fiction writers."[4] The observation does not necessarily apply to full-length and big-budget blockbusters with expanding production crews, but it is certainly true for the shorts, in which the same person can be responsible for the script, direction, and visualizations. This translates directly into a high degree of artistic control over the text, an advantage enjoyed in visual media only by independent game developers. On the other

hand, creative independence often comes at the price of working with constrained budgets and limited technical know-how. The number of titles makes it difficult to generalize about their thematic spread, but the production regimes have, to a significant degree, privileged certain plots, particularly in live-action titles. Post-apocalyptic shorts showcasing desolate or devastated locations constitute a significant group, recuperating the interest in space of earlier fantastic literatures that was superseded by temporal imagination in twentieth-century literary science fiction.[5] The availability of digital post-editing has led to the proliferation of texts utilizing cyborg vision (*Archetype*, 2011), surveillance footage (*Plurality*, 2012), software interfaces (*Perspective*, 2011), and various sight overlays (*Sight*, 2012), in itself a commentary on the heavily mediated experience of life. Many of these elements make SF shorts doubly post-cinematic: in addition to being absent from traditional exhibition channels, these techniques invite, or even enforce, repeated viewing and slow motion inspection. Finally, retro-inflected material enjoys significant popularity. Either simulated or "real" found footage can be found in *Reign of Death* (2009), *Kometen* (*The Comet* 2004), or *Die Schneider Krankheit* (*The Schneider Disease*).

Another major transformation of science fiction reflected in shorts is the international expansion of the genre. Indeed, no other SF mode or medium can boast diversity and global reach equal to those of short film.[6] The digital democratization of production and distribution has led to the unprecedented internationalization of the form. SF short film is a truly global phenomenon with productions from Argentina (*New Media*, 2011), Australia (*Arrowhead: Signal*, 2012), Denmark (*Connected*, 2009), France (*King Crab Attack*, 2009), Germany (*Ausgestorben* [*Extinct*], 1995), Hungary (*A 639 baba* [*Doll No. 639*], 2005), Iceland (*Eater of the Sun*, 2010), India (*Backdoor*, 2012), Italy (*La Citta Nel Cielo* [*The City in the Sky*], 2009), Israel (*Sight*, 2012), Kenya (*Pumzi*, 2009), the Netherlands (*Tears of Steel*, 2012), Poland (*The 3rd Letter*, 2010), Russia (*Butterflies of Trip City*, 2010), South Africa (*Alive in Joburg*, 2005), Spain (*Fade*, 2000), Sweden (*Kunskapens pris—balladen om den vilsne vandraren* [*The Price of Knowledge*], 2007), and Turkey (*Perspective*, 2011). Though most of these countries have developed their own traditions of SF in such media as literature, comics, television, or even film, very few such texts have ever achieved international recognition. Short film has changed this. In the United

States and Canada, it has become a form of expression for communities hitherto excluded from cinematic production—a number of Native American shorts, including *File under Miscellaneous* (2010) and *The Migration* (2008), have been released in the past few years. The borderless flows of the medium are best exemplified by Fede Álvarez's *Ataque de Panico* (*Panic Attack*, 2009), a Uruguayan short presenting an invasion of Montevideo by towering retro-looking robots. Most immediately, the short is a localized appropriation of the Dutch *Geweldenaren Van Ver* (*Tyrants from Afar*, 2004), a visual vignette of three special effects studios, but Álvarez's work also features multiple appellations to other texts: the robots resemble machines from *Sky Captain and the World of Tomorrow* (2004), itself conceived as a short, which had been in turn borrowed from the 1941 Superman animated short *The Mechanical Monsters;* the alien spacecraft and the final destruction invoke *Independence Day* (1996); and the empty swings resonate with the playground scene in *Terminator 2: Judgment Day* (1991). The film's viral success on YouTube, which preceded festival appearances by three years, led to a $30 million contract with an American production company, resulting in the fourth installment of the *Evil Dead* franchise (2013).

The globality of SF shorts does not merely reflect the changing patterns of cinema as it extends beyond traditional filmmaking centers; it also implicates shifting definitions of SF itself. A number of international shorts, such as the Indian *Mumbai 2025* (2010) or the Italian *La Citta Nel Cielo,* bear distinct marks of both Hollywood filmmaking and Western conceptions of science fiction. Others are uniquely inflected with national patterns of the fantastic: the Kenyan *Pumzi*, the Hungarian *A 638 baba,* or the Turkish *Eski Dünyanın Orduları* (*Armies of the Old World,* 2011) combine Anglophone SF formulas with local fantastic traditions. In these cases, SF shorts both reflect and contribute to the recognition of the diversity of fantastic traditions. They demonstrate that the previously dominant Anglophone divisions between SF and fantasy or the storytelling patterns popularized by American science fiction are merely some of the choices in the broad repertoire of fantastic strategies.

The global flowering of science fiction shorts is a part of the more general renaissance of the short film—over half of all titles defined by IMDb as shorts were made between 2001 and 2013. Given the overlaps

and the porousness of IMDb's tagging system, the distribution of titles between genres can be considered more or less equal. However, in science fiction, more than in drama or mystery, the tally goes against the grain of the traditional centrality of extended narrative in the genre. Though critics have extensively discussed the fluidity of boundaries in any genre medium, the SF short's cultural, social, and economic contexts distinguish it sharply from long-form SF film; they also urge us to reconsider current conceptions of not only science fiction cinema but perhaps of science fiction itself. SF shorts share many characteristics with long-form films and run the whole gamut of production techniques, aesthetic choices, and financing models. They can be live action and animated; they utilize found footage as well as original filming; they can be privately produced and studio backed. Where they dramatically differ from long SF film is in the paradigms of production and distribution. The former radically promote individual creativity outside the filmmaking structures; the latter, primarily the free vectors of online dissemination, often render the contextual differences among a narrative short, a node in a transmedial narrative, and a promo clip showcasing the FX skills of a young studio irrelevant and impossible to detect.

The post-2000 SF shorts are firmly embedded in a broader ecology of new visual forms, which includes mobisodes and webisodes of network and cable TV shows; short paratexts, such as fictional Tru Blood drink commercials; video game cut scenes as well as gameplay and speed-run footage; machinima; and a whole range of fan productions, many of which feature SF plots and protocols. Many texts in the medium also complicate the traditional interpretations of filmic works as autonomous artistic expressions—this phenomenon is most readily demonstrated by titles located at the intersection of art and commerce. Beautifully impressionistic, Wong Kar Wai's *There's Only One Sun* (2007) is at once a noir-ish story and an extended commercial for Phillips's Aurea Ambilight Televisions, whose visual and narrative aspects are circumscribed by the intent to showcase the product's dynamic range and color management. In 2010, the same company, in cooperation with Ridley Scott Associates, ran the Phillips Cinema Parallel Lines contest. After five directors from RSA produced three-minute shorts with six specific lines of dialog, amateur filmmakers were challenged to do the same. More than 600 shorts were entered, including

Robert Kouba's *Translucent Unicorn,* Gianni Galli's *Alone,* and Richard Simpson's *The Engagement.* Unlike *There's Only One Sun,* the winners did not technically advertise any products, but the industry-driven initiative distinguishes them from older practices of short filmmaking. Music video is another medium confounding the traditional media ecology of short films. Fantastic imagery has naturally been used in video clips from the very beginning of the form, including such famous instances as David Bowie's "Space Oddity"; the footage from Giorgio Moroder's restoration of *Metropolis* (1927) in Queen's "Radio Ga-Ga"; Billy Ocean's "Loverboy"; 2Pac's "California Love," which takes cues from *Mad Max* movies; or Smashing Pumpkin's "Tonight," which pays homage to Georges Méliès's cinema of attractions. With time, however, the visuals in many clips have become as important as the music, the trend intensified by artists hiring directors known for narrative ambitions, as is the case with Chris Cunningham's film for Bjork's "All Is Full of Love" (1999). Other recent examples of music videos that are, for all intents and purposes, SF shorts, include "Exodus" by Noisia and Mayhem ft. KRS One (2010) or Nine Inch Nails' "Survivalism," one of the tracks from *Year Zero* (2007), a science fiction transmedia project and concept album. Whether these clips are indeed SF shorts per se may be debatable, but regardless of the answer, there is more than mere accounting at stake. Considering SF commercials or music videos as instances of science fiction or excluding them reflects one's sense of the very shape of the genre.

Media categories are not the only axis of diversity in contemporary SF shorts—another is the manner in which they function within cultural circulations. Like their mainstream and avant-garde cousins, many science fiction shorts remain stand-alone works. Some examples include *Ausgestorben* (1995), *f8* (2001), *Die Schneider Krankheit* (2008), or *Grounded* (2011). As in other media and genres, adaptations account for a fair share of titles, too: *Tomorrow Calling* (1993) is based on William Gibson's *Gernsback Continuum* (1981); *Y: The Last Man Rising* (2012) adapts the eponymous comic book, and *Portal: No Escape* (2011) and *Beyond Black Mesa* (2011) are inspired by the video game *Portal* (2007) and the *Half-Life* games (1998–2004) respectively. Even more complex links to other texts are present in shorts that function as promotional tools for high-profile texts: originally released as three short sequences, *Halo: Landfall* (2007) was the first live-action production

in the *Halo* franchise and a teaser before the release of *Halo 3* (2007) video game.

Shorts also can be integral elements of transmedia narratives. The most accomplished example in this category is *Animatrix* (2003), a series of nine shorts accompanying the *Matrix* franchise, in which several installments contain information crucial to understand the full-length films. Other examples of such "Works as Assemblage"[7] include *Watchmen: Tales of the Black Freighter* (2009), which retells the comic-inside-the-comic plot from Alan Moore's classic, or *The Chronicles of Riddick: Dark Fury* (2004), an effective bridge between *Pitch Black* (2000) and *The Chronicles of Riddick* (2004).

Finally, a number of shorts have served as teasers to attract the attention of major studios and been remade as full-length movies. *Alive in Joburg* (2005) was a seed for *District 9* (2009), and *The World of Tomorrow* (1998) became *Sky Captain and the World of Tomorrow* (2004). Among new shorts signed for full-length productions are *Ruin* (2011), conceived as a demo of the FX studio and contracted by Fox for a live-action movie and possibly a franchise; *Project Kronos* (2013); and Ricardo de Montreuil's *The Raven* (2010).

This is a very rich landscape, but if there is one element that unifies these different manifestations of the form, it is their reliance on digital technologies involved in production and distribution, and the degree to which these technical developments have influenced the very shape of the medium cannot be overestimated. In science fiction, the opportunities afforded by digital filmmaking seem to have highlighted the function, or even, as Brooks Landon suggests, the innate character, of science fiction film as a primarily spectacular medium whose phenomenological attraction has been suppressed by the narrative tradition.[8] Many SF shorts convey their science fictionality in their very ocularity—both in individual elements such as iconic elements and locations, stylistic references, editing, even colors, and in the very nature of the focus on the film production technology as it clashes with the filmic reproductions of technology.[9] Scott Bukatman notes that special effects redirect "the spectator to the visual . . . conditions of the cinema" and bring "the principles of perception to the foreground of consciousness";[10] many shorts, even those lacking special effects, seem to produce the same effect.

At the same time, as evidenced in reviews and in much of SF film

scholarship, SF film is, both among critics and viewers, primarily perceived as a storytelling medium whose achievements are measured by the standards of narrative complexity, psychological integrity of characters, and originality, a mixture of traits of literary realism and modernism. A body of cinematic texts described as "the new cinema of attractions"[11] has notoriously suffered from scathing criticisms for failing to deliver what its creators never intended to provide in the first place. Because of their lower critical profile and the divorce from the economic circulations of Hollywood filmmaking and other major film industries, science fiction short film has to date inspired few polemics, but its relationship with more traditional SF media remains equally vexed.

Building on Tom Gunning's conceptions,[12] Brooks Landon has suggested that SF film is merely a pseudo-morph of SF literature.[13] I extend this proposition and assert that science fiction short film is a pseudo-morph of both SF literature and long-form SF film and that the main source of this pseudo-morphism is its openness to the spectacular aspects of underlying digital technologies, which tend "to play up form, style, surface, artifice, spectacle and sensation."[14] Naturally, there are numerous SF shorts—particularly those that are adaptations or media tie-ins, or which run close to the time recognized as the limit of the medium—that offer sustained narratives with a clear sense of the plot's progress and closure. A fourth adaptation of Kurt Vonnegut's *Harrison Bergeron* (1961), *2081* (2009), has been praised for clarity and coherence. Robert Kouba's *The Rift* (2012) presages, in general outlines, the major blockbuster *Pacific Rim* (2013), while *Pumzi* (2009), one of the first SF productions from Africa, imaginatively engages ecological issues. Finally, now in its fourth season, the *Futurestates*, a series of digital shorts commissioned by the Independent Television Service, has a strong narrative focus in its attempt "to take the current state of affairs in the United States, and extrapolate them into stories of the nation in the not-so-distant future."[15]

A far larger group of fantastic shorts, however, eschews narrative originality or coherence and instead relies on visuality. Although short on historical precedents in other post-1945 science fiction media, their plot austerity can be read as a sign of return of the non-narrative tradition in cinema, which has continued outside SF since the very beginning of the medium. Still, even in this category a very interesting

dichotomy can be observed. A number of titles replicate the tactics of what has been called spectacular[16] or post-continuity[17] cinema. *Portal: No Escape, Priority One* (2011) and *Y: The Last Man Rising* (2012) as well as many animated titles predominantly rely on the frenzy of kinetic action or special effects. This category is perfectly exemplified by Sam Nicholson's *Xxit* (2011). The plot, in which a bio-clone from the future moves back in time to save the original donor of her stem cells, is at best sketchy, but narrative complexities are of little consequence here. Visually, *Xxit* is a dazzling demonstration of impeccably executed effects, many of which invoke the visions of multicultural megalopolises of the future like *Blade Runner* (1982), *The Fifth Element* (1997), or *Total Recall* (2012). In a distinctly spectacular fashion, *Xxit* crowds urban landscapes; fight scenes; time travel teleportation; surveillance footage; high-speed pursuit; and a medley of characters, including the titular clone Xxit-7724 and the renegade cyberpunk scientist Jhona, into a scant eleven minutes. Such shorts can be perceived as extensions of the aesthetics of the blockbuster, which in itself has essentially become little more than a loose collection of shorter clips of spectacle. *Xxit* and similar shorts thus function as micro-spectacles reveling in long panoramic shots of post-apocalyptic landscapes or emphasize their materiality, the remediatory stitching of surveillance tapes, cyborg vision, data overlays, reused stock, found footage, and digital special effects.

In most cases, however, the budgets available to filmmakers do not permit the visual glamor of *Xxit*. Instead, many SF shorts are characterized by a slower pace and more economic visions. *Tag 26* (Day 26, 2002) features two characters in biohazard suits, presumably twenty-six days after some epidemic outbreak, as they are making their way through the contaminated landscape. When one of them tears his suit, the other removes his helmet and decides to stay, too, unable to face loneliness. *Exist* (2011) is, in many ways, an alien abduction story, but most of the film is little more than a countdown to the actual taking of one of the two characters, which lasts for 15 seconds and provides no information about the aliens, the scale of abductions, or their aftermath. Finally, there is a group of films whose visual sophistication equals those of high-budget productions, but the manner in which they are presented, combined with stripped-down scripts, invite an entirely different mode of viewing, more akin to audiencing a futuristic

tableau. Their focus shifts from the perception of a film as a string of images aimed at continuity to one in which a short becomes a series of images that can be aesthetically savored in separation. Writing about short film in general, Richard Raskin suggests:

> More than any other form of cinematic narrative, the short fiction film heightens our sense of the preciousness and immediacy of the moment, both in the events portrayed and in the storytelling process. In both respects, the short fiction film demonstrates that every second can be made to count far more than we might otherwise expect, and implicitly reminds us never to underestimate how much meaningful and enriching experience can be encompassed by the briefest span of time.[18]

Although Raskin worked with realist fiction shorts, his observation certainly applies to a number of SF shorts, whose brevity of temporal scope allows them to be perceived as imaginary postcards from the future. In others, the relative un-eventfulness and slow unfolding direct the viewer's attention to the texture of future time and place. This can certainly be found in such shorts as *Quietus: To the New World* (2004), whose pace and cosmic reflection owe much to Kubrick's *2001: A Space Odyssey* (1968); *Golem* (2013), which, although based on Stanisław Lem's fiction, visually relies on almost abstract morphing shapes; or Joshua DuMond's clinically minimalistic *A7–058* (2013), set in an austere room aboard a spacecraft in which a woman is woken up from stasis and ruminates on the fate of being the last human alive. This mode is most masterfully represented by Julian Cooke and Sebastian Dias's *New Media* (2011). While it does invite a conclusive reading of medial oversaturation and human passivity, its slow unfolding and the dreamlike iconography of tentacular machines present in SF from Wells's *War of the Worlds* (1898) to *Skyline* (2010) contribute to an experience more akin to viewing a moving series of photographs, an installation, rather than a film.

Such primacy of visuality over narrative has been a mainstay of the experimental tradition of short-filmmaking, but in science fiction, it constitutes a hotly debated issue implicated in the genre's self-representation, particularly among academic and professional critics.

With its history of definitional struggles described by Roger Luckhurst as well as the conviction of SF's special role in world commentary, many SF communities have harbored intense suspicions of fantastic visualities.[19] Given the narrative drive that SF film has inherited from classical Hollywood as well as its literary sibling, the extent to which SF shorts have, to varying degrees, abandoned narrative pretentions strikes many viewers as a regression from the newly earned cultural and commercial cachet of contemporary SF cinema. This perception is understandable but it is also grounded in a particular vision of the discourse, whose roots can be found in the Campbellian yoking of SF and rationality.

With their emphasis on ocularity over narrative, science fiction shorts invoke the beginnings of cinema as a medium and SF cinema as a genre. It is also possible to think of them as a reclamation of cinema's original form and purpose. The titles built around action and kinetics, such as *1945A* (2010) or Francisco Silva's *Sentinel* (2012) can be considered the latter-day reincarnation of the cinema of attractions, which, as Brooks Landon claims, can all be viewed as science fiction.[20] Other, slower and more meditative shorts resurrect the vision of cinema as a dreamlike, phantasmagoric medium present in the writing of such early theorists as Rudolf Arnheim or in some Surrealist cinema. Although, as a genre, science fiction has not been perceived as the best conduit for such sensibilities, *New Media* or *Quietus: To the New World* are very much informed by surrealist imagery and may well be viewed as the missing visual link between the surrealist tradition and SF.

Ironically, like early cinema, SF shorts can also be very ephemeral. Their global circulation enhanced by online dissemination and the lack of entanglements in complicated exhibition practices and territorial copyrights seems to promise much longer life than was the case with early films, so many of which are believed to be lost forever.[21] Simultaneously, however, their sheer number makes it difficult for individual titles to imprint themselves on the memory of a viewer whose attention span is often as brief as the running time of the titles in question. The wildly diverse vectors of production and distribution also render any attempts for comprehensive catalogs almost impossible.

With close to a thousand titles a year, science fiction short film resists generalizing theories focused on themes or motives. It is far more interesting, I think, to adopt approaches characteristic of other

digital media: the influence of the medium's materiality on the narrative material rooted in literary fiction; the forensic investigation of the texts' development; or the affective and phenomenological analyses focusing on visuality and spectacle, rather than cognitive values of storytelling. While many quarters of the SF world are still involved in battles over legitimacy and informed by the desire to demonstrate the genre's profundity to mainstream audiences and circuits, most science fiction shorts sidestep such political ambitions and provide their viewers with the contemporary equivalent of the 1950s sci-fi cinema at its worst or fifteen minutes of visual delirium at its best. In either case, their scale and individualized authorship say much more about the actual cultural circulation of science fiction than the heavily formalized and collectivized structures of spectacular cinema or large-budget video games.

NOTES

The research involved in the preparation of this essay was supported by a grant from the Polish National Science Center 2012/05/B/HS2/04095.

1. Ritch Calvin, "Short Sf Films 2010 (1–10 Minutes Duration)," *Science Fiction Film and Television* 5, no. 1 (Spring 2012): 115. Calvin uses a somewhat more arbitrary and inclusive definition of a short and considers all films running at up to sixty minutes. The Academy of Motion Picture Arts and Sciences describes a short as a motion picture with a running time of forty minutes or less, including credits, and most short film festivals accept entries of thirty minutes and shorter. Interestingly, in Calvin's listing, the number of examples for each running time decreases above the twenty-minute mark, compared to tens of titles lasting, for instance, thirteen minutes.

2. Eileen Elsey and Andrew Kelly, *In Short: A Guide to Short Film-making in the Digital Age* (London: British Film Institute, 2002), x.

3. Lev Manovich, *Software Takes Command* (New York: Bloomsbury Academic, 2013), 152.

4. Brooks Landon, "Diegetic or Digital? The Convergence of Science-Fiction Literature and Science-Fiction Film in Hypermedia," in *Alien Zone II: The Spaces of Science-fiction Cinema*, ed. Annette Kuhn (London: Verso, 1999), 43.

5. It is commonly accepted that SF's slow but gradual concretization into visibility in the second half of the nineteenth century was inextricably linked

to the changed perception of time in the Western societies. The beginning and the maturation of this cognitive transformation has been located in various periods—in the times immediately after the Copernican revolution (Adam Roberts, "The Copernican Revolution," in *The Routledge Companion to Science Fiction,* ed. Mark Bould et al. [London: Routledge, 2009], 9; Paul Alkon, *Origins of Futuristic Fiction* [Athens: University of Georgia Press, 1987], 4; "around 1800, when spaces loses its monopoly upon the location of estrangement and the alternative horizons shift from space to time" (Darko Suvin, *Metamorphoses of Science Fiction: On the Poetics and History of a Literary Genre* [New Haven: Yale University Press, 1979], 89); or following the Darwinian breakthrough that finally opened up for the Western mind evolutionary time scales progressing in time (Elizabeth E. Guffey, *Retro: The Culture of Revival* [London: Reaktion, 2006], 153).

6. This diversity does not, sadly, extend into the realm of gender. Like long-form Hollywood SF, SF shorts seem to attract few women filmmakers, an absence that is further aggravated by the small number of important and influential women directors in the art house and experimental short tradition.

7. N. Katherine Hayles, "Print Is Flat, Code Is Deep: The Importance of Media-Specific Analysis," *Poetics Today* 25, no. 1 (Spring 2004): 278.

8. Brooks Landon, "Diegetic or Digital?," 34–35.

9. J. P. Telotte, "Film and/as Technology: An Introduction," *Post Script: Essays in Film and the Humanities* 10, no. 1 (1990): 4.

10. Scott Bukatman, "The Ultimate Trip: Special Effects and Kaleidoscope Perception," *Iris,* no. 25 (1998): 79.

11. Drawing on his collaborative work with André Gaudreault, in "The Cinema of Attraction: Early Film, Its Spectator and the Avant-Garde" (*Wide Angle* 8, no. 3–4 [1986]: 63–70), Tom Gunning develops the conception of the cinema of attraction or attractions (64), a period in the history of the medium from its beginnings until 1906–7 characterized by the primacy of visuality and a different relationship that the image established with the audience. Although the original cinema of attraction was quickly eclipsed by the onset of the narrative tradition, at the turn of the twenty-first century Gunning's conception was adopted by several critics in their discussions of special-effects cinema. For critics such as Brooks Landon, Scott Bukatman, or Geoff King, numerous productions in such genres as science fiction or action film, although lacking the willingness "to rupture a self-enclosed fictional world" (Tom Gunning, "The Cinema of Attraction: Early Film, Its Spectator, and the Avant-Garde," in *Film and Theory: An Anthology,* ed. Robert Stam and Toby Miller [Oxford: Blackwell, 2000], 64), mark the recuperation of the cinematic mode with attenuated narrative complexity but focused on pure image and kinetic action. *The Cinema of Attractions Reloaded,* ed. Wanda Strauven

(Amsterdam: Amsterdam University Press, 2007), traces both the origins and the recent applications of the notion of the cinema of attractions.

12. In "An Unseen Energy Swallows Space: The Space in Early Film and Its Relation to American Avant-Garde Film," Gunning offers the following definition: "Relation of a pseudo-morphic to an authentic paradigm is that of a counterfeit to an original: a surface deceit that conceals a number of internal differences, an attractive appearance of affinity that cloaks a basic discontinuity in genus and species" (in *Film before Griffith*, ed. John L. Fell [Berkeley: University of California Press, 1983], 355).

13. Brooks Landon, *The Aesthetics of Ambivalence: Rethinking Science Fiction Film in the Age of Electronic (Re)production* (Westport, Conn.: Greenwood, 1992), 7.

14. Andrew Darley, *Visual Digital Culture: Surface Play and Spectacle in New Media Genres* (London: Routledge, 2004), 6.

15. "Futurestates: About," *Futurestates.tv*, 2013, http://www.futurestates.tv/about/.

16. In *Spectacular Narratives: Hollywood in the Age of the Blockbuster* (London: I.B. Tauris, 2001), Geoff King demonstrates that despite Hollywood's excessive reliance on pure spectacle in the last few decades, contemporary blockbuster productions retain definite narrative and ideological focus, even if the character of their presence has changed.

17. Steven Shaviro coined the term "post-continuity" in his study *Post-Cinematic Affect* (Winchester, U.K.: Zero Books, 2010) and developed it in a paper presented at a Society for Cinema and Media Studies conference ("Post-Continuity," *The Pinocchio Theory*, March 26, 2012, http://www.shaviro.com/Blog/?p=1034). In this new cinematic style "a preoccupation with immediate effects trumps any concern for broader continuity—whether on the immediate shot-by-shot level, or on that of the overall narrative." Going against a nearly universal condemnation of this mode of filmmaking, Shaviro demonstrates the genealogy and the cultural relevance of post-continuity.

18. Richard Raskin, *The Art of the Short Fiction Film: A Shot by Shot Analysis of Nine Modern Classics* (Jefferson, N.C.: McFarland, 2002), 173.

19. Roger Luckhurst, "The Many Deaths of Science Fiction: A Polemic," *Science Fiction Studies* 21, no. 1 (March 1994): 35–50.

20. Landon, "Diegetic or Digital?," 32.

21. Though the estimates vary widely, sources such as Martin Scorsese's Film Foundation estimate that more than 90 percent of all American silent movies before 1929 and 50 percent of American sound movies between 1927 and 1950 have been lost forever. The estimates for other countries can be expected to be comparable.

4 Forms of Journey and Archive

Remaking Science Fiction in Contemporary Artist-Filmmakers' Projects

JIHOON KIM

In the past decade, SF film and literature have moved beyond the normative venues of the movie theater and print and spread across a range of platforms in contemporary art. The most remarkable of these phenomena is the emergence of moving-image artworks that appropriate elements of science fiction films, including their imaginary spaces, possible futures, narratives of travel or exploration, and more. Several notable examples include Doug Aikten's monumental multiscreen piece *Electric Earth* (1999, 35mm, eight-channel projection, 15 mins.), Philippe Parreno's *The Boy from Mars* (2005, 35mm, single-channel projection, 13 mins.), Apichapong Weerasethakul's *Faith* (2006, HD, two-channel projection, 11 mins.), and *Primitive* (2009, HD, two-channel projection, 29 mins.), Ben Rivers's *Slow Action* (2010, 16mm, four-channel projection, 45 mins.), and Kelly Richardson's *Leviathan* (2011, HD, three-channel projection) and *Mariner 9* (2012, HD, three-channel panoramic projection).

These works exemplify the extent to which film and video installation has used the settings, spatiotemporal elements, and narrative tropes of SF film in several ways: Aitken deploys across eight screens a story of a black rapper's wandering through an imaginary urban desert landscape reminiscent of post-apocalyptic SF films. As his homage to the science fiction genre,[1] Weerasethakul's two-channel video piece *Faith* brings a man's dream of eternal love to a spaceship in which two astronomers approach but cannot meet in the no-gravity atmosphere of frictionless motion and wordless duration. Weerasethakul's dreams of an imaginary journey through the universe and of an encounter with an unknown Other echo Parreno's *The Boy from Mars*, a film without a clear plot that creates a situation in which an improbable technology (in fact, an electricity generator powered by the buffalo in Chiang Mai,

Thailand) forms light at dusk to illuminate the fictive appearance of a UFO from Mars. For its part, the interplay of nature and technology in *Boy from Mars*—and of fiction and reality as well as of the mythical and the futuristic—resonates with Rivers's post-apocalyptic SF film, which exists somewhere between documentary and experimental ethnography, and with Richardson's digitally enhanced images of natural landscapes, the swamp in *Leviathan* and Mars in *Mariner 9*.

The diversity of these works shows the extent to which contemporary film and video artists who adopt the tropes of science fiction as a notable object have opted for strategies of recycling or "remaking." The term *remake* has been coined by French art critic Jean-Christophe Royoux, who used it to refer to a common procedure of artists' film and video, or, what he calls the "cinema of exhibition (*cinema d'exposition*)" since the 1990s by which an existing film, its entirety or fragments, is reworked by another artist using different settings, actors, and technical arrangements. Since then, the strategies of remake and the relationships between a "remade" film or video and its host text have been so varied that it is nearly impossible to generalize them, although renowned artists like Douglas Gordon, Pierre Huyghe, Candace Breitz, and Omer Fast have all been included under this umbrella term.[2] Despite the prevalence of remakes, however, this procedure more likely indicates an ambivalent attitude toward film, marked by both the end of a history and the desire for exploring a possibility of remembering and creating something new in its wake. Royoux notes that the treatment of existing film as a remnant of the past (where the cinema enjoyed its status as a supreme art of the twentieth century) in remaking marks both the "sense of an inevitable post-cinematic era" and the "development likely to keep reviving and renewing future modes of appropriation."[3] Similarly, Erika Balsom writes that within the multiple reflections on the history of cinema in "remade" works we are able to identify "a trajectory that moves forward to clear a space for a new cinema of the gallery, a cinema of artists who will continue to push the boundaries of what is possible with the moving image as cinema moves into its second century."[4] With Royoux's and Balsom's views in mind, we can conjecture an underlying motivation of the artists and filmmakers who appropriate the tropes and worlds of science fiction in their works. The practitioners' strategies of "remaking" cinema as ways of investigating the history of cinematic images and

representation and the possible future of the moving image alike echo science fiction's double-edged directions of reflecting on both the past and future of the human in relation to nature and civilization from the standpoint of the present.

This chapter examines the ways in which contemporary artist-filmmakers—an array of artists who traverse between cinema and contemporary art with their cross-disciplinary, intermedial production of artworks that rework the remnants of cinema—remake the narratives and motifs of science fiction film and novels. It focuses on two recent projects, Pierre Huyghe's project *A Journey That Wasn't* (2005) and Dominique Gonzalez-Foerster's large-scale installation *TH.2058* (2008). The two works borrow two tropes from the existing SF canon, the journey and the archive. For *A Journey That Wasn't*, Huyghe traveled with his fellow artists to Antarctica to investigate a rumor about a strange white creature (an albino penguin), juxtaposing the quasi-documentary imagery of this journey with an SF narrative that both pays homage to Edgar Allan Poe's *The Narrative of Arthur Gordon Pym of Nantucket* (1838) and alludes to the current crisis of global warming. Huyghe's interest in the exchange between the fictional motif of scientific travel and the factual precariousness of the contemporary world resonates with Gonzalez-Foerster's *TH.2058,* an imaginary museum of a post-apocalyptic world in the future, in which canonical SF novels are collected and a series of SF films are looped like the fragments of memory after catastrophe on a gigantic LED screen.

Beyond their recycling of SF tropes by means of cinematic narrative and images, these two works are remarkable for a shared formal characteristic: the two artists' remaking strategies result not in moving image artifacts easily classified as film and/or video installation but as intermedial artworks that challenge the stable boundaries of the cinematic medium and the relative certainty of the space, time, and experience guaranteed by it. For just as *A Journey That Wasn't* exists as a combination of physical travel, video documentation, multimedia performance, and mixed-media installation, so *TH.2058* deploys a collection of existing books and sculptures, architectural constructs, artifacts, and a series of existing film fragments compiled and edited by Gonzalez-Foerster. Both projects are therefore characterized by the presence of heterogeneous materials and expressions that tend to remain separate from one another. Huyghe and Gonzalez-Foerster re-

work the journey and the archive as a connective tissue that endows materials and expressions with thematic and experiential consistency.

In what follows, I investigate the journey in *A Journey That Wasn't* and the archive in *TH.2058* through form as a conceptual device for linking disparate artistic materials and expressions and thereby creating a common aesthetic experience of the world in which reality and fiction are thrown into a circuit of mutual penetration. Contemporary art criticism has recently proposed this notion of form as a structure of connecting elements in ways that go beyond the medium-specific boundaries of an artwork in response to intermedial or multimedia art projects like Huyghe's and Gonzalez-Foerster's. Nicholas Bourriaud introduces this notion of form as he elaborates upon his now-famous "relational aesthetics" as a key tendency of contemporary art practices to reconfigure the connection between art and the realms of human culture and interaction. For Bourriaud, relational art endeavors to create a form that is extended from the typical features of a world; form thus functions as a "linking element" of heterogeneous materials and experiences, one that "only exists in the encounter and in the dynamic relationship enjoyed by an artistic proposition with other formations."[5] Bourriaud's conceptualization of form as a "linking element" that invites an ensemble of materials and conventions grapples with the notion of "format" proposed by art critic David Joselit. Employing as examples intermedial installation projects by Huyghe, Rirkrit Tiravanija, and others (also important for Bourriaud as examples of relational art), Joselit defines format as a "heterogeneous and often provisional structure that channels content" in order to establish "a set of links or connections—between people, images, spaces, events, and so on."[6] As I will demonstrate, the concepts of "form" or "format" are compelling to explore the idiosyncrasies of *A Journey That Wasn't* and *TH.2058* because they are predicated upon the two artists' appropriation of existing SF films or stories through a common form comprised of different materials and experiences: the journey for the former, and the archive for the latter.

By explaining the ways in which the journey and the archive function to make possible the encounters between heterogeneous materials and artistic expressions, I argue that both Huyghe and Gonzalez-Foerster consider SF not just as an object of appropriation but as the form (or format), in Bourriaud's and Joselit's senses, of their

"remaking," creatively adopting SF texts as ways of refashioning an imaginary universe that registers the crises of contemporary society. Huyghe's journey as a spatial form that blends fiction and reality and Gonzalez-Forester's archive as a temporal from for the fluid exchange between present and future both allude to the two precarious conditions of our contemporary world: the technological colonization of the earth (Huyghe) and the transformation of cultural artifacts into disposable, forgettable items (Gonzalez-Foerster). The two artists' development of forms, then, are attempts to create artworks as provisional environments that offer visitors the opportunity to reflect upon the conditions of their common world by allowing them to traverse between disparate materials and experiences, unburdened from the rigid distinction between art forms or between art and culture and to make creative connections between past, present, and future.

Journey-Form: *A Journey That Wasn't*

In his *The Radicant,* Bourriaud identifies the journey as the form that creates encounters between previously distinct artistic ideas and materials, one that responds to the growing precariousness of the contemporary world in which "the stability of things, signs, and conditions is becoming the exception rather than the rule."[7] A number of contemporary artists, Bourriaud continues, have recently opted for the journey and its corresponding artifacts (maps), discourses (the travelogue), icons (territories, deserts, jungles), and activities (expeditions) in order to explore the growing dissolution of spatial and material boundaries as well as experiences of mobility and dislocation, both of which are key consequences of globalization: "This obsession with the journey coincides with the disappearance of any *terra incognita* from the surface of the earth."[8] Accordingly, the journey leads to nomadic projects marked by the simultaneous linkage of heterogeneous materials and practices and by the overlapping representations of a space composed by these materials and practices. That is to say, each material or practice—be it a physical travel, a site-specific project based on the travel's path or destination, a video/textual documentation of the travel, or a retrospective reenactment of it—provides its own territory of the space; a larger yet non-totalized picture of the space is acquired only by the intersection of all the materials or practices—ephemeral or

permanent, planned or arbitrary, and random or routine. In this sense, the projects based on the journey-form are intended to perform, in the words of Fredric Jameson, a "cognitive mapping" of the postmodern world whose material surfaces and geographic borders are fundamentally unstable due to the continuous, multidirectional flows of information and signs.[9] Still, the artists' exploration of the journey-form aims not simply at geographically or topologically rendering the contemporary precarious world as transitory and multidimensional but also at reconfiguring the ideas of time and history previously bound to the stability of the physical space and its boundaries, as Bourriaud further notes:

> If time today has been spatialized, then *the heavy presence of the journey and of nomadism in contemporary art is linked to our relationship with history*—the universe is a territory, the entire dimensions of which can be traveled—the temporal as well as the spatial. Today, *contemporary artists enact their relations with the history of art under the sign of travel*, by using nomadic forms or adopting vocabularies that come from *the interest in "elsewhere."*[10]

It is in this context that Bourriaud considers *A Journey That Wasn't* as a compelling example of the journey as a form that generates "connections between time and place." The project was conceived less as a video piece attuned to the format of single-channel projection than as a cross-format, intermedial one predicated upon a combination of different forms, activities and practices.[11] It was initially triggered when Huyghe overheard a rumor that a singular white animal was living in Antarctica: an albino penguin, purportedly mutated by the effects of global warming on its ecosystem. At the same time, Huyghe also came upon the series of adventures on a whaling ship in Poe's *The Narrative of Arthur Gordon Pym of Nantucket* (including one to the South Pole), and decided to embark upon a one-month journey to Antarctica on a boat with ten collaborators (including artists and scientists) that carried out a series of activities in addition to searching for the albino penguin, including gathering scientific data on climate changes on an island they found in Antarctica. Huyghe then organized and staged a public performance in Central Park after the journey, in

the form of an opera accompanied by theatrical lights, visual effects, and a score based on data gleaned from the island. Subsequently, he made the single-channel video by editing together footage of Antarctica and Central Park, and installed it along with other architectural and structural elements. In this way, the project presents—and is grounded in—the journey both as a connecting form interweaving multiple media and locations, and as something doubled by the media: that is, Huyghe's actual voyage into Antarctica is recounted by the performance, the single-channel video, and the mixed-media installation coupled with the video, and this multiplication of the project necessarily encompasses different places such as Antarctica, Central Park, and the gallery in which it was shown. Given that each of the media and activities offers spectators a singular version of the journey that both overlaps with and is different from the others, it is possible to think of Antarctica (and the story of Huyghe's search for the penguin) as less a stable geographical location than a site whose meaning, territory, and map are constructed by discursive and representational practices.[12]

A precursor to the journey as a form transfigured and dispersed in different forms of representation and fiction can be found in *One Million Kingdoms* (2001), a short digital animation based on Ann-Lee project (1998–2002), a collaborative project of Huyghe, Philippe Parreno and other artists to explore a wide variety of activities and practices with a Japanese *manga* character whose copyright they had purchased. In this piece, the fictional female character AnnLee walks through a lunar landscape whose mountains grow sequentially as she progresses. This visual track is juxtaposed with a narrator's voice that recites actual recordings of Neil Armstrong mixed up with excerpts of Jules Verne's *Journey to the Center of the Earth* (1867). This short piece creates an entangled configuration of the different yet repeated histories of the journey into a new world, while at the same time repositioning them in a digitally created landscape that suggests both the current image production and an unknown and imagined future. The layering of different temporalities associated with the journey in *One Million Kingdoms* repeats in *A Journey That Wasn't*. In its initial stage, there was the intersection between the archetypical narrative of a journey into the unknown in Poe's novel and the rumor of the albino penguin as indicative of precarious environmental conditions in the present. Subsequently, the voyage derived from the encounter between the past

and the present, and fiction and science, was reenacted across a series of artistic activities involving different media, which necessarily created and doubled a temporal distance from it: that is, the multiplication of the single journey validates that it is impossible to represent the experience (as well as Antarctica and the penguin) transparently; in turn, this fundamental obscurity and elusiveness enables Huyghe to re-create it with different materials and expressions. As Huyghe notes in the name of his collective (The Association of Free Times), "Reality is not what it used to be; it has become relative. . . . If language fails to recount the experience, an equivalence, topologically identical to the occurrence, has to be invented."[13] The need to "invent" multiple ways of recounting experience responds to the fundamental instability of our understanding of space and time that Bourriaud identifies as a key motivation of the journey-form, and it is the reason that Huyghe defines the project as producing "zones of obscurity, areas of not-knowing."[14]

Significantly, Huyghe's conception of the work as a layering of different places and temporalities is predicated upon his fascination with fiction. For Huyghe, fiction is important because it takes different shapes as it is appropriated and recycled in artistic and cultural productions that trigger human memory. This repetitive reincarnation of fiction testifies to its fundamental blurring of reality: "What interested me was to investigate how a fiction, how a story, could in fact produce a certain kind of reality. An *additif* of reality."[15] Fiction, then, is meaningful inasmuch as it is translatable and reproducible through a dynamic exchange with reality, which it also constitutes. To put it another way, fiction corresponds to the cross-medial nature of what Bourriaud considers as "form," or what Joselit characterizes as "format." He thus sees the relationship between fiction and reality as under construction, operating upon a circuit of reciprocal influences. Mark Godfrey explains the exchange between fiction and reality in *A Journey That Wasn't* as follows: "The factual effects of global warming . . . encouraged him to invent a fictional hypothesis that went as follows: the retreat of the polar ice sheets should lead to the creation of new islands and to mutations in the Antarctic fauna; a journey to such islands should therefore result in a contact with a mutated species."[16]

In the video component of *A Journey That Wasn't*, two types of disjunctures complicate the representation of the albino penguin through the mutually constructed nature of fiction and reality, thereby inviting

the viewer to question whether the team's discovery of the penguin accomplished its desired aim—a scientific inquiry into the deleterious effect of global warming on the globe's ecological conditions by locating the penguin as proof of its mutational force. The first disjuncture is presented in the juxtaposition of the penguin and a flickering searchlight that the team installed as a key device of the station set up on an island in Antarctica. Huyghe's camera captures the albino penguin walking to the island's seashore from a distance in the series of long shots and extreme long shots, highlighting the contrast between the penguin and its surrounding gigantic landscape densely covered with snow. As in Direct Cinema, the camera takes the position of an invisible observer. This sense of wonder is interrupted, however, as night falls and the station's searchlight continues to emit its flickering light. The brightness of the light presents a stark contrast with the daytime shots inasmuch as it obscures the albino penguin's existence while simultaneously symbolizing the ideal of scientific inquiry—containing the alien or unknown other and making its details visible. A full shot of a penguin highlights this point: shot in darkness, it does not allow the viewer to see clearly whether or not its silhouette is that of an albino. This obscurity does not simply produce a critique of scientific idealism but also draws the viewer's attention to the ways in which the penguin might be seen as hovering between two possible existences: a real creature found by the fictional hypothesis and a fictional entity invented by the real journey (itself driven by this hypothesis).[17]

The second disjunction between fact and fiction is made as this cinema vérité style documentation overlaps with the shots presenting the climax of the performance in the Central Park. As Godfrey rightly notes, "No images or direct representations of Antarctica were shown in Central Park: rather, the island was transformed into a score of music and light."[18] Instead, what substitutes the real albino penguin is an animatronic automaton of a penguin, whose color is not identified due to the fact that it is shot with glaring stage lights (Figure 4.1). Thus, the replica alone does not guarantee that the performance be faithful to reenacting either what Huyghe's team witnessed with their naked eyes or what they documented with the camera. Rather, the replica's formidable yet elusive presence should be thought of as putting forward a series of affective powers attributable to the cooperation of the performance's audiovisual components. This spectacular immersive

Figure 4.1. Pierre Huyghe, *A Journey That Wasn't,* super 16mm and HD video transferred to HD video, color and sound, 21 minutes, 41 seconds, 2005. Courtesy of the artist and Marian Goodman Gallery, New York.

effect presents a stark contrast with the footage of the albino penguin wandering on the island, much more than the footage's overall stance of objectivity and contemplation. For the performance is conceived in ways that create and increase a distance from the team's journey and their documentation of it. If the performance can be regarded as a translation of both these phenomena, its status becomes more dynamic. Seen in this light, if the penguin in the footage appears as "the object of the search," then the penguin in the performance is "the subject of the work and the object of the spectacle."[19] Still, what is crucial in these multiple reincarnations of the penguin is their relationship. The second penguin, the animatronic replica armored with the spectacular effects, amplifies in imaginary ways the sense of wonder modestly suggested in the initial footage. At the same time, however, it also works to offset the scientific premise informed by the footage's observational style, while at the same time overwhelming spectators with mythical overtones. The latter aspect shows that the whole body of work in *A Journey That Wasn't,* encompassing both video and

performance, underscores the simultaneity of science and magic as an underlying tension of SF in its literary and filmic forms.[20]

To be sure, the complicated nature of this performance in relation to the projected image echoes the work's underlying purpose in the sense that, as Sjoukje van der Meulen neatly points out, it "lays bare the structure of experience as it occurs in the hybrid configurations of natural, mediated, witnessed, and fictional presence in the media society."[21] Expanding upon van der Meulen's view, we could say that the performance itself is based on a densely layered complex of pairs often considered binary: nature and civilization, science and magic, mediated and witnessed realities, imagined and found realities, and reality and fiction. But this is also clearly the case with the project's video component, in which observational shots and the documentation of performance coexist, and with the project's overall process from the initial conception to the end. It becomes clear that the journey is the crux of *A Journey That Wasn't*: its notions of drifting and displacement suggest the blurring of these binary oppositions, a blurring amplified by the multiplication of artistic expressions, placed on the same plane, and by the fundamental equivalence between them.

Archive-Form: *TH.2058*

For the past fifteen years, contemporary art production and curatorial practices across different media have explored the archive as the apparatus of storage, preservation, and access.[22] Prominent art critic Hal Foster has labeled this practice "archival art," arguing that it foregrounds its historical materials (including existing image, text, object) as "found yet constructed, factual and fictive, public yet private."[23] In doing so, Foster continues, the archival art "assumes anomic fragmentation as a condition not only to represent but to work through" and "proposes new orders of affective association."[24] Artists such as Thomas Hirshhorn, Sam Durant, and Tacita Dean incorporate Foster's dialectical view on the archival art, for their archival structures—be they collections, re-created monuments or constructs, audiovisual documentations, or installations—present both the possibility and impossibility of the archive. Their shared features—the heterogeneity and destined loss of found materials, the dispersion of their sources, and the decentralized and even chaotic aspects of their arrangements or categories—all

point to the structural instability of the archive. More significant, the artists take this instability as a foundation for evoking the viewer's critical awareness of the relation between archival structure and information, enabling her to create a memory based on nonchronological, shifting, and multidimensional associations between the archive's materials. Foster's notion of archival art argues that the archive is not simply a relatively stable, inert inventory of past records open for interrogation, but a kind of format inviting variegated materials and diverse kinds of access and exploration. As I demonstrate in the following, *TH.2058* is exemplary of archival art in Foster's sense as it takes the form of dispersed yet interconnected reservoirs of human knowledge and memory, constituting the archive less as something available for artistic inquiry than as a creative, imaginary artifact whose storage and transmission of the past is dynamic and constructed. As Okwui Enwezor notes, moving beyond unearthing the structural and functional principles underlying the use of the archival document or material, artists' interrogation of the archive in contemporary art often results in the "creation of another archive structure as a means of establishing an archaeological relationship to history, evidence, information, and data that will give rise to its own interpretative categories."[25] Still, what makes *TH.2058* stand out in comparison to other works of the archival art in contemporary art scenes lies in the complexity of its temporalities, strongly inspired by a wide variety of SF texts in its concept, structure, and the heterogeneous materials that it preserves and transforms.

A monumental project commissioned for Tate Modern's Turbine Hall (Figure 4.2), *TH.2058* is an aggregate of heterogeneous objects, materials, and architectural constructs inspired by post-apocalyptic SF films and novels, including George Orwell's *1984* (1949), Chris Marker's *La Jetée* (1962), Ray Bradbury's *Fahrenheit 451* (1953, and its film adaptation of the same title by François Truffaut in 1966), and Richard Fleischer's *Soylent Green* (1973). As in Orwell's novel, the work's installed version in the Hall imagines London in 2058, a civilization nearly destroyed by continuous floods and falling rain. The set presents a massive repository of memory objects associated with human civilization, conceived as an imaginary archive of the past seen from the perspective of a possible dystopian future. Blue and yellow bunk beds are strewn with books, monumental replicas of sculptural works, and a massive LED screen playing edited clips of scenes from different

Figure 4.2. Dominique Gonzalez-Foerster, *TH.2058,* installation view. Courtesy of the artist and Tate Modern.

films. Recalling the pile of outlawed books that the fictional authoritarian society orders to be burnt in *Fahrenheit 451*, they include *Fahrenheit 451, La Jetée: Ciné-roman*, Marguerite Duras's *Hiroshima mon amour*, George Perec's *Un homme qui dort*, as well as a dozen canonical SF novels (Philip K. Dick's *The Man in the High Castle*, J. G. Ballard's *The Drowned World*, William Gibson's *Pattern Recognition*). Similarly,

the sculptural works—also canonical artworks by Louis Bourgeois, Henry Moore, Maurizio Cattelan, Bruce Nauman, and so on—remind us of the museum of natural science before the nuclear war in *La Jetée*: a large tarantula for Bourgeois's *Maman* (1999); a skeleton of a dinosaur for Cattelan's *Felix* (2001).

As in Foster's definition of archival art, Gonzalez-Foerster establishes the archive as a connecting form that interweaves diverse found objects. Foster sees the archive in this type of art as "recalcitrantly material and fragmentary,"[26] in stark contrast to the database as the collection of immaterial data compiled and processed by the computer. The material heterogeneity of the books, sculptural works, architectural constructs, and films installed in *TH.2058*, as well as with the phenomenological heterogeneity of the experiences that each category of the objects prepares for visitors, resonates with Foster's definition. In addition, the work's underlying narrative of the imagined postapocalyptic London reveals the archive's "fictive" and "constructed" aspects, while its references to the histories of literature and visual art highlight the materials' "found" and "factual" dimensions. Finally, the work's logic of arranging the materials points to the matrix of citation and juxtaposition common to archival art, allowing visitors to make associations among materials in ways that do not necessarily obey their chronological order or original meaning. Gonzalez-Foerster conceived of the work as a kind of "ensemble of things," elaborating upon the strategies of quotation and reuse: broadly, by appropriating SF; more specifically, by adopting the principle of editing not simply for compiling and arranging the borrowed films but also for deploying other objects such as sculpture.

Gonzalez-Foerster explicitly indicates Walter Benjamin, Jean-Luc Godard, and Jorge Luis Borges as three figures that inspired her to conceptualize this heterogeneous archive of the past in a possible future. "(I referred to) Walter Benjamin for this use of quotes and literature and this hypertext. Godard in his *Histoire(s) du cinema*, but also a connection between music, literature, and film. And then Borges was always turning literature into a gigantic library or archive."[27] Although Gonzalez-Foerster's reference to Borges is obvious given the work's accumulation of canonical SF novels as a kind of library, perhaps it is Benjamin's ideas of montage and allegory that are most influential to her conception of the work as an archive. Like *The Arcades Project* (1927–40), *TH.2058* also constitutes a chain of quotations of disparate

objects that are recontextualized as the remnants of human civilization and culture viewed from an imaginary future of the twenty-first century while simultaneously maintaining their original meaning and materiality in the present: that is, in the words of Benjamin, the work develops the "highest degree of the art of citing without quotation marks," whose theory is intimately "related to that of montage."[28] In this juxtaposition a certain group of materials whose original sources are at first sight unrelated acquire a new common meaning. Duras's *Hiroshima mon amour* and Mike Davis's *Dead Cities* (2003) are not science fiction works as such, for example, but their depictions of post-apocalyptic worlds are thrown into relief when juxtaposed with other SF classics. Furthermore, Benjamin's concept of allegory has to do with understanding cultural objects of the past as discarded, forgotten, fragmented, ambiguous, imperfect, and/or deteriorated; in this sense, Benjamin sees the allegorist as the one that "rummages here and there for a particular piece, holds it next to some other piece, and tests to see if they fit together."[29] Following this principle, the scenario of *TH.2058* positions the visitor as a survivor who will be able to recognize the past embedded in the books, sculptures, and films that are ruins in the fictive deserted city. The sculptures of Bourgeois, Cattelan, and Nauman are now canonical works of contemporary art, but they are also seen to be the traces of human creativity that might be discarded remnants from the perspective of the dystopian future.

The Benjaminian understanding of montage and allegory also are central to *The Last Film*, Gonzalez-Foerster's editing of twenty-five existing films, perhaps the most significant part of *TH.2058* with respect to its citation of SF. This remarkable collection includes not only Hollywood SF films such as *Electronic Labyrinth THX 1138 4EB* (George Lucas, 1967), *Planet of the Apes* (Franklin J. Schaffner, 1968), *The Man Who Fell to Earth* (Nicolas Roeg, 1976), and *Mission to Mars* (Brian de Palma, 2000), easily recognizable and exemplary pretexts of dystopian futures. Instead, most of her excerpts spring from European art cinema or experimental films not usually considered part of the SF genre. Godard's *Alphaville* (1965), Andrei Tarkovsky's *Solaris* (1972), and François Truffaut's *Fahrenheit 451* (1966) belong to the tradition of European SF films produced under auteur cinema, but the main bulk of quotes refer to the films whose settings and styles go beyond the normative classification of SF: they include art films set against the contemporary or

mythic world (Gus van Sant's *Gerry*, 2002, Michelangelo Antonioni's *Zabriskie Point*, 1970, Pierre Paolo Pasolini's *Theorema*, 1968) and even avant-garde and artists' films (Michael Snow's *La Region Centrale*, 1971, Robert Smithson's *Spiral Jetty*, 1970, and Peter Tscherkassky's *Outer Space*, 1999). These non-SF films are given new meaning when assembled with their Hollywood or European SF counterparts. For instance, the slow-motion explosion scene from *Zabriskie Point* and that of a female character faced with the intrusion of an unknown force from *Outer Space* symbolize the moment of catastrophe as in the burning of books in *Fahrenheit 451*, and the scenes of humans wandering in the desert from *Gerry* and *Theorema* are read as images of crisis recurrent in the vast history of cinema. Overall, Gonzalez-Foerster's strategy of montage recontextualizes the quoted films within the circular loop of past and future, and of death and rebirth,[30] so that *The Last Film* presents both "a world in ruins" and "a film in ruins."[31]

Still, the temporal complexity of *TH.2058* as an archive lies not simply in the overlap of memory objects and the imagined future, but also in its function as shelter. In conceiving *TH.2058*, Gonzalez-Foerster established the shelter as an underlying concept, in order to forge a new relation between the work and its visitors beyond the imagined repository of past objects seen from a future: "I imagine people entering the shelter and maybe first experiencing it as a depressing, gloomy situation but then by spending some time inside, some new possibilities might appear."[32] These new possibilities are documented in *Noreturn*, a sixteen-minute short film featuring a group of schoolchildren playing in the exhibition space of Turbine Hall. The children portrayed in the film present an array of activities that go beyond the grasp of the protocols expected of adult visitors of the exhibition: they run through stacks of colored beds while chasing each other, sit underneath Henry Moore's *Sheep Piece* (1971–72), climb and sit on the beds. During these activities most of the children do not stop chatting, except for a few who are aimlessly looking somewhere or playing with their own video game console or cubic puzzle. We thus realize that the objects in *TH.2058* signify more—both the idea of shelter according to the imagination of the post-apocalyptic world, and that of the archive as the repository of the things and images that anticipate future knowledge and memory of the world.

The coexistence of accumulated materials and children's activities

expresses Gonzalez-Foerster's understanding of the archive as a "hetero-topic field," per Michel Foucault's idea of heterotopia as spaces that have multiple—often seemingly contradictory—layers of meaning and func-tion in non-hegemonic conditions: "We enter this heterotopic field that again gives another sense of value to each of these operations."[33] *Nore-turn* portrays the transformation of *TH.2058* from an artwork bounded by its exhibition values to a Foucaultian heterotopia in two ways. First, as an archive of the imagined twenty-first century as the preservation of human civilization and knowledge in the twentieth century, it echoes Foucault's consideration of museums, libraries, and archives as exem-plaries of heterotopia. For Foucault, these institutions exist both in and out of the present time—that is, they occupy a place in the present but their accumulation of materials, documents, or artworks is predicated upon "the idea of constituting a place of all times that is itself outside of time."[34] Second, Foucault also identifies a "heterotopia of crisis" and a "heterotopia of deviation" as two notable categories of heterotopias that have also existed in human cultures. The former (boarding schools, military troops) refers to a range of privileged—sacred or forbidden—places reserved for human beings who live in a state of crisis, such as children, adolescents, and the elderly, whereas the latter (prisons, psychiatric hospitals) indicate places for "individuals whose behavior is deviant in relation to the required mean or norm."[35] Foucault thus considers some heterotopias as perched on the border between these two categories; retirement homes for the elderly, for example, signal both aging as a crisis and idleness as a deviation from society. From this perspective, the children portrayed in *Noreturn* embody the si-multaneous presence of the heterotopia of crisis and the heterotopia of deviation. The project's scenario of the post-apocalyptic city allows us to think of the children as survivors of the future, and in the final scene of *Noreturn*, in which the children fall asleep on the bunk beds within the interplay of the noisy guitar soundtrack (played by the mu-sician Arto Lindsay) and flashes of bright light, creates an atmosphere of the future in crisis. At the same time, for the children of the contem-porary world, the installed objects serve as an ensemble of backdrops against which they can do whatever they want. Hence, their activities render the exhibition space of *TH.2058* to be a provisional "elsewhere" deviating and liberated from norms, replaced by freedom and idleness.

Viewed together, all these dimensions enable us to consider *TH.2058* to be more than an inert and stable repository of the past, inasmuch as it reconfigures the archive as an open, heterotopic form that is "capable of juxtaposing in a single real place several spaces, several sites that are in themselves incompatible."[36]

The forms of journey and archive exemplified by *A Journey That Wasn't* and *TH.2058* demonstrate the extent to which certain practices of "remaking" in contemporary art expand the boundaries of both cinema and SF. Just as the formal and narrative components of cinema are dislocated from their normative apparatus, transformed, and repositioned across different configurations and expressions encompassing single-channel video, multimedia performance, and mixed-media installation, so are tropes of SF removed from their previously sanctioned generic territories such as the novel and film. The expansion of the boundaries of cinema results in the remaking of SF, because the multidimensional exchanges between fiction and fact in Huyghe's project and the heterotopic rendering of the archive in Gonzalez-Foerster's project maintain and at the same time amplify the cohabitation of different temporalities that numerous SF films and novels have explored.

At issue, then, is what this intermedial expansion of cinema and SF ultimately achieves in the relation between the forms of cinema and SF and the worlds that they represent. As discussed earlier, Huyghe's and Gonzalez-Foerster's conception of forms is not limited to formal experiments with cinema and SF alone, but it is geared toward reimagining the worlds of the past or future previously rendered by their traditional forms. For the forms of journey and archive testify to a key tendency of contemporary art to reconfigure its engagement with the contemporary world by redistributing existing materials and expressions unbound by their original medium or discipline—in the words of Jacques Rancière, "of redisposing the objects and images that comprise the common world, or of creating situations apt to modify our gazes and our attitudes with respect to this collective environment."[37] In this sense, the journey into the unknown in *A Journey That Wasn't* and the archive of the twentieth century in *TH.2058* offer us the opportunity to see not simply multiple versions of our current world, but also the worlds of past and future that simultaneously coexist with it.

NOTES

1. In my interview with Weerasethakul, he made clear his interest in science fiction films and the ways in which this interest extended into *Faith* and his multimedia installation project *The Primitive* (2009) as follows: "My interest in elements of science fiction came back to me and we decided to make a spaceship—a vehicle that could take us to the distant past and to the future. . . . The spaceship in *The Primitive* is the place where memory is transformed and reborn. . . . So it acts on many levels: dream, transportation, and simple protection." Jihoon Kim, "Learning about Time: An Interview with Apichatpong Weerasethakul," *Film Quarterly* 64, no. 4 (Summer 2011): 50.

2. In her valuable study of the aesthetic and cultural tendencies of artists' film and video, Erika Balsom summarizes the variety of strategies of remaking cinema as follows: "A remake might investigate the representational codes of an existing work, it might reflect on its relationship to history, it might focus on the labor of spectatorship, it might fetishize a loved film, it might question what new possibilities for freedom and control are made possible by the digitization of cinema, or it might do something else entirely." Balsom, *Exhibiting Cinema in Contemporary Art* (The Netherlands: Amsterdam University Press, 2013), 112.

3. Jean-Christophe Royoux, "Remaking Cinema," in *Cinéma: Contemporary Art and the Cinematic Experience*, exhibition catalogue, Stedelijk Van Abbermuseum Eindhoven (Eindhoven, The Netherlands, 1999), 21.

4. Balsom, *Exhibiting Cinema in Contemporary Art*, 147.

5. Nicholas Bourriaud, *Relational Aesthetics*, trans. Simon Pleasance and Fronza Woods (Paris: les presses du reel, 2002), 21.

6. David Joselit, *After Art* (Princeton, N.J.: Princeton University Press, 2013), 52.

7. Nicholas Bourriaud, *The Radicant*, trans. James Gussen and Lili Porten (New York: Lukas & Sternberg, 2009), 80.

8. Ibid., 107.

9. See Fredric Jameson, *The Geopolitical Aesthetic: Cinema and Space in the World System* (London: BFI Publishing, 1992), 3–4.

10. Bourriaud, *The Radicant*, 124 (emphasis added).

11. This characteristic of the work, fitting into Bourriaud's "form" or Joselit's "format," is what Huyghe has long been interested in, as he clarifies in George Baker's interview with him: "Art objects should be seen as transitory, they are in-between, they are not ends in themselves. . . . I am interested in an object that is in fact a dynamic chain that passes through different formats." George Baker, "An Interview with Pierre Huyghe," *October* 110 (October 2004): 89–90.

12. The reconfiguration of a site as representational or discursive validates Huyghe's reference to the tradition of site-specific art. For an influential account of the concept of site-specificity, see Miwon Kwon, *One Place after Another: Site-specific Art and Locational Identity* (Cambridge: MIT Press, 2004).

13. The Association of Free Times, "A Journey That Wasn't," *Artforum International* 43, no. 10 (Summer 2005): 298.

14. Richard Leydier, "Pierre Huyghe: A Sentimental Journey," *Art Press* 322 (April 2006): 31.

15. George Baker, "An Interview with Pierre Huyghe," 84.

16. Mark Godfrey, "Pierre Huyghe's Double Spectacle," *Grey Room* 32 (Summer 2008): 48.

17. For this reason, Huyghe states that the desire for discovering the penguin "might produce the island" (The Association of Freed Time, "A Journey That Wasn't," 297).

18. Godfrey, "Pierre Huyghe's Double Spectacle," 54.

19. America Barkin, *Parallel Presents: The Art of Pierre Huyghe* (Cambridge: MIT Press, 2013), 212.

20. For the tension between science and magic in cinema, see Michele Pierson, *Special Effects: Still in Search of Wonder* (New York: Columbia University Press, 2002), 11–51.

21. Sjoukje van der Meulen, "Witness and Presence in the Work of Pierre Huyghe," *AI and Society* 27, no. 1 (February 2012): 16.

22. A few notable exhibition events for showcasing these practices include "Deep Storage: Collecting, Storing, and Archiving" (1997–2000, Munich, London, and New York), "Interarchive: Archival Practices and Sites in the Contemporary Art Field" (Köln, 2002), and "Archive Fever: Use of the Document in Contemporary Art" (New York, 2008).

23. Hal Foster, "An Archival Impulse," *October* 110 (2004): 5.

24. Ibid., 22.

25. Okwui Enwezor, "Archive Fever: Photography between History and the Monument," in *Archive Fever: Uses of the Document in Contemporary Art* (exhibition catalogue, New York: International Center of Photography, 2008), 18.

26. Foster, "An Archival Impulse," 5.

27. Jessica Morgan, "An Interview with Dominique Gonzalez-Foerster," in *TH.2058: Dominique Gonzalez-Foerster* (exhibition catalogue, London: Tate Modern, 2008), 172–73.

28. Walter Benjamin, *The Arcades Project*, ed. Rolf Tiedemann, trans. Howard Eiland and Kevin McLaughlin (Cambridge, Mass.: The Belknap Press of Harvard University Press, 1999), 460.

29. Ibid., 368. For other key works of Benjamin that deploy his concept of

allegory, see *The Origin of German Tragic Drama*, trans. John Osborne (New York and London: Verso, 2003); "Surrealism," Walter Benjamin, *Selected Writings Vol. 2: 1927–1934*, ed. Michael W. Jennings et al., trans. Rodney Livingstone et al., 207–21 (Cambridge, Mass.: The Belknap Press of Harvard University Press, 1999).

30. The most recurrent motif in *The Last Film* is that of rain represented by the scenes from *Solaris* and *Stalker*. Concerning this motif, Gonzalez-Foerster notes that water symbolizes not simply the background of the dystopian future city but also the resources for the rebirth of a new life: "Water is the starting point of organic life the way we know it, it's maybe the most primitive and important form of life on the planet" (Morgan, "Interview with Dominique Gonzalez-Foerster," 188).

31. Lug Lagier, "London, Bunker 11, Gallery D. AD 2058," *TH.2058: Dominique Gonzalez-Foerster*, 65.

32. Morgan, "Interview with Dominique Gonzalez-Foerster," 186.

33. Ibid., 177.

34. Foucault, "Of Other Spaces," *Diacritics* 16, no. 1 (Spring 1986): 26.

35. Ibid., 25.

36. Ibid.

37. Jacques Rancière, "Aesthetics as Politics," *Aesthetics and Its Discontents*, trans. Steven Corcoran (London: Polity Press, 2009), 21.

Part II Traveling Science Fiction
Translation, Adaptation, and Interpretation

5 Media Heterotopias and Science Fiction

Transnational Workflows and Transgalactic Spaces in Digitally Composited Ecosystems

HYE JEAN CHUNG

> *The only true voyage of discovery, the only really*
> *rejuvenating experience, would be not to visit strange*
> *lands but to possess other eyes.*
>
> ■ Marcel Proust, *Remembrance of Things Past*

Decades after the first installment of the *Star Wars* franchise was filmed, visual artist Rä di Martino discovered the abandoned sets used for the landscape of the fictional planet of Tatooine in the middle of the Tunisian desert. Because the Chott el Djerid region in Tunisia is uninhabited, many buildings and props used in the film were left behind. Though they are partially destroyed or buried by the sand and wind, the hot, dry climate of the desert preserved the structures to look like archeological sites of an ancient civilization.[1] These photographs, which were displayed at the Tate Modern in a group exhibition titled *Ruins in Reverse*, blur the boundaries between reality and fiction, and between history and science fiction, by exposing the material deterioration of an imagined future. Hauntingly evocative and temporally perplexing, these photographs meld past and future in a nostalgic and surrealistic amalgam. They also complicate the spatial coordinates of a place that is imagined as being located in a "galaxy far, far away," as the fantastical and nonterrestrial setting of Tatooine is conflated with the movie set in the Tunisian desert. Moreover, these photographs articulate the close relationship between materiality and imagination in the context of science fiction cinema, as well as the lingering power of a visual vernacular cultivated by Hollywood's global film industry.

Amid the fast-paced development and wide-scale deployment of

digital technologies in contemporary film production, computer-generated visual effects are increasingly used to create fictional environments that are distant from present reality, whether temporally (past or future) or spatially (outer space or realm of fantasy). Notwithstanding the emphasis placed on emerging digital technologies that enhance the "otherworldly" effect of these alien environments, however, much of the filming process in science fiction cinema entails practical sets and effects shot in real locations, as did the predigital films of the *Star Wars* series. This chapter examines the hybrid environments of contemporary science fiction films that incorporate real locations on Earth and computer-generated ecosystems to create "alien" (that is, otherworldly or futuristic) spaces by considering two films made by global Hollywood: *Prometheus* (Ridley Scott, 2012) and *Oblivion* (Joseph Kosinski, 2013).

I interrogate what happens when a physical, "earthly" location substitutes for an imagined, "unearthly" setting by studying how imagined spaces are produced by the creative workforce and digital pipelines of a global film industry. My concern here is to consider how these popular depictions of imagined spaces embody and construct a shared visual imaginary or vernacular of "Other" spaces—whether on this Earth or beyond—for global consumption. As Marcel Proust evocatively suggests, the "voyage of discovery" does not necessarily entail physical mobility but also new forms of visuality by possessing "other eyes," or new ways of seeing and sensing one's spatiotemporal coordinates.

Media Heterotopia: Compositing Global Creative Labor

As Simon Schama notes, "Landscapes are culture before they are nature; constructs of the imagination projected onto wood and water and rock."[2] In other words, landscapes are manufactured through cultural perceptions of nature and a culturally inscribed vision cultivated by evolving technologies of mediation. Both films, *Prometheus* and *Oblivion*, participate in an emerging trend of using Iceland to represent unearthly, primordial, and fantastical settings.[3] The Icelandic landscape is aesthetically and rhetorically coded by Hollywood's visual vernacular as a "primordial," "desolate," and "bleak" land in the context of contemporary science fiction cinema. In actuality, Iceland not only provided the raw materials through its landscape but also a large portion of the

labor, as a significant percentage of the workforce was hired locally during shooting. The two films also share several crewmembers, such as location manager Thor Kjartansson, production coordinator Birna Paulina Einarsdottir, and the Icelandic film and television production company Truenorth. This overlapping of creative labor (special and visual effects) on raw material (location) is emblematic of a global capitalist venture that encompasses a complex multinational network of resource, labor, capital, and technology to construct a heterotopic media assemblage. Although the workforce in media production has become globally dispersed under the "new international division of cultural labor,"[4] the seamlessly fused layers in digitally composited cinematic spaces often mask this geographical diversity.

In today's global media industries, many large-budget films are produced by compositing pro-filmic and digital elements. Consequently, production pipelines entail a long, laborious process that includes multiple stages of creative labor, such as concept, set, and costume design; building models, props, and practical sets; modeling, texturing, and lighting; and live action shooting on location or in the studio. Because of these various stages of creating disparate images, digital compositing, which merges live action and computer-generated imagery, is a vital procedure in making the final product look as finished as possible. Ron Brinkmann, a visual effects supervisor and founding member of Sony Pictures Imageworks, describes digital compositing as a "process of integrating images from multiple sources into a single, seamless whole."[5] He emphasizes the necessity to create the illusion that "everything in the scene was photographed at the same time, by the same camera," that is, the illusion that "real" and "not real" elements share the same time-space.[6]

As a description of both the production process and the final product, the term *composite* indicates a compression of multiple temporalities and a merging of multiple spatialities. The process of digital compositing creates cinematic spaces and bodies that integrate physical and virtual elements, and fuse together sites and bodies that are geographically distant and attached to diverse national territories. I propose that we consider these cinematic spaces as "media heterotopias" to recognize that they are composites of multiple audiovisual layers that retain the ghostly, yet perceptible, traces of geographically dispersed labor.[7] Despite similarities with Fredric Jameson's notions

of "depthlessness" in postmodern aesthetics and cultural production in regard to the weakening of historicity and temporality, Foucault's concept of "heterotopia" is more applicable here, I believe, because it acknowledges the *heterogeneous* material realities and layered textures of multiple components in a composited image. The concept of heterotopia is useful in discussing coexisting times and spaces, because heterotopias self-reflexively reinforce their otherness and reveal that all spaces are based upon complex material conditions of lived experience. Heterotopias thus encourage the idea that a single space can contain multiple layers of seemingly incompatible spatialities and temporalities. Although this process of compositing could be considered as conflating various layers into a flat, homogenous space, the layers retain their thickness, I contend, via a heterotopic perception or consciousness that recognizes the diversity of locations, resources, and workflows that collaborate to create such global media assemblages.

Spatial Dispersion and Concentration in Nonlinear Digital Workflows

By adopting digital technologies, global media industries are constructing new spatio-temporal formations. These new digital pipelines are facilitating a move away from the localized assembly line production model developed by Henry Ford and adopted by the classical Hollywood studio system toward a nonlinear, geographically dispersed workflow model that exemplifies a post-Fordist mode of flexible accumulation.[8] This spatial mobility constructs new regimes of creative production, in which digital labor and flexible capital circulate in increasingly intricate forms of transnational collaboration. Addressing the geographical diversity in contemporary forms of filmmaking, Alex McDowell, an industry insider and veteran practitioner, notes that a nonlinear digital workflow is bringing about a paradigm shift in media production—one in which a *simultaneous* collaborative space is replacing linear production processes.[9]

> There is just a single environment within which the film, the game, the piece of architecture is developed, and it starts with a core idea and one builds on that section by section. . . . It ex-

pands in a completely non-linear way globally in all directions, feeding information out and receiving information in to the central design hub, which is a collaborative space that allows a director and a game designer or an architect or an engineer: all of the people who are involved in making that piece of art or that product. They are all able to dip in and out of this immersive, non-linear workspace.[10]

Here he indicates how spatial concerns are replacing temporality as the central force in media production pipelines, emphasizing that the development of digital technologies is enabling the global dispersion of labor and the role of collaboration in an "immersive, non-linear workspace." These nonlinear, globally dispersed digital workflows produce and composite virtual terrains, or heterotopic spaces that incarnate transnational geographies (and transgalactic geographies in science fiction cinema).

An examination of extratextual elements is particularly illuminating in the genre of science fiction. As Brooks Landon has pointed out, the "spectacle of production technology" is often "self-reflexive celebrations of film technology itself," and is as significant as "narratives about the impact of technology."[11] The rapid and radical development of digital technologies in film production is indeed a culturally significant narrative that resonates in today's popular imagination, and echoes the sense of wonder and astonishment long thematized in science fiction. Frequently the spectacle *becomes* the story, and supersedes the narrative in significance by generating a logic and life of its own.

Science fiction films also articulate spatiotemporal complexity and technological innovation in both textual and extratextual spaces through their narratives and production processes. In *Screening Space*, Vivian Sobchack examines the science fiction genre to draw connections among our consciousness of space and time, technological transformations, and media representations. She discusses how technological developments in capitalist modes of production, distribution, and exhibition have created new spatial and temporal forms of "being-in-the-world," and how they are manifested in the narratives and aesthetics of science fiction films in the United States. In particular, Sobchack describes how electronic and digital technologies have altered our experience of spatial contiguity.

We are culturally producing and electronically disseminating
a *new world geography* that politically and economically defies
traditional notions of spatial "location." . . . Our new electronic
technology has also spatially dispersed capital while consoli-
dating and expanding its power to an "everywhere" that seems
like "nowhere." . . . It is the "political unconscious" of the new
American SF film that most powerfully symbolizes and brings
to visibility this apparent paradox of the simultaneous spatial
dispersal and yet "nuclear" *concentration* of economic and
political power. (emphasis added)[12]

These notions of dispersal, dislocation, and dissemination often
emerge in discourses on digital technologies and new forms of spatial
configurations that manifest in current structures of global capital-
ism. Two seemingly conflicting forces are apparent in this "new world
geography": the dispersal of space and the concentration of power.
By drawing connections between global media production and digital
technologies, media heterotopias also offer a glimpse of a "new world
geography," or a transnational geography that maps multiple temporal
and spatial trajectories emblematic of our global and digital times.

The Dissonance of the Unfamiliar in Digitally
Composited Ecosystems

Sobchack also identifies an "aesthetics of collision" between the alien
and the familiar as a core element in science fiction films. She de-
scribes a certain type of film that can "evenly balance both its alien and
familiar content—its fantasy and realism—in the same frame," which
evokes a response of amazement in the spectator at "their togetherness
and their collision, by their compatibility and their incongruence."[13]
This is manifested in the surprise ending of the science fiction classic,
Planet of the Apes (Franklin J. Schaffner, 1968), which reveals that the
supposed alien planet overrun by human-like simians is actually Earth
in the far future. In this case, the decayed ruins of the Statue of Liberty
mark the "alien" planet as Earth; a familiar icon in an unfamiliar con-
text provides the visual shock and narrative impact delivered by this
revelation. The audience realizes that the uncanny environment was
Earth all along. A familiar territory is thus made "alien," even horri-

fying, by the inversion of the biological and social hierarchy between human and ape.

In contrast, the revelation that the desolate, "otherworldly" landscape is post-apocalyptic Earth emerges relatively early and subtly in *Oblivion*. This film, however, presents an analogous moment of epiphany and disillusionment. Earth and humanity have been similarly conquered, but in this case, by a nonterrestrial force. In this post-apocalyptic world, Jack Harper (Tom Cruise) and his partner Victoria (Andrea Riseborough) are seemingly the last humans left on Earth. Rather than an inversion of the hierarchical relationship of terrestrial species, here the shock derives from a different sort of reversal: the realization that what was assumed human was in fact alien (Jack himself is a clone cultivated by the alien invaders), and what was assumed alien (that is, the Scavengers) was in fact human. This dramatic moment diegetically manifests what takes place in the extratextual realm of production, that is, the process of inverting the value of the familiar and the unfamiliar in digitally composited heterotopias.

Here Iceland is used as a double for the devastated ruins of the East Coast of the United States after the apocalyptic war between humans and alien invaders. Most of the film was shot in various locations in Iceland, namely, Reykjavík, Jarlhettur, Hrossaborg, and Dettifoss waterfall in Vatnajökull National Park. The film's associate producer Emilia Cheung explains that Iceland is frequently used for different landscapes in science fiction films because of its diverse natural environments, such as geothermal spots, waterfalls, geysers, and hot springs. She enthusiastically asserts that "it's like being in another world," while actor Tom Cruise describes the Icelandic landscape as "hauntingly beautiful."[14] Filmmaker Joseph Kosinski also emphasizes the "otherworldly" aesthetic of Iceland when he says that its landscape "looks like no other place on Earth," adding that it is the perfect backdrop for his vision for the film: "beautiful desolation."[15]

In the film, traces of human civilization are embedded into the natural environment through digital extensions, thus rendering the landscape even more uncanny and unfamiliar. To create these effects, the production crew filmed aerial plates while flying over volcanic terrain in Iceland. The environment was then digitally modified by inserting matte paintings of lakes, rivers, waterfalls, and relics of urban civilization (including such iconic buildings as the Empire State Building and

Figure 5.1. Jack Harper (Tom Cruise) contemplates the landscape of a post-apocalyptic world in *Oblivion* (Universal Pictures, 2013). This scene is one of the many shots in the film that digitally composite footage from location shooting in Iceland with computer-generated imagery.

the New York Public Library) to transform the Icelandic landscape into a deteriorated version of New York City. The compression of time and space is demonstrated in a sequence that was shot on location at Hrossaborg, a 10,000-year-old crater shaped like an amphitheater in Iceland to which digitally created images of billboards, banners, and stadium seats were added so it could masquerade as the ruined shell of a baseball stadium.[16] Meanwhile, the wrecked remnant of the Empire State Building observation deck was built as a physical set in a remote part of Iceland, resulting in an image of temporal and spatial disjunction. Although these heterotopic assemblages achieve an aesthetic of seamlessness, they also deliver an affect of dissonance by fusing the alien and the familiar. The uncanny incongruity of seeing Manhattan landmarks in ruins visually articulates the feeling of horror felt by the protagonist when he discovers the alien origins of his own human existence.

In *Oblivion,* digital composites of practical and computer-generated effects produce the jarring effect of dislocation, disjunction, and dissonance. Although visual effects are often utilized to create fantastical or futuristic entities and environments, here they are used to insert the

familiar into an unfamiliar setting to create an alien alternate reality. In this case, the familiar is defamiliarized to generate a visual incongruity and affective friction through an "aesthetics of collision," which indicates a sense of disjunction that persists despite efforts to erase material traces of heterogeneity through the seamless effects of digital compositing. This very sense of incongruity reveals the seams of the illusion and points to the transnational collaboration of technique and labor.

In the past the merging of the alien and the familiar was articulated thematically or visually in the diegetic narrative, but now this assemblage has been relocated to the production process. In contemporary science fiction films, technology is used in various practical, mechanical, and digital forms to camouflage the familiar, that is, to transform the familiar into alien territory. Moreover, digital technology plays a vital role in the spatial dispersal of global film industries, ultimately creating "a new sort of space that defies traditional geographical description."[17] The compositing of real/fantasy and digital/material in these computer-generated ecosystems runs parallel to a major narrative tension between familiar and unfamiliar, or human and nonhuman/alien, in the genre of science fiction. These technologically enhanced hybrid environments reconcile this tension while also manifesting the ambivalent nature of digitally mediating material realities that form the basis of a global experience of spatial dispersion or dislocation.

Material Traces of Heterogeneity and Transnational Geographies

Although the setting in *Oblivion* is Earth (albeit in an unfamiliar form), in the case of *Prometheus* Earth stands in for an alien planet on both textual and material levels, that is, in the film's narrative and production process. The digital extensions and visual effects are deployed to enhance the "otherworldly" quality of terrestrial locations (namely, Iceland), ultimately defamiliarizing Earth and the tangible reality of its topography. Here the significance of the "hetero-" in heterotopias extends beyond cultural and geopolitical difference to indicate the domain of interspecies or intergalactic difference. Although Brinkmann stressed the importance of producing an "image that doesn't betray that its creation was owed to multiple source elements,"[18] the

heterogeneous background of the multiple layers of a shot or sequence is often made apparent by an alien or uncanny quality in the mise-en-scène. Although the illusion of a seamless unity may remain intact, audiences can recognize that everything in the scene was *not* "photographed at the same time, by the same camera."

Illustrating the nonlinear workflow described by McDowell, the detail-oriented and labor-intensive constructed environments in *Prometheus* contain multiple modular assets that necessitate the distribution of labor across geographically diverse companies in global production pipelines. Much of the in-camera special effects (for example, mechanical effects, creature effects, and prosthetics effects) were used in live action sequences filmed on practical sets at Pinewood Studios in England.[19] Meanwhile, the visual effects shots for the film were distributed to vendors on three continents: Asia, Europe, and North America.[20] Interviews conducted with various creative workers attest to the fact that formerly disparate stages of pre-production, production, and post-production are increasingly becoming fused with, and simultaneous to, one another in "a collaborative space."[21] Here "space" can be interpreted as both literal and figurative, as it is applicable to a conceptual sense of *abstract* space, but can also refer to the *actual* spaces of production, whether shooting on location or a studio set. The various spaces of production leave their material residues on the imaginary spaces created there.

In *Prometheus* Iceland represents an alien territory, or an unearthly terrain untouched by human civilization. The production crew filmed one scene that takes place on primordial Earth on volcanic terrain adjoining the Dettifoss waterfall at the Vatnajökull National Park in Iceland.[22] Diverse geographies and technologies were utilized in visualizing the planetscapes of LV-223, a faraway planet where most of the story takes place. The barren landscape was inspired by sketches drawn by filmmaker Ridley Scott that were based on stock photographs of Wadi Rum, a desert valley in Jordan.[23] MPC used the practical technologies of Google imagery and satellite images to previsualize the planet surface. Then the production crew shot on location in Hekla, Iceland, to utilize its volcanic terrain. Physical and digital extensions were added to these images, including matte-painted textures; time lapse photography of clouds shot in Iceland; and scenic textures of mountains, rock formations, and lava plains in Iceland and Jordan that were gathered

with aerial photography. Many scenes that took place on the planet LV-223 were composites of practical and computer-generated effects. One sequence that shows two characters—Elizabeth Shaw (Noomi Rapace) and Meredith Vickers (Charlize Theron)—running away from a crashing spacecraft on the planet was filmed with the actors on location in Iceland, with smoke and pyro effects created by special effects technicians afterward. In multiple shots the planetscape is a virtual construct that is generated from photographic textures of volcanic terrain in Iceland and mountain desert rocks in Jordan.[24] Several sequences are digital enhancements of live action scenes filmed on location in Iceland or at Pinewood Studios in England. For instance, for the sequence of Vickers's escape module ejecting from the spaceship and landing on the planet, the practical debris effects were shot in Iceland, while the spacecraft was located at Pinewood and later inserted into the landscape plates shot on location.[25]

The production crews for both *Prometheus* and *Oblivion* thus deployed the filmmaking practice of grounding imaginary, futuristic images in tangible reality by compositing practical locations and digital extensions to create computer-manipulated ecosystems. Kosinski particularly stressed the necessity for in-camera footage for *Oblivion*: "If you want to transport an audience, particularly with science fiction, the world has to feel real and visceral. That meant building sets and vehicles as practical and functional objects."[26] Both films similarly used real terrestrial locations as raw materials to build their fictional otherworldly landscapes. The setting plays a particularly vital role in identifying the genre of science fiction. More than mere background, it functions as an integral part of the film's narrative, theme, and aesthetics. Dylan Clark, producer for *Oblivion*, similarly notes that "Earth is a main character in this movie. It's what Jack is fighting for, and Iceland shows an Earth coming back to life."[27] Holding a central position in the narrative, Earth is indeed closer to a character than setting or landscape in the film. Likewise, Iceland is more than mere background but closer to an in-camera special effect. For these two films, Iceland provided the raw materials to create a vision of a "primordial Earth," or Earth as it may have looked "a million years ago."[28] Kosinski "wanted all of Earth to resemble the Icelandic landscape," that is, to look desolate and primordial.[29] Similar forms of rhetoric and logic are evident in the diegetic narrative and production history of

Figure 5.2. In the opening sequence of *Prometheus* (Twentieth Century Fox, 2012), an alien being (called an "Engineer") prepares to hold a ritual on primordial Earth. This shot was filmed on volcanic terrain near the Dettifoss waterfall in Iceland and was completed by fusing practical and digital effects.

Prometheus. Iceland provided the landscape for the opening sequence that features the sacrificial ceremony of an alien species to bring about the birth of humankind on primordial Earth. In the visual vernacular of contemporary Hollywood science fiction, Iceland thus embodies a primitive or post-apocalyptic vision of human civilization through its role as a double for imaginary landscapes.

In current forms of transnational film production, it is common practice to use a specific site to double for another location for a variety of practical and financial reasons, such as accessibility, convenience, production budget, tax incentives, local talent, and geopolitical conditions. Arthur Max, the production designer for *Prometheus,* describes how they decided on Iceland as a suitable location after scouting in such places as Scotland, Morocco, Jordan, and Iceland "looking for monumental bleakness."[30] According to Max, the initial choice was in fact Morocco, but the unstable political situation in North Africa forced the production to relocate to Iceland.[31]

Iceland as a nation with cultural and historical specificity is relegated to visual images of primordial Earth in the two films. These images, however, are replete with traces of material physicality through an indexical relationship with territorial production spaces. Although it is popularly

used as a layered visual effect of non-nation-specific generality, Iceland also functions as a heterotopic space in which symbolic meaning and tangible materiality intersect. Therefore, the materiality of the national territory is embedded into the very fiber of the "otherworldly" spaces of the two films. In addition to Iceland's plasticity that camouflages its topography into primordial or post-apocalyptic landscapes, another incentive that commonly attracts Hollywood projects is a 20 percent rebate offered by the Icelandic government on all production costs. Film crews can also take advantage of the long summer hours of daylight to enhance productivity. Political and economic reasons aside, what is significant is that these substitutions in the production process, which utilizes, packages, and promotes Earthly terrains as alien or atemporal spaces, ultimately leave behind indelible marks, or "footprints," in imaginary and material forms. Despite its propensity toward spatial dispersal and digital imagery, Hollywood products do not "determine our lives from some sort of ethereal 'other' or 'outer' space."[32]

Therefore, the stakes are considerably high when we consider the terrestrial residues of Iceland's virtual masquerade in Hollywood science fiction cinema, as their imaginary landscapes are grounded upon material realities of the real world. Maurizia Natali describes film landscapes as more than "narrative backgrounds" or "spectacular settings," stressing their ideological power and material presence *beyond* the screen.

> [Film landscapes] bear the traces of political projects and ideological messages. They press onto viewers' senses, memories, and fears and become part of their memory, carrying the subliminal strength of a past, even archaic, worldview ready to come back as future progress. Like the footprints left on the surface of the moon by U.S. astronauts, Hollywood landscapes bear the footprints of the United States' recurrent Manifest Destiny.[33]

This image of "footprints" left behind on "alien" territory leads us back to the photographs taken by Martino. They serve as reminder of how the footprints of *Star Wars* persist not only as mediated images or nostalgic memories but also as material ruins in the desert of Tunisia. Although more readily associated with the evil Galactic Empire led by Darth Vader than with the imperialist fantasies of any particular nation, these abandoned remains are the discarded detritus of a

powerful cinematic industry that continues to expand its pervasive reach through globally dispersed pipelines and production sites. The Tatooine "ruins" in the middle of the Tunisian desert is a heterotopic space that is emblematic of the spatial dispersal of global media production and also the concentration of economic and political power in Hollywood. As physical relics of seemingly dematerialized cinematic representations of fictional worlds, these ruins are a metonym that silently testifies to the residual power of Hollywood's visual vernacular, which leaves enduring impressions on both imaginary and physical landscapes, as well as transnational and transgalactic geographies.

In this context, it is important to consider the economic and cultural implications of treating the national territory of Iceland as special effect or raw materials for digitally composited ecosystems in Hollywood-based films. Even as digital labor is increasingly dispersed in global production pipelines, Hollywood is still visibly and discursively inscribed as the central design hub of global cinema. Whereas certain sites of production develop as centers or nodes of production pipelines, others are relegated to satellite sites of production or peripheral industries that provide human labor and natural resources to this centralized hub that upholds and reinforces Hollywood's hegemony. Within a regime of creative production where major Hollywood institutions conceive, oversee, and finance the overall production, it is all too easy for the finished product to be stamped with the brand of large studios and production companies, or the name of "above-the-line" executives and artists (for example, producer, director, or actor).

In *Global Hollywood,* Toby Miller and his coauthors present a critique of Hollywood imperialism and neoliberal globalization as exploitation by way of runaway productions and outsourced work in the "new international division of cultural labor." Although the global systems of creative production described here do not necessarily situate peripheral cultural industries in a state of "dependent underdevelopment," neither are they as equitable as the term "collaboration" suggests. The aesthetic emphasis on the *seamlessness* of the finished product and the rhetorical emphasis on *collaboration* often mask the material realities of the digital workflow in global production pipelines, including the hierarchical relationship among geographically diverse sites of production, exploitation of human resources, and extraction of natural resources. Notwithstanding the positive effects generated by

the "central design hub" created by the spatial dispersion of nonlinear digital workflows, this global dispersion has deleterious effects that reveal the inequitable relations of economic and cultural capital both within and outside the Hollywood industry. Although Hollywood productions often benefit from the 20 percent rebate when filming in Iceland, Icelandic productions are currently facing downsized government subsidies, which will most likely have damaging effects on its local film industry.[34] (Hollywood filmmakers and producers who have worked in Iceland showed their support by signing a petition against the proposed cuts.[35]) Meanwhile, the globalized regime of Hollywood hegemony also adversely affects local companies, as attested by the recent financial troubles, including layoffs and bankruptcies, of visual effects studios based in Los Angeles.

Conclusion

Discourses on global and digital media often place rhetorical and aesthetic emphases on seamless integration of heterogeneous elements, thereby conflating differences and erasing fractures that exist in material conditions of media production. Whether the geographical diversity of production sites is clearly marked or cleverly hidden, media heterotopias are transnational spaces that retain tangible traces of globally dispersed labor and locales. The material conditions of each location are woven into the cinematic fabric to construct a mediated assemblage of globally dispersed locations that are composited to form transnational or transgalactic landscapes in contemporary cinema.

Being cognizant of the composite image's layered nature is not necessarily detrimental to the enjoyment of a film. In fact, it leads to an awareness of the myriad forms of labor that work to create this heterotopic alien space. This recognition is cultivated *textually* in the mise-en-scène of the film, and also *extra-textually* through interviews, "making of" documentaries, books, and articles in popular and trade press that explain details of the production history and technical aspects of filmmaking for the general audience.[36] These forms of cultural knowledge, I contend, allow us to examine and identify multiple layers of media heterotopias that are fused with digital compositing, and to see them through "other eyes" as deep, textured realms that retain material residues of geographically diverse spaces of production.

NOTES

1. The artist is described as "an archaeologist uncovering the contemporary detritus of the cinematic industry." http://www.e-flux.com/announcements/project-space-ruins-in-reverse/.

2. Simon Schama, *Landscape and Memory* (New York: Vintage, 1996), 61.

3. Other examples from the genres of fantasy and science fiction include *Stardust* (Matthew Vaughn, 2007), *Star Trek into Darkness* (J. J. Abrams, 2013), *Thor: The Dark World* (Alan Taylor, 2013), *Noah* (Darren Aronofsky, 2014), and *Interstellar* (Christopher Nolan, 2014).

4. Toby Miller, Nitin Govil, John McMurria, and Richard Maxwell, *Global Hollywood* (London: British Film Institute, 2001).

5. Ron Brinkmann, *The Art and Science of Digital Compositing* (Burlington, Mass.: Morgan Kaufmann, 2008), 2.

6. Ibid.

7. For more details on "media heterotopias," see Hye Jean Chung, "Media Heterotopia and Transnational Filmmaking: Mapping Real and Virtual Worlds," *Cinema Journal* 51, no. 4 (2012): 87–109.

8. For a thorough discussion on "flexible accumulation," see David Harvey, *The Condition of Postmodernity: An Inquiry into the Origins of Cultural Change* (Oxford: Blackwell, 1990).

9. Alex McDowell is the founder of the 5D conference and the production designer for *Watchmen* (Zack Snyder, 2009), *Charlie and the Chocolate Factory* (Tim Burton, 2005), and *Minority Report* (Steven Spielberg, 2002), the first film to have a separate digital art department.

10. Bill Desowitz, "Alex McDowell Talks 5D Conference and Immersive Design," *Animation World Network,* September 15, 2008, http://www.awn.com/articles/production/alex-mcdowell-talks-5d-conference-and-immersive-design.

11. Brooks Landon, "Diegetic or Digital? The Convergence of Science Fiction Literature and Science Fiction Film in Hypermedia," in *Alien Zone II: The Spaces of Science Fiction Cinema,* ed. Annette Kuhn (London and New York: Verso, 1999), 35.

12. Vivian Sobchack, *Screening Space: The American Science Fiction Film* (New Brunswick, N.J., and London: Rutgers University Press, 2004 [1980]), 232–33.

13. Ibid., 137.

14. Blu-ray Special Features.

15. Ibid.

16. http://www.thelocationguide.com/blog/2013/04/ng-film-tom-cruise-films-scorched-earth-sci-fi-feature-oblivion-on-location-in-iceland/; www.visualhollywood.com/movies_2013/oblivion/about.php.

17. Sobchack, *Screening Space*, 233.

18. Brinkmann, *The Art and Science of Digital Compositing*, 2.

19. Joe Fordham, "Alien Genesis," *Cinefex* 130 (July 2012): 34; Blu-ray Special Features.

20. Most of the work went to three large companies: MPC, a company with a globally dispersed network of studios based in London, Vancouver, Montreal, Los Angeles, New York, Amsterdam, Paris, Bangalore, Shanghai, and Mexico City; Weta Digital, based in Wellington, New Zealand; and Fuel VFX, based in Sydney, Australia. Additional visual effects work was further distributed to a number of smaller companies: Rising Sun Pictures, Hammerhead Productions, Luma Pictures, Lola Visual Effects, Prologue, Pixel Pirates, and Invisible FX, as well as previsualization vendors Halon Entertainment and Destroy All Monsters (Fordham, "Alien Genesis," 34).

21. Richard Stammers stressed the collaborative efforts of the multiple teams working on the film: "Visual effects definitely had a huge influence on what was possible in this film, but there was always good crossover between all departments—creatures, art department, set decorating, special effects, as well as visual effects. It was a really good group effort" (Stammers in Fordham, "Alien Genesis," 62).

22. Fordham, "Alien Genesis," 34.

23. Ibid., 41.

24. Ibid., 48, 57.

25. Ibid., 60.

26. Joe Fordham, "Last Man Standing," *Cinefex* 134 (July 2013): 96.

27. http://www.thelocationguide.com/blog/2013/04/ng-film-tom-cruise-films-scorched-earth-sci-fi-feature-oblivion-on-location-in-iceland/.

28. *Oblivion* Featurette, "The World of *Oblivion*" (available on IMDb: http://www.imdb.com/video/imdb/vi3620906521/).

29. Fordham, "Last Man Standing," 103.

30. Mark Salisbury, *Prometheus: The Art of the Film* (London: Titan Books, 2012), 60.

31. Ibid.

32. Sobchack, *Screening Space*, 234.

33. Maurizia Natali, "The Course of the Empire: Sublime Landscapes in the American Cinema," in *Landscape and Film,* ed. Martin Lefebvre (New York and London: Routledge, 2006), 100.

34. For more on the current state of the Icelandic film industry, see Ari Gunnar Thorsteinsson, "Why You Need to Start Paying Attention to Icelandic Cinema" (February 13, 2014), http://www.indiewire.com/article/why-you-need-to-start-paying-attention-to-icelandic-cinema; Lára Hilmarsdóttir, "Iceland Plays a 'Game of Thrones' over Film Incentives," *Wall Street*

Journal, November 6, 2013, http://blogs.wsj.com/speakeasy/2013/11/06/iceland-plays-a-game-of-thrones-over-film-incentives/.

35. Scott Roxborough, "Clint Eastwood, Darren Aronofsky, Terrence Malick Fight Icelandic Cuts," *Hollywood Reporter,* December 13, 2013, http://www.hollywoodreporter.com/news/clint-eastwood-darren-aronofsky-terrence-665542.

36. In the case of technological "tentpole" productions (i.e., large-budget films that are expected to be financially successful and consequently fund related films or launch film franchises), such as *Prometheus,* "making of" documentaries can exceed the length of the source film.

6 *F. P. 1* and the Language of a Global Science Fiction Cinema

J. P. TELOTTE

The German-English-French coproduction *F. P. 1 Does Not Answer* (*F. P. 1 Antwortet Nicht/I. F. 1 ne répond plus,* 1932) offers a revealing perspective on the early development of a global science fiction (SF) cinema. At a time when SF was still struggling for an identity and when an SF cinema was just beginning to emerge in a number of countries,[1] this film, through its narrative about the construction of a mid-Atlantic aircraft platform that would bridge continents, encourage international commerce, and bring different nationalities together, directly addressed issues of globalization and the cultural impact of futuristic technology. And like its subject, the film itself was an industrial effort aimed at speaking to a global audience, in fact, one of many generally referred to as multiple language version films (or MLVs), made during the interwar period and after the coming of sound, that were shot in different languages and often with different casts.[2] These matched thematic and industrial aims warrant examination, especially since they parallel another congruence, this one between SF and the cinema. Both had been—or were being—ironically heralded as "common languages," as ways to successfully address a modern global audience that Hugo Gernsback, one of SF's founding fathers, suggested, "live[d] and breathe[d] day by day in a Science saturated atmosphere."[3] However, the movies' own universal language of images was already being threatened by technological development: the coming of sound. By viewing these multiple congruences through the lens of *F. P. 1,* I believe we can better understand the role that an early SF cinema played in fashioning a visual language that might speak to a worldwide audience.

Before turning to *F. P. 1* and its multiple versions, we must first give some consideration to the nature and function of an emerging SF

103

genre. For in this period the most appropriate name for the form was still being debated in the popular literature—scientifiction, pseudo-scientific fiction, science fantasy—and SF was only beginning to find a significant place in the cinema. However, as Edward James notes, in both literature and popular culture "there was quite a boom" in speculation about "the future of every conceivable institution and aspect of life,"[4] one easily measured in a variety of allied texts: the emergence of popular science writing, a wave of early SF novels, the appearance of a few but relatively spectacular SF films, and the birth and proliferation of a pulp literature devoted to the popular imagining of science—led by such magazines as *Amazing Stories, Astounding Stories,* and *Wonder Stories.* In fact, John Cheng has suggested that the very titles of those periodicals—"amazing," "astounding," and "wonder"—were effectively "metaphors for a specific style to imagine science, clarion calls for its conversation."[5] That conversation was one that, it was suggested, could reach beyond local communities and across national borders precisely because science itself seemed a kind of Esperanto, a universal language of facts, physics, and mathematics. As Cheng offers, despite its sometimes overblown rhetoric, "interwar science fiction allowed facts to enable fiction"—and vice versa—and, in the process, to foster a broad and potentially unifying conversation about science itself, as amazing, astounding, and wonderful as it so obviously appeared to be.[6]

In the case of a spectacle-oriented film(s) like *F. P. 1,* that possibility of drawing on the amazing "language" of science and technology must have been especially appealing, because it would provide another way of coping with the difficulties of the relatively new sound cinema and would support the strategy of doing MLVs of the same story—in this instance, one in German, a second in English, and a third in French. Starting in 1929, the production of MLV films was seen as a solution to the potentially disruptive advent of sound. For especially in the European film community, where there was a strong initial resistance to dubbing, the MLV was viewed as "the optimal strategy to solve the problems of exporting sound films."[7] However, this approach was costly in terms of personnel and production schedules; as Joseph Garncarz calculates, it typically added approximately "two-thirds of the production costs of the 'original' version."[8] The one economy was in terms of what Charles O'Brien describes as "a sort of technical modularity"[9] that was employed for some of these works, a

practice wherein predominantly visual sections of a film would be imported into the other language versions with no significant change, as a narrative module, while other sections received more specific cultural treatment, involving not only new cast members speaking in another language but also various other considerations, such as "the target market's taste formations, censorship policies and practices, and other distribution- and reception-related factors."[10] However, the vogue for such films did not last long, and with an SF film like *F. P. 1*, made as the MLV phenomenon was fading, we can already glimpse why that approach would fail the test of universality. Its tendency toward a "technical modularity" would indeed be "technical," that is, focused on the spectacular science and technology that were this film's chief underpinnings. However, that modularity itself proved problematic, the "language" of science and technology ultimately less universal than was hoped, and the fiction something less than inspiring.

While nominally a coproduction of Britain's Gaumont Picture Corporation, France's Les Productions Fox Europa, and Germany's largest film company Ufa, *F. P. 1* was essentially the product of a German industry that, since the end of World War I, had relied heavily on foreign revenues for its survival and, since the coming of sound, had produced its most important films in multilanguage versions—perhaps most noteworthy among them Josef von Sternberg's *Der Blaue Engel* (*The Blue Angel*, 1930) and E. A. Dupont's *Atlantic*. In fact, of the 137 German sound films produced in the year before *F. P. 1* was made, more than a third were done as MLVs.[11] As was typically the case, *F. P. 1* director Karl Hartl reshot dialogue scenes with major actors who were well known to the target market audiences. In this instance, the chief players in the German version, Hans Albers, Sybille Schmitz, and Paul Hartmann, were replaced in the English-language scenes by Conrad Veidt, Jill Esmond, and Leslie Fenton, and in the French by Charles Boyer, Daniele Parola, and Jean Murat, while some of the supporting figures were also recast, most notably with Peter Lorre, who plays the photojournalist Johnny in the German version being replaced by Donald Calthrop as Sunshine the photographer in the English.[12] In keeping with that "modularity" aesthetic O'Brien describes, many establishing shots, backgrounds, special effects shots, and long shots are common to all versions, but some of those modules are edited differently and certain "detail" shots, suggesting cultural variances, are

indeed different—and tellingly so. Because the French version, *I. F. 1 ne répond plus,* is not available and is, by many accounts, presumed to be a lost film, the following discussion focuses on the extant German- and English-language releases.

In keeping with its global thrust—and supporting this chapter's interest in its language—the central concern of *F. P. 1* is precisely allied with many of its modular elements. That is, much of its SF language is bound up in the scenes involving the construction and inaugural use of the film's central conceit: that of an immense floating platform, situated in the middle of the Atlantic Ocean. In fact, these scenes are one of the films' primary appeals. Another and allied element of that appeal lies in its treatment of aircraft and of flight itself, something that Joseph Corn has described as "the winged gospel" of the Machine Age and a driving force in the "technological utopianism"[13] that surged through this period. As Corn argues, the "wondrous and miraculous" triumph of a relatively new human technology over the laws of nature "augured a new day in human affairs"[14]—an attitude that would figure prominently in other key SF films of this period, most notably the H. G. Wells–scripted *Things to Come* (1936) that describes what it terms "the Age of the Airmen." A third element of that language that we should consider is that of the technologist/scientist, the master of these new technologies, a role that *F. P. 1* splits between the engineer/designer of the floating platform, Droste, and his friend and master pilot, Ellissen, who is quick to accept any challenge of aerial conquest. Both occupy a heroic place in the narrative, but their treatment in the different MLVs perhaps most clearly underscores how the language of a cinematic SF varied during this troubled interwar period.

The platform, represented through both elaborate models and live-action images of a massive Hamburg dry dock that served as a stand-in for some of the onboard scenes, is a key marker of this film's SF status. It represents a conception that might seem hardly science fictional today, but that, in this period, was closely linked to recent headlines about the future of international flight and to an anticipated globalization that, many hoped, would be achieved via future advances in aviation.[15] Moreover, its very size signaled something essential to interwar SF conceptions, a *monumentalism* that was, as the artist Louis Lozowick offered, part of a new human "history . . . of colossal mechanical construction,"[16] typified by various massive icons of the Machine Age—

the Chrysler Building, the Empire State Building, Hoover Dam, the Golden Gate Bridge, and so on. That same monumentalism would prove central to such similarly styled films as *Metropolis* (1927), *Just Imagine* (1930), *Gold* (1934), and *Transatlantic Tunnel* (1935). In fact, *F. P. 1*'s art designer Erich Kettelhut had previously designed the massive sets and models for *Metropolis,* giving reason to William Johnson's observation that audiences of this period had come to see science, when depicted on the screen, as something that typically "meant more and bigger machines and engineering rather than any earthshaking discovery."[17] And the monumentalist aesthetic found throughout the era's SF films only attests to the belief in a thoroughly *engineered world*, a constructed environment that suggests futuristic science triumphing over current human limitations.

Common to both the German and English versions of *F. P. 1* are the shipyard scenes of the platform's construction and those of the completed platform anchored in the ocean, like an emblem of humanity's triumph over nature. It is, as early scenes at the Lennartz Shipyards indicate, a big dream that had been relegated to the Lennartz archives, but one that, thanks to Ellissen's efforts to call attention to it, proceeds to take massive shape. The first third of the German version anticipates the platform: through a wall-sized map on which Droste illustrates his plan, a blueprint drawing briefly glimpsed in passing, headlines announcing that Lennartz will build the platform, and various images in the shipyard that measure the project's scale through the many workers seen in the backgrounds of various shots. In fact, the *New York Times* review of the film focused on this element of the narrative, remarking on "the hosts of toilers looking like flies," and finding the completed "monster platform at sea . . . alone extraordinarily interesting."[18] The deployed platform, depicted through extreme long shots of a nicely detailed model, receives ample screen time, typically in extended shots of ten or twelve seconds at a time. But the film emphasizes that it is a place of work, like a giant ship, by suturing these effects shots to scenes of the sailors and other workers doing tasks, lounging on the massive open deck, or engaged in confrontations on that deck after the platform has been sabotaged by an agent of a mysterious power (referred to simply as *geheime Machte*—literally, a "secret power"—in the film). We again glimpse its size when Ellissen and Claire Lennartz fly overhead in a rescue mission and crash-land on

its deck, when the crew panics and abandons the platform, and when Ellissen takes off in search of help as the platform begins sinking. Finally, the narrative offers several long shots of the platform as rescuers arrive and we see shadows of various planes flitting across the massive deck before two triumphal pennants are raised, one a German flag and the other bearing the "F. P. 1" legend. As we have noted, all of these shots emphasize the great size of this construct, while also presenting it as a kind of stage on which are being played out larger human, even nationalistic aspirations to overcome obstacles, to bridge continents, and to move into the future. The conclusion with the pennants being raised above the platform stands as a signal of that spirit's triumph, as effected through a monumental display of human technology.

Employing that modular approach, the English version of the film repeats many of these scenes but truncates them, thus its shorter length—74 minutes to the German version's 104 minutes. Here the platform first appears, in a nice characterizing touch, as a kind of idle sketch Droste is making when he is introduced into the narrative, as if he were more a dreamer than a true engineer, and in short order it recurs as a montage of headlines in the local newspapers, again announcing Lennartz's plans to build an "Island of Steel and Glass," as one newspaper puts it, and as a large design plan in the shipyard's office. However, the construction scenes in the shipyard offer almost no glimpses of it in the background. Rather, they appear to be process shots, offering tightly framed and intimate conversations between Ellissen and Claire Lennartz, who are supposedly watching the activity but mainly flirting with each other. Once completed, there is no long shot of the model at sea, only scenes of activity throughout the platform to measure out its size by showing the action in its different sections. There are several long shots of the model, glimpsed for a few seconds each when Ellissen and Claire fly to the platform, but as in the German version, the primary images are when their plane attempts to land on the deck (portrayed, in modular fashion, by the same shots as in the German production), when the crew panic and abandon the platform, and later when Ellissen takes off to find help, again largely repeated from the other MLV. In every case we see only partial images, fashioned from the Hamburg dry dock, with the mise-en-scène essentially mirroring the German release.

However, a major change occurs in this version's depiction of the

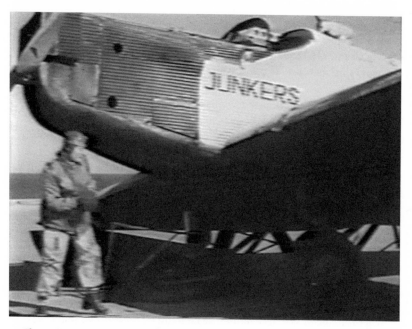

Figure 6.1. Hans Albers and another "star" of *F. P. 1*: the resurgent German aircraft industry.

rescue and final triumph of the platform. It is played out very simply with a ship bringing oil to start the platform's pumps and engines and a series of long shots, showing the model at sea with planes and ships all around it, while Droste and Claire, in loving embrace, look out at this largely *maritime* activity. Although this ending emphasizes the platform's importance, the raised flags of the German version here give way to the romantic relationship, effectively linking this monumental achievement with, by implication, another monumental event—the love that has helped bring it to pass—thereby giving this construct a more personal, if no less triumphant, *human* instead of a technological measure.

An even more pronounced change occurs in the two versions' treatment of one of the Machine Age's most important icons, aircraft and, more broadly, of flight itself—elements that justify the platform's existence. In this period, as Corn relates, the airplane had become a key image in a kind of "secular religion of technology" and a recurrent

symbol of a technological utopianism.[19] Cheng also reminds us that "few people in the early twentieth century had actually flown. Everyone else was left to finding a way to . . . imagine the experience"[20]—an imagining that is central to the German version of *F. P. 1*. The narrative strikes this note on its opening—an introduction neither in the original script nor in the realized English version[21]—as we hear the martial music of "Das Fliegerlied," a song about the wonders of flight and those new heroes of the air, and view a seventy-second montage of aircraft flying in formations, doing aeobatics, soaring through and above the clouds—all signaling a central focus on aircraft, while immediately establishing a theme of technological transcendence. Later, when Ellissen receives an offer from the Mannheim Motorwerks, offering him the use of their new Model 7000 plane for an attempted around-the-world flight, he demonstrates the lure of flight by jumping at the opportunity, readily dropping his budding romantic relationship with Claire as well as his support for Droste's project. He effectively flies out of the narrative, as we see his plane taking off and soaring into the sunrise, suggesting in the process that perhaps aircraft technology is the real future here. When that mission fails and he returns two years later, Claire recruits him to fly her to the platform to investigate its mysterious loss of communication. The scenes of Ellissen and Claire flying in a state-of-the-art, low-wing monoplane are extensive, and culminate in his crash-landing on the sabotaged platform amid gunfire—all carefully framed to emphasize the identity of the craft, a Junkers W 33, an advanced experimental German plane of the period. Repeatedly framed with the Junkers name on his plane, Ellissen is again linked to the German aircraft industry that was starting to flex its muscles just prior to the advent of the Nazi regime.

And when he heroically manages to fly an older biplane from the platform in search of a rescue ship, his effort initiates a kind of flying frenzy. After being picked up by a steamer, he broadcasts a message that mobilizes squadrons of aircraft, with two planes receiving special attention. We see barrels of oil and other supplies trundled aboard a Junkers G 38 and a Dornier Do X, two of the largest and most powerful aircraft in the world at that time—and the latter one that had recently made headlines with its own attempted distance flights and publicity tour of German port cities. The twelve-engine Do X, we should note, was a special showpiece of the German aircraft industry and had been

Figure 6.2. The central science fiction image of the film: *F. P. 1* at sea.

designed and built in violation of the Treaty of Versailles's limitations on German aircraft production,[22] so its apparent participation in the rescue would have struck a special note of national pride—and perhaps defiance as well—for German audiences. Moreover, the resulting lengthy rescue montage, again accompanied by the strains of "Das Fliegerlied," becomes a kind of paean to this and the other pointedly German aircraft involved, attesting to the power—and future—of the country's aircraft industry.

In contrast, the British version downplays that imagination of flight, enlisting instead an older and traditionally British "gospel" of sea power. It thus omits both the opening flight montage and the climactic one centered on the giant Do X and other German aircraft. Instead, it begins with a nightclub dance scene—also in the German version—where Claire and Ellissen first meet. In the course of their subsequent romantic conversation at the Lennartz shipyard, she upbraids him for his fixation on aircraft, but to little effect, for here too,

when offered the use of a new plane for a nonstop, around-the-world attempt, Ellissen quickly seizes the opportunity and, in keeping with the principle of modularity, we see the same scene of a plane flying into the frame—and away from the action surrounding the platform's construction. The later scenes of Ellissen and Claire flying to the platform use the same cockpit mock-up and long shots of the Junkers W 33 as in the German version, but the shots are fewer and truncated, and when Ellissen crash-lands and emerges from the cockpit, he is framed more tightly to obscure the appearance of the Junkers name. More significantly, the final rescue of the platform is, by editing out all the scenes of aircraft activity, staged as implicitly a ship-to-ship accomplishment, with that treaty-defying piece of technology, the Do X, disappearing from the narrative. But of course this version was directed to a seafaring nation and one that was still the preeminent world sea power, so this quite different emphasis was appropriate, perhaps even a comforting, but alternative, suggestion about a technology-fueled future: that it would follow more traditional lines and pose less of a threat to the status quo.

Supporting these differing messages are the contrasting depictions of the key "technologists" in each version, the engineer Droste and the aviator Ellissen. The engineer, as Cecelia Tichi has chronicled, was one of the period's key figures, a sign of the importance of technology, as well as "a symbol of efficiency, stability, functionalism, and power,"[23] while the aviator suggested the ability to put that technology into practice, and was emblematic of society's "airmindedness."[24] Thus, in her discussion of the German version, Stefanie Harris refers to them as "divergent heroes of the nation."[25] And both versions of *F. P. 1* present these two figures as allies in looking to the future; it is, after all, Ellissen who brings Droste's plans to public attention, effectively enabling the platform's construction. However, they also become rivals for the same woman, Claire Lennartz, so to allow one of these appealing figures to win out, the narrative must locate some fault or problem in the other. In both cases the engineer proves a figure who fights for his platform's construction (and literally fights against its sabotage), shows leadership and strength of character when his men panic, and sees the platform through to success. There is, in fact, little difference in how this figure is played in the two films, although neither Paul Hartmann nor Leslie Fenton seems a conventional romantic lead; rather, their

attraction is linked to their common portrayal of Droste as not just a dreamer but, in Tichi's words, a force of "stability."

But Ellissen, as we might expect, is portrayed very differently, although the respective actors, Hans Albers and Conrad Veidt, add significantly to that differentiation. Both versions present Ellissen as, quite literally, a "flighty" figure, almost an embodiment of the "Fliegerlied" song that recurs on the soundtrack in the German *F. P. 1* and that we hear Albers humming as he undertakes the seemingly suicidal rescue flight at the end of the film. We have already noted the essential plot point of both versions, Ellissen's quick abandonment of both Claire and the platform project when he has a chance to undertake a record-breaking flight. Yet even before that effort, Claire scolds him for his very unstable ways, appealing in the German version to the importance of *Heimat, aufgabe, pflicht* (Home, responsibility, duty)— tellingly, this link between technological activity and one's duty to the homeland is not made in the English version. Rather, in the English film she simply observes, with an obvious hint of her romantic hopes, "This rushing around the globe doesn't get you anywhere. You ought to settle down." The subsequent failure of that round-the-world attempt seems to support her judgment, especially given Ellissen's obviously reduced circumstances when he reappears. And a concluding note, as Ellissen, having lost the girl, sets his mind to another quest, this one to the Andes in search of condors, only reaffirms the notion that he might be a bit too adventurous, perhaps too "air-minded" for the earthly constraints of love, marriage, and the serious business of engineering a global society.

However, the character contrast that the two versions of *F. P. 1* stage and that helps explain Claire's choice of the engineer over the aviator is troubled by Ellissen's casting. Joseph Garncarz observes that, because "it was not viable [economically] to shoot multiple-language versions which were too different from each other," films wherein "roles are interpreted with significant differences appear to be the exception,"[26] but *F. P. 1* is clearly one of those "exceptions." For as Garncarz notes, Hans Albers of the German version "plays a 'daredevil,'" while Conrad Veidt in the English "plays a 'gentleman.'"[27] However, that distinction was almost inevitable, because in 1932 Albers was arguably Germany's most popular actor, one described as "the bearer and symbol of the German idea of a man,"[28] while Veidt, previously known for his horror roles in

films like *The Cabinet of Dr. Caligari* (1919), *The Hands of Orlac* (1924), and *Waxworks* (1924), had recently played a variety of aristocrats, dandies, or historical figures in such works as *13 Men and a Girl* (1930), *Der Kongress Tanzt* (*The Congress Dances*, 1931), and *Der Schwarze Husar* (*The Black Hussar*, 1932). However, he was seldom the leading man, more often an aloof, and in some cases even tragic character.

Siegfried Kracauer's characterization of Albers as a "human dynamo with the heart of gold"[29] is very close to the mark here, and gives a sense of why that aviator image is somewhat troubled in the German version. For as the sort of figure that, Kracauer suggests, "everyone"—or at least every German of the time—"wished to be in life,"[30] Albers's Ellissen simply seems more appealing than Droste and, in his own energetic way, conveys a greater sense of possibility and readiness for the future. In contrast, Veidt plays the role like an aloof aristocrat, and by the end of the film seems drained of energy, as we see in his final scene wherein, instead of convincing himself that he might go off on another great adventure, another chance to fly high, he simply resigns himself to pursuing those condors in South America as he closes his eyes in exhaustion. Though Veidt's Ellissen seems tired, as if there were no more place for him in the world of the future, Albers's character remains jaunty and energetic—whistling, joking—like someone who still might soar with the condors. In sum, his Ellissen seems to represent much of what the flying platform itself does, a dynamic potential for the future, and as such he renders the choice in the German version between the engineer and the aviator, between the platform and the aircraft, a most difficult and unconvincing one. Indeed, it seems almost appropriate in this version that the final scene between Droste and Claire finds them not arm in arm but on opposite sides of the frame, symbolically separated by the planes in the background.

But that very difficulty underscores the point of this comparison. The various MLVs of this era were, on the one hand, expressly designed to speak clearly across national lines, in this case, to convey a message about our technologically driven future that a variety of cultures might understand and embrace. To speak that message all the more clearly, *F. P. 1* attempted to seize upon a number of powerful and evocative symbols of the period—symbols that were right at home in the era's fledgling SF cinema. The monumental and futuristic technology, the latest aircraft, the engineer, and the aviator—these were all sta-

ple images of Machine Age SF and ones that, as various commentators have suggested, generally spoke powerfully to period audiences about the "efficiency, stability, functionalism, and power" of an approaching technological utopia.

Yet, on the other hand, the implications of those images in the film's German and English versions are troubled, at some conflict with the sort of universal language that many expected of both the movies and the new genre of SF. Ironically, the different film versions highlight some very uncommon cultural attitudes that attached to those powerful symbols, and in the process point up the difficulties in finding a truly common language for an SF cinema. For while in this interwar period there was a sense that science and technology might themselves constitute a new sort of language, one that could reach out to a truly international audience, the emblems of science and technology, that language's basic elements, remained inflected with what we might think of as a local dialect, one that speaks directly to a sense of national identity in this era. For the German audience, perhaps already anticipating the rebirth of the *Luftwaffe*, the airplane was clearly the technology of the future, and the aviator its principle acolyte, a heroic figure even at his "flightiest," while for the British the plane remained an extension of that empire's continuing mastery over the sea, and the courageous pilot was something of an adventurer, lacking in the sort of stability that would be needed to engineer the technological utopia toward which the world seemed to be heading. And the colossal technology, like the oceangoing platform of *F. P. 1*, was for German viewers something of a national emblem, testimony to the culture's capacity for monumental achievements, even in the wake of defeat, economic collapse, and political turmoil—hence, the many lingering shots on the model work of the platform. However, to the British that platform, briefly glimpsed as it was, seemed more a confirmation of individual achievement, a sign of the ability to realize one's greatest dreams, and a link to past cultural glories.

Of course, such cultural differences are hardly surprising. As Garncarz reminds, "An export-geared film industry had to adapt its own products to serve the national cultural traditions of the target country,"[31] including its own. But those differences do stress the varied ways that technology and technological figures spoke to those different cultural audiences. Though the MLVs of this period were developed

to ease the loss of a common visual language, embodied in the silent film, a work such as *F. P. 1* demonstrates how problematic even that visual language could be, as in trying to speak globally about the era's concerns over science, technology, and progress, it also underscored the very lack of consensus about those same issues—a lack that might begin to explain the relative weakness of an SF cinema in this same period. The very different takes on the futuristic city that would form the centerpieces of such better known films as the German *Metropolis* (1927), the American *Just Imagine* (1930), and the British *Things to Come* (1936) perhaps more dramatically image such a lack of consensus, but given their subject and industrial purpose, the *F. P. 1* MLVs clearly point up the rather slippery "vocabulary" with which an emerging global SF cinema was in this period already struggling.

NOTES

1. For an overview of the development of an international science fiction cinema during the interwar years, see my *A Distant Technology: Science Fiction Film and the Machine Age* (Middletown, Conn.: Wesleyan University Press, 1999).

2. The multiple language version (or MLV) was a common approach that many of the larger film studios—in the United States and Europe—took to address the coming of sound. Although many in the film industry simply assumed that voices might be dubbed to create export versions of popular films, early in the advent of sound it was found that different nationalities had different attitudes toward such a practice. As Charles O'Brien chronicles in *Cinema's Conversion to Sound: Technology and Film Style in France and the U.S.* (Bloomington: Indiana University Press, 2005), both "the American and French cinemas," for example, "place[d] a strong emphasis on a tight synchronization of the actors' voices with their images" (1), in part because the film experience was itself seen as representing "a unique perceptual experience," one that produced "a fascinating enlargement of aspects of everyday phenomenal life that ordinarily went unnoticed" (4). Consequently, those national film industries that relied heavily on exports—particularly the United States, France, Germany, and England—invested heavily in the production of MLVs between 1929 and 1932, while even smaller national film industries, such as that of Czechoslovakia, which had to address several different language groups in their own country or their border areas, also adopted the practice.

3. Hugo Gernsback, "Science Wonder Stories," *Science Wonder Stories* 1, no. 1 (1929): 5.

4. Edward James, *Science Fiction in the Twentieth Century* (Oxford: Oxford University Press, 1994), 43.

5. John Cheng, *Astounding Wonder: Imagining Science and Science Fiction in Interwar America* (Philadelphia: University of Pennsylvania Press, 2012), 84.

6. Ibid., 104.

7. Joseph Garncarz, "Making Films Comprehensible and Popular Abroad," *Cinema & Cie* 4 (2004): 72.

8. Ibid., 73. Garncarz also notes that, despite the savings and technical feasibility of dubbing instead of producing MLVs, studios were reluctant to release dubbed prints because "contemporary audiences," particularly those in the major European markets, "could not bring themselves to identify the voice of one person with the body of another in the creation of a new 'synthetic person'" (73).

9. Charles O'Brien, "Multiple Language Versions and National Films," *Cinema & Cie* 6 (2005): 56.

10. Ibid., 56.

11. I take these figures from Klaus Kreimeier's history *The Ufa Story: A History of Germany's Greatest Film Company, 1918–1945* (New York: Hill and Wang, 1996), 195–96.

12. Ginette Vincendeau's "Hollywood Babel: The Multiple Language Version," *Screen* 29, no. 2 (1988): 26–27, identifies three types of such "international" films, work done simultaneously in different languages and with different casts, "films made from the same source material, but with a short time gap" between their production, and the "polyglot film," in which each actor speaks in his or her own language.

13. Joseph Corn, *The Winged Gospel: America's Romance with Aviation* (Baltimore: Johns Hopkins University Press, 2002), 154.

14. Ibid., 4.

15. True international flight was, at the time of *F. P. 1*'s production, still a vision of the future. In 1932 Pan Am offered Caribbean service that was hailed as "the longest over-water route of any air line in the world—500 miles," while it was also announcing contracts with Sikorsky and Glenn Martin companies for new "super-flying boats" with a range of 2,400 miles that, it was hoped, would inaugurate longer-distance service within "two or three years." See Lauren D. Lyman, "Round-World Routes Fast Being Linked-Up," *New York Times,* December 4, 1932, XX13.

16. Lozowick's comment is cited in Richard Guy Wilson, Dianne H. Pilgrim,

and Dickran Tashjian's *The Machine Age in America: 1914–1941* (New York: Abrams, 1986), 30.

17. William Johnson, "Introduction: Journey into Science Fiction," *Focus on the Science Fiction Film* (Englewood Cliffs, N.J.: Prentice-Hall, 1972), 6.

18. Mordaunt Hall, "*F. P. 1 Antwortet Nicht*," *New York Times*, September 16, 1933, p. 9.

19. Corn, *The Winged Gospel*, 27.

20. Chang, *Astounding Wonder*, 254.

21. Stefanie Harris calls attention to this shift in the opening from both the script and the original Kurt Siodmak novel in her article "Calling the Nation: Karl Hartl's *F. P. 1 antwortet nicht* (1932)," *South Central Review* 29, nos. 1–2 (2012): 38–39.

22. In fact, the Do X conducted a grand flying tour of the major German coastal cities in 1932, the very year of *F. P. 1*'s release, in an effort at demonstrating the new airline services that would soon be available to the German public and, eventually, to the rest of the world thanks to Germany's advanced technology.

23. Cecelia Tichi, *Shifting Gears: Technology, Literature, Culture in Modernist America* (Chapel Hill: University of North Carolina Press, 1987), 98.

24. Corn, *The Winged Gospel*, 12.

25. Harris, "Calling the Nation," 22.

26. Garncarz, "Making Films Comprehensible," 75.

27. Ibid.

28. Quoted in Kreimeier, *The Ufa Story*, 291.

29. Siegfried Kracauer, *From Caligari to Hitler: A Psychological History of the German Film* (Princeton, N.J.: Princeton University Press, 1947), 214.

30. Ibid.

31. Garncarz, *The Ufa Story*, 75.

7 Enthiran, the Robot

Sujatha, Science Fiction, and Tamil Cinema

SWARNAVEL ESWARAN PILLAI

Sujatha, one of the three screenwriters of the film *Enthiran, the Robot* (2010), was arguably the most popular Tamil writer of the past four decades (1968–2008).[1] Unlike most Tamil writers, he was a scientist who later became a writer of both fiction and nonfiction, with science being his privileged area of focus.[2] This chapter explores how Sujatha's unique status as a popular Tamil writer, particularly of science fiction, influenced the narrative of *Enthiran* by engaging with some of his significant and seminal short stories that had direct impact on its plot. *Enthiran*, Sujatha's final foray into screenwriting, is a rare mainstream Indian film that simultaneously draws from Asimov's ideas on robotics and the ubiquitous convention of the double role in Tamil cinema. In this chapter, I analyze *Enthiran* to explore how an iconic Tamil screenwriter navigates the reservoir of mythos and narrative traditions in Tamil culture and the transnational impact of science fiction as a genre, underscoring how he mediates these diverse preoccupations. Such an analysis sheds light on Tamil cinema's complex engagement with science fiction.

Furthermore, the unique case of *Enthiran* foregrounds the fraught question of authorship in cinema. Its screenplay is cowritten by arguably the most popular Tamil writer of the second half of the last century. Yet unlike many of his earlier screenplays, which are based on his novels/novellas, *Enthiran* is not an adaptation; the story and screenplay originally were written for the film. Therefore *Enthiran*, the most successful Indian science fiction film so far, offers us an opportunity to engage with the idea of the writer as the author of the film because it is Sujatha's distinct style and worldview that drive the narrative. Toward this end, I engage with Sujatha's investment in science fiction, his preferred genre, and his worldview, through an analysis of his iconic short stories, to underscore the centrality of culture to his writings: as

the antithesis to the flight of fantasy, it opens up the dialectical space of science fiction; the adventurous leap into the unknown future is tempered by the harsh reality on the ground of traditions and beliefs.

Sujatha and Tamil Cinema

Sujatha's huge success in weekly magazines as a writer of short stories, serialized novels, and essays on diverse topics, including cinema, anticipated his foray into the realm of cinema in the late 1970s when his short story "Gaayathri" (1977) was made into a film with the then-rising star Rajnikanth. The very next year saw Rajnikanth and Sridevi act in the film *Priya* (1978), which was adapted from one of the many Sujatha novels that had for its protagonists private detective Ganesh and his witty assistant Vasanth, recalling Sir Arthur Conan Doyle's iconic duo, Sherlock Holmes and Dr. Watson. Similarly, Sujatha's collaboration with the other significant Tamil star Kamalahasan is well known, and his contributions as a screenwriter from *Vikram* (1986) through *Dasavatharam* (2008) highlight his unique position as an expert on science as well as fiction and his marketability as a popular writer of science fiction in Tamil. Although Sujatha engages successfully with many genres, including the historical, thriller, and detective, he is acknowledged even by his harshest critics as Tamil's pioneer and unparalleled writer of science fiction.[3]

Of the above mentioned films, *Enthiran* occupies a special place because it signifies Sujatha's two primary interests: science fiction and the specificity of Tamil culture. Its screenplay reflects many of the central concerns that preoccupy Sujatha as a short story writer and a novelist. For instance, the title alludes to Sujatha's popular science fiction novel *En Iniya Enthira* (*My Dear Robot*) (1986) wherein the robot Jeeno develops sentience and is dismantled in the end, anticipating the robot Citti in *Enthiran*.[4] *Enthiran* opens with an invitation to a new man to descend to the earth, but this new man, we soon realize, is an android. Dr. Vaseegaran, the scientist who has been working for a decade on a new robot that would resemble him in appearance and action, successfully finishes his mission with the invention of Citti. Vaseegaran's mission is to empower the Indian army by replacing its personnel with the easily multipliable Citti, and thereby save human lives in war. Therefore, he seeks clearance of his invention from the

AIRDI (Artificial Intelligence Research and Development Institute) that is headed by his mentor Dr. Bohra, who has been unsuccessful in a similar attempt at inventing an android.

During the evaluation of Citti, Bohra draws attention to the fact that Citti's design is not in conformity with Isaac Asimov's three laws of robotics and demonstrates how Citti could be manipulated to attack his own creator Vaseegaran, as he has no sense of discrimination, and, therefore, could be dangerous if used by the army. Consequently, Vaseegaran tries to infuse Citti with human emotions to enable his sense of belonging and judgment, and he is successful. Sana, Vaseegaran's girlfriend, seeks Citti's help in the difficult childbirth of her friend, and Citti applies his knowledge of symphysiotomy, stunning the medical fraternity through his success. The extensive media coverage results in Bohra congratulating Vaseegaran, and Citti getting clearance from the AIRDI. Meanwhile, when Sana expresses her gratitude to Citti for helping her friend by kissing him, he falls in love with her. Though Sana tries to explain to him that she can only be his friend and asks him to forget her, Citti keeps longing for her, which leads to his disobedience of his mentor/competitor Vaseegaran and his failure of the test conducted by the Indian Army.

As a result, a visibly shattered Vaseegaran chops Citti into pieces and dumps him in a landfill site, only to be recovered by Bohra who reassembles Citti and embeds him with a red chip that enables his transformation into a monster. Citti exercises his newfound power by kidnapping Sana and imprisoning her at the premises of the AIRDI. He gets drunk with power as he replicates himself and kills Bohra and then tries to capture Vaseegaran, who infiltrates the AIRDI posing as a robot. Vaseegaran's challenging of his power leads Citti to create havoc in the city through spectacles of gigantic designs wherein multiple Cittis assemble and reassemble. Finally, Vaseegaran is able to demagnetize Citti and remove the red chip that was responsible for turning his creation into a monster. Nonetheless, Citti has to pay for his misdeeds, and the court acquits Vaseegaran but orders him to dismantle Citti to avoid mishaps in the future. As Citti dismantles himself in front of an emotional Vaseegaran and Sana, the film fast-forwards to 2030, wherein we see schoolchildren with their teacher visiting him in a museum.

This brief storyline throws light on some of the major influences

on *Enthiran*'s screenplay. On the one hand, we find the allusion to Asimov as the iconic writer of science fiction associated with the three laws of robotics;[5] and on the other, we find a disavowal of his basic premise that the robot will never harm any human being. While the project of gradually humanizing an android by conferring sentience on it, as exemplified by Asimov's novella *The Bicentennial Man* (1976) and its film adaptation (*The Bicentennial Man*, 1999),[6] seems attractive to Sujatha, he also invests in Citti's consequent longing for Sana and his clash with Vaseegaran to emphasize the melodramatic plot structure of the love triangle. In addition, the convention of the double role allows for a clash between good and evil—a ubiquitous plot in Tamil cinema spawned by the landmark success of *Uthamaputhiran* (1940), adapted from John Whale's popular film *The Man in the Iron Mask* (1939) that was based on Alexander Dumas's French classic. Although the impact of such successful Hollywood films on the narratives of Tamil talkies from the early period of the 1930s has been discussed by Tamil film historians such as Theodore Baskaran, the semantic convention of the double role, in which the similar-looking but differently made-up heroes emblematize the binary of good and evil, had its syntactic origins in the attempts to critique the colonizer and cleverly navigate through the censor board of the British government. *Enthiran,* however, retools this generic convention to address contemporary discourses surrounding the attack on Other(s)/nation(s) with automatons in the era of globalization, marked by the game of hide-and-seek with visible/invisible enemies.

Thus, in its repurposing of the SF genre, the film recalls the meditations of one of its foremost theorists, Rick Altman. Summarizing his seminal exploration of a semantic/syntactic approach to film genre, Altman observes that "[the] syntactic expectation, set up by a semantic signal, is matched by a parallel tendency to expect specific syntactic signals to lead to predetermined semantic fields, (e.g., in Western texts, regular alternation between male and female characters creates expectation of the semantic elements implied by romance, while—at least until recently—alternation between two males throughout a text has implied confrontation and semantics of the duel)."[7] Though the previous passage with its parallels of romance and confrontation resonates with *Enthiran*'s narrative in its love story between Dr. Vaseegaran and Sana and the conflict between Dr. Vaseegaran and Citti, one could

extend it further to read the parallel text of confrontation as the one between Frankenstein and his monster, leading to the semantics of the destruction/disassembling of the Other.

Altman further suggests the significance of the "multiple conflicting audiences" and the producers with "divergent interests" in interpreting the semantic and syntactic elements and provides us with the third paradigm of the pragmatic, to account for the "competition among multiple groups that characterizes genres."[8] The dynamic space in which competing interests are at play in determining the always shifting nature of the genre offers the potential for the marginalized to become a mainstream genre.[9] Even as they point to the fluidity in the shifting constellations of elements, Sujatha's last two films—*Dasavatharam*, labeled as a "science fiction disaster" film, and *Enthiran* as a "science fiction melodrama" film—also highlight the "multiple codes" and "multi-discursive" quality of the genre whose definition is mediated by differentially invested groups such as producers, audiences, and "ritual and ideological critics."[10] Sujatha's readers, familiar with his literary and cinematic works and strapped with their own expectations and readings and rereadings of his texts, assume prominence in the marketing of his films. The fact that nouns in science fiction disaster/melodrama have not turned into adjectives as in "musical comedy" or "western romance" also point to science fiction's rarity in Tamil cinema's generic history and its infrequent consumption among Tamil cinema audiences.[11] Therefore, the production and marketing of a costly project like *Enthiran* as a science fiction film was predicated primarily on Sujatha's star status as a writer of science fiction among readers of popular fiction in Tamil.[12]

Tamil cinema's first science fiction film was *Kalai Arasi* (1963), wherein two aliens, resembling humans, arrive on Earth on an unusual mission of seeking help for their people who have made great strides in science but are utterly backward in the performing arts. Iconic Tamil star MGR (as Mohan) travels to the alien land to retrieve his abducted sweetheart Vani, who is teaching dance and music to the princess there. He reaches her with the help of his lookalike jester (in an earlier example of a double role) and finally brings her home, his act mirroring Dr. Vaseegaran's retrieval of the abducted Sana. The other significant Tamil films in the science fiction genre, *Vikram, Dasavatharam*, and *Enthiran*, follow the trend set by *Kalai Arasi* in combining action,

songs, comedy, and special effects, except that now science became a metonymical signifier displaced in the Lacanian sense by rocket science, bioterrorism, and robotics. More important, however, is the fact that Sujatha as the screenwriter/signifier undergirds the association of these films with science. Nevertheless, by underscoring the void of performing arts/culture in a scientifically advanced futuristic world, Tamil's primordial science fiction film anticipates the lack at the center of *Enthiran:* the robot who is ignorant of the specificity of Tamil culture and tradition.

Sujatha's Authorial Themes

A short discussion of Sujatha's authorship is in order here to understand the significance of culture in his narratives driven by the science fiction genre. In his SF short stories, Sujatha often juxtaposes the contemporary with the ancient or the futuristic mainly to break the linearity of time and foreground how cultural traditions and habits provide a link for our understanding of past, present, and future, and the otherwise unfathomable and limitless idea of time. It is in this context that he reinvents episodes from ancient epics like the *Mahabharatha* or draws from mythos and juxtaposes them with a futuristic world while intertwining them with the specificity of Tamil culture. In *Nachupoigai* (The pond of poison), for example, he revisits a key moment in the *Mahabharata* when all the four younger brothers of Yudhisthira die after drinking poisoned water from the pond in an episode called *Yaksha Prasna* (Story of the righteous crane) that appears in the *Vana Parva* or *The Book of the Forest*.[13] Later, Yudhisthira answers correctly Yaksha's/Nature-spirit's philosophical and metaphysical questions to redeem his brothers' lives. Sujatha, in his retelling of this story for a modern audience, characterizes Yudhisthira as scientifically informed and portrays him as being able to read through the cause of his brothers' temporary unconsciousness through the carbon monoxide and thiopentone that has contaminated the water. Therefore, he outwits the Yaksha by answering his questions correctly, but instead of asking for the gift of his brothers' lives, confidently apprises the surprised Yaksha of the reason for his brothers' plight, and tells him that if they take long enough to regain their consciousness he can administer them with dextrose, from the fruits found on the trees nearby, as the antidote.

In contrast to "The pond of poison" where the present (signified by science and reason) is invoked from the mythical past of the world of *Mahabharatha* and its iconic characters, in his popular short story "Thimala" that is set in 2080, Sujatha showcases a futuristic world to recall the present: in a world dominated by speed, Nithya travels on an air taxi and arrives with her husband Athma at Thimala and is carried by a conveyor belt into the sanctum of a temple.[14] When she asks for prayers in Tamil, a prerecorded female voice recites lines from the old Tamil text of *Nalaayira Divya Prabandam* (the divine collection of 4,000 hymns by the poet-saints Alvars/Azhwars [sixth and ninth centuries A.D.]). The priest asks the devotees to have a good glimpse of the Lord in what was once known as Tirumala, the most visited place of pilgrimage in the world. Although Sujatha predicts the changes in the way people will commute to reach the Lord at the mountaintop, he also underscores the continuity in Nithya's unchanging devotion (or blind faith), as she waits for a year to get her admission ticket, but on reaching the Lord gets only twenty seconds to glimpse him.[15]

This juxtaposition of the mythic past or the robotic future with the present also undergirds the narrative of *Enthiran*. The film, however, goes a step further, invoking both the mythic past and alluding to the calamitous future from the vantage point of the present. Citti's monstrous act of imprisoning Sana recalls the act of the iconic villain Ravana of the *Ramayana* who similarly abducted Sita against her will; Ravana as the ten-headed ruler of Lanka symbolically prefigures the capacity of Citti to replicate; and the very creation of Citti as a robot for the army suggests, like the atom, the catastrophe of one more scientific invention that awaits humanity, as exemplified by Citti's attempt to murder Dr. Vaseegaran. When the easily replaceable chip at his center is changed, Citti, despite his lovable antics, epitomizes the limitless destructive potential of the drones and forebodes a bleak future that awaits humanity, as revealed by his passion for boundless annihilation.

The violent confrontation between Vaseegaran and Citti challenges the utopian hopes offered initially by the robot, in a spectacular but increasingly gray and dystopic landscape that recalls Sujatha's meditations on science, history, and fiction. In his essay on Asimov, Sujatha points to the influence of Edward Gibbon's *The History of the Decline and Fall of the Roman Empire* on Asimov's writing and claims that he rewrites history in the form of science fiction. Though crediting

Asimov for writing science fiction works as if they were fast-paced thrillers, Sujatha critiques him for not taking risks when it comes to writing and admits that he prefers reading Asimov's essays on science to his fiction.[16] We therefore can understand why Sujatha chose a script based on a (generally amicable and Asimovian) robot that enabled him to draw from myths instead of history for his narrative, for a risk-free undertaking of an expensive film with a superstar. Yet, unlike Asimov, Sujatha laces his script with the struggles of a scientist with technology when confronted with a robot unbound by rules. Such a confrontation enables the juxtaposition of the utopian hopes surrounding science and technology with the dystopia of humanity's greed and manipulation, symbolized by Bohra, and its desire for control, epitomized by Vaseegaran.

Sujatha's most distinct authorial signature, however, can be found in his treatment of the limitations of science, as reflected by two of his critically acclaimed short stories that also provide us with insights on *Enthiran*'s provenance. "Adimai" (The Slave) is about a computer named Shekar who is generally invisible, with sensors for eyes and ears embedded inside the walls of a family's home.[17] Shekar's occupying of the space between the couple and his increasing intimacies with the wife spawn jealousy with respect to this technology and its/ his cultural transgressions. (In this sense, the story also anticipates a key sequence in *Enthiran* involving an unclad young woman, as I discuss in the following section.) This mirrors Sana's increasing fondness for the robot in the film: Chitti has the time to listen and carry out her orders like a(n) *adimai*/slave. The climactic moment when the husband in the short story must seek out the help of the computer in order to terminate it, cutting off the twenty-two cables that carry the power to the main computer, prefigures the climax of *Enthiran*, when Citti is forced to willingly dismantle himself in front of his master Vaseegaran. Nonetheless, unlike in the short story in which Sujatha is able to punctuate the demon of suspicion and jealousy inside Shekar through his climactic act of moving toward the cables, the contingency of mainstream cinema does not allow such freedom in Enthiran's closure. Vaseegaran cannot be demonized to the same extent, as the aura surrounding the hero has to be preserved.

In Sujatha's "Agayam" (The Sky), the master-slave dialectic is transformed into preoccupations with philosophical questions related to

knowledge/superstition.[18] This short story revolves around Anand, his girlfriend Kanchana, and Yam the robot, who are traveling on a spaceship toward Asteroid-99 to explore the possibilities of inhabiting the asteroid to find a solution to the overpopulated world. As the journey proceeds, Anand feels threatened by Yam's capacity to think, suspecting it of conspiracy due to its ability to act independently. He cannot verify his doubts, because Yam is the conduit for all communications with the outside world. Yam, the short form of Yanthiram/Enthiram (machine or engine), who starts doubting the agitated Anand's sanity, not only prefigures Enthiran (the robot—the neologism coined by Sujatha) by being an android-humanoid in its form, but strikes Anand on his head and transgresses the Asimovian second law of robotics— not to harm any human being—when the conflict escalates. The intelligent but doubtful Kanchana has the power to choose between her two equally dangerous friends when she is given the orders to terminate Anand but cannot fully trust Yam to be her companion. She subsequently leaves the difficult choice between Anand and Yam to chance by transferring the burden of decision-making to Yam, asking it to touch one of her two fingers. This cultural tossing of the coin at the climactic moment in "Agayam" recalls Sujatha's preoccupation with traditions in "Thimala," and his authorial theme of the intricate relationship between science and Tamil culture. The haunting question regarding the limits of reason, in the context of unconscious fears and anxieties surrounding power, when weighed against the burden of decision making at crucial moments, is resolved through the recourse or regression back to culture. Such a momentous recourse to culture is also present in *Enthiran* in the fire accident sequence, which is arguably the most disturbing, and therefore the most discussed by the media, and analyzed in detail next.

Enthiran: Culture and Its Discontents

For Sujatha, culture is closely associated with science, particularly sociobiology. In his famous "Last Page" columns in the literary magazine *Kanaiyaazhi* that he wrote for more than three decades, we get an insight into his take on the intertwining of these realisms. In "Three Scientists and Gods," Sujatha discusses sociobiologist E. O. Wilson's ideas regarding the part played by genes and culture in evolution. He

also cites Wilson's "important book," *Genes, Culture, and Mind,* to underscore how culture is not transmitted through genes but as information from ethnic groups to their successive generations.[19] For instance, according to Sujatha, we might have received our teeth from our genes, but the knowledge to protect them by using toothpaste is transmitted through culture. This transmission and lack thereof plays a complex role when Citti, though sharing a similarity in appearance with Vaseegaran, is caught among people from whom he seems insulated from cultural transmission. Moreover, Wilson underscores changes in genes as prefiguring those cultures; according to Sujatha, this explains the rigidity of differences and Othering in the unchanging Tamil society. It also offers a cue for understanding Citti's predicament and Vaseegaran's efforts at modifying him in *Enthiran.*

When Citti performs the only superhuman(e) act in the film of rescuing common people—his other feats primarily being activities to please Sana either by obeying her commands or by avenging the thugs who trouble her—caught in a fire by transforming himself into a Super-/Spiderman, he is castigated instead of celebrated. Initially, when he saves an old man and his grandson, Vaseegaran is delighted as Citti has rightly read his ability to withstand the 799 degree Celsius of the heat in the buildings that are ablaze. Subsequently, when Citti rescues an old woman and a physically challenged man, Vaseegaran feels a sense of pride at his discovery as he watches the many television crews with cameras and anchors interviewing the people who were rescued. Vaseegaran calls Bohra and asks him to watch on his television the heroic act of the robot that he had deemed a threat to human lives and society.[20]

The subsequent fire accident episode, however, is quite different because there are no such evil intentions at play. Vaseegaran wants Citti to rescue people caught in the blaze without harming them, and Citti tries his best. But the peak moment of crisis in the sequence when he has to save the reluctant unclad girl in her bathtub foregrounds the crisis at the heart of Tamil culture itself. When the helpless mother of an adolescent girl (Selvi) cries for help to save her daughter who is taking a bath when the fire breaks out, Citti quickly responds by flying like Superman, gliding through the pipes and windows like Spiderman, and scanning through his electronic eyes for the specific bathroom of the victim. When Citti wades through the blaze and reaches her, she is reluctant and refuses help because she is "not having any dress/clothes

on her." Citti responds by saying that he too is not "dressed," remind-
ing us of his formal dress, the attire signifying the andro-humanoid
robot's mirroring of his creator Vaseegaran, that was burned up when
he first entered into the blaze to rescue the helpless victims. This draws
our attention to the metallic surface of Citti/Enthiran, different from
Superman's signature dress or Spiderman's cobweb-painted costume
during a key moment of his superhuman action, though he mimics
their body language in his flight and gait. Despite the girl's reluctant
appeals to let her be, Citti not only swiftly carries her back in his arms
but flies directly into the crowd and the news-hungry media. As ex-
pected, the frightened girl is further humiliated as the cameras focus
on and attack her.

A shocked Vaseegaran admonishes Citti for not having covered her
with cloth before bringing her down. She's "naked," he says disapprov-
ingly. Citti responds: "(Nonetheless) she's alive." Though Vaseegaran
drapes the girl with his coat on arrival, the disconsolate girl runs away
from her mother and the aggressive media and is inadvertently killed
by a passing tanker. Citti/Enthiran's superhuman acts are thus under-
mined by the concluding act of this sequence, prompting Vaseegaran
to change the very being/genes of Citti by inducing sentience in him to
enable him to feel, emote, and discriminate, and for the transmission
of culture. Later, however, this sentience leads to greater complications
as Citti falls in love with Sana and develops an Oedipal complex (as
suggestively hinted by Sana herself during a song). The unrequited and
forbidden love leads ultimately to Citti's rivalry and enmity with his
creator Vaseegaran, and finally to his own destruction.

This fire sequence thus emerges as the most significant in *Enthiran*,
marking it as the only moment of rupture in an otherwise linear film
that reworks the proven formula of the double role and love triangle in
Tamil cinema, reinventing it this time by replacing the evil Other by a
robot instead of the corrupt twin brother or lookalike. The evilness of
the robot initially is predicated on its being a machine that lacks the
sense of discrimination between a girl's cry for help to be rescued and
her sense of shame or honor and later, despite his sentience, again on
the lack of his ability to discriminate between Sana's fondness for him
and actual romantic love. While the latter ploy is a formulaic structur-
ing of the love-triangle narrative, the former moment is unique in the
history of Tamil cinema.

Figure 7.1. A sentient Citti falls in love with Sana. Rajnikanth and Aishwarya Rai in *Enthiran*. Film still courtesy Gnanam.

Citti's response to the unclad teenage girl Selvi's rejection of his help, that he is also without dress or cloth, as it reveals his indiscriminate/ ignorant behavior toward a naked adolescent girl, also points to the double standards of a patriarchal culture. Citti is not only an android but also a humanoid designed and created by Vaseegaran as his replica. As he plays the Superman/rescuer, his being nude is not even noticed, whereas had he been a Superwoman the narrative would have been significantly altered. In a culture where men can be bare-bodied or minimally dressed almost anywhere, including in public spaces, and women are required generally to cover themselves fully almost everywhere to protect their "honor," Citti's nakedness is not noticed, whereas the unclad Selvi has to pay with her life.[21] The hypocrisy at the center of such patriarchal traditions comes to the fore when even the scientist-researcher Vaseegaran complains about Selvi being unclothed whereas the robot without sentience is glad that she is alive. Driven by the agents (the media) and the representative (Selvi's mother symbolizing the family) of cultural production, Selvi is forced

into her untimely death. Citti's fault lies not in his efforts to rescue her, as the raging fire would have soon devoured her, but in not rescuing her from the eyes of the media and her family and neighbors. Citti's lack of sentience is revelatory of his lack of bias between man and woman, whereas unlike him, the sentient (representatives of) Tamil culture, which is self-aware and can perceive and emote, looks at the uncovered Selvi as having committed a serious crime or transgression of its unwritten laws applicable only to women, and forces her to literally commit suicide as a punishment.

While marking *Enthiran* as unique in its rupturing of the (super) hero narrative, as Dr. Vaseegaran and Citti fall from grace, this sequence simultaneously gives us an insight into the patriarchal dimensions of Tamil culture. This dimension becomes clearer as Citti gradually becomes sentient, and consequently, his instincts and impulses are brought under control by the law of the father(s), symbolized by Vaseegaran and Bohra. Their law is made increasingly explicit in equal measure in Citti's evolution from android-humanoid to a human being during the latter half of the film. Finally, this pivotal and disturbing sequence recalls the centrality of Tamil culture for Sujatha. As we have seen above during the climax of the short story "Agayam" (The Sky), the protagonist Kanchana takes recourse to a cultural tossing of the coin, and thereby, Sujatha undergirds his narrative with the continuing relevance of cultural habits as the deciding factor when his protagonist encounters the limits of reason. In *Enthiran,* however, he points to such unreasonable actions as deeply embedded in a cultural unconscious as the very conditions of possibility for Citti's journey into the process of becoming a sentient being. My detailed analysis of *Enthiran*'s narrative and the fire accident sequence, with its juxtaposition of the Super/Spider man with an unclad teenage girl, thus suggests how science fiction and Tamil culture become the spaces signifying the limits of imagination and reality that provide the dialectical impetus for Sujatha's interrogation of contemporary life and his distinct authorship.

Sujatha's authorship, thereby, resonates with that of Philp K. Dick's in the several famous adaptations of his works: for instance, *Total Recall* (1990), *Blade Runner* (1992), and *Minority Report* (2002). Arguing for one of the central themes of Dick's authorship as predicated on blurring the area between good and evil, and the human and the

nonhuman, scholars Aaron Barlow and Dominic Alessio draw attention to Dick's focus on the shortcomings of the human and his investment in questions of morality and its redefinition in terms of style (film noir) or through the interrogation of race and religion.²² As we have seen in this chapter, Sujatha's science fiction too foregrounds the failings of the human by pitting it against the nonhuman, often through a stylized love story/triangle, and interrogates morality in the context of the specificity of and the hypocrisy surrounding Tamil culture. Thus, transnationally, we can see two iconic authors of the science fiction of the past century engaging with the genre to address their anxieties regarding the predicament of the human and its complex relationship with ethics.

NOTES

1. S. Rangarajan, who wrote under the pseudonym of his wife's name, Sujatha, was popular for his science fiction as well as his columns on science, particularly on computers. See S. Ramakrishnan, ed., *Endrum Sujatha* (Chennai: Uyirmmai Pathippagam, 2011), 2, for details. *Enthiran, the Robot* is henceforth referred to as *Enthiran* in the chapter.

2. Even critics who fault him for his catering to a large audience through popular Tamil magazines like *Kumudam* and *Ananda Vikatan* admire his style, which draws from Eastern as well as Western traditions, and regard him as the preeminent writer among the innovators of a deft and informal writing style in Tamil that marked a break from the literary finesse of an earlier period exemplified by the writings of the other landmark popular Tamil writer of the past century, Kalki Krishnamurthy.

3. The other famous and long-standing collaboration Sujatha had in the film industry was with Mani Ratnam and S. Shankar, two of the most popular and successful filmmakers in India. Sujatha worked with Mani Ratnam, arguably the most famous among contemporary Indian directors, on the scripts of *Roja* (1992), *Thiruda* (1993), *Uyire/Dil Se* (1998), *Kannathil Muthamittal* (2002), and *Aayutha Ezhuthu* (2004), and collaborated with the commercially unparalleled Shankar on *Mudhalvan* (1999), *Boys* (2003), *Anniyan* (2005), *Sivaji* (2007), and *Enthiran* (2010). Sujatha was, thus, involved as a writer with some of the most successful and discussed films in Tamil during the past two decades. Sujatha passed away in 2008, and *Enthiran* was released in 2010 (and credits him as one of the three writers of the film). Despite this gap, the narrative of the film bears testimony to Sujatha's authorship and his

appeal to the popular Tamil imagination. My reasons for reading *Enthiran's* screenplay predominantly as Sujatha's work is predicated on the first draft of the script that he wrote in 2001 when director Shankar wanted to make the film with Kamalahasan as the hero. See Naman Ramachandran, *Rajnikanth: The Definitive Biography* (New Delhi: Penguin Books, 2012), 225.

4. See for details Sujatha, *En Iniya Iyanthira* (Chennai: Thirumagal Nilayam, 1986).

5. See for details Isaac Asimov, *I, Robot* (New York: Doubleday & Company, 1950).

6. See for details Isaac Asimov, "The Bicentennial Man," *The Complete Stories, Volume 2*, 568–604 (New York: Doubleday & Co., 1992).

7. See for details Rick Altman, *Film/Genre* (London: BFI, 1999), 39.

8. Ibid.,, 208–10.

9. Ibid., 211.

10. Ibid., 208.

11. Ibid., 50–53.

12. The film also includes Tamil cinema's megastar Rajnikanth and the internationally known Aishwarya Rai as its main actors, and the Academy Award winner A. R. Rahman as its music director.

13. See for details Sujatha, *Vingyana Sirukathaigal* (Chennai: Uyirmmai Pathippagam, 2007), 246–50.

14. Ibid., 229–36.

15. This scene resonates with present conditions at Tirumala/Tirupathi, the location of the most famous temple of Lord Venkateshwara in India.

16. See for details Desikan, ed., *Kanaiyazhi Kadaisi Pakkangal (1965–1998)* (Chennai: Uyirmmai Pathippagam, 2006), 379–81.

17. See for details Sujatha, *Vingyana Sirukathaigal*, 258–66.

18. Ibid., 316–42.

19. See for details Desikan, *Kanaiyazhi Kadaisi Pakkangal*, 473–75.

20. Earlier, in the sequence of the clearance test at the AIRDI (Artificial Intelligence and Research Development Institute), Bohra orders Citti to attack his mentor Vaseegaran, and successfully demonstrates why Citti cannot be allowed to replace a soldier in the army, as he is only a machine that cannot independently think for itself. This sequence, as it underscores the limitations of the robot in discriminating between a friend and an enemy, also reveals the reason for the moment of crisis as the jealousy and evil intentions of Bohra that find expression in his malicious order to Citti. Nevertheless, Vaseegaran is shocked by the indiscriminate behavior of the automaton.

21. The stripping and gang rape in Delhi on December 16, 2012, and Guwahati (Assam) of students which set India on fire epitomizes such void at the center of a patriarchal culture. See for details: Anita Anand, "How the

Delhi Gang-Rape Has Changed Indian Women Forever," *Telegraph*, February 21, 2013, http://www.telegraph.co.uk/women/womens-life/9879930/How-the-Delhi-gang-rape-has-changed-Indian-women-forever.html.

22. Aaron Barlow draws attention to Philip K. Dick's as well as Ridley Scott's lasting influence on science fiction and foregrounds the film noir mode as distinctly marking their authorial style in *Blade Runner*, whereas Alessio Dominic focuses on Dick's film adaptations in the context of "race, religion, reality and the far-right," in their claims regarding Dick's authorship. See for details Aaron Barlow, "Reel Toads and Imaginary Cities: Philip K. Dick, Blade Runner and the Contemporary Science Fiction Movie," in *The Blade Runner Experience: The Legacy of a Science Fiction Classic*, ed. Will Brocker, 43–58 (London: Wallflower Press, 2005); Dominic Alessio, "Redemption, 'Race,' Reality, and the Far-Right: Science Fiction Film Adaptations of Philip K. Dick," in *The Blade Runner Experience*, 59–76.

Part III Spatial and Temporal Alternative Modernities in the Global South

8 Polytemporality in Argentine Science Fiction Film

A Critique of the Homogeneous Time of Historicism and Modernity

JOANNA PAGE

By far the largest producer of films in Latin America since the 1990s, Argentina has seen a boom in both independent and commercial cinema during the past two decades, ranging from low-cost experimental filmmaking and video activism to lucrative box office hits and successful genre films of all kinds. Incursions into science fiction have been relatively rare, however. The high-budget special effects that are a hallmark of the genre in Hollywood or Europe present a challenge to most filmmakers, as might the broader difficulty of imagining Argentina, with its chronic underfunding of scientific research, at the spearhead of intergalactic missions. Most of Argentina's few science fiction films have drawn on the more cerebral concerns—paradoxes of time and space—of the nation's very rich heritage in fantastic literature. Examples would include the highly acclaimed *Invasión* (Hugo Santiago, 1969) and the more recent *Moebius* (Gustavo R. Mosquera, 1996).[1] In other films, the "credibility gap" that has rendered implausible Argentina's role in pioneering space age technology has been bridged in two principal ways: through retrofuturism, and through a reflexive and parodic treatment of the codes of the science fiction genre itself. Examples of the retrofuturistic variant would include *La sonámbula* (*The Sleepwalker,* Fernando Spiner, 1998) and *La antena* (*The Antenna,* Esteban Sapir, 2007), both of which also reflect specifically on the role of cinema, and the cinematic apparatus, in the registering and reshaping of temporalities.[2]

An interrogation into modern conceptions of temporality is also at the heart of the two films discussed in this chapter, *Estrellas* (*Stars,* Federico León and Marcos Martínez, 2007) and *Cóndor Crux, la*

leyenda (*Condor Crux, The Legend,* Juan Pablo Buscarini and Swan Glecer, 2000). These productions consciously exploit the ironies that arise when the science fiction genre is torn from its more usual domain in a hypermodernized First World. While often playful in their execution, they also present a more serious critique of modernity's construction of time as linear and irreversible. It is this construction of time that has become the object of an urgent postcolonial critique of historicism developed recently by Dipesh Chakrabarty and, in relation to cinema, by Bliss Cua Lim.[3]

The Historicity of Science Fiction

The question of the historicity of science fiction divides two prominent theorists of the genre, Fredric Jameson and Carl Freedman. They agree on a basic definition of historicity, as a defamiliarizing, distancing quality that gives us a historical perspective on the immediacy of the present, allowing us to understand its place within a web of causes and effects.[4] For Freedman, "science fiction is of all genres the most devoted to historical concreteness"; he even suggests that "science fiction is, perhaps paradoxically, a version of historical fiction."[5] This is because the defamiliarizing effects of science fiction produce exactly that distancing with regard to the present that is essential to a historical perspective.

For Jameson, however, the historical novel arises in conjunction with "the emergence of historicity" in modern thought, while science fiction "corresponds to the waning or the blockage of that historicity" in the postmodern context.[6] Jameson's assessment of the historicity of science fiction is not consistent across his work, however. In later analyses, he acknowledges that science fiction, unlike fantasy, does retain a sense of history,[7] and that in the mid-twentieth century at least (and particularly in the work of Philip K. Dick), it "renders our present historical by turning it into the past of a fantasized future."[8] More recent science fiction, he claims, fulfils the important purpose of making us aware of our "mental and ideological imprisonment" in the present,[9] by "dramatiz[ing] our incapacity to imagine the future" as radically different to our current moment.[10] In other words, it succeeds precisely where it fails to convince us with its visions of a future that is qualitatively different from the present. For the most part, however, Jameson rehearses

this argument in purely negative terms, reading science fiction as emblematic of the "crisis and paralysis" of historicity in postmodern culture.[11] If, for Jameson, thinking historically (in a Marxist framework) means constructing linear relationships of causality that link the past to the present, it is entirely logical that postmodernism's "omnipresent and indiscriminate appetite for dead styles and fashions"[12] should represent for him a crisis in such historical thinking and point to our era's inability to engage critically with its late capitalist present.

With greater insight, however, Walter Benjamin saw that "the concept of the historical progress of mankind cannot be sundered from the concept of its progression through a homogeneous, empty time. A critique of the concept of such a progression must be the basis of any criticism of the concept of progress itself."[13] This is precisely the critique mounted by the two Argentine films I discuss here. It is their disruption of linear and homogeneous notions of temporality that permits them to dismantle the logic of modernity, progress, and capitalism. In place of the doctrine of the inevitability and acceleration of homogenizing forces of globalization, they offer two alternative visions: first, a more accurate understanding of modernity as a coproduction between the first world and its postcolonial other, and second, an appreciation of the multiple and heterogeneous temporalities that have shaped, and will continue to shape, our experience of modernity.

Scrapyard Spaceships: Amateurism and Anachronism in *Estrellas*

For Freedman, drawing on Darko Suvin's seminal work, the historicizing function of science fiction largely lies in the effect of "cognitive estrangement" it produces in relation to the present.[14] He cites H. G. Wells as a prime example of a science fiction author who demonstrates a sophisticated and critical historical understanding of his imperialist European present. In *The War of the Worlds* (1898), Freedman indicates, Wells creates "a genuinely anti-imperialist novel" that works "to estrange British colonialism by showing Britain itself in the (then but not later) almost unimaginable position of colonial victim."[15] The deliberately anachronistic and highly reflexive approach of *Estrellas* performs a similar estrangement operation, producing another "almost unimaginable" vision: a science fiction film made in a shantytown.

As it does so, it exposes the extent to which science fiction, futuristic visions, and alien encounters are embedded within certain (North American and European) narratives of technological modernity. In its portrayal of the encounter between advanced first world filmmaking and deprived shantytown communities, it challenges the linear notion of temporality that underpins accounts of a modernity rolled out from Europe to the colonies and that allows cultural, social, or economic difference in the colonized other to be recast as historical anachronism.

Estrellas is a playful documentary about an entrepreneur (Julio Arrieta) who sets up a theater company in a Buenos Aires shantytown to provide work for its inhabitants as authentic-looking extras in films about poverty, corruption, or violence. A crucial part of Julio's self-appointed role as mediator between the shantytown dwellers and film directors involves minimizing the clash of two very different time regimes as the former are thrust with little preparation into the rigorous schedules of capitalist production, in an industry in which each additional day's shooting can cost thousands of dollars. Julio hastens to reassure directors that he will be able to limit the costs of such a risky collaboration, promising to make sure that the actors are quiet when the cameras roll and don't slope off before the end of the day. Time, Barbara Adam observes, has proved "a most effective colonizing tool": as time in the modern age has come to be strictly equated with the production time of commodities, "any group or society that deviates from this 'norm' or endeavours to question its wisdom, value and desirability is considered backward, lazy, uncivilized."[16]

While cheerfully continuing to market his actors for typical roles as thieves and drug dealers, Julio embarks on an enterprise of a rather different nature: to make a science fiction film in the shantytown. It is conceived as an attempt to displace hackneyed representations of the shantytown and to defy the conventions of the science fiction genre, wrenched from its customary coordinates in the highly modernized metropolises of the developed world. Julio asks, "Don't shantytown dwellers also have a right to have Martians?" Rhetorical and amusing, the question nevertheless emphasizes the stark anachronism of creating science fiction in a space often considered to be one of modernity's wastelands. As in the later *District 9* (Neill Blomkamp, 2009) and *Attack the Block* (Joe Cornish, 2011)—science fiction films set respectively in a Johannesburg shantytown and a deprived South

Figure 8.1. A makeshift spaceship in *Estrellas* (2007).

London tower block—the contrast serves to heighten themes of social exclusion and prejudice.

Scenes from the making of the science fiction film are incorporated in *Estrellas,* and the directors lose no opportunities for fun, highlighting the amateurish character of the project by including out-takes and unedited scenes without proper lighting or post-production work. In filming breaks, the bored "aliens" remove their headgear to indulge in a little name-calling and engage in desultory fisticuffs; shooting is interrupted by noisy kids and the incoherent singing of a local drunk. The spacecraft used in the film (see Figure 8.1) is assembled from a miscellany of unwanted junk: the body of an old Citroën, bicycle handlebars, and a floor polisher attached to the side to simulate a fulminating weapon of attack.

Although the film trailer we later see covers up these infelicities with a generous supply of dry ice and lighting effects, the behind-the-scenes shots included in *Estrellas* do nothing to render plausible an image of the shantytown inhabitants prevailing against the superior technology and organization of the alien invaders. Indeed, the film does not allow science fiction any credible footing in the shantytown. As Clara Kriger suggests, the homemade costumes and props "are imbued with a kitsch aesthetic," arousing fond memories of the comical

Martian outfits and wobbly flying saucers of 1950s B movies.[17] The film's (mis)appropriations of the science fiction genre remain ironic and its plot resolutions unconvincing. The shantytown dwellers are raised too hastily from extreme marginalization to the front line of the nation's defense, and the aliens are not vanquished by sophisticated technology or a unified armed response, but by dirty water and slime, which causes them to melt. There is a clear echo here of *The War of the Worlds*, in which the all-powerful Martians who wreak devastation on our planet are finally killed by bacteria to which they had no immunity.

Our sense of the anachronistic reveals to us the extent to which we are conditioned to expect a very narrow range of themes and subjects (poverty, misery, violence) in a film located in a shantytown. The shantytown is most often portrayed in cinema and other media as a lawless, impoverished place trapped in underdevelopment, a yet-to-be-modernized enclave within an otherwise modernized city. This is certainly what Alan Parker was looking for when he came in search of a historical location for his film *Evita* (1996). However, as Julio relates in *Estrellas*, Parker left disappointed: there were just too many television aerials. Indeed, far from a premodern enclave, Julio's shantytown is a place that participates actively in multiple exchanges across its borders. The film's treatment of these exchanges uncovers something of the complex relationship between center and periphery that is often elided in historicist accounts of modernity. Julio is at pains to construct the relationship between the shantytown inhabitants and first world filmmakers as one of symbiosis. "We have a mutual need for each other," he insists: if the shantytowns lack technology and need work, filmmakers need authentic-looking extras and locations, as well as a good supply of cheap labor for production assistance. In effect, Julio's enterprise mimics the imperial distribution of labor, according to which Europe supplied technology and supervision, and the colonies supplied the workforce. The discourse of mutuality—and indeed, by the end of the film it would be difficult to say who is exploiting whom—draws our attention to Europe's continued reliance on the third world, whether in the form of human labor or of "authentic" backdrops for period dramas and social conscience films.

The consistent positioning of the shantytown in *Estrellas* as integral to modernizing processes rather than lagging behind them suggests a very different understanding of modernity than the linear one that

underpins colonial and neocolonial discourses. It is one that resonates instead with Fernando Coronil's Occidentalist perspective. Coronil maintains that modernity does not first originate in Europe, then to be imposed upon the rest of the world; it is *produced by* the relationship between Europe and its colonies, in which the colonies provided much of the wealth and means of expansion that underpinned modernity. In this vein, Coronil criticizes Taussig's *The Devil and Commodity Fetishism in South America* (1980) for constructing Colombian peasants and Bolivian miners as emblems of a precapitalist world, living in a place beyond the reach of commodity fetishism. Although Taussig's intention is to turn anthropology's gaze back toward Western culture and to defamiliarize capitalism, Coronil charges him with ignoring the fact that "these peasants are in fact coauthors of the history of Western capitalism and should be seen as part of the Western world. Just as their slave ancestors contributed to the making of the Occident, these peasants are engaged today in reproducing Western capitalism."[18] *Estrellas,* by contrast, is most attentive to the complex dynamics of such cultural and economic exchanges. The shantytown is not presented as a self-contained, precapitalist society that might guide the film's viewers to an alternative way of life and thereby defamiliarize the workings of capitalism, but one that is linked in multiple ways to the city, nation, and world beyond its borders. It is an already mediatized place whose own ideas of identity and authenticity have been coauthored with discourses emanating from other centers. Rather than simply being positioned at the receiving end of Western modernization, the shantytown in *Estrellas* is shown to have an impact on forms of consumption in the West, fulfilling and creating further demand for manufactured "authenticity" and for (often formulaic) films about poverty and violence in the developing world.

In this way, the film disrupts a linear understanding of modernity as a phenomenon rolled out from the center to the periphery, sustained by the ever-increasing expansion of capitalism that radiates out from the West to farther and farther reaches of the world. It is this conception that Dipesh Chakrabarty finds embodied in historicism, as the assumed existence of a single, homogeneous time, into which all the world's events can be fitted. It was historicism, claims Chakrabarty, "that allowed Marx to say that the 'country that is more developed industrially only shows, to the less developed, the image of its own

future.'"[19] The "less developed" world is thereby consigned to exist anachronistically as a relic of the past, already superseded by the modernized world: overlooked by it, an ugly by-product of it, or a passive receptor of its goods.

This is very much the vision that informs Jameson's historicist critique of postmodernity and capitalism. Postmodernity for Jameson is synonymous with the global triumph of capitalism, which has swept away all precapitalist "enclaves" and ensured "their utter assimilation into capitalism itself."[20] As a result, "no society has ever been so standardized as this one, and . . . the stream of human, social, and historical temporality has never flowed quite so homogeneously."[21] To write, as Jameson does, of a "lag" in economies, and the presence of "archaic" elements as hangovers of a premodern past,[22] is to inscribe world history within a single, unified trajectory. Postmodernity emerges as the future to which all economies are heading, as the postmodern is characterized "as a situation in which the survival, the residue, the holdover, the archaic, has finally been swept away without a trace."[23] If, as Chakrabarty observes, "from Mandel to Jameson, nobody sees 'late capitalism' as a system whose driving engine may be in the third world,"[24] Estrellas affords us a glimpse of the crucial role of the periphery in the construction of modernity and complicates any division of the world's places into archaic or contemporary. The shantytown full of television aerials and its image-savvy inhabitants refuse to be positioned as archaic or uniformly undeveloped for the purposes of historical dramas or colorful social problem films. The "anachronism" of making a science fiction film in an Argentine shantytown confronts us with a continued desire to inscribe the histories of nations within the homogeneous time of colonialism and modernity.

Cóndor Crux and the Polytemporality of Technology

Darwin City, 2068. The world has been plunged into darkness and its citizens corralled into domed urban enclaves. The absolute power wielded by the Gloria Mundi Corporation has obliterated all hopes for a new future; that is, "until one day, someone decided that it was time for some recycling. . . ."

Recycling the past in Cóndor Crux, la leyenda provides a way to reimagine the future when utopian visions have become unthinkable.

Darwin City, the seat of the technocratic regime, is an artificial bubble isolated from the rest of Latin America and severed from the continent's indigenous roots. That the city is a futuristic vision of Buenos Aires is abundantly clear from its position on the map in the opening sequence of the film, and an early shot of the Obelisk from an airborne police patrol unit as it flies down the Avenida 9 de Julio (see Figure 8.2). Produced at the end of the neoliberal 1990s, the film can be read as a warning of the dangers of the acceleration of Buenos Aires and Argentina away from the rest of the continent. The Corporation—reminiscent of the powerful multinationals that gained monopolies over Argentine industries as a result of Menem's unchecked neoliberalism—has acquired control over all media and satellite transmission. Cóndor Crux, the banished hero, must embrace the destiny written for him by the gods before returning to liberate his city from the evil grip of its dictator, and to reintegrate the ultra-modernized Darwin City/Buenos Aires with traditional, rural, and indigenous Latin America. If the city's inhabitants have been subjected for decades to the lie that life anywhere else is impossible, the film attempts to show how much they need the more traditional skills and knowledge of indigenous cultures in order to break free from the triple grip of economic privatization, political repression, and navel-gazing psychoanalysis.

Crux's journey begins in a settlement in the Amazon jungle, which he later discovers to be none other than the mythical El Dorado. Travelling onward with Sonia (the guardian of El Dorado) and Junco (an indigenous boy from the village), Crux finds temporary relief from his pursuers in the sacred city of Machu Picchu, where he undergoes a kind of spiritual fusion with a pre-Hispanic heritage that binds him to his divine destiny. In this scene, Crux is raised from the ground to face his mythical self, painted in the form of a condor on the roof of the Incan temple. From above, we see him superimposed on a circular design etched into the temple floor that evokes one of the calendars widely used in Aztec, Mayan, and Incan civilizations. In the esoteric sequence that follows, pre-Hispanic motifs are briefly tattooed against a vibrant collage (see Figure 8.3). Past, present, and future merge as Incan statues acquire the highly reflective, shiny surfaces of digital modelling, ancient symbols are superimposed on the faces of the film's characters, and CGI animation mimics the shifting patterns of the kaleidoscope, a very early precursor in the generation of moving images.

Figure 8.2. Heading toward the Obelisk along a futuristic Avenida 9 de Julio in *Cóndor Crux, la leyenda* (2000).

The flamboyant virtuosity of this sequence takes us out of the temporal and spatial coordinates of the film's diegesis, and in fact far beyond any accurate understanding of history and geography. The animal forms that emerge from the kaleidoscope are drawn quite indiscriminately from Aztec, Mayan, and Incan symbology. The condor belongs to Andean mythology and was also an important Incan symbol, but the monkey shown is not an Incan one but the Mayan dancing monkey, while the concentric circles and parallel lines of the birds resemble Aztec renderings. This pre-Hispanic potpourri completely ignores historical context in its evocation of pure "pastness." We would seem to be thoroughly immersed in the kind of postmodern intertextuality Jameson decries as "the operator of a new connotation of 'pastness' and pseudohistorical depth, in which the history of aesthetic styles displaces 'real' history."[25]

In an even greater insult to history, of course, the fusion sequence references a past that is patently not Crux's at all, whose white European features—like those of the majority of inhabitants of current-day Buenos Aires—contrast strongly with the much darker skin of his new indigenous companions, with whom he appears to share little racial heritage. The film's blatant ahistoricism is key, however, to its utopian projection of a future integration that overcomes the racial

Figure 8.3. A Mayan dancing monkey is rendered in psychedelic CGI animation in *Cóndor Crux, la leyenda* (2000).

and cultural divisions of the past. The deliberately eclectic fusion sequence has the effect of creating a kind of pan-American symbology in which all the forces of pre-Conquest America are concentrated to bring Buenos Aires back to an encounter with the past, and to the rest of the continent, from which it had severed all ties. The ritual Crux

undergoes binds the human to the divine, the individual to the sweep of history, and the present to its mythical origins. It supplements and intersects the "machine time" or "clock time" of modernity that, as Adam reminds us, "is a time cut loose from the temporality of body, nature and the cosmos, from context-bound being and spiritual existence."[26] Invoking the temporalities of nature and myth is one way in which the film disrupts the homogeneous, linear time of modernity. It combats a vision of Latin America as a collection of separate enclaves, isolated from each other by the different trajectories they have taken in relation to tradition and modernization. It also performs an encounter between two different temporalities, between historical time and mythical time, in such a way that they are shown to interpenetrate, and the latter is not dismissed as more archaic than the other.

Like many science fiction films, *Cóndor Crux* often stages the victory of the ancient or apparently obsolete over the highly advanced and modernized. The rebels' call to revolution is made with the aid of an old, disused satellite. When Crux and his father discover that the transmission of the vital code to unlock it has failed and all seems lost, the system is activated by the simple sequence played by the Indian boy on an ocarina. The eight moving discs on the control panel throb and gyrate to the melody played on the little eight-holed instrument, just as—metaphorically—the present and future of Darwin City now dance to the tune of the past, its redemption written in ancient prophecy. For his triumphant flight back to liberate Darwin City, Crux has no option but to borrow an eighty-year-old Antonov, a heavy-duty Soviet transport plane first flown in the 1980s.[27] The plane serves him well until it runs out of fuel; he then descends gloriously into the dome, dodging Phizar's missiles, precariously perched on an old hang glider he finds in the plane. The decisive blow that kills the evil technocrat is struck with Sonia's rudimentary jungle spear.

But *Cóndor Crux* does not—in the Romantic vein of much science fiction—simply extol the ancient and the natural in place of the technologically advanced: it reminds us of the extent to which new technology draws on the old without superseding it, in a manner that complicates any linear model of development. The polytemporality of technology is brought to the fore in the many machines in the film that are shown to mimic the inventions of nature, such as the fabric of Crux's hang glider, stretched into the form of a condor's wings, or

Figure 8.4. The panels of a futuristic spacecraft blend with Incan stonework in *Cóndor Crux, la leyenda* (2000).

even the Antonov, code-named "Condor" by NATO.[28] It is also strikingly demonstrated in a visual analogy that links Darwin City's most advanced aeronautical design with Incan engineering. As Crux's aircraft lands neatly on a stone terrace at Machu Picchu, the pattern of its grey fuselage panels exactly mimics the precision-cut stonework of the Incas, even to the point of replicating the darker hues around the edging that show the effects of environmental pollution over time (see Figure 8.4). We notice for the first time that the aircraft's landing struts look suspiciously like the legs and feet of an animal rendered in stone. What had appeared futuristic in its design just a few frames ago now seems to be integral to the architecture of the past.

This scene does not enact a return to the past, but forges a surprising point of convergence between past and present. It is precisely in relation to the simultaneous presence of the archaic and the advanced in our use of technology that Bruno Latour encourages us to consider time as a spiral rather than a line. According to this model, "the past is not surpassed but revisited, repeated, surrounded, protected, recombined, reinterpreted and reshuffled," and elements that appear far from each other along the line traced by the spiral may turn out to be very close when the loops are compared.[29] This understanding of temporality complicates the use of categories such as "archaic" or "advanced,"

as "every cohort of contemporary elements may bring together elements from all times." Michel Serres, arguing a similar point, uses the example of a car as "a disparate aggregate of scientific and technical solutions dating from different periods."[30]

In Jameson's account of the homogenizing effects of postmodernity, he is careful to state that these are at present largely to be observed in the West.[31] The remnants of traditional or alternative forms of society in other parts of the world are fast disappearing, however, and will soon—in his view—be erased in the inexorable march of capitalism and modernization toward the very limits of expansion. Although *Cóndor Crux* repeats the colonial desire to find what the self lacks in other, more "primitive" cultures, it challenges the historicist underpinning of colonial discourse by imagining an alternative in which the ethnographic other is not a relic of the past but fully coeval with the present. In line with Chakrabarty, Bliss Cua Lim describes the processes by which supernatural beliefs or other "premodern" cultural differences are *"temporally managed"*—in discourses ranging from sixteenth-century colonial missionary accounts to ethnographic cinema—"by being positioned as already known and surmounted precursors, not something disturbing that persists alongside and within the modern but as relics of superseded chronological antecedents."[32] By contrast, Sonia's spiritual beliefs in *Cóndor Crux* may be "traditional" in the sense that they predate modernity, but nowhere in the film are they positioned as outmoded. Pre-Hispanic gods are not relegated to the past but play a vital cultural and political role in the present.

It is entirely fitting that polytemporality should be one of the major themes of the first 3D animated film to be made in Argentina, following hard on the heels of Pixar's *Toy Story* (1995), the world's first feature-length 3D animation. In our day, 3D animation is arguably the mode of film production that combines the most archaic forms of art and technology with the most advanced. The complex algorithms that underpin the computerized creation of 3D effects typically follow earlier stages in which characters are sketched by hand or molded out of clay. *Cóndor Crux* made extensive use of traditional storyboards and then frame-by-frame line drawings, using pencil and paper, to produce a 2D animation. 3D effects were added later, in order to give the appearance of live action rather than computer-generated imagery. Significantly, this is done not only by reconstructing the shading

and shadows that make shapes and textures more realistic, but also by evoking the older technology of analog filmmaking. Motion blur is introduced to mimic a camera panning at speed, backgrounds blurred to imitate a camera's use of shallow focus, and when Crux's aircraft judders out of control, images are shaken rapidly on a vertical axis as if the camera cannot be held steady. What would it mean to call this film, or any film, "contemporary," if "superseded" technologies—analog filmmaking and line drawings—are essential to the film's most advanced techniques? Firmly inscribed in the film's production process and its aesthetic design is the same polytemporality emphasized in its narrative, and which Serres and Latour understand to be characteristic of all human relations with technology.

At the end of the film, a new Darwin City is built that replaces the perpetual night, artificiality, and geometric architecture of the old one with sunlight, greenery, and voluptuous curves. The narrator whose voice we heard at the beginning of the film is revealed as the indigenous boy Junco, now a wizened elder, recounting the history of Darwin to a group of young children. In a final gesture of regional integration—and utter disrespect for the laws of natural habitats—an Andean condor flies majestically across the cityscape as it recedes from our view. *Cóndor Crux*'s crimes against history are just as flagrant, but the film's intent is precisely to question any linear model of temporality that assumes that the past is superseded by the present and the future.

Conclusion: Topological Time and the Critique of Modernity

Latour attributes this linear time of supersession to an invention of modernity. As he states, "The moderns have a peculiar propensity for understanding time that passes as if it were really abolishing the past behind it," considering themselves divided from the Middle Ages by "epistemic ruptures so radical that nothing of that past survives in them."[33] This produces a sense of time "as an irreversible arrow," which is also the time of capitalization and progress.[34] Against this understanding of time, *Estrellas* and *Cóndor Crux*—in common with many Argentine science fiction films—encourage us to view technology and discourses as "polychronic," to use Serres's term, and every historical era as "likewise multitemporal, simultaneously drawing from the obsolete, the contemporary, and the futuristic."[35]

The reflexive and ludic exploration in *Estrellas* of the conventions of the science fiction genre challenge linear models of development by positioning the shantytown as a coauthor of Western modernity rather than simply a place overlooked by modernization, an ugly by-product of it, or a passive receptor of its goods. By performing a convergence between historical time and mythical time, *Cóndor Crux* demonstrates the extent to which the evolution of human culture and technology is more topological than chronological, looping back to incorporate the apparently antiquated and folding in on itself to bring past and future into sudden proximity. If this perspective appears ahistorical, then—as Serres suggests—our theory of history may be based on an "inadequate and naïve" understanding of time.[36] Both *Estrellas* and *Cóndor Crux* dramatize a conflict or an exchange between different ways of organizing time, each of which is fully capable of producing meaning. By defamiliarizing, deconstructing, and reconfiguring stories of capitalist development and technological advance, these films expose the illusion of inevitability in which such trajectories are shrouded. They respond to Benjamin's call for a critique of "homogeneous, empty time" as the crucial basis for a critique of the notion of progress, allowing us to imagine different ways in which the history of modernity and capitalism may be told, or alternative stories that may yet unfold.

NOTES

1. The script for *Invasión* was written by Borges and Bioy Casares, and *Moebius* also acknowledges an important debt by naming a nonexistent subway station after Borges.

2. See Joanna Page, "Retrofuturism and Reflexivity in Argentine Science Fiction Film: The Construction of Cinematic Time," *Arizona Journal of Hispanic Cultural Studies* 16 (2012): 227–44.

3. See Dipesh Chakrabarty, *Provincializing Europe: Postcolonial Thought and Historical Difference* (Princeton, N.J.: Princeton University Press, 2008); Bliss Cua Lim, *Translating Time: Cinema, the Fantastic, and Temporal Critique* (Durham, N.C., and London: Duke University Press, 2009).

4. Fredric Jameson, *Postmodernism, or, the Cultural Logic of Late Capitalism* (London: Verso, 1991), 284.

5. Carl Howard Freedman, *Critical Theory and Science Fiction* (Middletown, Conn.: Wesleyan University Press, 2000).

6. Jameson, *Postmodernism, or, the Cultural Logic of Late Capitalism*, 284.

7. Fredric Jameson, *Archaeologies of the Future: The Desire Called Utopia and Other Science Fictions* (London: Verso, 2005), 61.

8. Ibid., 345.

9. Ibid., xiii.

10. Ibid., 288–89.

11. Jameson, *Postmodernism, or, the Cultural Logic of Late Capitalism,* 284.

12. Ibid., 286.

13. Walter Benjamin, "Theses on the Philosophy of History," in *Illuminations,* ed. Hannah Arendt, trans. Harry Zorn (London: Pimlico, 1999), 252.

14. Freedman, *Critical Theory and Science Fiction,* 16–23.

15. Ibid., 53.

16. Barbara Adam, *Time* (Cambridge: Polity, 2004), 136.

17. Clara Kriger, "*Estrellas,*" *Miradas desinhibidas: El nuevo documental iberoamericano, 2000–2008,* ed. Paulo Antonio Paranaguá (Madrid: Sociedad Estatal de Conmemoraciones Estatales, 2009), 48.

18. Fernando Coronil, "Beyond Occidentalism: Toward Nonimperial Geohistorical Categories," *Cultural Anthropology* 11, no. 1 (February 1996): 69–70.

19. Chakrabarty, *Provincializing Europe,* 7; see Karl Marx, "Preface to the First Edition," *Capital,* trans. Ben Fowkes (London: Penguin, 1990), 91.

20. Jameson, *The Seeds of Time* (New York: Columbia University Press, 2004), 27.

21. Ibid., 17.

22. Jameson, *Postmodernism, or, the Cultural Logic of Late Capitalism,* 307.

23. Ibid., 309–10.

24. Chakrabarty, *Provincializing Europe,* 7.

25. Jameson, *Postmodernism, or, the Cultural Logic of Late Capitalism,* 20.

26. Adam, *Time,* 115.

27. The historical detail is fully accurate in this case, even down to the plaque on the dashboard that gives the place of construction as Kiev.

28. This detail is not explicitly mentioned in the film but the in-joke would probably have been picked up by those viewers versed in military history.

29. Bruno Latour, *We Have Never Been Modern* (Cambridge, Mass.: Harvard University Press, 1993), 75.

30. Michel Serres and Bruno Latour, *Conversations on Science, Culture, and Time,* trans. Roxanne Lapidus (Ann Arbor: University of Michigan Press, 1995), 45.

31. Jameson, *Postmodernism, or, the Cultural Logic of Late Capitalism,* 309.

32. Lim, *Translating Time,* 16.

33. Latour, *We Have Never Been Modern,* 68.

34. Ibid., 69.

35. Serres and Latour, *Conversations on Science, Culture, and Time,* 60.

36. Ibid., 59.

9 Virtual Immigrants

Transfigured Bodies and Transnational Spaces
in Science Fiction Cinema

EVERETT HAMNER

In the director's commentary for his feature-length debut, *Sleep Dealer* (2008), Alex Rivera interprets the first film he ever saw, *Star Wars* (George Lucas, 1977), as an immigration narrative. As he points out, Luke Skywalker is a peasant farmer living in a desert landscape whose home is destroyed by an imperial army. This leaves him little choice but to head toward the realm of his oppressors, not unlike many immigrants today. Although sharing in the mass love affair with this space opera, Rivera is struck that Luke is perceived so heroically.

> When he flees his home and tries to get past the border guards, essentially we're all rooting for him. We want him to break the law, we want him to get through, to get to the other side. And yet in our society and in our political culture, there is a massive movement and cultural energy toward sealing borders, toward stopping people's movements.

That incongruity inspired a film echoing some elements of *Star Wars,* but also exploring the consequences when contemporary border-crossers triumph less fully than young Jedi knights. Indeed, *Sleep Dealer* joins a growing body of twenty-first-century science fictional immigration narratives that are rethinking assumptions about geopolitical boundaries and transnational spaces. With gargantuan and miniscule budgets alike, such films are emerging from and being set in increasingly diverse locations, especially in the Global South. Often spawning controversy, they challenge depictions of stable divides between the haves and have-nots. Even as the physical barriers between nations and socioeconomic groups grow more visually imposing,

those represented on-screen—even if initially impressive—are more and more likely to be exposed as superficial, porous, and unsustainable.

Strikingly, this penetration and evasion of national boundaries increasingly appears in SF cinema alongside imagined fusions of human bodies with alien and cybernetic biotechnologies. The boundaries erected between people groups are being traced and extended to the cellular and digital levels, so that ostensible differences between self and other become tangible simultaneously at societal and microscopic scales. Returning to *Star Wars,* consider the more recent prequel, *The Phantom Menace* (George Lucas, 1999), in which another peasant boy (Luke's future father) is uprooted from his desert home. In the original film (1977's *A New Hope*), we watched an elderly Obi-Wan Kenobi recruit his protégé on the basis of intuition and personal history, but two decades of film history later, Obi-Wan's younger self and a Jedi partner must first analyze the "midi-chlorians" in Anakin Skywalker's bloodstream. For Lucas's more recent installments, biometrics allows precise measurements of leadership, courage, and awareness; it is only after such authentication that the Jedi can offer to serve as Anakin's escorts (coyotes?) through enemy space. This practice of utilizing microbiological testing to confirm personal characteristics and justify opportunities to reach beyond traditional geopolitical and socioeconomic limits has grown increasingly common in the new millennium. But SF cinema is also becoming bolder in its Foucauldian critiques of these assessments: the *Star Wars* universe may affirm their ease and reliability, but other films like *Gattaca* (Andrew Niccol, 1997) warn that they could exacerbate the new caste systems emerging under global capitalism.

In probing this entanglement of biotechnology and immigration, this chapter begins with brief looks at Ridley Scott's *Blade Runner* (1982) and two of its early twenty-first-century descendants, *Code 46* (Michael Winterbottom, 2003) and *District 9* (Neill Blomkamp, 2009). Using *Monsters* (Gareth Edwards, 2010) as an additional entry point, the chapter then concentrates upon *Sleep Dealer*'s unique story of cyborgification in the U.S.–Mexico borderlands. Twenty-first-century SF films are more regularly taking advantage of the genre's capacity to interrogate the physiological methods by which nation-states and various neoliberal entities maintain absolutist geographical boundaries, but Rivera's work in particular exposes the corporate ideology

Figure 9.1. Alex Rivera's *Sleep Dealer* (2008) rethinks portrayals of the U.S.–Mexico borderlands that feature only green fields to the north and dusty shantytowns to the south.

by which otherwise successful immigrants may be denied individual and communal agency. Yet with all of its dystopian imagery and its condemnation of abuses, *Sleep Dealer* ends up far from hopeless: it also shows how, upon recognizing their status as puppets, contemporary border crossers sometimes find new opportunities to turn techno-capitalism against itself, utilizing virtual networks to reconceive transnational spaces and to uncover the material conditions that foreground some narratives and suppress others.

Although aiming to uncover new dimensions of science fiction cinema, the methodology employed by this chapter is hardly unprecedented. My working hypothesis is that SF is uniquely well suited as a mode of thinking to concurrently acknowledge painful historical injustices (often via allegory) and to conceive alternative futures wherein human beings make different choices. There are many worthy definitions of the genre along these lines, but I emphasize its capacity to render tangible techno-cultural forces that are often so ubiquitous as to go unrecognized in our daily lives. As Istvan Csicsery-Ronay Jr. explains, "[The technological empire] is so pervasive a force of social gravitation that it feels like nature. . . . Sf must be counted as the primary

institution of art that makes this new regime habitable by the imagination."[1] Of course we must also remember that this capacity did not first emerge in the twenty-first century. Whenever a genre mutates, some antecedents of its current traits usually can be found in earlier textual expressions. One can look at least as far back as *Metropolis* (Fritz Lang, 1927) to find SF cinema linking technologically modified bodies with shifts in race, class, and politics. What is relatively new in the genre, though, is the visual predominance of immigrants and borders within stories about our increasingly digitalizable, microscopically legible selves. Filmmakers are now thematizing unsanctioned immigration and other crossings of political boundaries as a rebellion against techno-scientific imperialism, so that early twenty-first-century SF film explicitly connects national identity and emerging forms of biotechnology in ways only incipient in earlier works.

To better appreciate both contemporary SF's inheritance and its innovations, take Scott's film noir classic, *Blade Runner,* and Winterbottom's unjustly neglected tale of unbridled genetic testing, *Code 46,* which appeared two decades later. Like *Star Wars,* Scott's masterpiece is rarely described as an immigration narrative, yet the freedom (or lack thereof) to move across political boundaries—even if located between planets rather than nations—is central to its premise. When organic android Roy Batty dies a preprogrammed death in the climactic scene, his defiant last words culminate an escape from off-world colonial enslavement; he succumbs only after confronting those who would deny his personhood and convincing the bounty hunter played by Harrison Ford that his "artificial" kind is worthy of existence. Ultimately, Rick Deckard (Ford) renounces his role as a type of Immigration and Naturalization Services (INS) agent, departing with a female replicant into an undefined future and arguably recognizing his own "illegal" status. If Jonathan Auerbach observes that film noir has long been a preeminent genre for filmic expositions upon national loyalty, even claiming that "there could be no film noir without the FBI,"[2] *Blade Runner* witnesses SF cinema's similarly enduring interest in the surveillance practices of groups like the INS, Homeland Security, and transnational corporations.

As the core narrative of Scott's dark classic is recycled by the brighter *Code 46,* both the repetitions and the modifications testify to the growing interplay of biotechnology and immigration issues.

Following Katherine Hayles's logic wherein we are already posthuman, Winterbottom envisions an Earth invaded not by replicants but by biotech security entities with names like "The Sphinx." In many ways, this is an expansion of the power housed in the similarly Egyptian pyramids of *Blade Runner*'s Tyrell Corporation: instead of producing a limited number of cyborgs who tug upon the definitions of human and nonhuman, the bio-surveillance industry of *Code 46* reengineers and monitors everyone. Winterbottom's protagonist must find the source of a Shanghai production center's problem with "cover" (or visa) stealing, but he follows Deckard's lead in switching sides, abandoning his blade-running responsibilities—as well as those as husband and father—in favor of an ill-fated romance. The main difference, and a rather bleak one, is that he clearly fails to escape, crashing his getaway car and returning to his family (perhaps even his role as corporate tool) after a seemingly routine memory wipe.

At the same time, *Code 46* foregrounds the border fence and the geographic expanse between privilege and oppression in a manner absent from Scott's film. Shifting from a noir Los Angeles into a washed-out, glaring cityscape in which information about personal identity is all too readily available (William uses one of Maria's hairs to acquire a genome scan in mere hours), the film's future includes an impressive wall between its absolutely separated "first" and "third" worlds, with miles of barren desert creating a permanent divide. This is not the Flat Earth of Thomas Friedman, but a world whose obsession with correct *papeles* (papers) and absolute compartmentalization of the rich and poor is greater than ever (a divide stretched even further by 2013's *Elysium*, in which upper-crust society literally removes itself to Earth's orbit). Yet as Yosefa Loshitzky recognizes, "*Code 46*'s message is that it is not the future which is so frightening, but the present."[3] We are not really looking at a future Shanghai, but a collage of shots taken in contemporary Shanghai, Dubai, Hong Kong, and elsewhere, as if to remind us that specific locations and cultures matter little under global capitalism. Whereas *Blade Runner* famously deleted the green wilderness of its theatrical version's "happy ending" in the director's cut and subsequent editions—thus removing any geographical distance the film originally envisioned between life within and outside social protections—*Code 46* uses its aerial shots and long takes to emphasize the physical gap between developed sophistication and under-

developed invisibility. As Maria concludes in overdubbed narration that we learn has been offered throughout the film from a state of exile, "They don't care what you think if you're afuera [outside]. Why bother? To them it's as though we don't exist." Appropriately, even as the film portrays global elites' assimilation of select non-English terms into a single dialect, most former speakers of "foreign" languages are rendered inaudible.

Some critics have been frustrated by this muting of the disadvantaged Other, observing with Kathy-Ann Tan that "*Code 46* ultimately fails to offer a satisfactory alternative realm from which the subaltern can speak."[4] However, this is not necessarily the goal of Winterbottom's film. The dystopian realms created by SF cinema need not be understood mimetically. Rather, I would encourage consideration of *Code 46*'s massive border checkpoint and the surrounding desert emptiness as a lament for the many Marias forced into idealized but abandoned Madonna roles by seemingly unquestionable financial measurements of individual and social value. Still, Tan and others are right that this film does not yet envision the border as a dynamic space; for the poor, its checkpoints provide daily opportunities for hawking wares to travelers, but not places where anyone can live. That sense of the physical landscape around geopolitical demarcations as a realm in which individuals and communities actually play and work, are born and die, must be found elsewhere.

It might be objected that *District 9* features an urban ghetto rather than a true international border, but this film is just as concerned as *Code 46* with the inextricability of immigration and biopolitical manipulation. Whatever one may think of Blomkamp's grotesque humor, the film initially treats the division between haves and have-nots just as directly and starkly as does Winterbottom's film. In this case, the humans have all the guns and the alien "prawns" are imprisoned in a Johannesburg shantytown with massive walls; the real difference, though, is that ultimately these barriers prove surprisingly porous. When the new camp supervisor, a blithely insensitive employee of "Multi-National United (MNU)," accidentally sprays himself with an alien oil-like substance and begins turning into a human–prawn hybrid, he is able to escape MNU's medical personnel and vast paramilitary force long enough to sneak back into the sequestered zone, the one place in the sprawling city where he has a chance of hiding.

As his genetic mutation from human to partially alien DNA foments his transformation from tormentor to alien sympathizer, he gradually recognizes that the neoliberal corporation he has blithely served is willfully ignoring the personhood of those it designates illegal.

Many reviews and essays have noted the problematic nature of the film's racial politics, not least in its treatment of the Nigerian immigrant. John G. Russell compares *District 9* to *Avatar* (James Cameron, 2009) in its reliance on "a new kind of racial performativity in which actors of color assume a guise more palatable to whites than their true form and provide white filmmakers an opportunity to play with issues of race in a more 'entertaining' and less controversial manner while providing themselves plausible deniability should it prove otherwise."[5] That is, twenty-first-century SF film is finding a way to have its aliens and eat them too, employing irony and satire to such a degree that it gets away with ridiculing the ethnic Other because no one knows when to take it seriously. John Reider's view is that therefore "even *District 9*'s critical impulses have to become its parasites,"[6] while Andrea Hairston concludes the film is "caught in the colonial impulse it seeks to disrupt."[7] Perhaps the most forgiving approach is Eric D. Smith's insistence that

> holding together in *impossible* accord the incommensurable realities of slum city and gated suburb, human and alien, black and white, salaried professional and abject refugee under the monstrous sign of global class struggle, *District 9* outlines the emergent political subjectivity of the *real* state of exception, a solidarity without essence and without borders in which we are all refugees, in which we are all monsters.[8]

But does the film actually achieve this unity "without borders," or does it simply render its boundaries more permeable than SF traditionally does, trusting that extreme differences in physical appearance will maintain the necessary categorical differences between species (and by analogy, races)?

This question about the visibility of difference invites attention to a less-commented-upon aspect of *District 9*, the exigencies of the production location itself. We learn from the director's commentary that the main shooting site (the shantytown inhabited by the prawns) was

an impoverished "suburb" of Johannesburg, one whose residents were permanently relocated to a new neighborhood with brick structures, as Blomkamp somewhat proudly explains. Throughout this alternative soundtrack, in fact, he ruminates about living in one of the city's richer suburbs during shooting, each day descending into the muck of impoverished South Africans' existence in order to film. One assistant producer is lauded for her ability to turn up as many rotting animal carcasses as needed at a moment's notice, and Blomkamp repeatedly notes how revolting he found the shantytown. By contrast, he ruminates, "You have these gated communities that have all the money in the world and electric fences and biometric fingerprinting devices to open the gate. And outside of these gated communities you have poverty that doesn't exist anywhere really except Africa and parts of India." On one hand Blomkamp cannot emphasize starkly enough the split he observes—"It's the elite get richer and richer and the masses get poorer and poorer until finally you end up in a place where you have a city or a country that's got five percent of the population controlling all of the wealth and everybody else lives in abject poverty"—but on the other, his film portrays the slim hope that the most oblivious and exploitative of bureaucratic functionaries could become infected with genuine empathy for those he has afflicted.

Indeed this plot depends on conversion by epidemic, a motif also evident in the public health fears explored by Emily Maguire's chapter on zombies in this volume. The division between "us" and "them" is not just geopolitically but also biologically determined, and thus it is subject to sudden and dramatic shifts when one is bitten (or in *District 9*'s case, sprayed) by a new and different source of contagion. In fact, much the same process is at work on the other side of the Atlantic in *Monsters* (2009). Relying upon the lowest budget of the films I examine here, this B-movie romantic comedy/horror flick appears as if it were rushed through production in hopes of capitalizing upon *District 9*'s box office draw. Presupposing that NASA has discovered other life within our solar system, Gareth Edwards's film explains that a probe bringing back samples broke up during reentry over Mexico, thus relocating the contamination crisis. Unfortunately, because the spaceship scattered organic material over the northern half of the country, the entire region has to be sequestered as an "infected zone." With the U.S. and Mexican militaries having spent years attempting to contain

the squid-like aliens spawned from this disaster—the allegory does not attempt subtlety—the main characters are a media mogul's adventurous daughter and a photographer in southern Mexico, a peon the boss entrusts with escorting his "little girl" to a ferry ride home. Of course the irresponsible photographer gets drunk, their passports are stolen, and they have to take the tougher route via land, traversing alien-infested paths and rivers with guidance from former coyotes. When they miraculously reach the border, our hero and heroine find a monumental but broken wall, one they contemplate at length before passing. Soon after being collected at an abandoned gas station, the travelers and their military escorts are assaulted by "the creatures." Unsurprisingly, neither the immigrant stand-ins nor the aliens end well; as one realizes upon reviewing the story-concluding but film-opening title sequence, the woman is apparently killed, while the alien creatures are last seen fighting soldiers.

As the main characters reflect upon first seeing the border wall, "It's different looking at America from the outside," which may be understood as the film's central insight. Undoubtedly, whether imagined as literal aliens or human beings treated as aliens, would-be immigrants have too rarely felt welcome at the U.S.'s southern border, and even a hastily constructed thriller like *Monsters* can effectively interrogate that history. In the process, though, it also has something to tell us about the relationship between U.S. and Latin American filmmaking. At first, Edwards's disaster tale might seem to illustrate the kind of tripartite distinction between Hollywood, Mexican, and Latino filmmaking offered by Camilla Fojas. She argues that

> Mexican border films are strongly nationalist, discouraging northerly migration and debunking the myth of the "American Dream." They thematize the entanglements of cultural contact and the experience of displacement and economic exile, whereas Hollywood border films tend to focus on the heroic mission of the Texas Rangers, border guards, DEA agents, or other police personnel.[9]

However, SF films outside of the Hollywood studio system, like *Monsters*, sometimes complicate this binary paradigm, neither rejecting the promised land outright nor merely celebrating those who defend

it. Instead, much twenty-first-century SF better fits the third category Fojas identifies, the "Latino border films" that "challenge the presumptions of U.S. nationalism and subsequent cultural attitudes about immigrants and immigration and often critically reconstruct their Hollywood kin,"[10] but still find some appeal in life north of the Río Bravo. As we will see, *Sleep Dealer* particularly epitomizes this third category insofar as its critique aims at north *and* south, challenging non-Latino U.S. audiences as well as Latinos and Latin Americans. In a sense, this is a lower-budget *District 9* that has something to say to those who identify with the prawns as well as those who find themselves uncomfortably aligned with the MNU.

Some of *Sleep Dealer*'s innovations as transnational SF cinema have already been outlined by Lysa Rivera. She urges greater attention to "an under-examined history of Chicano/a cultural practice that employs science-fictional metaphors to render experiences of marginalization visible and to imagine alternative scenarios that are at once critically informed and imaginative."[11] Seeing NAFTA and the neoliberalism it enabled as a galvanizing force for increasingly transnational science fiction, she argues that "post-NAFTA borderlands science fiction . . . is the *formal* articulation of a specific historical narrative: namely the history of US/Mexico capitalist labor relations in the region and militant fights for an alternative framework."[12] In this sense, SF film functions not only as post-factual allegory but as active intervention, fleshing out borderlands by insisting upon their dynamic possibilities as much as their static barriers. Of course, as she notes, the "future" of our stories can become "not so much a site of progress and humanistic harmony as a return to the colonial past,"[13] so that "cyborg labor" serves as "nothing more than a politically-charged symbol for real life labor practices under late capitalism."[14] Therefore in her reading, *Sleep Dealer* exposes the irony by which biotechnology may lead not to Latin American liberation, but more thorough slavery.

This is also the main argument offered by Luis Martín-Cabrera, who demonstrates that the film shows "how technology and cognitive labor may actually reproduce forms of colonial exploitation and oppression rather than leading to automatic liberation from the shackles of physical labor."[15] As with Rivera's interpretation, I think this is undeniable. However, my assessment of the film's transnational and biotechnological vision is more mixed. *Sleep Dealer* certainly sounds

Figure 9.2. Cyber-capitalist marionettes control Memo in *Sleep Dealer*, but the film also imagines a subaltern repurposing of such biotechnology.

a strongly cautionary note about bioengineered abuses; there is little doubt that the film laments Memo's treatment at the hands (wires?) of Cybertek, the virtual reality sweatshop where he finds employment upon arriving in Tijuana. And Rivera's film could hardly be more biting in attacking a *cybracero* future in which the United States extracts all of its southern neighbors' labor while caring for none of the laborers. But even as it powerfully laments the exploitation of Latin Americans, *Sleep Dealer* also suggests the potential for some forms of technology to serve a progressive politics. The apparent key is that immigrants gain relative mastery over biotechnology rather than merely becoming its organic slaves, a self-reproducing source of battery power like that envisioned by *The Matrix* (Andy Wachowski and Lana Wachowski, 1999) and its sequels. Ultimately, this is a dream in which immigrants, legal and otherwise, eventually receive opportunities for genuine inclusion and full dignity, so that the U.S.–Mexican borderlands become dynamic spaces of cultural interchange free from the aerial supervision visible in both *District 9* and *Sleep Dealer*. Rivera's film suggests that only when immigrants can strengthen ties to their original hometowns, moving regularly and legally across national borders, will techno-capitalism's tendency to divide humanity from itself

be significantly thwarted. It is especially insistent that the cultivation of transnational spaces—certainly including land adjacent to geopolitical border markers, but also extending much farther north and south—will be critical elements of any such reality. In this vision, emerging cybernetic and biotechnology could enable not just abuses but also intercultural cooperation.

At its most basic level, *Sleep Dealer*'s plot turns on the use of cyberspace to outsource labor without importing laborers. The young adult at the film's center, Memo lives in a southern Mexico that Rivera originally located decades into the future, but during production began recognizing as closer to the present. His corn-and-bean-farming father exhausts himself hauling river water monopolized by a multinational corporation with a dam, pipelines, and high-security remote cameras, and Memo looks to cyberspace as an escape route. Inadvertently, however, his hacking draws the attention of the corporation's U.S.-based military force, which sends a drone to destroy his home and kill his "bad guy" father, a purported "aqua-terrorist," while broadcasting the mission live on its own reality TV show. This tragedy sends Memo north toward the U.S. border, where he acquires the implanted nodes with which to jack his nervous system into *el otro sistema*, the global economy. Working twelve-hour shifts as a cybracero, he controls—and is often controlled by—a robot welder perched dozens of stories above San Diego, though his body remains in a sleeplike trance in Tijuana. The film's sarcastic description of this arrangement, delivered by Memo's employer, is that "this is the American Dream. We give the United States what they've always wanted: all the work, without the workers. . . . Your future starts today." As Memo slowly realizes, the harsher reality is that "my energy was being drained, sent far away. What happened to the river was happening to me."

The film's protest of such virtual and material exploitation is unrelenting. But there is also another science fictional novum here, the more ethically complex possibility of using nodes to upload and sell one's memories, and this is where the film's commitment to individual agency above technological formula emerges. *Sleep Dealer* not only challenges virtual power mongering, but also acknowledges the liberating potential of cybertechnology, as we see its main characters genuinely benefiting from their opportunities to participate in the larger global economy. As Luz's character especially demonstrates,

everything depends on the extent to which the voluntary cyborg truly controls the biotechnology to which she is married. A young woman Memo meets on the bus north, Luz relies on a new form of immersive, hyperpersonalized journalism to pay her student loans, the creditors of which threaten to seize her possessions. In short, she sells a limited access to her own subjective experience, at least in visual and aural terms. What she saw is what her audience sees, along with her over-dubbed narration of the experience, and undoubtedly this technology is using her as much as she is using it. Upon meeting Memo, she simply uses him for his story, drawing out the guilt he feels for his father's murder. However, as their relationship turns romantic, Luz has second thoughts about exploiting her unknowing source and grows frustrated with the limitations placed on her narrative. When we first watch Luz upload her memories, the software's biofeedback system refuses her the license she desires in telling the story. "Your DNA is your password," she later tells Memo, but this biological contact is also the system's means of constraining her authorial voice. The program refuses all attempts at fictional innovation or even abstract reflections upon meaning, demanding that she break the story into its most basic elements, as if there were a completely neutral and objective way it might be rendered. Gradually this effort separates the couple; as the blocking and mirrors in a bar scene suggest, Memo is caught between the actual Luz, who is falling for him, and the memory-journalist who remains the tool of techno-capitalism. When a friend tells Luz, "You can't hide anything," she notes, "Maybe that's the problem." The more powerful the technology, the more quickly and fully the tool users can become the tools.

Still, the film holds out hope that this dynamic can be reversed. Eventually, we learn that the individual buying Memo's online story installments was the drone pilot who, following orders, killed Memo's father. A second-generation Latino, Rudy is now dealing with his own guilt; he has betrayed his parents' homeland, but they share and affirm his treachery. It is thus an especially momentous decision when he travels across the border and confesses to the horrified Memo, who eventually decides to help Rudy perform some measure of penance. Rudy again pilots a drone into Mexican airspace, but this time without permission and in order to destroy the dam that had stolen Memo's livelihood, the water on which his family depended. Most crucially,

Rudy's decision defies his parents' readiness to shoot first and ask questions later. His father had been a soldier too—perhaps even en route to U.S. citizenship, as many Latino immigrants hope today—and when Rudy asked if he ever doubted his actions, he only repeats propaganda about how many lives Rudy's work has probably saved. Rivera's film thus illuminates the lasting bondage of empire, even for those who have seemingly escaped its oppression through assimilation. The first generation Latinos in *Sleep Dealer* are unable to face the steep costs they paid for success in a new land, and it is left to their offspring to decide whether those sacrifices remain acceptable.

Even in observing Rudy's abandonment of his parents' American dream and return to Mexico, though, it is equally worth considering how *Sleep Dealer* unites Latin Americans and Latinos in turning imperial technology against its invisible marionettes. Rudy's departure from his parents' values is one kind of conflict between first- and second-generation immigrants, but the confrontation between Memo and Rudy yields a different sort of trust. Memo is a would-be first-generation (virtual) immigrant who simply wants to help his family survive; meanwhile, Rudy is a second-generation Latino so inured to U.S. culture that he had not crossed the border in twelve years. When Rudy eventually uses the same technology with which his reality TV show described him as rooting out terrorists—as if his drone were flying over Afghanistan rather than Mexico—to reverse his corporation's theft of Memo's livelihood, *Sleep Dealer* demonstrates how solutions to border issues lie as much in justice for those south of the border as in new opportunities to the north. If *Monsters* recognized that U.S. imperialism looks quite different from outside its walls, Rivera indicates that remaining inside the walls can be equally imprisoning. As Martín-Cabrera observes, the film "proposes a much-needed transnational alliance between Chican@s and Mexicans in order to resist neocolonial capitalist exploitation and military control on both sides of the border."[16]

This vision of multigenerational, transnational cooperation comes into focus when one views *Sleep Dealer* beside Rivera's 2003 documentary, *The Sixth Section*. The earlier film follows predominately illegal immigrants from Boquerón, Mexico, in their move to Newburgh, New York, and then their integration of these cities into a single economic and cultural terrain. The "hometown association" in New York joins

thousands of similarly loose, nearly invisible organizations in supporting their governmentally abandoned Latin American homelands. Yet Rivera's film resists easy answers: these border-hopping immigrants finance a new baseball stadium in Boquerón with $10 and $20 contributions that total $50,000US, then struggle to hire players because everyone young enough has migrated north. Similarly, they purchase an ambulance in New York and transport it 3,000 miles south only to lack an available driver. They are more successful in funding band instruments, a kitchen for their school's kindergarten, and a basketball court. But what they dream of most is a project their government abandoned, the repair of a massive underground well that would allow farmers at home to grow their crops again. One immigrant says, "If we had enough water, I would go back immediately." The connection to *Sleep Dealer*'s climax could not be tighter: in documentary and SF film alike, Rivera's work emphasizes the potential of multiple generations of immigrants to work across national boundaries and protect access to their homeland's natural resources.

For as *Sleep Dealer* joins several of its predecessors in insisting, borders are not the just-so stories they pretend. We see both sides of the fence repeatedly—even its endpoint some yards into the Pacific, where it extends in order to keep out terrorist surfers, as Luz jokes. The film closes with images of Memo trudging up a hill with water, just as he did near Oaxaca, but this time to nourish a small garden he has planted directly beside the fence. On the Mexican side, there is a shantytown, and on the U.S. side, green fields, but Memo's plot extends the vegetation across the border. This is emblematic of Rivera's overall aesthetic and the increasing transnationalism of SF film: it can only do so much to resist an ideology of absolute divisions and exploitation, but at its best, it performs the very cross-generational and transnational solidarity it recommends. Celebrated by *New York Times* film critic A. O. Scott alongside other "Serious Directors/Small Films" selections, *Sleep Dealer* relied upon transnational participation and unconventional economics even at the core of its technology. Made for $2 million—by comparison, *District 9* cost $30 million and *The Phantom Menace* $115 million—it utilized more than 400 special effects shots created through volunteer labor. Rivera grouped them into twenty sets of twenty and farmed them out to friends and willing acquaintances

Figure 9.3. Laboring here without virtual reality assistance, *Sleep Dealer*'s main character illustrates global SF film's concern not only with future possibilities, but also with ordinary, long-standing issues like water access.

willing to do off-hours work, and the contributions came from sources as far-flung as Anibrain India and as famous as Skywalker Sound. In his DVD commentary and in interviews, Rivera refers to this pastiche approach as a means of creating "Zapatista SF" or even a "*rasquache* aesthetic" (a Chicano arts movement term that often irreverently celebrates the pragmatic achievement of maximum value from minimal resources).[17] Most significant, this approach refuses to sacrifice one side of the border to the other, a determination still evident when the credits roll first in English, then translate into Spanish as they proceed up the screen. Whichever direction one may be moving, Rivera's film insists, it cannot be toward a "future that starts today," as the Cybracero corporation promises, but toward the polytemporal hope with which Memo's narration concludes, "a future with a past." Joining earlier SF cinema in reflecting and lamenting assumptions that national borders must be incontrovertible or that power can flow in only one direction, it posits a different future in which individual and specific communal choices matter more than rhetorical abstractions or enforced patriotism and in which borderlands and other transnational spaces are characterized by dynamic interchange rather than static isolation.

NOTES

1. Istvan Csicsery-Ronay Jr., "Empire," in *The Routledge Companion to Science Fiction,* ed. Mark Bould et al. (New York: Routledge, 2009), 371.

2. Jonathan Auerbach, *Dark Borders: Film Noir and American Citizenship* (Durham, N.C.: Duke University Press, 2011), 24.

3. Yosefa Loshitzky, *Screening Strangers: Migration and Diaspora in Contemporary European Cinema* (Bloomington: Indiana University Press, 2010), 128.

4. Kathy-Ann Tan, " 'If You're Not on Paper, You Don't Exist': Depictions of Illegal Immigration and Asylum in Film—on Michael Winterbottom's *In This World* (2002) and *Code 46* (2003)," in *Multi-Ethnic Britain 2000+: New Perspectives in Literature, Film and the Arts,* ed. Lars Eckstein et al. (New York: Editions Rodopi, 2008), 313.

5. John G. Russell, "Don't It Make My Black Face Blue: Race, Avatars, Albescence, and the Transnational Imaginary," *Journal of Popular Culture* 46, no. 1 (2013): 213–14.

6. John Rieder, "Race and Revenge Fantasies in *Avatar, District 9* and *Inglourious Basterds,*" *Science Fiction Film and Television* 4, no. 1 (Spring 2011): 55.

7. Andrea Hairston, "Different and Equal Together: SF Satire in *District 9,*" *Journal of the Fantastic in the Arts* 22, no. 3 (2011): 342.

8. Eric D. Smith, *Globalization, Utopia, and Postcolonial Science Fiction: New Maps of Hope* (New York: Palgrave Macmillan, 2012), 158.

9. Camilla Fojas, *Border Bandits: Hollywood on the Southern Frontier* (Austin: University of Texas Press, 2008), 4–5.

10. Ibid., 2.

11. Lysa Rivera, "Future Histories and Cyborg Labor: Reading Borderlands Science Fiction after NAFTA," *Science Fiction Studies* 39, no. 3 (November 2012): 415.

12. Ibid., 417.

13. Ibid., 418.

14. Ibid., 421.

15. Luis Martín-Cabrera, "The Potentiality of the Commons: A Materialist Critique of Cognitive Capitalism from the Cybracer@s to the Ley Sinde," *Hispanic Review* 80, no. 4 (Fall 2012): 590.

16. Ibid., 595.

17. Carlos Ulises Decena and Margaret Gray, "Putting Transnationalism to Work: An Interview with Filmmaker Alex Rivera," *Social Text* 24, no. 3 (Fall 2006): 131.

10 Walking Dead in Havana

Juan of the Dead and the Zombie Film Genre

EMILY A. MAGUIRE

Two men sit on a homemade raft, gazing at the afternoon sun shining on a turquoise blue Caribbean Sea. "Don't you ever think about just rowing on to Miami?" asks one. The other shakes his head, and then answers: "Why, man? Over there, I'd have to work. . . . I'm a survivor. I survived Mariel, I survived Angola, I survived the Special Period and that thing that came after. This is Paradise, and nothing will change that." There is a heavy tug on the line, and he reels it in. A pale, half-eaten, undead human face stares up at him. He (Juan) doesn't know it yet, but he has just discovered something else he will have to survive. . . .

When Alejandro Brugués's *Juan of the Dead (Juan de los muertos)* debuted at the Havana International Film Festival in 2011, Cuban audiences were treated to something unprecedented: a zombie movie set and filmed in Havana, by a Cuban director, with a largely Cuban cast.[1] This was a new kind of film for Cuba; Brugués's comic imagining of a zombie apocalypse on the island offers a direct departure from the realist tradition that has dominated Cuba cinema since 1959.[2] Though the figure of the zombie has its roots in Haitian folklore, *Juan de los muertos* draws its inspiration from the flourishing—and recently reenergized—tradition of North American and European zombie films that, beginning with George A. Romero's *Night of the Living Dead* (1968), portray zombies as victims of an illness—stemming from radiation, a virus, or plague—that transforms them into the flesh-eating undead.[3] Indeed, through both title and plot, Brugués's film identifies itself as a Cuban version of *Shaun of the Dead* (2004), Edgar Wright's spoof of the zombie film genre in which two English slackers take on a zombie apocalypse.[4] In *Juan of the Dead,* the slackers are Cuban, but

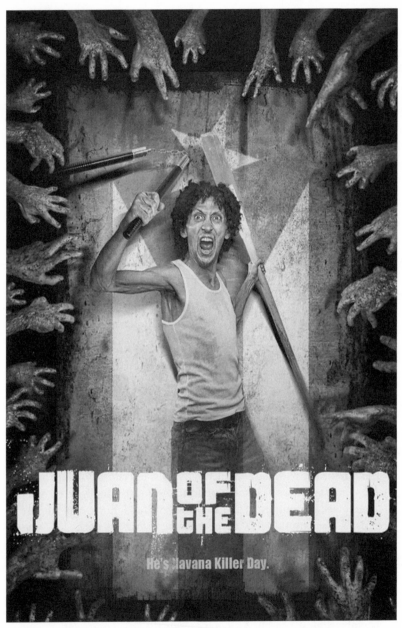

Figure 10.1. The poster for the English-language market release of *Juan of the Dead* uses classic zombie motifs but highlights the film's Cuban location.

like their British counterparts, they rise to the occasion to fight the zombies when the crisis presents itself.

But is *Juan of the Dead* simply a Cuban remake of its British predecessor? Brugués's movie is far from the only non-English zombie film to have been made recently; in addition to a robust tradition of Italian zombie movies, the film industries of places as diverse as Hong Kong, Pakistan, Norway, and India have all recently produced zombie films.[5] Istvan Csicsery-Ronay Jr. posits that English-language science fiction continues to be the dominant paradigm for science fiction produced elsewhere, and argues that this dominance affects how non-U.S. science fiction is viewed: "For this reason, we continue to speak of independent-minded or nationally distinctive sf in relation to those models—as 'independent,' 'national,' or 'alternative.'"[6] Csicsery-Ronay's observation carries an inherent criticism; for him, a truly global science fiction should no longer rely on these labels or their implicit divisions. Yet for films like *Juan of the Dead,* the advantage of the zombie genre may lie precisely in the encounter between the international and the national; the science fiction mode of the zombie film offers a cinematic language that is simultaneously concrete and yet separate from the material and ideological paradoxes of life (and film) in contemporary Cuba. The staging of a zombie apocalypse in Havana allows Brugués to satirize some particularly Cuban issues: the changing relationship between the individual and (collective) society, the post-Soviet climate of "getting by," the prevalence of what Cubans call *el doble moral* (double morality), and the question of—and anxiety over—diaspora. *Juan's* humorous intertextual references tie it to the corpus of English-language zombie movies, but they also connect it to classic Cuban cinema, often in ways that place these cinematic traditions in complex dialogue. Even as these very Cuban zombies expand the possibilities of the zombie genre itself, Juan adds another twist to what it means to "survive" a zombie apocalypse in the island's brave new world by challenging the very definition of survival.

From *Zombi* to Zombies

Although a Cuban zombie film could be considered a novelty, the appearance of a zombie film on the island marks the zombie's return to the Caribbean. Rooted in African belief systems, the modern concept

of the zombie is drawn from Haitian folklore.[7] Anthropologist Alfred Metraux, author of one of the first monographs on Haitian Vodou, defines *zombi* (the plural of the Haitian Kreyol term) as "the living dead—corpses which a sorcerer has extracted from their tombs and raised by a process which no one really knows."[8] Haitian *zombi* are not scientifically produced monsters but rather the result of magic. Occupying "that misty zone which divides life from death," a *zombi* serves the sorcerer who "made it," existing in a state of complete subservience unless it is given salt, at which point it awakens from its undead state and attempts to return to its tomb.[9]

As a being forcibly bound to a master, existing in a space between life and death, the Haitian zombie incarnates the dehumanizing effects of the system of chattel slavery. Zombies were described as being sent to do undesirable tasks, to work odd hours, or to labor late into the night. In its controlled docility, the zombie represents a worker who is literally incapable of resistance. As Kerstin Oloff observes, "The zombie's continued relevance as a figure that encodes alienation is rooted in the Haitian experience of the emergence of modern capitalism, which depended on, and was propelled by, the exploitation of the colonies."[10] When connected to the figure of the slave, the zombie offers a postcolonial critique that ties this early labor system in the Caribbean to subsequent models of labor exploitation in the region.

The *zombi*'s connection to Vodou made it the object of considerable interest to early travel writers to Haiti, who saw the island as the repository of an "exotic" Caribbean otherness. William Seabrook's classic early travel narrative *The Magic Island* (1929), which describes the author's apprenticeship with a Haitian Vodou priestess, includes a long section about zombies, as does Zora Neale Hurston's *Tell My Horse* (1938), an account of the African American writer's travels to Jamaica and Haiti.[11] Focusing on Vodou and folkloric traditions, both texts present an image of Haiti as the locus of an enigmatic realm of non-Western magic in contrast to Western (North American) reason. These supposedly real accounts of zombies, which were hugely popular, became fodder for fictional publications such as Theodore Roscoe's *A Grave Must Be Deep!* (serialized in *Argosy Weekly* in 1935) and Richard E. Goddard's *The Whistling Ancestors* (1937).[12] Zombies added an exotic touch to these pulp novels' exaggeratedly dramatic tales.

Like their print counterparts, early Hollywood zombie movies bor-

rowed from both the content and tone of narratives like Seabrook's. Films such as *White Zombie* (1930) and *I Walked with a Zombie* (1943) present Haitian culture as darkly mysterious, dangerous, and "other" to Western logic and order.[13] Both films feature North American (white) women who travel to Haiti and, through a complicated chain of events, are themselves turned into zombies. The Haitian environment—and Haitian culture—is represented as contagious, and zombies serve as both vehicles for and symbols of contagion.

Director George Romero may have drawn on the Haitian zombie for his first zombie film, but as Peter Dendle notes, Romero "single-handedly re-defined the zombie."[14] *Night of the Living Dead* (1968) is set in small-town America, not the Caribbean, and Romero's zombies are distinct from Haitian zombies in several significant ways. The zombies in Romero's films—and the many films, books, and television programs that have followed—maintain human form, but as Kyle William Bishop observes, they are no longer human in the full sense of the word: "They have no developed brain functions; that is, they cannot process information, learn from their mistakes, act in their own self interest, or even speak. Instead, zombies act on instinct and drive alone, mindlessly pursuing the basest of needs in an orgy of unchecked indulgence."[15] This changes the scale of zombie attacks, as well as the rate of zombification; zombies in post-Romero films nearly always outnumber their human protagonists, appearing as a crowd of undead who appear to act together through a shared desire for human flesh.[16]

Romero's construction of the zombie clearly draws from science fiction rather than from the fantastic. No longer are zombies generated through magical enslavement; instead, they are literally contagious, the product of an illness such as a virus or an extreme dose of radiation. The fact that their appearance often stems from a "rational" cause makes zombies an example of Darko Suvin's now-classic definition of science fiction as "cognitive estrangement," a situation different from reality that nonetheless holds to a similarly rigorous logic.[17] Zombies are no longer magically "made" from the dead-and-buried to serve a master; instead, they are drawn from the ranks of the infected living, who, bitten by zombies, are "reborn" as zombies and proceed to infect others through their desire to feed on human flesh. Haitian zombies are created to serve a human master's demands; Romero's zombies instead respond solely to biological drives.[18]

In his work on film genre, Rick Altman argues for understanding and analyzing genres based on both "semantic" and "syntactical" terms. Film genres are recognized as such by grouping together films that display similar "semantic" characteristics—stock characters, environmental elements—and through the shared relationships or themes that these films explore (their "syntax"), as well as the ways in which they dialogue with history—both real and cinematic.[19] Seen through these "complementary" points of analysis, zombie films can be seen as constituting an independent genre, one distinct from the broader corpuses of both science fiction and horror films.

From a semantic perspective, the profile Romero established for the zombie has been followed by a majority of subsequent films. The zombie's main characteristics, as elaborated by Daniel Drezner, are

1. Zombies desire human flesh; they will not eat other zombies.
2. Zombies cannot be killed unless their brain is destroyed.
3. Any human being bitten by a zombie will inevitably become a zombie.[20]

Given that zombies lack fully functional brains, the dramatic focus of zombie movies is often not the zombies themselves but rather the human "survivors" who join together to fight against the walking dead.[21] Drezner observes that zombie films are often set after an initial zombie outbreak has occurred: "Like international relations scholars, the creators of zombie narratives are more interested in how the living dead affect human institutions."[22] If zombies are defined by their lack of humanity, zombie movies explore how human survivors relate to each other in this crisis situation, showcasing the ways in which ordinary citizens take on "heroic" characteristics as they band together to protect themselves from zombie contagion. Even as they offer a humorous take on the zombie genre, *Shaun of the Dead* and *Juan of the Dead* explore this "common man as hero" paradigm.

The zombie genre has also established a syntactic, as well as a semantic, coherence. Zombies simultaneously "embody physical corruption, reminding us of our own mortality,"[23] and represent contagion; the fear is not to be killed by a zombie, but to eventually become one. In addition to reminding viewers of the delicate connection between life and death, zombies have frequently served as metaphors of mind-

less conformity. Romero's second zombie film, *Dawn of the Dead*, set in a shopping mall, can be read as an allegorical critique of mindless material consumption. As Bishop observes, "The metaphor is simple: Americans in the 1970s have become a kind of zombie already, slaves to the master of consumerism, and mindlessly migrating to the malls for the almost instinctual consumption of goods."[24] Later films, while less critical of consumerism, have used the zombie figure to criticize the "mindless" way in which people live their lives. In this sense, modern zombies also reference the figure of the slave, if only metaphorically.

The ruined physical infrastructure and societal breakdown of a world in the grip of a zombie outbreak is a landscape shared by many recent zombie films. Yet the alternate worlds created by science fiction are not separate from the physical and temporal locus of production: Carl Freedman argues that science fiction is the genre "most devoted to historical concreteness,"[25] because, like historical fiction, science fiction also establishes a productive distance from which to comment on the present, in this case from the future rather than the past.[26] However, the future in science fiction exists not as a faithful representation of temporality but "as a locus of radical *alterity* to the mundane status quo."[27] By creating a radically different future, both *Shaun* and *Juan* make use of the cognitive dissonance of a zombie outbreak to humorously critique certain aspects of society. Yet as Christine Gledhill argues, the productivity of film genres lies precisely in the ways in which a genre's boundaries are altered: "Genre analysis tells us not just about kinds of films, but about the cultural work of producing and knowing them."[28] While *Shaun*'s zombies reveal the lethargy and conformity at the heart of British society, Brugués's film gestures toward the death of socialist ideals, celebrating the survivor instinct (and its emerging guerrilla capitalism) as much as it parodies it. If zombies are a radical otherness, *Juan* show how very strange (and "other" to itself) Cuban society has become.

Shaun versus Juan: The Birth of a Cuban Everyman

A brief comparative look at *Shaun of the Dead* and *Juan of the Dead* reveals the Cuban twist that Brugués gives to the films' shared semantic and syntactical elements. Shaun, Wright's protagonist, is a contemporary British everyman: a nice guy with a decent but unexciting

job (managing an electronics store) and a decent, if unexciting, life. Shaun's idea of a night out is to spend an evening down at the local pub, the Winchester, with his juvenile best friend Ed and his girlfriend Liz. Though aware of (some of) his inadequacies, Shaun can't seem to find the energy to make a change. When Liz, who wants life to be more exciting, decides she has had enough of his inertia and dumps him, the arrival of the zombie outbreak the following day gives Shaun both the motivation and the opportunity he needs to redeem himself. He and Ed discover how to fight off the zombies, "rescue" Shaun's mother and Liz, and lead a small group of survivors to the Winchester. It takes the arrival of the zombies—creatures even more conformist than Shaun himself—to reveal a brave and determined leader underneath Shaun's modest, apathetic exterior.

Shaun's opening credits present the key to the film's humor. The camera engages in several wide shots that show ordinary Londoners engaged in their daily lives, riding the bus, sorting groceries. The joke is that these people *already look like zombies;* they go about their day in an automatic fashion, with little or no awareness of or reaction to the world around them. So closely do they resemble zombies that when the zombie epidemic begins, the undead are indistinguishable from uninfected humans. Shaun himself, at the beginning of the film, is equally zombielike; we see him enter the corner store to grab a soda and fail to notice the bloody handprints on the refrigerator. If the zombies in *Dawn of the Dead* are "a gross exaggeration of late-capitalist bourgeoisie: blind consumption without any production,"[29] *Shaun* pokes fun at how early twenty-first-century urban capitalist labor turns us all into zombies. Only the dire straits in which humanity suddenly finds itself is finally enough motivation to rouse Shaun from the stupor in which he lives his life.

Juan, the protagonist of *Juan of the Dead,* might be seen as an antihero rather than an everyman. He spends his days drinking rum, romancing his upstairs neighbor, and illegally fishing in Havana's bay, accompanied by his friend Lázaro, who, like his British counterpart Ed, is an even more uncouth slacker than Juan himself. Odette Casamayor-Cisneros might identify Juan as "a weightless character," a protagonist typical of recent Cuban fiction.[30] Indifferent to the "myth" of heroic Cubanness, Juan lives in a "floating" state, planning nothing, attached to nothing, taking what comes day by day. As we see in

the film's first exchange, he readily admits that he prefers not to go to Miami because there he would have to work, adding, "Here, I'm a gatherer, like the Arawaks. It's just a question of waiting," a description that jokingly identifies him as an authochthonous character. Juan is divorced, and his ex-wife lives abroad in Spain. His attractive adolescent daughter Camila, back in Havana on vacation, wants nothing to do with her father, whom she perceives as a thief and an alcoholic failure. The zombie outbreak allows Juan to redeem himself in the eyes of his daughter, not because he rescues her, but because the arrival of the zombies gives his life a focus it has been lacking.

Unlike Shaun, Juan has no need to be roused from the stupor of capitalist drudgery; his conversion to "hero" after the zombie outbreak is in line with his unorthodox, unsanctioned habits of survival. If Shaun is blind to the zombie outbreak until one of the undead literally almost bites him, Juan is almost immediately aware that something is amiss and planning a way to work the situation. When he gathers a ragtag group of friends to combat the zombies his motive (other than survival) is financial profit, not masculine redemption.

Juan's opening sequence, set in Havana's urban landscape, is a Cuban variation on *Shaun's*. Certainly, the camera's slow pan reveals an older woman trundling down the street with a shopping cart, and people moving in a slow, meandering fashion that could be described as "zombified." Yet the *timba* beat in the background (with a catchy, rhythmic chorus) adds a pulse that is missing from the British film's opening sequence. Also notably absent from the opening is the vision of people at work presented in the portrait of London. Set in post-Soviet, post–Special Period Havana, *Juan* uses the zombies' disruptive conformity to poke fun at *both* old revolutionary socialist fervor and the new opportunistic capitalist ethos.

Spoofing Cuba

Brugués's film begins by parodying the standard rhetoric of Cuban socialism. Despite the zombie's long history, when zombies begin appearing in Havana, residents (including Juan and Lázaro) have no idea what they are. The government responds by labeling the zombies "dissidents," thus fitting this new crisis into the old rhetoric. Television news coverage warns Cubans to stay away from these dangerous individuals

who are "backed by the U.S. government." The irony of labeling zombies dissidents will not be lost on viewers; clearly, the undead are the ultimate conformists. The first appearance of a zombie in Juan's neighborhood underscores the irony of the government's response, as it is none other than Mario, the president of the local CDR (Committee for the Defense of the Revolution), the neighborhood Socialist Party office. When Mario begins wreaking havoc at a neighborhood meeting, lumbering down the front steps of his building and grabbing the first neighbor he can find to feed on, his appearance provides Juan with the first clue that the zombies are not, in fact, dissidents. After listening to the government news broadcast, Juan observes, "You've gotta be fucking kidding me, man. Mario's no dissident. I've never seen a fat guy who was more of a rat and a faggot in my life." Mario has thus gone from figuratively feeding on people (accusing them of being "antirevolutionary" to benefit his own standing in the party) to literally eating them. The most "loyal" of Cubans has become a literal parasite. Other visual symbols of the revolution will also be subsequently overturned; a demonstration moving down the *Malecón* (Havana's seawall) turns out to be people fleeing the zombies; a crowd gathered at the Plaza de la Revolución is not a group of live government supporters but a dangerous throng of the undead.

In her study of Filipino cinema, Bliss Cua Lim posits that fantastic elements in cinema can reveal the existence of what she terms "inmiscible times": "multiple times that never quite dissolve into the code of modern time consciousness, discrete temporalities incapable of attaining homogeneity with or full incorporation into a uniform chronological present."[31] Lim argues that this act of temporal mistranslation has been used by colonialism to declare different cultures as primitive. In *Juan,* interestingly, it is the aging revolutionaries—and the discourses of the revolution—that are framed as temporal anachronisms. The zombification of Mario and his fellow "good Cuban citizens" makes visible the ideological and temporal rifts in Cuban society. Despite the skepticism of people like Juan and Lázaro, the old revolutionaries like Mario—and, the film ironically suggests, revolutionary fervor itself—have not gone away; instead, they are present as monstrous, reanimated things. The zombification gives new meaning to the anthem that is sung at the neighborhood gathering, "*Morir por la patria es*

vivir" (To die for the fatherland is to live). Juan now must literally kill these monsters to save himself (and the country).

If socialist rhetoric thus fails to do anything to contain the zombies, Brugués shows that the techniques of socialist action are equally ineffective for dealing with the new crisis. At one point, Juan and his friends are "kidnapped" by a truckload of revolutionary-style commandos. Declaring that they are rescuing survivors in order to arm them and "raise the walls of a new community," they strip Juan and his friends naked (presumably to reveal any zombie bite marks) and chain them together in the back of a military-style convoy truck. The commander, a handsome man in fatigues, announces, "Whoever is not with the community is against the community," directly echoing Fidel Castro's famous pronouncement, "Within the Revolution, everything; against the Revolution, nothing." This strategy turns out to be fatal when it is revealed that one of the enchained men is infected. His complete zombification leads to a mutiny in the back of the truck as the men try to escape being bitten, and this "new society" ends before it begins when the driver is accidentally shot in the chaos and the truck crashes into a sign reading "Revolution or Death" (*Revolución o muerte*).

As those who have previously triumphed in society become the zombie epidemic's first victims, Juan becomes the most unlikely of heroes, in that to a great extent he has given up on heroism itself. His early description of himself as a survivor is significant. To be a survivor is not to triumph; it is to get by, to live by making the best of a series of bad situations. The ability to *resolver* (literally, resolve), to cobble together a solution, allowed Cubans to make it through the worst scarcities of the Special Period, the post-Soviet economic crisis of the 1990s. As Cuban sci-fi writer Yoss points out, Juan "is the personification of the 'average' Cuban's resilience, of his capacity to make necessity a virtue, to live by invention."[32] Ironically, the person who shows himself to be best able to deal with the zombie crisis is not a shining example of Cuba's "New Man," the model socialist individual envisioned by Ernesto "Che" Guevara, but someone Guevara might have viewed as a social failure.[33] Juan is no tireless worker willing to sacrifice everything for the socialist project; he has no political ideals, zero ambition, and is motivated largely by self-interest rather than altruism. Yet as the film reveals, his capacity for invention, his ability to see through rhetoric,

and his willingness to adapt to new situations are precisely what allow him to survive the zombies.

A motley collection of similarly pragmatic social misfits joins Juan in his fight against the undead. In addition to Juan's friend Lázaro and Juan's daughter Camila, they include La China, a transvestite who makes a living as a petty thief; El Primo, La China's large Afro-Cuban friend, who sports a Mike Tyson–like tattoo on his face but faints at the sight of blood, and Vladi California, Lázaro's son, a handsome hustler who spends his time romancing tourists and dreaming of escaping the island. A thief, a gay transvestite, a hustler, a tattooed black man: the group represents all of the elements of Cuban society that the revolution has at one time or another condemned or marginalized. Yet like Juan, they are all "survivors" in the new post-Soviet Cuba.

Juan and his friends do not set out to fight the zombies. In fact, when Mario attacks the neighborhood meeting, his appearance provides a welcome distraction from the discussion of a recent rash of car radio thefts for which La China is responsible. Only when the zombie epidemic reaches epic proportions does Juan decide that the situation "requires a plan." The plan he has in mind, however, is not a plan for surviving the zombie apocalypse but a plan for *capitalizing* on it. Ever the canny observer, he sees the zombie outbreak as an opportunity for personal gain rather than heroism. As he explains, "We're faced with a crisis, and there's only one thing we can do. . . . Charge them for it." He and his friends form a "company," hiring themselves out to families who need someone to kill off their zombified family members. "*Juan de los Muertos: matamos a sus seres queridos*" (Juan of the Dead: we kill your loved ones) is their slogan. When Camila, aghast at Juan's flagrant ability to take advantage of the situation, expresses her outrage, Juan explains, "Cami, we're Cuban; this is what we do when things get bad." With this, Brugués pokes fun not only at the rigidity of the old Cuban order—the socialist rhetoric that fails to adapt to a novel crisis—but also at what Cubans call *el doble moral* (double morality), the egotism and self-interest of the new "do it yourself" Cuban capitalism. Juan and his friends do help people, a notable example being when Juan saves a young boy from his zombified father, but knowing that the status quo may not remain so for long, they are on the lookout for any way to come out ahead. When Vladi and Lázaro return from a scavenging raid pushing a wheelchair filled with cases of rum, Juan asks, "And the

old guy?" "He died. We had to leave him," declares Lázaro, but Vladi adds, "Not necessarily in that order," the implication being that they have killed the old man (or left him to be eaten by zombies). Lázaro in particular uses the chaos to his advantage: when he comes across a neighbor who owes him money, he attacks him, even though the man is clearly not a zombie.

Zombies and Cuban Cinema

By showing how Juan and his friends—and the Cuban authorities— respond to the zombie crisis, *Juan* pokes fun at the mixed messages of Cuban society, particularly the way in which revolutionary ideals contrast with contemporary (survival) practices. Brugués's film achieves this in part by establishing an intertextual relationship with Cuban cinema, using these (often parodic) references as a means of communicating a particularly Cuban series of meanings about images, individuals, or events. As Sara Armengot observes, these references demonstrate that *Juan,* despite its novelty as the island's first zombie film, is not "an outlier in the Cuban film canon," but can in fact "be productively read within the robust national filmmaking tradition."[34] Yet these allusions also illustrate a cognitive dissonance between the historical context of the earlier Cuban films and Brugués's movie.

Perhaps the most notable cinematic reference in *Juan* is to Tomás Gutiérrez Alea's classic film *Memories of Underdevelopment* (1968).[35] As both Armengot and Stock have noted, Juan's use of a telescope to observe the city is a direct reference to Sergio, the protagonist of Gutiérrez Alea's film, a disaffected pseudo-intellectual who spends his days pondering the changing urban landscape visible through his telescope.[36] Juan is no revolutionary, but neither does he have any bourgeois pretensions. Where Sergio's mediated observations of the city emphasize his isolation and his inability to incorporate himself into revolutionary life, despite his (albeit ambivalent) desires to do so, Juan's scrutinizing of the city is practical and strategic: this is a good view from which to safely survey the state of things, gauge zombie activity, and plan one's next move.

Juan's (and the camera's) gaze from his rooftop position is significantly non-nostalgic. In contrast to previous cinematic visions of Havana—from Gutiérrez Alea's *Strawberry and Chocolate* (1993)

to Fernando Pérez's *Havana Suite* (2003) to Florian Borchmeyer's *Havana—The New Art of Making Ruins* (2006)—that linger on the pathos to be found in the decaying urban façades, *Juan* incorporates the city's crumbling infrastructure into the destruction wrought by the zombies.[37] (The inside joke is that Havana's ruins needed few touch-ups to become the perfect set for a zombie apocalypse.) In one humorous scene, Juan and Lázaro lounge on the rooftop at sunset. "It's too bad that building is there [in the way]," comments Lázaro, and in that very moment the building collapses and falls away. Contentedly, the two men put on sunglasses and enjoy the view.[38]

Zombie Island

In spite of the zombie apparatus, the climax of *Juan* comes back to a very Cuban question: Should Juan stay or should he go? Realizing that the zombies vastly outnumber them, Juan, Lázaro, Vladi, and Camila—the surviving members of the group—make a plan to escape. They turn a late 1950s American car into a raft and launch it into the Havana Bay, planning to head for Miami. But will Juan leave with them? This dilemma of diaspora has been at the heart of much recent Cuban cinema, including Juan Carlos Cremata Malbertí's *Nada +* (*Nothing More*, 2001) and *Viva Cuba* (2005), Benito Zambrano's *Habana Blues* (2005), and Brugués's own first film, *Personal Belongings* (2007).[39] In these films, the choice is largely a question of personal volition (and/or economic need); characters are not faced with a life-or-death decision. The zombie crisis in *Juan* gives that issue literal teeth, and the decision seems to be clear. Yet despite being clearly outnumbered, with no solution in sight, Juan insists upon staying.

Why does Juan decide to stay? Has this self-interested (if loveable) opportunist suddenly decided to make "the ultimate sacrifice"—to die fighting, even if it is no longer clear for what? Is he choosing to "live with zombies" because this is what he has been doing metaphorically all along? Many zombie films (including *Shaun of the Dead*) end with the crisis in some way "resolved," yet Brugués prefers to leave everything hanging. We never find out if a solution to the zombie outbreak exists, nor do we know if Juan, the consummate survivor, can survive this last challenge.[40] Like Cuba, Juan has become used to "surviving." Brugués's film suggests it may be impossible for him to live any other way.

NOTES

1. *Juan of the Dead*, DVD, directed by Alejandro Brugués (2011; Spain, Cuba: La Zanfoña, La 5ta Avenida, 2012).

2. Although, as Anne Marie Stock notes, Juan Padrón's animated vampire comedies, *Vampires in Havana* (1985) and *More Vampires in Havana* (2003), might be considered precursors to Brugués's film, *Juan of the Dead* is the first live-action Cuban film of its kind. See Anne Marie Stock, "Resisting Disconnectedness in *Larga distancia* and *Juan de los muertos*: Cuban Filmmakers Create and Compete in a Globalized World," *Revista Canadiense de Estudios Hispánicos* 37, no. 1 (2012): 61.

3. See *Night of the Living Dead*, DVD, directed by George A. Romero (1968; Hollywood, Calif.: Gaiam Entertainment, 2001).

4. *Shaun of the Dead*, DVD, directed by Edgar Wright (2004; Burbank, Calif.: Universal Studios, 2004).

5. The Italian zombie film tradition, most active during the 1980s, is anchored by the multiple zombie films of Lucio Fulci, beginning with *Zombie* (1979), but includes work from directors such as Umberto Lenzi and Dario Argento. For recent foreign zombie films, see Wilson Yip's *Bio Zombie* (Hong Kong, 1998); Omar Khan's *Hell's Ground* (Pakistan, 2007); Tommy Wirkola's *Dead Snow* (Norway, 2009), and Krishna D. K. and Raj Nidimoru's *Go Goa Gone* (India, 2013). Interestingly, both *Bio Zombie* and *Go Goa Gone*, like *Juan of the Dead*, are parodies of the genre. When one of the characters in *Go Goa Gone* asks why there should be zombies in India, his friend responds, "It's globalization!"

6. Istvan Csicsery-Ronay, Jr. "What Do We Mean When We Say Global Science Fiction? Reflections on a New Nexus," *Science Fiction Studies* 39, no. 3 (November 2012): 483.

7. See Hans W. Ackermann and Jeanine Gauthier, "The Ways and Nature of the Zombie," *Journal of American Folklore* 104, no. 414 (1991): 466–94.

8. Alfred Métraux, *Voodoo in Haiti,* trans. Hugo Charteris (1959; reprint, New York: Schocken Books, 1972), 282.

9. Ibid., 282–83.

10. Kerstin Oloff, "'Greening' the Zombie: Caribbean Gothic, World Ecology, and Socio-Ecological Degradation," *Green Letters: Studies in Ecocriticism* 16, no. 1 (2012): 31.

11. See Zora Neale Hurston, *Tell My Horse: Voodoo and Life in Haiti and Jamaica* (1938; reprint, New York: Harper Perennial, 2008), and William Seabrook, *The Magic Island* (1929; reprint, New York: Kessinger Publishing, 2003).

12. See Theodore Roscoe, "A Grave Must Be Deep!" *Argosy Weekly* (December 1934–January 1935), and Richard E. Goddard, *The Whistling Ancestors* (1936; reprint, Vancleave, Miss: Ramble House, Dancing Tuatara Press, 2009).

13. See *White Zombie*, directed by Victor Halperin (Burbank, Calif.: United Artists, 1932), and *I Walked with a Zombie*, directed by Jacques Tourneur (Burbank, Calif.: RKO Radio Pictures, 1943).

14. Peter Dendle, "The Zombie as Barometer of Cultural Anxiety," In *Monsters and the Monstrous: Myths and Metaphors of Enduring Evil*, ed. Niall Scott (London: Rodopi, 2007), 50.

15. Kyle William Bishop, *American Zombie Gothic: The Rise and Fall (and Rise) of the Walking Dead in Popular Culture* (2010; reprint, Amazon Digital Services), Location 2032 of 4699.

16. Ibid., Location 1737 of 4699.

17. See Darko Suvin, "On the Poetics of the Science Fiction Genre," *College English* 34, no. 3 (December 1972): 372–82.

18. Scholars such as John Rieder and Istvan Csicsery-Ronay Jr. have remarked on the connections between imperial narratives and the development of science fiction literature. It is interesting to note that despite their differences from Haitian zombies, in their cannibal aspect, Romero's zombies are still closely tied to colonial images of the primitive savage. See Csicsery-Ronay Jr., "Science Fiction and Empire," *Science Fiction Studies* 30, no. 2 (2003): 231–45, and John Rieder, *Colonialism and the Emergence of Science Fiction*, (Middletown, Conn.: Wesleyan University Press, 2012).

19. See Rick Altman, "A Semantic/Syntactic Approach to Film Genre," *Cinema Journal* 23, no. 3 (Spring 1984): 6–18.

20. Daniel Drezner, *Theories of International Politics and Zombies* (Princeton, N.J.: Princeton University Press, 2011), 21.

21. Two recent films, *Zombieland* (2009) and *Warm Bodies* (2013), challenge—or at least play with—this concept by offering zombie protagonists who seek to understand the nature of their [lack of] humanity. Puerto Rican writer Pedro Cabiya's novel *Malas hierbas* (*Weeds*, 2009), narrated by a zombie scientist, does something similar. Nevertheless, these examples are too few to challenge to the dominant vision of zombies as incapable of logical thought.

22. Drezner, *Theories of International Politics and Zombies*, 27.

23. Kevin Alexander Boon, "Ontological Anxiety Made Flesh: The Zombie in Literature, Film, and Culture," in *Monsters and the Monstrous: Myths and Metaphors of Enduring Evil*, ed. Niall Scott (London: Rodopi, 2007), 35.

24. Kyle William Bishop, "The Idle Proletariat: *Dawn of the Dead*, Consumer Ideology, and the Loss of Productive Labor," *Journal of Popular Culture* 43, no. 2 (2010): 235.

25. Carl Freedman, *Critical Theory and Science Fiction* (Middletown, Conn.: Wesleyan University Press, 2000), 43.

26. For another look at Freedman's discussion of the relationship between science fiction and the historical novel, see Joanna Page's chapter in this book.

27. Ibid., 54.

28. Christine Gledhill, "Rethinking Genre," in *Reinventing Film Studies*, ed. Christine Gledhill and Linda Williams (London: Bloomsbury, 2000), 222.

29. Bishop, "The Idle Proletariat," 237.

30. Odette Casamayor-Cisneros, *Utopía, dystopia e ingravidez: Reconfiguraciones cosmológicas en la narrativa postsoviética cubana* (Frankfurt: Iberoamericana/Vervuert, 2013), 315–16.

31. Bliss Cua Lim, *Translating Time: Cinema, the Fantastic, and Temporal Critique* (Durham, N.C.: Duke University Press, 2009), 11–12.

32. Por Yoss, "La épica farsa de los sobrevivientes: O varias consideraciones casi sociológicas sob re la actualidad y el más reciente cine cubano, disfrazadas de ¿simple? reseña del filme *Juan de los muertos*," *Korad* 7 (October–December 2011): 51.

33. For a text that lays out Guevara's ideals of the socialist New Man, see his seminal essay, "Socialism and Man in Cuba," 1965; reprint in *The Che Guevara Reader: Writings on Politics and Revolution* (New York: Ocean Press, 2005).

34. Sara Armengot, "Creatures of Habit: Emergency Thinking in Alejandro Brugués' *Juan de los muertos* and Junot Díaz's 'Monstro,'" *Trans* 14 (2012): 4. http://trans.revues.org/566.

35. *Memories of Underdevelopment (Memorias del subdesarrollo}*, directed by Tomás Gutiérrez Alea. (Havana, Cuba: ICAIC, 1968).

36. Armengot, "Creatures of Habit," 52, and Anne Marie Stock, "Resisting Disconnectedness," 61.

37. *Strawberry and Chocolate (Fresa y chocolate)*, DVD, directed by Tomás Gutiérrez Alea, (1993; Havana, Cuba: ICAIC/Dolby Digital, 2009); *Habana Suite (Suite Habana)*, DVD, directed by Fernando Pérez (2003; Havana, Cuba: ICAIC/Cinema Tropical, 2004), and *Havana: The New Art of Making Ruins (Havanna—Die neue Kunst, Ruinen zu bauen)*, DVD, directed by Florian Borchmeyer and Matthias Hentschler (2006; Studiocanal, 2007).

38. The interactions between Juan and Lázaro also reference Gutiérrez Alea's *Strawberry and Chocolate* (1993). The story of the friendship between David, an idealistic college student, and Diego, a gay dissident writer, *Strawberry and Chocolate*'s emotional climax is the farewell embrace between the two men, a moment that signals the bonds they have formed in spite of their differences. In what appears to be a similarly touching scene, Lázaro, thinking he may be about to die, asks Juan for "just one more favor": will Juan let him perform oral sex on him? Juan, initially aghast, finally agrees, and only then does Lázaro admit the request was a joke. The film thus mocks the cathartic moment offered by Gutiérrez Alea's film, making visible a strain of sexual anxiety that has been running through the film's largely homosocial environment.

39. See *Nothing More* (*Nada+*), directed by Juan Carlos Cremata Malberti (Havana, Cuba: ICAIC, 2001); *Viva Cuba*, DVD, directed by Juan Carlos Cremata Malberti (Havana, Cuba, 2005; Film Movement 2007); *Habana Blues*, DVD, directed by Benito Zembrano (2005; Cuba, Spain: Polychrome Pictures, 2007); and *Personal Belongings*, directed by Alejandro Brugués (2008; Maya Entertainment, 2009).

40. Anne Marie Stock interprets this as an optimistic ending that shows Juan as "self-reliant and determined" ("Resisting Disconnectedness," 63). Despite Juan's determination, however, his solitude, and the fact that he is vastly outnumbered by the zombies, seem to set a more ambivalent tone.

Part IV Techno-Capitalism and Techno-Desires
The Gendered Affect of Post-Cyborgs

11 Who Does the Feeling When There's No Body There?

Critical Feminism Meets Cyborg Affect in Oshii Mamoru's *Innocence*

SHARALYN ORBAUGH

"Manifestos provoke by asking two things: where the holy hell are we, and so what?"[1] This was the explanation offered by Donna Haraway in a 2006 interview for why she has twice adopted the manifesto format for her theorizing about the human/posthuman future.[2] In this chapter I argue that Oshii Mamoru's films function as manifestos that pose the questions "Where the holy hell *are we going*, and so what?" As humanity moves inexorably into the state of the posthuman, it is crucial that we consider the psychological, epistemological, and ethical consequences of the changes we face, and both Haraway and Oshii are at the forefront of contemporary post-anthropocentric, ethically grounded theorization of the posthuman condition.

Haraway represents a branch of critical feminist theory that takes the human/posthuman condition as one of its primary concerns. In his discussion of the work in this vein by Judith Butler, N. Katherine Hayles, and Donna Haraway, Arthur Kroker underscores the fact that "their theoretical imaginations are *directly invested in the fate of the body*" (emphasis added).[3] I juxtapose the cinematic theorizing of Oshii with the critical feminist theorizing of Haraway because his work, too, is directly invested in the fate of the body and all of its inflections. Although Oshii references Donna Haraway in the 2004 *anime* film *Ghost in the Shell 2: Innocence* (hereafter *Innocence*) on which the majority of my discussion focuses, he claims not to have read her work.[4] Nor have I found any indication that Donna Haraway has viewed any of Oshii's posthuman-themed films. Reading the two together is adamantly not a search for influences or genealogies. Rather, such a juxtaposition shows how the work of these two theorists—though

they differ in gender, sex, nationality, language, and mode and medium of expression—mutually resonates in productive ways. Moreover, because narrative, and particularly visual narrative, is capable of *demonstrating* (rather than just stating) the force and ramifications of a speculative argument, attention to the details of Oshii's cinematic science *fiction* imagination reveals crucial political elements of techno-biopolitics that are less clearly articulated in *non-fiction* theory.[5] In other words, SF cinema can itself function as theory, as we shall see.

This chapter begins with a general consideration of the many resonances and few disjunctures between Haraway's explicitly theoretical and polemical arguments and the arguments implicitly put forward in Oshii's fiction films. It then shifts the focus to a specific time period—the early to mid-1990s—when Donna Haraway's "Cyborg Manifesto" gained prominence, when the figure of the cyborg was ubiquitous in Hollywood SF film and TV, and when Japanese director Oshii Mamoru made his breakthrough animated film, *Kôkaku kidôtai: Ghost in the Shell* (1995, hereafter *GiTS*), a complex exploration of cyborg subjectivity.[6] It then proceeds to examine the *evolution* of the theorizing of the posthuman in Haraway's thought and Oshii's post-*GiTS* SF films: in the late 1990s and 2000s both Haraway and Oshii turned to a consideration of animals as new figures "to think with." Finally it concludes with a discussion of Oshii's *Avalon* (2001) and *Innocence* (2004), analyzing the significance of the *details* of his posthuman scenarios and the value of cinema—most particularly SF cinema—in thematizing philosophical or theoretical issues in technobiopolitics.[7]

Haraway and Oshii

One of Haraway's most significant contributions to critical (posthumanist) feminism is her insistence on what she calls "situated knowledges" or "situated epistemology" as the foundation for any kind of useful thinking.[8] Trying to think through the ramifications of our posthuman present and future in ungrounded terms leads to the kind of ethically blind, purely celebratory (or condemnatory) abstractions common to much techno-globalization theory—what Haraway calls "blissed-out techno-idiocy."[9]

One crucial form of situated knowledge is the telling of stories. Haraway's frequent inclusion of personal narrative (anecdotes) in her

expository writing is precisely for the purpose of keeping her theories grounded in the specific, so that the actual consequences of a situation can be fully understood in all their particular, complicated, relational, affective significance. Haraway does not create *fictional* narratives, but she does often acknowledge the importance of a fictive—and especially a *science* fictive—imagination.[10]

Along those same lines, I argue that narrative story making of any kind—fact or fiction, based on one's own experiences or based on the made-up experiences of invented characters—can prove similarly efficacious in situating and grounding theoretical work. In the words of cognitive linguist Mark Johnson, "Narrative imagining—story—is the fundamental instrument of thought. Rational capacities depend upon it. *It is our chief means of looking into the future*, of predicting, of planning, and of explaining. It is a literary capacity indispensable to human cognition generally" (emphasis added).[11]

When artists create fictional stories, in order to make them plausible and engaging they ground those narratives in specific times and places, focused around characters with specific biographies. In the genre of SF, those characters and circumstances need not (yet) be real or possible, but are, when skillfully done, convincingly specific. This is why (science) fiction is important in considering the ethical ramifications of the (post)human condition. Stories allow us to see how various situated knowledges—in the form of believable (even if fantastic), interesting characters—play themselves out in various speculative scenarios. Stories remove speculation from the objective, abstract (and therefore affectively blank) to the personal and particular (and therefore ethically rich). The affect generated by a complex, sympathetic character in (science) fiction evokes the engaged response that makes us want to answer the second half of Haraway's question about manifestos: "Where the holy hell are we, *and so what?*"

As a maker of SF-themed films, both live action and animated, Oshii returns again and again to a particular set of posthuman themes. If, as Arthur Kroker contends, Donna Haraway's lifetime of work constitutes an "epic story of domination," then Oshii's lifetime of work is an *epic story of evolution*, but, in yet another resonance with Haraway's work, Oshii's vision of evolution maintains a focus on the structures of domination that continue to threaten the posthuman condition.[12]

For both Haraway and Oshii a crucial epistemic focus is affect of

various kinds, but particularly love. Just as Haraway explores the implications of the deep love and physical (but nonsexual) intercourse—including the sharing of genetic material—she enjoys with a member of a different species (her dog Cayenne), Oshii explores the implications of love and literal (but nonsexual) intercourse—including the sharing of existence-constitutive data streams, the cybernetic equivalent of genetic material—between fictional characters with varying ontologies: human, cyborg, animal, doll, and disembodied but intelligent web-based beings. Love, desire, connection, and what I call intercorporation across ontological boundaries is a fundamental element of Haraway's and Oshii's work.[13]

But one of the differences between Oshii and critical feminists like Haraway and Hayles, especially post-2000, is the way they deal with embodiment. In her companion species work Haraway does care about the species-determined embodiments of the two creatures who love each other and their entwined cultural and genetic histories, and this concern comes through clearly when she is keeping the story personal—when writing about her own dog Cayenne, for example. For the most part, however, she does not engage directly with the literal, embodied consequences of the trajectories of those histories—the new technologies, including breeding and reproductive technologies, that simultaneously challenge and reify old ontological boundaries. It is Oshii who creates the variously embodied characters who then live out not just the past or present but also a bit of the future. The specificities of their differing embodiments are given devoted attention in a medium that allows them to be experienced in a sensorily resonant and engaging way.

To repeat, one of the interesting differences between Oshii's recent work and that of critical feminists is his ongoing focus on the *literal* cyborg—that is, the amalgam of the machinic and the organic in one (post)human body, as well as on entirely nonorganic but intelligent, animate/d beings such as androids, gynoids, and dolls. Accordingly, one of the most consistent questions for Oshii is, Who does the feeling when there's no *body* there? In other words, how can we have affect and connection when our bodies are increasingly hybridized with inorganic matter (or are entirely artificial), and the feelings/memories that have always been stored in the body are now archived externally in computers? To understand the significance of Oshii's continued em-

phasis on the cyborg it is necessary to go back to a time when this was not unusual.

The Cyborg's Hey-Day: 1985–1995

Cyborgs were in vogue in the 1980s and early '90s, making conceptual waves in both scholarly and popular culture in many parts of the world. In 1985 Haraway published the first version of "The Cyborg Manifesto" in an academic journal, and in 1991 she published an updated version in her book *Simians, Cyborgs and Women*.[14] In 1995, Chris Hables Gray edited *The Cyborg Handbook*, which brought together cyborg-related scholarship from aerospace science, sociobiology, engineering, medicine, literature, art, anthropology, and politics, highlighting the ubiquity and importance of the cyborg in many intellectual fields.[15]

Popular SF films such as *Star Wars IV, V,* and *VI* (1977, 1980, 1983), *Blade Runner* (1982), *Terminator* and *Terminator 2* (1984 and 1991), *Robocop, Robocop 2* and *3* (1987, 1990, 1993), *Alien* (1979), *Aliens* (1986), and *Alien 3* (1992), and TV's *Star Trek: The Next Generation* (1987–94) had brought cyborgs to the attention of viewing publics in North America and around the world.[16] The cyborgs in film and TV, as well as many of those discussed in scholarly work, were literal amalgams of the machinic and the organic, humans who had been altered (enhanced or invaded) by technology or whose bodies incorporated technological prosthetics. With few exceptions, the cyborgs in mainstream films and TV were terrifying, hypermasculine, and graphically visible as different from the "natural" human: Darth Vader in the *Star Wars* films, the Terminator, the Borg in the *Star Trek* films and TV universe[17]—all of these were hypermasculine, mostly evil figures who show hardly any emotion at all, certainly no pity or gentleness. Even when there were good-guy cyborgs in Hollywood films, or when a fundamentally good character was involuntarily cyborgized, like the protagonist of *Robocop* or Captain Picard in *Star Trek: The Next Generation*,[18] they tended to remain hypermasculine figures who were, willingly or not, extremely violent. The happy ending for most of these characters—or the happy ending they wished to achieve, but could not—was a return to the fully organic human.

These depictions suggested that humans are *terrified* of the idea of our bodies becoming too closely melded with machines, and we see

only flesh as being truly, authentically human. And this focus on ontological terror continued in mainstream popular culture and Hollywood films and TV beyond the 1990s. We need only recall the scenes from *Star Wars III: Revenge of the Sith* (2005) and *Star Wars VI: Return of the Jedi* (1983), which bookend the birth and death of Darth Vader: when the young Anakin Skywalker is horrifically injured at the end of the former film, he is made physically functional again by being placed in a cybernetic suit encasing his whole body and a helmet that completely covers his head. When the helmet is put over Anakin's head for the first time, we see it from his point of view, coming down to swallow him up and forever change his embodiment, and it is a sickening image. Although we know that it was psychological pressure and fear that changed the good character Anakin Skywalker into the evil Darth Vader, the change in his embodiment from organic human to cyborg seems to play an equally significant role in his transformation. The film implies that affect is inextricably tied to embodiment: with a totally artificial body like that, how could he experience positive emotion? In the latter film, when the dying Darth Vader asks Luke to take off his cyborg-armor helmet so he can look at his son with his organic eyes, the implication is that he can only return to being "good" by returning to his original organic form.

One of the most salient aspects of all of the posthuman films of Oshii Mamoru is that the cyborgs they depict are not always terrifying, hypermasculine, evil characters. On the contrary, many of his cyborg protagonists are feminine in shape, and Oshii is interested in exploring what cyborg subjectivity is like "from the inside," so that viewers get a much more nuanced, complex sense of what it might feel like to be posthuman. It is no surprise, then, that at this point in time—the mid-1990s—when cyborgs were ubiquitous, Oshii's compelling, complex, and philosophically rich film *GiTS* became a huge cult hit among fans of SF film, both inside and outside Japan, and influenced later investigations of the cyborg in both the scholarly and the popular realms (such as the *Matrix* films).[19]

Haraway's early cyborg, however, was rather different from the human-machine amalgam imagined in film and television. In Haraway's 1985/1991 manifesto the word *cyborg* primarily described a socialist-feminist *relationship* between people (women) and technology. For her, the cyborg was a good *metaphor to think with*—a way of *situating* the changes that technology was bringing to real women's

Figure 11.1. *Star Wars* III. Anakin Skywalker sees the helmet coming down to encase his head and turn him into Darth Vader.

Figure 11.2. *Star Wars* III. From Anakin Skywalker's point of view we see the helmet coming down to encase his head and turn him into Darth Vader.

lives. When Haraway advocated that women accept "cyborgization" she *did* mean accepting a relationship between body and technology, and unlike Hollywood films she did not posit a natural, unalloyed, organic body that would be defiled by its relationship with machines.[20] But, at the same time, in her thinking with and about the cyborg she rarely emphasized the kind of cyborg that is a *literalized* version of a new kind of embodiment, represented by, for example, the increasing number of people with pacemakers, artificial cybernetic limbs, or other technological prostheses or enhancements. Although Haraway did not exploit the terrors of monstrous cyborgian embodiment favored by Hollywood in the 1980s and '90s, neither did she address the embodied sources of those terrors.[21]

In taking the *metaphor* of the cyborg and transforming it into *embodied* narrative protagonists, Oshii is able to explore the particular situated epistemology of the cyborg more fully and concretely than either Haraway's theorizing or Hollywood's terrified narrativizing, and therefore better able to make us care about the "so what?" of changing ontologies.

1996 and Beyond: The Rise of the Clone and the Animal

But the cyborg was not the only kind of technologically mediated body in the news in the mid-1990s. Dolly the sheep was cloned in 1996, and it may have been this incident among others that turned the attention of Haraway and other critical feminists to the issue of animals and their relation with both humans and technology. Haraway (in 2003) has demoted cyborgs to the role of "junior siblings in the much bigger, queer family of companion species,"[22] and Hayles has proposed the "cognisphere" as a tool for thinking about the "dynamic cognitive flows between human, animal, and machine."[23] In other words, rather than focusing on the cyborg/machine as the primary means for decentering the human, both have shifted the focus to a wide range of entities that enable that decentering, moving toward what Rosi Braidotti calls a "post-anthropocentric" way of thinking about the present and future.[24] Perhaps because of their previous concentration on the machinic—cybernetics and cyborgs, respectively—Hayles and especially Haraway have in their recent work shifted the emphasis to the *organic* entities that border the human.

Since the 2001 film *Avalon,* Oshii has included animals in several of his most provocative cinematic theorizations of the posthuman future—he has queered his filmic cognisphere in many of the same ways as Haraway and Hayles. But I argue that the decentering of the human in *Innocence*—Oshii's exploration of the complex coevolution of a myriad of entities—addresses issues and "companion creatures/entities" (not just species) that critical feminists have so far failed to consider in any depth. Though critical feminist theory requires us to keep continually in mind that evolution is always *co*evolution, that "subjectivity" is really "relationality all the way down" (as Haraway puts it), Oshii's films *demonstrate* the force and ramifications of that fact more fully than abstract prose can. And, significantly, Oshii retains a focus on the literally embodied cyborg *in addition to* all the other kinds of posthuman entities that inhabit *Innocence.* Whereas Haraway seems to shy away from her earlier attachment to the figure of the cyborg—she says that she no longer cares for the term *posthuman* because it has been coopted by "blissed-out techno-bunnies" looking for the next evolutionary stage such as downloading consciousness onto a computer chip[25]—Oshii recognizes that the cyborg continues to be a useful instantiation of the techno-hybridity of our current (and future) condition.

GiTS, Avalon, Innocence

Although prior to 1995 Oshii had directed films depicting cyborgs of various kinds, it was in *GiTS* that he addressed the nature of post-humanity directly. The protagonist of the film, Kusanagi Motoko, is a cyborg working for a government security force. Only her brain is organic, retaining, she believes, her own original identity and memories. But Kusanagi is uncertain about this, and wonders whether her memories and emotions have been artificially implanted by the same company that made her cybernetic body. She becomes curious about a bodiless intelligence inhabiting the Net, called the Puppet Master. In order to confirm that it truly is a life form, the Puppet Master wants to merge its essence with that of another life form—in other words, to reproduce—and then it wants to die, which again is what real life forms do. The Puppet Master convinces Kusanagi that the two of them should merge, which they do through a technological link-up rather

than through human sexual reproduction. The merging is successful, and at the end of the film the Puppet Master has disappeared and evidently "died," and Kusanagi has moved up to the next step of posthuman evolution, capable of traveling the Net freely as a data stream, freed of her body but retaining, in some undefined sense, her own selfhood.

One of the questions this film poses, then, is, What is the nature of posthuman reproduction when the body is entirely artificial?

GiTS won critical acclaim around the world and influenced a number of other SF directors: the Wachowski brothers reportedly made *The Matrix* (1999) as a sort of response to some of the issues raised in *GiTS*. *The Matrix* provocatively suggests that the world we experience as real is just a simulacrum, but we will never realize that unless we are lucky enough to escape our machine-invaded bodies and return to the real world. The protagonist, Neo, is presented as a savior figure, and in one tear-jerking scene he is brought back from death by the strength of a woman's love. In other words, like *Star Wars,* this is a film that features the typical Hollywood scenario: the possibility of escape from horror into happiness; the possibility of true love conquering all, even death; and the relentless privileging of the idea of "returning" to the pre-cyborg, organic, true version of the human. But, if—as Hayles has famously contended—already we are all cyborgs, this nostalgic move is not at all useful in terms of thinking through the ethical, practical, and psychological issues that we face as we move ever further into our posthuman future.[26] Instead it merely confirms and enshrines our terror.

For the most part, Oshii's films manage to avoid valorizing that nostalgic desire to return to an organic paradise of "authentic" selfhood. His 2001 live action film, *Avalon,* was a response *back* to *The Matrix,* in an ongoing international conversation among SF filmmakers about the nature of the posthuman future.[27]

Avalon is a live-action film, but Oshii spent tremendous time and effort in post-production doing CGI on the film, including extensive work on the protagonist's face. The result is a visually intriguing amalgam of live action and animation.

As in *GiTS,* whose protagonist was a feminine-shaped cyborg, the protagonist of *Avalon,* named Ash, is female. And, again like Kusanagi, Ash is a warrior; in this case, she is an extremely skilled player in the virtual reality war game Avalon.

The film follows Ash as she, like Kusanagi in *GiTS*, becomes tempted to evolve upward to a different level of posthuman being. In Kusanagi's case this involved merging with technology so completely that she left embodiment behind, and something similar happens in *Avalon* to Ash. In Ash's case, however, the levels of being through which she ascends are the skill levels of the game.

In the beginning of the story Ash's real world is depicted as dark and monotone. Its people are poorly dressed, the buildings old and decrepit, the food unappealing. Her virtual world, the world inside the game Avalon, is exciting, violent, eventful, and rather bright, but also monotone. By the end of the film, Ash has moved up to a level that looks like the reality we all know, and this level is called "Class Real," making the viewer wonder if finally Ash has reached the world that we know as the real world: maybe she has emerged *out* into real reality. But, in the last scene of the film, Class Real is revealed to be just another level of virtual reality and she moves *beyond* it, to a level called Avalon, which we do not see and are left to imagine (just as we were left to imagine what Kusanagi's new reality would be like at the end of *GiTS*).

Unlike in *The Matrix*, where the return to "real" reality is presented as the highest good, Oshii's film suggests that we can never know what or where reality is—any or none of the levels of the game may be reality, and to privilege one over the other is an arbitrary choice. In other words, in this film Oshii seems to be rejecting *The Matrix*'s nostalgia for "the human," in favor of a completely posthuman worldview. In *Avalon* there is no nostalgia, no tear jerking, no triumphant ending.

Throughout most of the film, Ash certainly appears to be the perfect example of the emotionless, violent cyborg, even though she is apparently a fully organic human who only intercorporates with a machine when she wears her virtual reality helmet and enters the game. She exhibits little emotion while playing the virtual reality game, but even less when she takes off the helmet and returns to her "real world."

However, there is one context in which even the cold, posthuman Ash exhibits positive affect: when she returns home to her flat and interacts with her dog, a basset hound. The sensory and emotional richness of the scenes of Ash with her dog act in stark contrast to the achromatic look and impassive tone of the rest of the film to that point, and imply that it is only through social interaction with the

Figure 11.3. *Avalon*. Ash smiles with pleasure as she smells the food she has made for her dog.

animal with which she co-habits that Ash can regain something of that affectively-dense embodiment.

It was thus in *Avalon* that Oshii first used an important canine character to theorize the affective potentialities of cohabiting companion species. But in *Avalon* the dog is still just "something to think with"—the film is about Ash's evolution and the dog is only a small part of that. It is in his next film—the animated *Innocence*—that Oshii takes his posthuman, post-anthropocentric theorizing to a higher level. As he remarked in an interview when *Innocence* was screened at the Cannes Film Festival (where it was nominated for the Palme d'Or), "This movie does not hold the view that the world revolves around the human race. Instead, it concludes that all forms of life—humans, animals, and robots—are equal. . . . What we need today is not some kind of anthropocentric humanism. Humanity has reached its limit."[28] Unlike many recent theorists of evolution into the future, Oshii does not focus on *either* the relationship of humans and machines (early cyborg theorists), *or* that of humans and their organic companion species (recent Haraway, recent Derrida, and so on), but rather he narrativizes in detail a "queer family of companion species" that includes many kinds of ontologies living together and interacting in complex ways.[29]

The protagonist of *Innocence* is Batou, a masculine-shaped cyborg who works for Division 9, just as Kusanagi Motoko did in *GiTS*. In fact, Kusanagi and Batou were close friends in the earlier movie, and in *Innocence* we discover early on that Batou had loved Kusanagi and is intensely lonely now that she has evolved into a disembodied life form and is no longer in his world. If one of the central questions of *GiTS* was, What is the nature of posthuman reproduction; in *Innocence* one of the central questions is, What is the nature of posthuman love? To put it another way, *Innocence* poses the question: Is love possible only for human beings, or are emotions and affect also possible in artificial beings?[30]

As our protagonist, Batou, seeks to solve a murder mystery involving completely artificial, female-shaped androids (gynoids), he is really longing for and seeking a reunion with Kusanagi, his lost love. And, in the end of the film, he does get to meet her again, temporarily downloaded into an artificial body, and she assures him that she still exists and is near him whenever he accesses the Net. She then disappears, and Batou goes back to his life. He does not evolve into any higher form of the posthuman, but throughout the film he interacts with a wide variety of animate/d entities, who all live, work and in some cases have sex together: mostly organic humans, other cyborgs, cloned animals, automata, dolls, and disembodied life forms.

Throughout the film, Batou exhibits very little affect or feeling. He does occasionally grimace in especially tense situations, but never shows on his face any more tender emotions. The only exceptions are the scenes that show him interacting with his dog.

In the first such scene Batou returns to his lonely flat and sees his dog, a basset hound, running to greet him. We see Batou heat special food for the dog in the microwave, tasting the food for temperature and texture. As he puts the food down on the floor and the basset hound eagerly begins to eat, Batou gently moves its long ears out of the way.

As the scene continues, Batou sits in his easy chair while the dog, having finished eating, plays with its toys—a mechanical dog that is also a music box, and a ball with the image of a large fish inside it. When the dog nudges the ball with its nose, the fish appears to swim and the two creatures appear to gaze into each other's eyes. The dog even seems to be watching its own reflection in the toy. As when the viewer witnessed Anakin Skywalker seeing the helmet descending to swallow him up (a terrifying image of involuntary cyborgization and

Figure 11.4. *Ghost in the Shell 2: Innocence.* Batou tastes his dog's food.

loss of self), we here see the dog seeing itself (a charming image of autonomous non-human selfhood). The scene ends as Batou scans a 3D photograph that he found at a crime scene and the dog comes and plops its heavy head into Batou's lap. Batou frowns with surprise, but makes no move to push the dog away.

Although Batou's face hardly changes when he interacts with his dog, the emotion he feels is palpable in the care he takes over its food and medicine. The range of sensory modes that come into play in this scene is striking: besides vision, we have Batou smelling and tasting the food, feeling its temperature, gently touching the dog's ears to move them out of the way, hearing the dog's whimpers of pleasure, and allowing the dog to flop into his lap. This scene recalls the similar sensory richness of the two scenes in *Avalon* in which Ash is caressing her dog and preparing its meal. In both of these cases, dogs act as affective magnets in drawing positive emotions and sensorily rich experiences out of their normally impassive cohabiting (post)humans.

Oshii has said that he wrote the screenplay for *Innocence* in order to answer a question that was put to him in an interview: "If humans have no memory and no body, in what sense are they still human?" His answer in the interview was one word: *omoi,* which can be translated as thought, feeling/emotion, or even love, depending on the context.[31] Oshii explains that he wrote the film to explore what happens when

Figure 11.5. *Ghost in the Shell 2: Innocence.* The dog and fish seems to gaze at each other.

Figure 11.6. *Ghost in the Shell 2: Innocence.* Dog sees self reflected in toy.

memory and the body are untrustworthy as foundations of selfhood, and when love/emotion is the only remaining marker of self; he wanted to imagine what the next stage of posthumanity would be under those circumstances. He says, "Even if we are already resigned to the loss of [the body and memory], I believe that love/emotion remains (*omoi ga*

nokoru). It may be some kind of feeling toward a particular woman, or toward the dog who lives with you, or toward the body you have lost." "The love that a person leaves behind is the evidence that they have lived."[32]

Conclusion

There has been much theorizing in recent years about the idea of the animal and its relation to whatever it is that humans are or are evolving into—Deleuze and Guattari's idea of "becoming-animal," for example, or Derrida's "The Animal That Therefore I Am," or the recent attention to Kojève's notion of "animality"—but most of these theories involve the animal simply as a metaphor or tool for thinking about the (human) self: they remain anthropocentric. According to Oshii and Haraway, however, it is crucial to keep the literal, embodied animal in mind when attempting to understand the evolution of the queer family of companion species. Haraway emphasizes the literal, physical, daily, embodied, and affective interaction with animals—particularly dogs—that has been a part of our evolution for millennia. We have *coevolved*, and now are, literally, physically and genetically part of each other. And she rejects the fluffy idea, common to many animal lovers, that the relationship of dogs to humans is one of unconditional love. She sees dog–human relationships as a matter of "seeking to inhabit an inter-subjective world that is about meeting the other in all the fleshly detail of a mortal relationship." She adds, "Receiving unconditional love from another is a rarely excusable neurotic fantasy; striving to fulfill the messy conditions of being in love is quite another matter." What are important are the "fleshly, meaning-making details of worldy, face-to-face love."[33]

In his cinematic work, Oshii pursues the same line of argument, by *showing us* the "inter-subjective world" of Batou and his dog in all its "fleshly detail." It is clear that Batou could not be who he is without the presence of the dog. And perhaps more important, Oshii shows us the *dog's subjectivity* apart from Batou, as it gazes into the eyes of the fish inside its toy. In *Innocence* we see not humans and dogs, with a focus on their past coevolution and present cohabitation (which is Haraway's theme), but rather the "fleshly, meaning-making" interactions of a cyborg and a (cloned) dog, a (cloned) dog and an inorganic fish, cyborgs and dolls, mostly organic humans and automata, as well as

the interactions of a range of other organic and inorganic (but still live and intelligent) entities, with a focus on their current cohabitation and their future coevolution.

In the recent work of critical feminist thinkers like Haraway, Hayles, and Rosi Braidotti, a distinction is implied between post-*humanism*—a post-anthropocentric, anti-Humanist philosophical position with which they identify—and *posthuman*-ism, which is characterized as an outmoded celebration of the cyborg or other form of futuristic human.[34] Oshii's work rejects this split and contends for the continued importance of posthuman-ism alongside post-humanism, though not solely in a celebratory mode. His films thematize a post-anthropocentric anti-Humanist philosophy that *thoroughly* decenters the human by literalizing a compelling range of posthuman (and postanimal, and postanimate/postorganic) beings and making us care about them.

Oshii's answer to the question "Where the holy hell are we going?" is that the "we" who are making this trip include a wide range of independent subjectivities, and where we end up will be a matter of our complexly intertwined coevolution. And his answer to "So what?" is "*omoi ga nokoru* (love/emotion will continue)"—not a nostalgia for an Edenic past, nor a blissed-out techno-bunny vision of a perfect future, but a cautious and fleshly vision of ongoing relationality.

NOTES

1. Nicholas Gane and Donna Haraway, "When We Have Never Been Human, What Is to Be Done?" *Theory, Culture & Society* 23 (2006): 135–58; 136.

2. Donna Haraway, "A Cyborg Manifesto: Science, Technology, and Socialist-Feminism in the Late Twentieth Century," *Simians, Cyborgs, and Women* (New York: Routledge, 1991) and *The Companion Species Manifesto* (Chicago: Prickly Paradigm Press, 2003).

3. Arthur Kroker, *Body Drift: Butler, Haynes, Haraway* (Minneapolis: University of Minnesota Press, 2012), 5.

4. *Innocence* (2004, dir. Oshii Mamoru; script Oshii Mamoru; Production I.G.) includes a female character named Haraway who expresses great sympathy for mechanical beings, and Oshii has acknowledged that he based her on Donna Haraway. Ueno Toshiya and Oshii Mamoru, "Anime wazure kara hajimaru: 2D to 3D no hazama de [Anime begins from disjuncture: at the border between 2D and 3D]," *Yûriika* (*Eureka*) 36, no. 4 (2004): 58–74; 70.

5. "Technobiopolitics" is Haraway's amended and enhanced version of Foucault's concept of "biopolitics."

6. *Kôkaku kidôtai: Ghost in the Shell* (1995, dir. Oshii Mamoru; script Itô Kazunori, based on the manga by Masamune Shirow; Production I.G.).

7. *Avalon* (2001, dir. Oshii Mamoru, screenplay Itô Kazunori, Japanese/Polish production).

8. "Critical (posthumanist) feminism" is my term for the current iterations of what was once called cyborg feminism, which drew heavily on Haraway's and Hayles's work. Because both Haraway and Hayles have now to some extent disavowed the importance of the cyborg as well as the term *posthuman*, I put the term *posthumanist* in parentheses here and discuss it further in the conclusion.

9. Gane and Haraway, "When We Have Never Been Human," 145.

10. "You . . . can't think [companion] species without being inside science fiction. Some of the most interesting species stuff is done through both literary and non-literary science fiction projects—art projects of various kinds" (Gane and Haraway, 140). Rosi Braidotti also mentions the importance of science fiction in post-anthropocentrist studies in *The Posthuman* (Cambridge: Polity Press, 2013), 57–58.

11. Mark Johnson, *The Literary Mind: The Origins of Thought and Language* (Oxford and London: Oxford University Press, 1996), 4–5.

12. Kroker, *Body Drift*, 15.

13. "Intercorporation" refers to mutual incorporation of the other. See Sharalyn Orbaugh, "Sex and the Single Cyborg: Japanese Pop Culture Experiments in Subjectivity," in *Robot Ghosts and Wired Dreams: Japanese Science Fiction from Origins to Anime*, Christopher Bolton, Istvan Csicsery-Ronay Jr., and Takayuki Tatsumi, eds., e 172–92; 178–79 (Minneapolis: University of Minnesota Press, 2007).

14. N. Katherine Hayles's important critical work, *How We Became Posthuman: Virtual Bodies in Cybernetics, Literature, and Informatics* (Chicago: University of Chicago Press) was first published a few years later, in 1999.

15. Chris Hables Gray, ed., *The Cyborg Handbook* (New York: Routledge, 1995).

16. Here I do not distinguish between true cyborgs, such as Darth Vader, who is an amalgam of organic and machinic parts, and intelligent androids, such as *Star Trek: The Next Generation*'s Data or Bishop of *Alien*—in both cases their physical composition is left vague but may include no organic material.

17. It was in 1996 that the film *Star Trek: First Contact* was released, exploring the nature of the cyborg at length. This film featured a cyborg "queen," the only feminine-shaped being among the Borg depicted. It was not until 1999 that a female Borg character, Seven of Nine, debuted, in the fourth season of *Star Trek: Voyager*.

18. In "The Best of Both Worlds," parts I and II, which first aired on June 18, 1990, and September 24, 1990. Written by Michael Piller.

19. Brian Ruh, *Stray Dog of Anime: The Films of Oshii Mamoru* (New York: Palgrave Macmillan, 2004), 2, citing "Chat with the Wachowski Brothers," *Official Matrix Website*.

20. In "A Cyborg Manifesto," for example, she emphasizes that stories valorizing a lost Eden encode a "longing for fulfillment in apocalypse" (175).

21. This is not to say that Haraway was indifferent to the body: she offers the example of the physical suffering of exploited women laborers, such as immigrant Malaysian women in Japan. But these are women with "normal," human embodiment rather than the visions of the machine-human amalgam common in Hollywood SF film.

22. Haraway, *Companion Species Manifesto*, 11.

23. Hayles does acknowledge the continued importance of the cyborg: "The cyborg is an instantiation of situated knowledge in the cognisphere, not just an old-hat, superseded metaphor for the posthuman" (165). The way her acknowledgment is phrased, however, makes it clear that many thinkers have relegated the cyborg to the "old-hat" dustbin. N. Katherine Hayles, "Unfinished Work: From Cyborg to Cognisphere," in *Theory, Culture & Society*, 159–66 (Thousand Oaks, Calif.: Sage, 2006), 165.

24. Braidotti, *The Posthuman*, 64ff.

25. Gane and Haraway, "When We Have Never Been Human," 139–40.

26. Hayles, *How We Became Posthuman*, passim.

27. *Blade Runner* in its various cuts is another film that is clearly part of this international conversation.

28. Quoted in Steven Brown, *Tokyo Cyberpunk* (New York: Palgrave Macmillan, 2010), 121.

29. Cf. Derrida "The Animal That Therefore I Am," posthumously published in 2008. ("The animal that therefore I am," in Jacques Derrida, *The Animal That Therefore I Am*, ed. by Marie-Louise Mallet, translated by David Wills [New York: Fordham University Press, 2008].)

30. For detailed analyses of *Innocence*, see Orbaugh, "Sex and the Single Cyborg," 2008, and Brown, *Tokyo Cyberpunk*, 2010.

31. Oshii Mamoru, "*Shintai to kioku no higan ni* [On the equinox between body and memory]," *Oshii Mamoru ron: Memento Mori* [Essays on Oshii Mamoru: Memento Mori], ed. Nihon Terebi (Tokyo: Nihon terebi hôsô kabushikigaisha, 2004), 29–35.

32. Ibid, 36.

33. Haraway, *The Companion Species Manifesto*, 31, 34, 35.

34. See, for example, Kroker, *Body Drift*, 19; Gane and Haraway, "When We Have Never Been Human," 140; Braidotti, *The Posthuman*, 49.

12 The Invention of Romance

Park Chan-wook's *I'm a Cyborg, but That's OK*

STEVE CHOE

Although Park Chan-wook's *Vengeance Trilogy*[1] has been celebrated by film critics and festival attendees, *I'm a Cyborg, but That's OK* (2006) has received a much more lukewarm response from these same audiences. In this chapter I make a case for how Park, as an auteur working within the commercial South Korean film industry, continues his interrogation into film genres in *Cyborg*. If the trilogy critiques the conventions and the moral occult of the revenge thriller, his 2006 film critiques the conventions of the science fiction film and romantic comedy, as well as the humanist assumptions that underlie them.

The film begins with Young-goon (Su-jeong Lim), an assembly-line factory worker who imagines herself to be a cyborg. Convinced that transistor electricity is her only means of nourishment, Young-goon cuts open her wrist and inserts wires into the bloody gash. Park displays admirable virtuosity in this opening sequence, relishing in the sheer joy of the cinema by utilizing precise camera movements and cutting between credits and flashbacks in time and place. The opening is followed by the sterile settings of a psychiatric ward, where the film settles into the story. Already admitted as a patient, the psychotic Young-goon, with unkempt hair and bleached eyebrows, begins speaking to clocks and florescent lights. She believes that she can communicate with these devices when wearing her grandmother's dentures. Irrevocably convinced of her technological constitution, Young-goon becomes anorexic, refusing human food.

As the film continues, we meet a host of delusional and mentally unstable characters in the ward, as if plucked from Milos Forman's *One Flew Over the Cuckoo's Nest* (1975). They exhibit obsessive behaviors, at once cruel and then humorous the next moment. A narcissistic, overweight woman eats the white radish that Young-goon refuses to eat. A salary man who thinks that he is at fault whenever anything goes

Figure 12.1. Young-goon enters the psychiatric ward for the first time.

wrong walks backward in a display of extreme politeness. And a young boy believes that he is born with an invisible rubber band that constricts his waist. At the institution, Young-goon meets a patient named Il-soon (played by superstar talent Rain), who has been institutionalized for his kleptomaniac tendencies and unrelenting obsession with the cleanliness of his teeth. In his first movie role, Rain serves as the film's leading romantic male protagonist as the two young psychotics fall in love. By the end of the film, he learns to affirm her delusion of cyborg-being, and despite her continued mental illness, convinces the emaciated Young-goon to eat a mouthful of rice.

In his review for the *Guardian,* film critic Peter Bradshaw writes disapprovingly of *Cyborg* and criticizes the film for "taking very lightly the anger and alienation of people genuinely suffering from mental illness." For him, "the origins of Young-goon's depression are not treated with any great dramatic depth. There are bizarre reveries, including a yodeling musical interlude, but this is a frustrating and unsatisfying piece of work."[2] In the following I argue that Park's ostensibly "light" treatment of the mentally ill, far from being what Bradshaw calls a "softcore fantasy," should be read more affirmatively. The depiction of Young-goon and the patients in the psychiatric ward is at once a rejection of the melodramatic codes normally associated with the

representation of mental illness, as well as a presentation of an extreme instantiation of romantic love—one that, through its flights of fantasy, asks how love between two people may be depicted, and how it is possible at all.

Bradshaw's disapproval responds to Park's treatment of trauma in his film and its seeming refusal to depict mentally ill characters who obey the conventions of the sentimental melodrama. In contrast to Jeong Yoon-Chul Jeong's *Marathon* (2005),[3] a tear-jerker about a mother who encourages her mentally disabled son to run a marathon, Park refuses to depict the main protagonists sympathetically, negating the generic depiction of disadvantaged characters who overcome their personal struggles. As the spectator sympathizes with the young couple, *Cyborg* eventually fails to satisfy her demand to see them redeemed, returned to mental health, and live happily ever after. Park's film also operates in stark contrast to a film like *Shrek 2*, the third-highest-grossing film in South Korea in 2004, in which the two main protagonists are redeemed at the conclusion of the film while viewers are left with the reassuring message: "I'm an Ogre, but that's OK." In this DreamWorks animation, Shrek and Fiona are apparently okay because what matters is the content of their moral character and that one loves and is loved, regardless of their outward, nonhuman appearance. Another kind of contrast with Park's film may be made to Jean-Pierre Jeunet's *Amélie* (2001). Like *Cyborg*, *Amélie* exteriorizes the whimsical fantasies and dreams of the female protagonist through computer graphic spectacles. But unlike the French award winner, Park's film does not partake in its brand of generic melodramatic sensibility: Young-goon does not help the helpless, and she is not rescued from her shell of psychological delusion at the end of the film.

Throughout his film, Park creates damaged characters while observing them with a non-normative, amoral gaze. The film eschews the conventional narrative trajectory of a traumatized subject who works through the past in order to return to normalcy, as neither Young-goon nor Il-soon seems capable of coming to terms with their own traumatic pasts. Perhaps it is this "nonserious" treatment of the young psychotics that Peter Bradshaw finds so objectionable. They seem not to be redeemable human beings, but unsympathetic and treated much too ironically. Indeed, Young-goon and Il-soon are both cyborgs described by Donna Haraway in her well-known manifesto: "The cyborg

has no origin story in the Western sense; a 'final' irony since the cyborg is also the awful apocalyptic *telos* of the 'West's' escalating dominations of abstract individuation, an ultimate self untied at last from all dependency."[4]

In a 2008 interview with the filmmaker, Alex Fitch suggests that *Cyborg* seems to be influenced by sci-fi imagery in American and Japanese cinema. He cites examples such as the man-machine hybrid in *Tetsuo: The Iron Man* (1989) as well as stories of mental patients living in a science fiction world in *Slaughterhouse Five* (1972) or Terry Gilliam's *Twelve Monkeys* (1995). Though Park's appreciation of American and Japanese genre films is well known, he nevertheless responds that "I guess you can see those influences but those films are not what I thought of when I was making this film. In fact, I was worried about finding any traces of other films and when I noticed anything like that, I tried to erase the influence."[5] Despite his reputation as a cinephile-filmmaker, Park nevertheless claims that any similarities to other films remain merely coincidental, attesting to his anxiety of influence and a vigilant negation of cinematic referentiality. However, later in the interview the filmmaker explains that he remains keenly aware of the multiplicity of meanings inspired by the references and generic codes deployed in his films. Thus, while he knows that viewers will read into the signs deployed in his film—the dentures, white radish, or even the meaning of life—Park affirms the semiotic multiplication brought to bear on them, despite their typical genrification and melodramatization.[6] He aims to erase all filmic traces in *Cyborg*, traces that may or may not be intended, and yet this erasure also aims to open up worlds of meaning beyond those that may be too easily folded back in their typical sentimentalization common to the melodramatic mode.

The definition of melodrama I am utilizing comes from a key chapter by film scholar Linda Williams. In "Melodrama Revised," she calls melodrama "the fundamental mode of popular American moving pictures."[7] Specifically, she identifies a number of characteristics that subtend character development in narrative cinema. Focusing on victim-heroes and the recognition of their virtue,[8] melodrama presents "characters who embody primary psychic roles organized in Manichean conflicts between good and evil."[9] As Williams isolates these fundamental characteristics of the melodramatic mode, she also provides great insight into how characters in a film are imbued with

interiorities, psychologies, and intentions that are to be ascertained by the spectator through the interpretation of the characters' externalized behavior. Through observation of what characters do and the expressivity of their faces, spectators are encouraged to imbue them with identities that are believable and attest to the reality of the moral self. Perception and moral judgment are thus simultaneous through character development in melodramatic narrative cinema. In order to make this moral truth crystal clear, the film's conclusion returns to an original state of things, allowing melodrama to reiterate the humanity of the film's protagonists through the recognition of their virtue. "Melodrama begins, and wants to end, in a space of innocence."[10] If the film is to have its happy ending, narrative must restore the social relations that began it. If they are not reestablished, the film ends unhappily. Nostalgia arises in conjunction with the desire to return to innocence, often an innocence that remains fantastical, never having existed in the first place.

In contrast to the American melodrama, the depiction of Young-goon's trauma and her delusional fantasies resists generic interpretation, thus resisting the entertainment of the spectator with the melodramatic trajectory of how the sick may return to health. This resistance clearly frustrates critics such as Peter Bradshaw who demand "great dramatic depth" when presented with the cinematic depiction of mental illness. Young-goon and Il-soon remain illegible to the gaze of such a spectator, always already habituated to the expectations of American popular cinema, and who expects the experience of redemption through the recognition of the characters' inherent, humanistic virtue.

In this, *Cyborg* invites symptomatic interpretation while quickly disavowing and frustrating it. In his reading of Park's celebrated film *Oldboy*, film scholar Kyung Hyun Kim shows how this 2003 film achieves "a postmodern condition marred by schizophrenia."[11] He writes that the "admittedly coy comic gags and 'cool' effects"[12] throughout the film give way to a fundamental unknowability with regard to its key signifiers: the taste of *gunmandu* (pan-fried dumpling) that stays in Oh Dae-su's memory, the anonymous name of his high school, the recurrent images of ants, or the history of a rumor. Park deploys these signs, not simply to embed them within a closed network of self-referential, narrative meaning, but to underscore the slipperiness inherent to sig-

nification itself, inside and outside the text. His postmodernism gives way, for Kim, to an aporia with respect to knowledge and to the capacity of the viewer to constitute meaning in *Oldboy*. Similarly in *Cyborg*, signs point to logical dead ends, ambiguities persist and do not coalesce into innuendo, and symptoms cannot be traced to an originating cause. The film seems to dabble in the discourse of Freudian psychoanalysis but at the same time does not acquiesce to its teleological demands. When Young-goon "comes out" to her mother and declares that she is a cyborg, the mother misunderstands and she treats her like a young girl who has become pregnant or acquired a secret deformity. "It won't interfere with the way you live," the mother remarks, "just don't let anybody know." The etiology of Young-goon's anorexia ultimately frustrates psychological interpretation.

One may delve into Young-goon's personal history and connect the loss of her grandmother to her imaginations of becoming cyborg. Through a number of flashbacks we are informed that her grandmother believes herself to be a mouse, and one may speculate on how her delusions are passed on through generations. The granddaughter remembers when her grandmother's rodent-like nibbling and gnawing of white radish led to her being taken away by the "white ones," Young-goon's term for the medical practitioners who wear hospital scrubs. However, the connection between this traumatic memory and her believing to be a cyborg is never made clear. Could her mental illness have something to do with Young-goon working endlessly at the radio factory? Or could it have something to do with their ceaseless listening to the radio at home? These questions are not clarified in Park's film.

The same hermeneutic frustration remains when ascertaining the nature of Il-soon's malady. At one point in the film he explains that he began to steal obsessively and exhibit signs of antisocial behavior after his mother left him and took her electric toothbrushes. A possible cause–effect relationship is speculated upon but not confirmed. At best, one may identify his continual tooth brushing as a kind of defensive formation, a compulsion to repeat that is admittedly treated less tragically and more comically. Il-soon's unfolding narrative does not give us any better understanding of his symptoms, and no answers are provided that might conform to a melodramatic understanding of the psyche, how he has dealt with trauma, and why his delusions take the form they do.

Figure 12.2. Young-goon asks her grandmother about the meaning of life.

Throughout her life as a cyborg, Young-goon is concerned above all with her purpose. As a mechanical being, she believes that the vagaries surrounding the "meaning of life" may be circumvented, precisely by disavowing her humanity. In Young-goon's fantasies, her dead grandmother repeatedly appears to dispense with insight into "the meaning of existence." But each time, just as her grandmother is about speak, an interruption forecloses this communication. Young-goon cannot hear her grandmother's voice while she lies in a large glass laboratory cylinder. In another fantasy she is whisked far away by a giant rubber band around her waist, recalling the malady of a fellow patient in the psychiatric ward. A great admirer of Hitchcock, Park populates his films with McGuffins, objects and signs that seem to express meaning, but upon closer inspection remain empty, hermeneutic dead-ends. *Cyborg's* diegetic world is insular, ahistorical even, as if to deliberately refuse representation of real individualities or types while remaining within the culturally nonspecific walls of the mental institution.

Frustrating attempts to be read as a genre film or interpreted symptomatically, *Cyborg* demands another mode of analysis. In order to elaborate a possible direction, I will interpose a philosophical discussion into Park's cinematic deconstruction of the melodrama and its concomitant hermeneutics. An indication forward may be gleaned

from a 2009 interview, where Park is asked what role his university training in philosophy has played in his writing and filmmaking:

> If I were to comment on the specific trend in philosophy or a specific school of thought, perhaps I can say that I still have a trace of existentialism left from my studies. And also I have learned this attitude towards logic, or attitude towards the process of thinking, where I would have this subject, and I would create a sentence around the subject. And then keep following this chain of thought that derived from this subject until I'm met with a wall where I can't go anywhere. Or, if I can put it another way, I have learned how to dig deep down and try and look for the root of where this subject originates from.[13]

This chain of thought may be characterized as essentially critical, one that takes its "subject" and pushes it to its breaking point, where one is met "with a wall" and confronted with an irreducible aporia. What remains important is not an originating source where signification is anchored, but the movement of thought itself as expressed through the powers of the cinema. With this in mind I will now explicate this movement further, taking recourse to close readings of the film in order to isolate a discourse surrounding the origin of sci-fi romance/melodrama, and a kind of ethical thinking that may be aligned with the unfolding of *Cyborg*.

An existential thinker that Park studied while a student at Sogang University in Seoul is the Danish philosopher Søren Kierkegaard. In one of his most well-known works, *Fear and Trembling*, a work with which the filmmaker may have been familiar, the problem of unrequited romantic love is framed as a problem of faith taken to its most irrational limit. In the preamble to the text, we may remember how Kierkegaard discusses a kind of romance that dispenses with "feelings" commonly understood as necessary to romantic love. Though the latter is contingent upon devising strategems for winning the beloved, Kirekegaard shows how the figure of the Knight of Faith, who remains estranged from his beloved, nevertheless loves the princess without condition, without prescription, and without compromise. His uncompromising love "would take on for him the expression of an eternal love, would acquire a religious character, be transfigured into a love for the eternal

being which, although it denied fulfillment, still reconciled him once more in the eternal consciousness of his love's validity in an eternal form that no reality can take from him."[14] Crucial for Kierkegaard is that the Knight of Faith affirms the impossibility of his love, not only in this world, but also in the world of imagined fantasy. He does not envision a moment when his love will be requited. And yet, the philosopher continues, "by faith, says that marvelous knight, by faith you will get her on the strength of the absurd."[15] By "absurd," Kierkegaard refers to the incompossibility of the Knight's love circumscribed by everyday notions of pastness and futurity that delimit the present by modern notions of teleological historicity. The absurd does not give us a conclusive purpose of existence, such as one that a cyborg would demand, but only leads us to the next aporia, the next bend in the spiral of history. To conclusively renounce the princess would mean to give up on love in this world as well as in the next, yet the Knight of Faith finds joy precisely in this renunciation, not in order to imagine an alternative, utopian world where he will win the princess eventually, but one in the here and now. It is precisely the affirmative attitude toward this virtual here and now where the absurd may be grounded.

This affirmation, a gesture that is profoundly ethical, underpins the whole of Park's film, the affirmative "okay" of cyborg-being. In order to convince Young-goon to eat, Il-soon devises what he calls a "rice megatron," fashioned from his pocket photograph of his mother, that he claims will convert human sustenance into electrical energy. Of course, this device does not actually perform this action. Functionally it is only a paperweight imbued with sentimental value. In a scene that seems to express some vague, sexual connotation, again without conclusive psychosexual significance, Il-soon implants the megatron inside her. He raises a knife to her back to open her up, but just as he is about to penetrate her skin, a black marker deftly replaces the knife. Il-soon draws a small door and opens her up. Cutting to her face, Young-goon smiles in pleasure as she receives his mechanical gift. Throughout, the scene unfolds as if two children were play-acting, as if they were learning about sexuality for the first time.

By interacting on her level of belief, while not patronizing and eschewing premeditated deception, Il-soon gains Young-goon's trust so that she can eat a spoonful of rice. In the cafeteria where this happens, all the patients consume a spoonful just as she does, heightening the

drama. When Young-goon swallows, her insides glow and become visible as in an X-ray image. And like Maria's heart-machine in Fritz Lang's 1927 *Metropolis,* we see the megatron inside her function as a motor that will sustain her life. Her mechanical interior, composed of gears and other machine parts, appears as if superimposed onto her skin. Il-soon's gift to Young-goon essentially is a counterfeit apparatus, yet it nevertheless fulfills the exchange of gift and counter-gift that constitutes the social relation. This exchange leaves a kind of spectral excess that affirms Young-goon's "absurd" belief in her own hybrid, cyborg ontology. While this ethics operates both within the everyday economy of giving and receiving between individuals, it also exists to foreclose hasty condemnation of her cyborg-being, exhibited by the psychiatric "white ones," and which immediately reinstates the dynamics of power and manipulation between doctors and their patients. It is significant that the kleptomaniac Il-soon, instead of taking from others, here gives the megatron, not in order to demand a return gift, but to give unconditionally, without reserve and without melodrama, precisely on the strength of the Kierkegaardian Absurd. Throughout *Cyborg,* Park seems to return to this Absurd as the source of his negative criticality, to bring the generic forms of sci-fi and the rom-com to aporia, not only in order to reveal their contradictions but also to think their very origins.

At one moment in *The Movement-Image,* Deleuze aligns Kierkegaard's ethical thinking to the thinking cinema itself. In the chapter on the affection-image, Deleuze introduces an image of pure potentiality that he calls "any-space-whatever," which signifies the representation of an undetermined, virtual space that underlies the production of affect. What is at stake is the faith that such a production is possible at all. Deleuze writes that such questions of faith weave "a whole set of relations of great value between philosophy and the cinema."[16] Both play out the deconstruction and subsequent leap of faith from the any-space-whatever into pure potentiality:

> It is because, in philosophy as in the cinema, in Pascal as in
> Bresson, in Kierkegaard as in Dreyer, the true choice, that
> which consists in choosing choice, is supposed to restore
> everything to us. It will enable us to rediscover everything, in
> the spirit of sacrifice, at the moment of sacrifice or even before

the sacrifice is performed. Kierkegaard said that true choice means that by abandoning the bride, she is restored to us by that very act; and that by sacrificing his son, Abraham redis-covers him through that very act.[17]

Making reference to the narratives Kierkegaard analyzes in *Fear and Trembling*, Deleuze aligns the paradoxical moralism espoused by this existential philosopher with the absurd faith that the cinema can con-stitute meaning at all. What is miraculous is the sensorimotor link between brain and screen, a linkage of body and technology, that gives rise to belief, in the world and in the loved other. This is pre-cisely the faith that Il-soon continues to have in his psychotic princess, Young-goon.

When Park says that in his films he chooses a subject then tries to "keep following this chain of thought that derived from this sub-ject until I'm met with a wall where I can't go anywhere," he seems to work through this chain of thinking through cinematic means. I have been trying to argue for a rigorous critique of romance through the logic of melodrama and the constitution of human being in *Cyborg*. This thinking, achieved with the help of the prosthetics of the cinema, remains untimely with regard to the generic melodrama, because *Cyborg* seems at once to reveal the technics of what is called the human while resisting the absolute surrender to this Western metaphysics. Park's film appropriates the melodrama of the human subject and, moreover, overturns this metaphysics from within. In this, *Cyborg* does not straightforwardly deploy the conventions associated with the American melodrama and its discourse of human love. On the other hand, the film also should not be read as simply a localization of global Hollywood conventions. The critical line of thinking at work here operates in a language that is not national, but in a specifically cinematic language that attends to the present state of an always al-ready global American ideology, and one that reworks genres, criti-cally thinking the history of this globality through the chronotope of the cinema. Here the give-and-take between Korean and American cinemas, across time and space, gives way to a critical, discursive reg-ister that does not acquiesce to an either/or logic, either global or lo-cal, but affirms the exchanges possible between both. The ontology of these exchanges, these gifts, without compromise, without reserve,

and without premeditation, seems to inform the way Park approaches his own critical practice, his own cinephilia, a love for its thoughtful flux and which can never be absolutely possessed.

Indeed, Park's words and Young-goon's cyborg-being as it unfolds throughout the film trajectory recall philosopher Bernard Stiegler in his theorization of technics and time. In his analysis, Stiegler writes that time-consciousness is inescapably circumscribed by our metaphysical mechanisms of calendric and cardinal time, the prosthetic means by which time is exteriorized and made legible. He describes this exteriorization, however, as essentially deconstructive. That is, modern time consciousness is an exteriorizing process of denoting difference, of spacing, continuously delineating past from present, while unraveling metaphysics to the point of its untenability. The model for this delineation, Stiegler notes, is the cinema, unfolding like a melody in time and whose principle, "to connect disparate elements together into a single temporal flux,"[18] precisely expresses the deconstructive action inherent to the experience of duration.

This critique of technics as evolving toward ruination, like the life of the mortal human being, is at stake in Park's film as well. In the very last scene of the film the couple wait in the rain for a lightning bolt that will end their lives. They sit near a tent and hold a long metal pole into the air. Rain comments, "More than our socks are wet." This scene proves once more elusive, even a bit facile in that Il-soon's vaguely sexual remarks yield no psychoanalytic secrets, bringing us once more to ponder Park's Absurd. They wait, not for the utopian, sci-fi vision of the future, but seek the deconstruction of its nostalgic representation, living at the threshold of a metaphysical aporia. They wait, in other words, for a miracle that is impossible and belies their mental condition. "The movie is not interested with the concept of cure," Park remarks, commenting on *Cyborg*, "In my view, a cure is impossible. It's suggesting that even in that situation we should just eat and keep living."[19] Young-goon's trauma and her delusional fantasies resist generic explanation, rejecting the entertainment of the spectator with a melodrama of how the sick returns to normalcy, in order to produce new questions, ethical and cinematic, and to affirm new possibilities of being with the loved other. In waiting, in other words, she and Il-soon keep open the possibilities of a romance-to-come, and yet through this waiting, their romance is restored to them.

NOTES

1. Including the films, *Sympathy for Mr. Vengeance* (2002), *Oldboy* (2003), and *Sympathy for Lady Vengeance* (2005).

2. *The Guardian*, Review of *I'm a Cyborg, but That's OK*, April 4, 2008, www.theguardian/film/2008/apr/04/worldcinema.drama1.

3. *Marathon* was the fourth-highest-grossing Korean film the year *Cyborg* appeared.

4. Donna Haraway, "A Manifesto for Cyborgs: Science, Technology, and Socialist Feminism in the 1980s," in *The Haraway Reader* (New York: Routledge, 2004), 9.

5. Interview with Park Chan-wook, www.wheelmeout.com/4_5.php.

6. See Rick Altman, *Film/Genre* (London: BFI, 1999).

7. Linda Williams, "Melodrama Revised," in *Refiguring American Film Genres: Theory and History*, ed. Nick Browne, 42–88 (Berkeley: University of California Press, 1998), 42.

8. Ibid., 66.

9. Ibid., 77.

10. Ibid., 65.

11. Kyung Hyun Kim, *Virtual Hallyu: Korean Cinema of the Global Era* (Durham, N.C.: Duke University Press, 2011), 194.

12. Ibid., 198–99.

13. "Park Chan-wook—*Thirst, Oldboy*—7/23/09," www.grouchoreviews.com/interviews/292.

14. Søren Kierkegaard, *Fear and Trembling*, trans. Alastair Hannay (New York: Penguin Books, 1985), 72.

15. Ibid., 78.

16. Gilles Deleuze, *Cinema 1: The Movement-Image*, trans. Hugh Tomlinson and Barbara Habberjam (Minneapolis: University of Minnesota Press, 1986), 116.

17. Ibid.

18. Bernard Stiegler, *Technics and Time, 3: Cinematic Time and the Question of Malaise*, trans. Stephen Barker (Stanford, Calif.: Stanford University Press, 1998), 15.

19. Young-jin Kim, *Park Chan-wook*, trans. Colin A. Mouat (Seoul: Seoul Selection, 2007), 117.

13 A Disenchanted Fantastic

The Pathos of Objects in Hirokazu Kore-eda's *Air Doll*

MICHELLE CHO

> *Our machines are disturbingly lively, and we ourselves frighteningly inert.*
> ■ Donna Haraway, "A Cyborg Manifesto"

Air Doll (2009), which director Hirokazu Kore-eda adapted from the manga *Kuki Ningyo* (The Pneumatic Figure of a Girl) by Yoshiie Gouda, presents a modern-day fable in which a doll develops an unexpected consciousness of its objecthood. Having precedent in the Pygmalion fantasy, *Air Doll* initially suggests the clichéd sexual fantasy of the antisocial, *otaku* male.[1] *Air Doll* also contains intertwined references to *Pinocchio* and *The Little Mermaid,* though it undercuts the sentimental humanism of the Disney animated adaptation of the latter with the melancholy ending of the Hans Christian Andersen version. In *Kuki Ningyo,* the doll is a substitute person, an ambiguous, posthuman being that highlights the malleable boundary between artificial and organic, human and humanoid. For the protagonist of *Air Doll,* unlike the marionette or the mermaid, the ability to stand in for a human does not result in magical access to human essence or species-being because the film defines the human on the basis of being treated as such; we will see that this entails being objectified in a continually shifting spectrum of social relations and self-reflection. Hence, the film both confirms and questions the ontological stakes of recognition and the ethical dilemma of the subject's condition of possibility: identification with the other as an object of other subjects' use.

Despite its familiar intertexts, *Air Doll* consistently overturns the expectations of either the fulfillment of sexual fantasy or the sentimental attachment to the value of human experience that transformative narratives like fairy tales normally signify. In contrast, *Air Doll* conceptualizes the human by using clichéd or trite forms of expression

to produce an enigmatic and ambiguous humanoid figure, whose in-betweenness defends an unnamable, unfigurable singularity. By enacting the cliché of the doll come to life, the film remarkably reverses the values of conventional humanism, through excessive sentimentality conveyed through style, motifs, characters, and sound design. Thus, rather than defining the human on the basis of its capacity for sympathetic identification (that is, recognition), the film presents the cliché or the substitute as the means of preserving difference. *Air Doll* imagines the subject's embodied form as a membrane enclosing an interiority that refuses symbolization, a figuration of subjectivity that reflects the limits of the modern project to decode the workings of the mind.

In my reading of *Air Doll*, I focus on the film's gesture of positing the subject as an empty container, an "air doll," so to speak. I argue that the film thematizes the separation of interior reality and external appearance in order to question the effects of this perceived categorical distance on the prospects and possibilities for forging nonviolent social relations. By arguing for genre cliché as a form of emptiness—in terms of the flatness of undifferentiated and generic roles like the doll—and emptiness as the necessary condition for the positive articulation of the human and its others, this chapter examines the function, beyond commercialism, of the formal innovations of a global "fantastic" cinema that I call the "disenchanted fantastic." This is a fantastic realm that suggests not an intrusion of the fantastic into a realist world but rather a displacement of the binarized understanding of reality and fantasy into a question of the relation between interiority and exteriority. I analyze the appearance and function of the fantastic in *Air Doll* in two related registers: first, as an example of the expanding sensibility of a global "fantastic" cinema, and second, in its varied treatments of the form and function of privatized fantasy as simultaneously a survival strategy against hostile and depersonalized social relations and a key to the social forces of atomization that result in the absence of community in the lived spaces of late capital.

Film marketers or genre film audiences have only recently begun to use "fantastic film" as a descriptor. However, the growth of fantastic film festivals in the past two decades seems to suggest that the term has accrued a certain intelligibility as a synonym for nonrealist genre films, promising a particular cinematic experience for a rapidly expanding group of viewers. Thus, the demonstrated preference for genre film-

making evidenced in the last several years, even by auteur filmmakers like Kore-eda,[2] is partly based on the principle of transnational legibility. Indeed, in the expanding network of American, European, and Asian fantastic film festivals, "fantastic film" is now capable of signifying popular genre film in general, to appeal to the widest swathe of possible audience demographics.[3] A European network of fantastic film festivals, the European Fantastic Film Festivals Federation (EFFFF), was established in 1996 and includes twenty fantastic film festivals in various European cities. The EFFFF bestows annual awards on the best European and Asian fantastic films called the "Méliès d'Or" in homage to the forebear of fantastic cinema, illusionist and filmmaker Georges Méliès. Non-European festivals include the large Asian film festival, the Pucheon International Fantastic Film Festival (PiFan), founded in 1997 and held in Pucheon, South Korea; the Fantasia Fest in Montreal, Canada, inaugurated in 1996; and the Fantastic Fest in Austin, Texas, founded in 2005. PiFan and Fantasia showcase Asian fantastic cinemas, and most fantastic film festivals include action, thriller, mystery, and anime, in addition to the conventional "fantastic" genres of horror, sci-fi, and fantasy. While it is still the case that festival viewers represent a small and dedicated group of filmgoers, the interest in global genre cinemas extends beyond that of cult film reception, as the genre cinemas produced under the auspices of global fantastic cinema range from comfortably commercial products to those works that target niche audiences. In keeping with most international film festival events, the expanding network of fantastic film festivals has proven extremely effective as markets, with the emphasis of film festivals shifting from host cities' public culture programming to industry activities.

In light of the use of genre to produce legibility in increasingly transnational contemporary film markets, processes of localizing generic conventions hinge on the portrayal of the relationship between characters' interior and exterior realities—whose tension I take as the primary characteristic of the "disenchanted fantastic." Although this relationship can sediment into its own subgenres, for instance the psychological puzzle film, in which objective and subjective realities are blurred to subvert the spectator's assumption of a controlled observer position, I argue that the disenchanted fantastic's critical potential stems from the refusal to reinforce the equation of empirical reality and social fact, which would afford fundamental ontological status to

global capital's misogynist and exploitative social relations. The disenchanted fantastic seeks to express the irrational substrate of rationalized social space, as opposed to the intrusion of the supernatural, into disenchanted, modern reality. I hope to show that the genre's capacity for abstraction, as well as its transnational legibility, reconceptualizes both the fantastic and the parameters of the human articulated in the disenchanted fantastic's critique of rationalized societies.

Let me proceed, then, by contextualizing the category of the disenchanted fantastic. The generic framework I propose here draws from the ambiguity of the distinction between observation and imagination, reality and fantasy in film narrative and spectacle. This conceptual category takes as its point of departure Tzvetan Todorov's reading of Kafka's "Metamorphosis," which quietly revises the primary structural categories upon which Todorov centers his genre study, *The Fantastic.* Through Kafka, Todorov designates a new, modern modality of the fantastic, in contrast to the nineteenth-century mode defined by the hesitation evinced by the reader of fantastic narratives. Of Kafka's text, Todorov explains, "the 'normal' man is precisely the fantastic being; the fantastic becomes the rule, not the exception."[4] An important feature of this reversal between the fantastic and the exceptional is a surprising lack of surprise, which for Todorov marks a qualitative change in the character of the fantastic, whose earlier mode served a paradoxically realist social function; the reader and the hero "must decide if a certain event or phenomenon belongs to reality or to imagination. . . . It is therefore the category of the real which has furnished a basis for our definition of the fantastic."[5] Todorov concludes his text by designating Kafka's "generalized fantastic" the "new fantastic," in which the *separation* between the supernatural and the rational ceases to be the focus of the narrative, but rather, their imbrication within the subject himself.

The fantastic as presented by *Air Doll* portrays the overlapping coexistence of multiple worlds by demonstrating the failure to resolve ambiguity by turning to interiority as a stable space of refuge. The difficulty facing this attempt underscores the heterogeneity of cinema's uncanny spaces. The uncanniness of disenchanted fantastic cinema stems from the emergence of the unfamiliar in the familiar through the estrangement of reality turned generic—where various regimes of genre signification are used to portray the predicaments of contempo-

rary social relations. Though the generalization of the term *fantastic* clearly serves primarily as a marketing device, uniting audiences in diverse locations by reference to ostensibly familiar genre expectations, I propose that it might nevertheless have some explanatory value: the enlarged sphere of the fantastic allows us to better understand the implications of the increasing genrification of global cinema as an index of the attempt to suture different and indeed incommensurable realities by an appeal to the disparity between psychic and social fact.

One important factor of the expansion of the fantastic film category to include a variety of genres beyond science fiction and fantasy has been the discourse of the extreme, particularly in the context of East Asian cinemas, usually connoting the visually explicit transgression of social norms concerning violence and sexuality. The association of extremity and fantastic film negotiates the relationship between individual and collective fantasy in embodied fashion, especially in the violence made spectacular in extreme cinema.[6] In *Air Doll,* the body is figured both as a container for interior experience and as a conduit for identification, through the traces of physical contact and affective response that mark the body's surface.[7] The disenchanted fantastic thus features the paradox of elevating the body through its very vulnerability. Bodies fail to stabilize the border between interior and exterior reality, thus displaying the fragility of this boundary as the subject's primary defense against the encroachment of the social. Rather than maintaining a mind/body dualism, the disenchanted fantastic foregrounds the body as the site both separating and linking fantasy and reality. In so doing, the genre establishes the continuity between perception and interpretation in the experience of worlding, in a manner that distinguishes it from the world-making characteristics of science fiction. What the disenchanted fantastic shares with SF is a focus on disenchantment, in the Weberian sense of rationalization. Thus, the disenchanted fantastic and SF are proximate genre categories, but in the case of the former, the realist function of a continuous relation to extradiegetic reality persists as a legacy of the traditional fantastic. The primary characteristic of the disenchanted fantastic, then, is an ambiguous or ambivalent world-making function.

Like Kafka's "Metamorphosis," *Air Doll* grounds itself in a fantastic world in which supernatural elements coexist with rather than interrupt recognizable reality. In the film a life-sized inflatable sex doll

comes to life one morning, for no apparent reason, and acquaints her-self with her neighborhood. The film displays the following features: (1) the projection of interior states in voiceover and frame-breaking interludes; (2) the confusion of internal and external reality as a pri-mary source of narrative conflict; and (3) a focus on interpersonal re-lationships that transgress the supposed boundaries of what Jameson has called "the reified atomization of capitalist social life."[8] The epony-mous air doll, Nozomi, continually misunderstands the words and in-tentions of others, not because of her lack of empathy, but conversely, because of everyone else's narcissism. Moreover, Nozomi's path from innocence to experience is set against a cast of neighborhood charac-ters who are transparent representations of stereotypes, including her owner Hideo, an emotionally stunted, middle-aged man who works at an anonymous chain restaurant. He finds refuge from the petty humilia-tions of his service sector job in the home life he forges with his sex doll, complete with daily domestic rituals. The neighbors she discovers when she ventures outside of Hideo's apartment on the morning she "wakes up" are similarly one-dimensional: a harried single father and his latchkey daughter, who has a fixation on Ariel of Disney's *The Little Mermaid*; an aging, unmarried woman trying to preserve her beauty and self-esteem; a bulimic shut-in recently transplanted to the city; and a pair of lonely senior citizens, one of whom has a habit of turning up at the local police station to confess to crimes of passion she hears about on the daily television news.

All of these people feel empty like Nozomi, and she discovers in her interactions with them that the main feature of her new human world is the insatiable need for identity to fill this void. This is suggested rather bluntly in the case of the bulimic, whom the film usually pre-sents mid-binge, frantically trying to gain substance through compul-sive food consumption. The two older women, one who tries to regain her visibility by wearing beautifying face masks and anti-wrinkle con-traptions and the other who seeks recognition by inserting herself into fantastic narratives about scandalous crimes of passion, demonstrate the narrow parameters of female gender identity: beautiful object or corrupting agent.[9] However, the film demonstrates to devastating ef-fect in its climax that Nozomi is precisely *not* like these people; she is *literally* empty and not a person but a doll. Nozomi's appearance suggests elements of cuteness that have become coded invitations to

Figure 13.1. Nozomi learns her first lesson after venturing out of her owner's apartment: how to sort trash. Dressed in a fetishistic French maid costume, she wanders around the city inviting objectification in a state of wide-eyed wonder.

the projection of sexual fantasy; thus all of her interactions, even the most banal, take on a feature of sexual exchange. Her body becomes a site of projected desire, and the film's most deliberate formal gesture of estrangement seems to be translating the world of manga aesthetics into live action, with its excessive abstraction, particularly its neotenous faces and cute/sex appeal—Nozomi's fetish costumes, saucer eyes, and perpetual state of wonder.[10]

The first things that Nozomi does with her newfound consciousness are to find a job and fall in love. Against fabular norms, she does not fall in love with her owner. Instead, she finds him rather repulsive, and during scenes of his continued use of her as a sex doll, Nozomi's face conveys a willful attempt at dissociation, suggesting that she registers his use as violation. Nozomi finds a job at the local DVD store and develops a crush on a coworker who helps her learn about movies, which *Air Doll* suggests provide an infinitely rich world of experience (no distinction is made between real life and cinema). The owner of the store complains that a DVD is just a substitute for a real movie experience, by which he means the experience of watching a film in a theater. Junichi, Nozomi's love interest, is a curiously blank individual as well; he seems contented by Nozomi's company, despite her utter naïveté.

Figure 13.2. Nozomi's body deflates after her accident at work. Actress Bae Doona's face is for the first time juxtaposed with the prop limbs of an actual inflatable doll; at all other times, the film requires the viewer to project the materiality of the doll onto Bae Doona's body.

The film's aesthetic of whimsy and cuteness continues unabated, except for the disquieting scenes with Hideo and Nozomi in which she must *pretend* to be a doll again (though we are to understand that she is still a doll), until the moment when Nozomi's objecthood is rendered uncannily literal, when she accidently falls off a stepladder at work and punctures her arm. As she lies helplessly deflating on the ground, Junichi comes to her rescue, taping over her gash and reinflating her with his breath.

Nozomi's air hole is located at her belly button, and the scene is both an image of rebirth and of sexual pleasure. For Nozomi, Junichi's breath is qualitatively different from the air that she pumps into herself every morning, and the intimacy of the encounter makes her blissfully happy for several days after the incident. Here, the film suggests that Junichi's physical breath, taken as a symbol of love's substance, has had the magical effect of filling Nozomi's emptiness. In these scenes, the film establishes Nozomi's blossoming into human subjecthood, as she is introduced to the pleasures of commodity consumption: she stops wearing the French maid uniform she finds in Hideo's closet and instead goes shopping for her own clothes at a department store, where

she also buys cosmetics to cover up the plastic seams visible along the contours of her body. Nozomi happily roams the city, collecting cheap trinkets and glass bottles; she has a fixation on the refractive properties of glass and other transparent forms that envelop emptiness, with which she feels an affinity as such an object herself. She reaches the heights of rapture when she sees Junichi again and he tells her that he feels very much the same as her: empty inside. This misunderstanding sets the stage for the intrusion of violence by which the film ruptures the promise of plenitude via identification.

Nozomi's fantasy of fullness is literally deflated when she realizes that she and Junichi's relationship cannot be exclusive, because she is merely a stand-in for Junichi's ex-girlfriend. Nozomi's expertise in substitution—she states several times in the film that she is an "air doll, a substitute for handling sexual desire"—has taught her that the logic of substitution is interminable, emptying out the particularity of the objects that replace each other, a lesson also conveyed by her initiation into consumer identity. This is why the substitution of various identities to fill the inner void of subjectivity is also an incessant activity. Despondent over this realization, Nozomi offers herself up to Junichi, as she comes upon the solution that her attitude of utter selflessness will make her relationship to him unique and irreplaceable. She says to him, "I don't mind if I'm a substitute for someone else. I'll do anything for you. That's what I was born for." Nozomi still holds to the possibility that the void opened up by her arbitrary awakening might be fulfilled in her dedication to and subsequent embrace of her identity as an object of use. Junichi seems intrigued, but not *moved* or touched by her avowal that she wants nothing more than to lay herself at his disposal. The paradoxical assertion of absolute uniqueness through self-erasure does not inspire Junichi to reciprocate, in the manner one might expect of a sentimental romance, thus showing the idealized principle of romantic identification to be necessarily figurative, never literal.

In an earlier scene, Junichi asks Nozomi how "it" felt during their first intimate encounter, when she was saved at the video store after her accident. Nozomi assumes that "it" means the sensation of being filled with Junichi's breath, but he clarifies that he is more curious about the feeling of losing air. "Was it painful?" he asks. "Yes," she answers. This curiosity about death and its relation to sexual desire returns in the request Junichi makes to Nozomi once her offer to "do

anything" is on the table. He tells her that there is one thing *only she can do* for him, which is to let him release her air.[11] Junichi's sadism is the flipside of Nozomi's invitation of attachment. He reassures her, "I'll breathe into you like before." Thus, we see that his intention is to bring her to the brink of extinction and back, so that the process can be repeated. Moreover, Junichi's actions bring to bear the cognitive dissonance between the assumption that Nozomi is human and the fact that she is, in the diegesis, still a sex doll. The film presents this activity—Junichi's *fort-da* game, which follows the rhythmic form of sexual intercourse—as simultaneously perverse and proper, for it seems a reasonable way of treating an inflatable toy.

In this scene, *Air Doll*'s development of the perilous seriality of identification through consumption reaches its apotheosis. Throughout the film, Nozomi's cuteness and innocence, in her exaggerated vulnerability, invite aggression and violence.[12] This is the veiled meaning behind the impulse of care also elicited by the childlike or infantile form. After being emptied and filled several times by Junichi, Nozomi wants to reciprocate, because this projective identification (that Nozomi and Junichi are the same) is the idealized form of human relation cultivated by her experiences with others and codified in romantic films and images, as elsewhere in the culture she observes so acutely. Because Junichi has told her that allowing him to let out her air makes her unique and is something only she can do, she endeavors to gift him with this *same uniqueness*. She looks for his "plug" and tells him that she will fill him with her breath, just as he did for her. She brings sharp scissors and tape into bed and "punctures" Junichi so she can fix him with tape too. However, the misunderstanding perpetuated through her interaction with him that they are both "empty" leads her to become a murderess. Unlike the infamous Abe Sada, who in 1936 killed her lover when he tried to return to his wife, Nozomi kills Junichi out of the only form of love she knows: projective identification. After realizing what she has done, she places Junichi's body in a trash bag and deposits him on the sidewalk for pickup in the "burnable" trash pile. She had been instructed, earlier, that humans are burnable, but plastic dolls, such as herself, are not. Since humans are burnable, they are also potential objects of burning desire, unlike the substitute, the doll.[13] After realizing the incommensurable difference between herself

Figure 13.3. Nozomi discards herself in the trash. The melancholic image of Nozomi cradling another abandoned doll conveys their shared pathos, whether the connection of woman (human) and doll is understood metaphorically or literally.

and Junichi, Nozomi, like the little mermaid of Hans Christian Andersen's tale, embraces self-determination in death. She removes the tape covering her wound and places herself on the unburnable trash pile.

What distinguishes Nozomi from the little mermaid, however, is that Nozomi discovers the limit of self-sacrifice. Unlike Andersen's character, who refuses to save herself by stabbing her beloved in his sleep with an enchanted knife procured by her mermaid kin, Nozomi exposes the violence inherent in the idealization required by the economy of sacrifice; once this idealization is deflated, its forces of destruction and aggression scatter uncontained, like the air that escapes Nozomi's body. Thus, Nozomi's emptiness is not a privileged space of interiority that shores up humanist values, but rather a space continually violated, even when this violation goes by the name of love. Junichi's human breath neither signifies inspiration nor does it serve to furnish the doll with feelings or empathy. These she has in abundance, for no discernable purpose and from no transcendental entity. Nozomi's interiority does not provide access to human sentiment or experience—it simply maintains a space of emptiness. The act of

reciprocity that works according to the logic of possessive individual-
ism cannot be the means by which to achieve relation; in contrast, this
logic leads the air doll to destroy her lover through her idealization.

What I suggest makes Kore-eda's nihilist parable so interesting, de-
spite the triteness of its conventions, is that it achieves the maximum
impact of its bleak message about the impossibility of identification
as the basis of relation by deploying sentimentality, melodrama, and
cliché. Nozomi's voiceover often serves a didactic purpose; in one im-
portant interlude, she recites a poem called "Life":

> It seems life is constructed in a way that no one can fulfill it alone
> Just as it's not enough for flowers to have pistils and stamens
> An insect or breeze must introduce a pistil to a stamen
> Life contains its own absence, which only an Other can fulfill
> It seems the world is the summation of Others
> And yet, we neither know nor are told that we will fulfill each
> other
> We lead our scattered lives, perfectly unaware of each other.[14]

The voiceover presents a simplistic and sentimental worldview,
belied by the complexities indicated by the film's refusal of either tri-
umphant or tragic humanism. Ironically, the naturalist "fulfillment"
metaphorized in the poem as pollination is biological reproduction,
something Nozomi cannot achieve because she has no reproductive
organs; indeed she has nothing inside of her that could be insem-
inated, only empty space to be filled with air. In an article entitled
"Envisioning a Community of Survivors in *Distance* and *Air Doll,*" Je
Cheol Park interprets the ending as an affirmation of the poem and the
film's overall message of community building through identification,
which Park calls the film's "metalanguage."[15] Rather than taking this
voiceover as a straightforward assertion of the film's "message," I read
the contradiction in its simple didacticism against the unanswered
implications of Nozomi's story. Is she culpable for Junichi's murder?
Is she capable of registering his death as loss? Is their relationship a
love suicide? Is the reduction of Junichi and Nozomi to burnable and
unburnable trash a critique of sentimentality itself?

The image of Nozomi on the trash heap suggests the film's stubborn
reticence about the substance or meaning of human relations, resort-

ing to another cliché to figure the openness of the question: Nozomi's escaping air. As Nozomi expires, the sound of her air amplifies, a heavy breathing sound that echoes through a series of parallel-edited shots of the various "empty" characters who remain, thus recirculating Nozomi's nonsubjective feelings through the visualization of an indeterminate, disenchanted fantastic. Through this use of the fantastic, not to emphasize the boundaries between the supernatural and real, the film shows the continuity between individuality as commodity and individuality as self-sacrifice, raising the ethical questions that are dismissed by claims of their absolute opposition. In refusing categorical distinctions among the human, the nonhuman, the inhuman, and the posthuman, and by choosing a doll as its central figure, *Air Doll* strenuously resists the binary understanding of the social and the biological that affects discourses of the posthuman and the cyborg, such as those critiqued in this volume by Sharalyn Orbaugh. At the same time, *Air Doll*'s approach to the doll's plight as a necessarily gendered one signals its engagement with the cyborg's place in feminist critique.

As Orbaugh and others have noted,[16] dolls have a history of being feminized as substitute *women*. Nozomi both maintains and subverts this association, in a manner that produces a sympathetic monstrosity, which also makes her tragically human. The film could be said to critique the conflation of sex and gender, in the process of demonstrating their convergence in the function of the sex doll—for the strictly functional use of a sex doll entails replacing the organ function of the woman in coitus with a synthetic substitute. In Nozomi's case, the sex doll is made not only to fulfill the female sexual function but also feminine gender roles such as domestic counselor, infantilized ingénue, and loose woman, all of whose sexual availability affirms the other characters' masculinity. These gendered social functions are seen to be separate from but mistaken for the sexual function, and the male characters all use the fact of Nozomi's female anatomical form as an alibi for the ways in which their use of her appends the social function of gender in a specifically *human* power dynamic. This mixed use provides a further rationale for Nozomi's act of violence, since the latter is structurally identical to the literal-metonymic substitution that conflates doll and woman, on the basis of gender function over material reality, and social identity with being as such. In tales like *Pinocchio* and *The Little Mermaid,* access to humanness is given through the

desire to be human, thus valorizing the capacity to love and be loved by others as the defining feature of the human. Nozomi is "loved" by her handlers in the sense that sex connotes the erotic drive. But does this love make her human? Yes, but only in failed identification, because Nozomi's intersubjective relations with others, including her projection onto others of her desire to identify, capture her in the reciprocal bind of (mis)recognition.

Air Doll revises the categories of human and nonhuman by defining the human as that being who displays the symptomatic tendency to use fantasy to disengage from a shared social reality. In other words, humans share a common inhumanity, treating others as objects of use and consumption, the logic of which involves the limited recognition of the other as an element of fantasy, a projection of desire. In *Air Doll*, two categories of object converge in the figure of the doll because of her inhuman humanity: the commodity, consumed and used up, objectified and fetishized, and the object as the other of the self, the "not-me" that is granted an existence independent of fantasmatic projection.[17] *Air Doll* develops the pathos of objects, in both senses of the term, to suggest the dangers of a social order based exclusively on identification with others as subjects who consume, as the social body is figured in the film. The call for a nonidentificatory sociality—a human–object connection—refigures the human, against its commoditization, as that which is constituted, not destroyed, by its availability to others.

NOTES

1. The term *otaku* refers to a type of fandom marked by social dysfunction, in which the obsessive interest and attachment to the often imaginary characters of anime, manga, and games prevent the *otaku* from achieving so-called normal sociality. Thomas Lamarre critiques the term as a "media type," alongside other identity terms instated and circulated by Japanese mass media, which figures prominently in a media discourse that seeks to regulate proliferating consumer identities rather than describe actual practices of consumption and identification. See *Anime Machine: A Media Theory of Animation* (Minneapolis: University of Minnesota Press, 2009), 108–9.

2. *Air Doll* marked a departure for Kore-eda Hirokazu, a widely celebrated realist auteur, whose films have garnered him critical acclaim as the

contemporary heir of Ozu. Kore-eda's documentary work and his film adaptations of widely publicized current events, like *Nobody Knows* (2004), have secured Kore-eda's reputation as a sensitive observer of contemporary Japanese society. However, I argue that *Afterlife* (1998) sets a precedent for Kore-eda's engagement with a disenchanted fantastic mode.

3. The Pucheon International Fantastic Film Festival, the festival example I cite from personal experience of attending from 2008 to 2013, categorizes its films to cater to both locals and cinephile festival visitors; categories run the gamut from family-friendly programs ("Family Fanta") to auteurist genre film retrospectives ("Strange Homage") to the midnight screenings of the most extreme and explicit titles ("Forbidden Zone"). See the festival website: http://www.pifan.com/eng/index.asp.

4. Tsvetan Todorov, *The Fantastic: A Structural Approach to a Literary Genre*, trans. Richard Howard (Ithaca, N.Y.: Cornell University Press, 1974), 173.

5. Ibid., 173, 167.

6. See Chi-Yun Shin, "Art of Branding: Tartan 'Asia Extreme' Films," *Jump Cut: A Review of Contemporary Media* 50 (Spring 2008). www.ejumpcut.org/archive/jc50.2008/TartanDist/index.html.

7. Some viewers of *Air Doll* have questioned Kore-eda's choice of casting Bae Doona, a South Korean actress, as the star of *Air Doll*, voicing concerns over the colonial legacy of Japan's conscription of Korean women into sexual slavery during the period of war mobilization. I argue that, rather than expressing a conscious neocolonial intent, Bae's casting gestures at *Air Doll*'s self-conscious engagement with global film markets. Bae developed a transnational audience after appearing in Korean auteur Park Chan-wook's *Sympathy for Mr. Vengeance*, whose predecessor *Oldboy* gained international fame after winning the Grand Jury Prize at the Cannes film festival in 2006, and whose work has been branded as representative of Asian Extreme. Bae also appeared in a popular Japanese high school film *Linda, Linda, Linda* (dir. Yamashita Nobuhiro, 2005) as a Korean exchange student, a character not dissimilar to Nozomi, *Air Doll*'s protagonist. Reprising the role in *Air Doll* of a subject who adapts to a foreign culture by consuming its cultural commodities and acquiring linguistic proficiency, Bae figures a form of postnational subjectivity, while simultaneously problematizing the consumer model of identity.

8. Fredric Jameson, *Signatures of the Visible* (New York: Routledge, 1992), 24.

9. Christine L. Marran has written about the criminal figure of the "poison woman" as a sign of the gender anxieties evoked by modernization in Meiji-era Japan in *Poison Woman: Figuring Female Transgression in Modern Japanese Culture* (Minneapolis: University of Minnesota Press, 2007). Made

famously pornographic (or infamously) by Nagisa Oshima's *In The Realm of the Senses* (1976), the case of Abe Sada is included in Marran's account of these "poison women" and is also an important intertext in *Air Doll*.

10. The work of Thomas Lamarre and others on manga and anime focus on this imbrication of cuteness and violence, especially in the relationship of the human to technology and in the sexual dynamics suggested by the stylization of anime characters, the ancillary practices of *cosplay* (dressing up as anime/manga characters), and the obsessive quality of media consumption in the figure of the *otaku*. For a psychoanalytically framed exploration of the sexualization of the cute but warrior-like anime heroine, see Saito Tamaki's *Beautiful Fighting Girl*, trans. J. Keith Vincent and Dawn Lawson (Minneapolis: University of Minnesota Press, 2011). In *Anime Machine*, Lamarre offers a counter-reading of the sexualized form of the *shōjo* (fantasy girl) to Saito's, the latter of which seems to emphasize the sealing off of perversion in fantasy by arguing for the *normativity* of most *otakus'* actual sex lives.

11. For an insightful discussion of the trope of air in cinema and the complex associations among air, death, and sex, see Kevin L. Ferguson, "Painting in the Dark: The Ambivalence of Air in Cinema," *Camera Obscura 77* 26, no. 2 (2011): 33–63.

12. In "The Cuteness of the Avant-garde," Sianne Ngai argues that "in its exaggerated passivity and vulnerability, the cute object is as often intended to excite a consumer's sadistic desires for mastery and control as much as his or her desire to cuddle." Further, Ngai calls cuteness "an aestheticization of the small, vulnerable, and helpless." The indecency of cuteness seems to be its passive aggression, a discussion that Ngai takes up in relation to modernist poetry and the contemporary art of Murakami Takashi and Nara Yoshimoto. Ngai focuses in her article on the affective disposition elicited by cute objects and the ways in which cuteness as an aesthetic forms (or deforms) such dispositions. In contrast, I develop the question of whether the aesthetic of cuteness might also enable the cinematic expression of the *object's* experience. See Sianne Ngai, "The Cuteness of the Avant-garde," *Critical Inquiry* 31 (Summer 2005): 816–17.

13. I refer here to the concept of *moe*, or burning desire, a slang term used by anime fans. *Moe* is also the name of the child in *Air Doll*, the daughter of Nozomi's neighbor, who is fixated on dolls and *The Little Mermaid*. My thanks to Margherita Long for pointing out this reference during a lively discussion group with Kim Icreverzi and Regina Yung Lee that planted the seeds for this chapter.

14. *Air Doll*, Dir. Kore-eda Hirokazu, Perf. Bae Doona, Arata, Itsuji Itao, Asmik Ace Entertainment, 2009.

15. Je Cheol Park, "Envisioning a Community of Survivors in *Distance*

and *Air Doll*," *Film Criticism* 35, nos. 2/3 Special Issue on Hirokazu Kore-eda (Winter/Spring 2011): 166–86.

16. See Sharalyn Orbaugh, "Emotional Infectivity: Cyborg Affect and the Limits of the Human," *Mechademia* 3 (2008): 150–72; and Mari Kotani, "Doll Beauties and Cosplay," trans. Thomas Lamarre, *Mechademia* 2 (2007): 49–62.

17. I adapt this discourse from the work of object relations psychoanalytic theorists Melanie Klein and D. W. Winnicott. See Melanie Klein, *Love, Guilt, and Reparation: And Other Works 1921–1945 (The Writings of Melanie Klein, Volume 1)* (New York: Free Press, 1975); and D. W. Winnicott, *Playing and Reality* (New York: Routledge Classics, 2005).

Part V National, International, Intergalactic
Socialist and Postsocialist Science Fiction Cinema

14 Alien Commodities in Soviet Science Fiction Cinema

Aelita, Solaris, and Kin-dza-dza!

JILLIAN PORTER

The alien appearance of earthly goods was a powerful generator of Soviet science fiction (SF) cinema. In Iakov Protazanov's *Aelita* (1924), a radio message from Mars turns out to be an advertisement for American tires. In Andrei Tarkovsky's *Solaris* (1972), outer space is cluttered with bourgeois bric-a-brac. And in Georgii Daneliia's *Kin-dza-dza!* (1986), an ordinary grocery run launches an intergalactic adventure through black-market economies, in which resources are scarce, matchsticks are more valuable than money, and social status is measured by the color of one's trousers. This chapter explores *Aelita, Solaris,* and *Kin-dza-dza!* in the context of the ever-shifting conditions of Soviet consumer culture. I consider the paradox of Soviet commodity exchange and offer a brief overview of Soviet SF literature and cinema before examining Protazanov's, Tarkovsky's, and Daneliia's films in turn. Apart from the status they enjoy as the three most celebrated Soviet films about space exploration, what unites *Aelita, Solaris,* and *Kin-dza-dza!* is that in each, commodities appear when they are least expected, disrupting historical progress toward communism, and implicating the Soviet Union in global networks of economic and cultural exchange.[1]

One indication of why commodities seemed so otherworldly in the Soviet Union can be found in the Bolsheviks' widely disseminated political primer, *The ABC of Communism* (1919). Guided by Marx's definition of the commodity as a good produced for private sale, authors Nikolai Bukharin and Evgenii Preobrazhenskii envision a communist future in which there would be no buying or selling, no money, and hence "no commodities, only products."[2] Yet the economy never reached the end-goal of communism, as party theorists initially maintained it would, and the exchange of commodities never ceased.

Indeed, just four years after the Revolution, as the Civil War ended and the fledgling state found itself unable to meet the basic needs of the citizenry, Lenin's own New Economic Policy (NEP, 1921–28) sanctioned small-scale private trade in consumer goods. Even after the end of the NEP, petty private trade in foodstuffs and handicrafts persisted at flea markets and bazaars, and a variety of services continued to be performed and paid for outside the channels of state planning and regulation.[3] Meanwhile, commodities produced outside the country circulated on black markets throughout the Soviet era, forming an ever-expanding shadow economy. Each in its own way, *Aelita, Solaris,* and *Kin-dza-dza!* witness the commodity's refusal to yield to a future in which it had no place.

These films offer fascinating counterexamples to SF narratives of commodification and consumption in capitalist societies. As the contributors to the edited volume *Red Planets: Marxism and Science Fiction* (2009) have shown, since the nineteenth century SF has enabled writers, filmmakers, and critics to imagine the grim consequences of global capitalist development and possible alternatives to it.[4] Whereas *Red Planets* focuses on works and theories of SF produced under capitalism, however, Soviet SF showcases the broad spectrum of ideological potentials the genre held in a state that was founded on Marxist principles and strove throughout its history to build a future in ever-more-perfect accord with them.[5] Soviet SF ranges from pulp fiction and pop films to politically committed works by major writers and directors, and from propagandistic works that celebrate the advent of communism to subversive ones that reveal alien elements—like commodities and the desire for them—at large in the USSR.

Like the Soviet commodity, SF was an ideologically suspect good that was subject to varying degrees of official tolerance, promotion, or taboo. Fostered by the translation of H. G. Wells's and Jules Verne's novels into Russian in the late nineteenth century, by 1917 literature dealing with life on other planets or in societies with radically advanced science and technology had become immensely popular with Russian readers. This popularity led some party officials to consider such literature, which eventually came to be called *nauchnaia fantastika* (scientific fantasy), a valuable tool for promoting state ideology.[6] Commissar of Enlightenment Anatoly Lunacharsky himself cowrote a screenplay for a 1919 film adaptation of Jack London's dystopian novel,

The Iron Heel, and in 1924, the party organ, *Pravda* (*Truth*), printed advertisements for *Aelita*. Yet in the same period, writers such as Evgeny Zamyatin and Mikhail Bulgakov turned to SF in works registering the psychological and physical tolls social reorganization threatened to take on the population. Coming under increasing suspicion throughout the 1920s, SF was openly attacked at the 1934 Writers' Congress: one major writer of children's literature described it as ideological "contraband," full of the "smuggled goods" of bourgeois adventure fiction.[7] After Socialist Realism became the only officially acceptable form of art, SF was largely repressed for more than two decades. Still, opportunities to circumvent the censors with self-publishing (*samizdat*) or publishing abroad (*tamizdat*), along with the relatively relaxed censorial oversight over children's fiction, allowed some production of literary SF to continue.[8] In the nationalized film industry, by contrast, the technical and financial requirements of the medium gave the state a far greater degree of control over production, and SF cinema was for a time nearly eliminated.[9]

The Cold War rehabilitated SF in both literature and film, as many cultural authorities began to hope it could promote state goals by popularizing scientific knowledge and celebrating Soviet achievements. In literature, works by the officially accepted Strugatsky brothers and others soon surpassed the level of popularity SF had enjoyed even in the 1920s. As the sensational Soviet successes with satellites and rockets rapidly increased the perceived importance of space exploration in the technological and ideological competition with the United States, regular production of space-related films began. These typically propagandistic films, many of which were intended for youth audiences, ranged from semi-fictional, educational biopics about rocket engineers and astronauts to SF adventure films about the Soviet conquest of the cosmos. Meanwhile, SF continued throughout the Cold War to serve dissident writers as a vehicle for criticism of the government, and by the 1970s, Andrei Tarkovsky and a handful of other prominent directors began making films about the negative consequences space exploration, nuclear armament, and other technological developments might have on human life. Taking advantage of the official acceptance of the genre, and describing fantastical settings and circumstances, SF writers and filmmakers seem to have received less scrutiny than was directed at the creators of more realistic works. As in the 1920s, from

the 1960s to the end of the Soviet period SF displayed a remarkable ability to blur the boundaries between propaganda and critique.

Roll Over, Marx: *Aelita*

The commodity form is what helps to push Iakov Protazanov's ambivalent film about interplanetary revolution, *Aelita,* between these boundaries. As the international coproduction of Russian and German studios, the first Soviet film to be widely distributed abroad, and a film that secured Protazanov's position as the only major pre-Revolutionary Russian director to continue making successful films in the nationalized Soviet film industry, *Aelita* was itself a border-defying commodity. The story it tells, too, is one of commodities that invade foreign spatial, temporal, and ideological contexts. The film begins when radio stations around the world receive a mysterious radio message: "Anta Odeli Uta." An engineer named Los at the Moscow radio station interprets the message as a transmission from Mars. He dreams of traveling to that planet, falling in love with its queen, Aelita, and helping the exploited Martian masses to stage a proletarian revolution, which he trusts the queen to support. When Aelita suppresses the uprising instead, Los suddenly wakes up in a Moscow train station and sees a worker putting up fresh posters that read "Only buy tires of the brand 'Anta Odeli Uta. New York 134 Avenue 359.'" Thus, what had seemed like an extraterrestrial message turns out to be alien only in national and ideological terms, and a utopian vision of universal revolution gives way to a material reality of global capitalism.

How are we to read this advertisement for American tires in the Soviet capital? Los evidently interprets it as a reminder that the revolutionary struggle has not yet been won. He determines to forget his utopian fantasies of universal revolution and refocus his energies on the practical projects of Soviet state building and homemaking. In the end, he gets back to work at a large construction site and returns to the wife from whom he had become estranged while dreaming of Aelita. Yet Los's response to the ad does not account for the bizarre and seemingly anachronistic sale of American commodities in Moscow of the 1920s, which suggests that capitalism is spreading throughout the Soviet Union.

Aelita registers the ideological dissonance of the Soviet 1920s, when the controversial New Economic Policy allowed a brief return

to private enterprise and commodity exchange. The Bolsheviks introduced the NEP in hopes of stimulating the war-ravaged economy, aiming to encourage production of basic consumer goods until state-owned manufacturing could take over. According to the promoters of NEP, it was necessary to slip slightly backward into capitalism in order to move forward to the communist future. Yet as commodities filled shops once more, and a new generation of relatively wealthy entrepreneurs—so-called Nepmen—arose amid general poverty, many staunch revolutionaries criticized the NEP as too great an ideological compromise, fearing that it would encourage the spread of materialism and greed. As what Ian Christie has called "*the* key film of the New Economic Policy period," *Aelita* focuses on people torn between utopian hope for the future, the imperative to work hard in the present, and a reactionary desire for material comfort.[10] Intercut with scenes of Los's Martian fantasies, the film details everyday life in Moscow: the Civil War ends, and citizens busy themselves distributing or procuring rations, sharing or securing housing, supporting the new state with unceasing labor or undermining it with bribe-taking, theft, and smuggling. Los's wife, who initially works tirelessly in support of the party, gradually succumbs to the desire for such luxury goods as chocolate and dainty shoes. While the end of the film might seem to resolve these tensions, as Los and his wife become reconciled to hard work in the present, it also highlights just how contradictory and illegible official messages were regarding the role of commodities in the new society: like the mysterious phrase, "Anta Odeli Uta," the new policies of NEP paradoxically promoted capitalism and communism at once.

The tire is a commodity especially well suited to capturing the disorienting contradictions of public discourse during NEP. On the one hand, tires index the fast approach of a technologically advanced modernity. Though not so marvelous as a spaceship, the automobile was nevertheless a startling novelty in the Soviet 1920s, when rubber tires were just beginning to roll cars full of people and goods around the cities and toward the future. On the other hand, the circular form of the tire suggests the dizzying spin of apparently endless revolution. The tire thus provides an image of time—heretical from the standpoint of the Marxist theory of historical progress toward communism—as a cycle rather than a line. And indeed, *Aelita* disrupts the linear flow of time by representing both Mars and Moscow as futuristic

yet retrograde, with the former developing dazzling new technologies under old conditions of monarchical governance and slave labor, and the latter pursuing communism by means of capitalist commodity production. Furthermore, appearing in the film as a markedly American innovation, the tire stages a movement at once geographic and ideological between the Soviet Union and its capitalist competitors. In this way, *Aelita* not only inaugurates what would become a tradition in Soviet SF cinema of using narratives of space exploration to articulate the economic and cultural relationships between the Soviet Union and other nations, but also reveals the commodity's special power to embody the global interconnectivity that would remain both necessary and threatening to the Soviet project of rebuilding the world. Long after the release of *Aelita* and the years of NEP, as the Soviet economy and the Soviet people continued to depend on domestic as well as international commodity exchange, Tarkovsky and Daneliia would follow Protazanov's lead in mobilizing commodities to unsettle official narratives of scientific and historical progress.

Time in a Teacup: *Solaris*

Alien commodities again breach temporal and spatial borders in Tarkovsky's *Solaris*. Tarkovsky's interest, however, is not in commodities for sale, but in those removed from networks of exchange—those collected, treasured, and displayed. In the first part of the film, a state psychologist named Kelvin spends his last night on Earth at his father's country house, where the surfaces are cluttered with porcelain vases, a bust of Socrates, prints depicting the flights of hot air balloons in late eighteenth- and early nineteenth-century France, and other collectibles. The house itself is a kind of collectible: Kelvin's father explains that he built it as a copy of his grandfather's home because he does not "love new things." As what appears to be a Russian dacha, or summer house, this structure seems all the more out of place when it turns out to be located not far from a hypermodern metropolis, the filming of which Tarkovsky carried out in Tokyo. In this way, the house becomes a souvenir of personal, national, and cosmopolitan tradition, lovingly preserved in a postnational, future-oriented world.

After lingering for a time among the narrative-arresting objects at the house, Kelvin travels to a space station hovering above the oceanic

planet of Solaris. Although the sleek metallic surfaces of the space station initially oppose it to the cozy, domestic interiors of the old-fashioned house on Earth, this divide breaks down when the space station library is revealed to contain another collection of old goods. Though the film does not clarify the history of their production or acquisition, many of these objects appear to predate the establishment of the Soviet Union or to have originated beyond its borders, and the eclectic collection would seem to have been amassed through active trade on international commodity markets. Statuettes, candelabras, masks, musical instruments, and antiquarian books line the library display shelves, while the walls are decorated with reproductions of paintings by sixteenth-century Dutch painter Pieter Brueghel. Like the country house, the library contains a bust of Socrates, an object that thus binds a technologically advanced cosmic future to a treasured earthly past.[11]

Tarkovsky's collectibles appear all the more significant when one considers that they are not to be found in the 1961 novel by Stanisław Lem on which Solaris is based. Moreover, it is in the library that one of the crewmembers, Dr. Snaut, utters the central speech of the film, declaring that "man needs man" more than he needs new scientific knowledge. As the essential set dressings for this speech, the objects in the library signal a desire to preserve the past rather than seek the future. These collectibles are intimately associated with private memories that plague the crewmembers and hinder their official mission. Kelvin, who has traveled to the station in order to investigate reports of strange occurrences, encounters his own memories there in the form of several seemingly living replicas of his late wife, Hari. When he learns that Solaris is producing these incarnations of his memories, he finds himself torn between his private desire to remain on the space station with Hari and his official duty to return to Earth and report his findings. The old goods in the library appear all the more alien in this space-age future, and all the more intimately associated with a cherished human past, when at one point the artificial gravity on the space station is switched off and Kelvin and Hari drift through the library, suspended in time and space along with a floating candelabra and an illustrated copy of Don Quixote. At the end of the film, Kelvin's private desires prevail. He is shown returning to his father's cluttered country house, but as a torrential rain pours through the ceiling, soaking the collectibles inside, the camera pulls back to reveal that the house is on

an island in the midst of a great ocean—Kelvin has not gone back to Earth after all, but has immersed himself in the strangely preservative waters of Solaris.

The charged ideological valence of collecting in the Soviet Union sheds light on Tarkovsky's association of collectibles with private desires that conflict with public responsibilities. In the 1920s, an official campaign against private coziness and kitsch had sought to sweep bric-a-brac from the home in favor of a more ascetic communist aesthetic. Although in the 1930s the party relaxed its attack on domestic comfort, opting to encourage service to the state by offering rewards in the form of luxury goods, the collecting impulse continued to be viewed as a sign of vulgar materialism until the late 1950s, when the party began to encourage young people to collect commemorative stamps and lapel pins featuring space-related images, in particular.[12] Much like SF literature and film, during the Cold War space memorabilia was suddenly promoted as a tool of state propaganda. Moreover, the changing policies on collecting formed but one narrow aspect of a broader shift in official attitudes to consumption: the 1960s saw the advent of Soviet consumer society as economic planners dedicated more energy to the production of household appliances and other goods symbolic of modern life.[13] Here, too, space-related imagery was called upon in celebration of Soviet achievements, with vacuum cleaners named "Rocket" and "Saturn," and advertisements for other modern products making use of cosmic themes.[14] Against the historical backdrop of ideologically charged home décor and rising, highly politicized consumption, *Solaris* stands out as a manifesto for collection of a different sort: the collectibles in this film celebrate no state, serving instead the private purposes of acquisition, arrangement, and display.

Collection was one of Tarkovsky's chief aesthetic impulses. Explaining his cinematic methods in *Sculpting in Time,* Tarkovsky writes, "The cinema director is rather like a collector. His exhibits are his frames, which constitute life, recorded once and for all time in myriad well-loved details, pieces, fragments."[15] In *Solaris,* the collections of commodities in the country house and the library replicate in miniature the larger collection of frames in the film. Moreover, Tarkovsky makes his collecting aesthetic explicit by decorating the walls of the country house with prints depicting hot air balloons designed by aviation pioneers Joseph-Michel Montgolfier (1740–1810) and Jacques-Étienne

Montgolfier (1745–99). These collectible prints allude to Tarkovsky's previous film, *Andrei Rublev* (1971), which begins with the exhilarating flight of a hot air balloon. They therefore mark *Solaris* as belonging to the director's growing "collection" of films.

Collecting is analogous to what Tarkovsky called his filmmaking practice of "sculpting in time": the collector "sculpts" using the medium of petrified time collectibles embody—not just the "congealed labor time" of which Marx wrote, but also the shelf life of personal ownership and display. In Walter Benjamin's words, "It is the deepest enchantment of the collector to enclose the particular item within a magic circle, where, as a last shudder runs through it (the shudder of being acquired), it turns to stone."[16] In *Solaris*, one especially arresting shot of a teacup overflowing with tea and rainwater hints at the sculptural quality of Tarkovsky's collecting. If a teacup is a collectible par excellence, and one produced through a sculptural process at that, tea was one of the first global commodities to be traded on a mass scale. Meanwhile, water and other fluids recur in Tarkovsky's films as materializations of the "time pressures" with which he sought to sculpt. Indeed, in *Sculpting in Time*, the director describes various time pressures as different bodies of water: "brook, spate, river, waterfall, ocean."[17] The image of the overflowing teacup, which forms part of the initial sequence at the country house, points forward to the final submersion of the house and all the collectibles therein by the waters of the oceanic planet. As both highly personal and cosmopolitan collectibles, the commodities in *Solaris* display the aesthetic claim Tarkovsky makes on the SF genre: his film does not celebrate the national space program, as Soviet SF cinema of the 1960s typically had, but rather showcases anti-utilitarian and preservationist impulses that freeze the forward march of progress.

Out of Matches: *Kin-dza-dza!*

In Daneliia's ironic cyberpunk film, *Kin-dza-dza!*, official narratives of progress break down completely, as hypertrophic commodity exchange renders the borders between places, times, and economic systems alarmingly indistinct. The film begins when a Russian builder named Vladimir returns home from work and lights up a cigarette. If Vladimir's profession inserts him into a long line of "positive heroes"

from Socialist Realism, Daneliia relegates any work of state building this hero might perform to a pre-diegetic past, suggesting the obsolescence of such models in the Soviet 1980s. Furthermore, Vladimir's use of a safety match—a celebrated Soviet manufacture that had proved especially successful on international commodity markets—triggers a narrative in which ordinary state-produced goods are in desperately short supply. On his way to the store for some macaroni and bread, Vladimir and a young Georgian named Gedevan, whom he chances to meet on the street, are suddenly transported to a desert planet named Pliuk, in the galaxy Kin-dza-dza. Hinting at a certain insularity of Soviet consciousness, Vladimir cannot at first imagine that they may have left the boundaries of the USSR: he speculates instead that they must be in the Karakum or some other desert in one of the Central Asian republics. When a space ship drops down in the sand nearby, Vladimir's sense of geographical possibilities begins to expand, and he concludes they must be in a *kap-strana* (cap[italist]-country) after all. When it turns out that the Soviet comrades have in fact been transported to another planet, they must learn to navigate alien commodity markets in order to obtain food, water, and a return passage to Earth. Fortunately for them, matches turn out to be the most valuable currency on Pliuk, and they use those Vladimir has in his pockets to make illegal deals in black-market bunkers and a state-run supermarket. Finally, they are transported through time and space back to Moscow, arriving at the very moment with which the film began, when Vladimir comes home, lights a cigarette, and heads out to the grocery store. As the cycle of trade begins anew, the longed-for future becomes a thing of the past.

Kin-dza-dza! attests to the disintegration of dominant Soviet discourses of value on the eve of perestroika and glasnost. In the face of a scarcity of state-produced goods, black-market trading—especially in foreign commodities—became an ever-more-conspicuous feature of Soviet life. At the same time, rapid transfers of state power contributed to a cultural mood of increasing instability: Brezhnev's death ended his two-decade term as party secretary in 1982, and by 1986 the country had witnessed the sudden deaths of the next two leaders as well—Yuri Andropov in 1984, and Konstantin Chernenko in 1985—and the rise of yet another: Mikhail Gorbachev. In a short essay about making *Kin-dza-dza!*, Daneliia describes the impact these historic events had on the film. In a particularly amusing example, Daneliia explains that a bottle

of vinegar Gedevan carries with him throughout the film was originally a bottle of Georgian moonshine the young man had brought from his home city of Batumi to Moscow. After shooting scenes in which characters drink the moonshine, the filmmakers were dismayed to learn that the new secretary, Gorbachev, had launched an official campaign against homebrew, rendering it necessary to replace references to vodka in the script with those to vinegar, a substance no one would logically bring from Batumi to Moscow, let alone offer to others as a beverage.[18]

Daneliia's elevation of matches to the status of the supreme currency in the Kin-dza-dza galaxy demonstrates a more deliberate engagement with Soviet material culture. The Soviet Union was for decades a leading international exporter of safety matches (that is, matches that must be struck on the box).[19] The success of this particular commodity may well have inspired the Strugatsky brothers to cite experiments with matches as the cause of a fanatical scientist's demise in one of their best-known stories, "Six Matches" (1958). Within the Soviet Union, officials not only touted domestic matches as the best in the world, but they also used matchboxes to disseminate various types of propaganda. Some Soviet matchboxes, which have become collectibles today, advertise other state-produced goods, such as milk, honey, or vacuum cleaners. Others warn against alcoholism or instruct parents on how to keep their children safe. Soviet space exploration, too, was a frequent matchbox theme, with designs joining symbolism of the party or the state with iconic representations of *Sputnik,* spaceships, or planets such as Mars, on which the USSR had made a historic soft landing in 1971. Much like the commemorative space-themed stamps and lapel pins the party began promoting as collectibles in the late 1950s, Soviet matchboxes carried official messages into the homes, and even into the pockets, of everyday citizens. Meanwhile, popular jokes circulated about the unreliability of Soviet matches, and a 1980 film comedy by popular director Leonid Gaidai called *After Matches (Za spichkami)* satirized the hyperbolic importance placed on them.[20] *Kin-dza-dza!* relies on the much-vaunted yet publicly derided value of this staple commodity to poke fun at the scarcity of state-produced goods and the failure of Soviet science and industry to reach the grand goals of the Revolution.

Daneliia's film thus offers a distinctly late Soviet, comedic restatement of these words by H. G. Wells: "Science is a match that man has just got alight. . . . And around him, in place of all that human comfort

and beauty he anticipated—darkness still."[21] Pliuk—the desert planet
on which most of the film takes place—is a world in which the pursuit
of progress (whether economic, scientific, or ideological) has led to
environmental degradation, exploitation, and chronic shortages of es-
sential consumer goods. The initial ambiguity as to whether Vladimir
and Gedevan have been transported to one of the Soviet republics or
to a capitalist country persists throughout the film, as Pliuk features
elements of both capitalist and socialist economic organization. In one
especially striking scene, masses of workers in an underground factory
labor to keep a memorial to the ruler of Pliuk afloat over the planet's
capital city. Even as the workers may resemble those in a capitalist fac-
tory (or, indeed, the enslaved Martian proletariat in the underground
factories of *Aelita*), the ideological and symbolic purpose of their labor
calls the Soviet deification of party leaders to mind. Like the supreme
value Soviet matches acquire on Pliuk, the ambiguous political system
on that planet advances Daneliia's satire of Soviet social and economic
conditions. Ultimately, Pliuk appears as something of an undesirable
capitalist otherworld lurking beneath the surface rather than beyond
the boundaries of the Soviet Union, and *Kin-dza-dza!* consigns any
expectation of an abundant, commodity-less future to the past.

Conclusion

Surveying the rising critical interest in Soviet and post-Soviet SF in
recent years, Sibelan Forrester and Yvonne Howell make the compel-
ling observation that this genre "offers a way to read the history of
the future."[22] Extrapolating from this view, we might say that what is
most distinctive about Soviet SF is that it allows us to read the history
of one particular vision of a communist future—a vision so powerful
that the quest for it forged a new national identity in a vast and multi-
ethnic empire and reconfigured twentieth-century regional and global
networks of political alliance and trade. If the enormous impact space
exploration had on the Soviet cultural imagination makes SF works
about the cosmos an especially rich field of inquiry for anyone wishing
to study the making and unmaking of this vision of the future, *Aelita,
Solaris,* and *Kin-dza-dza!* reveal the extent to which that vision was
from its inception shaped by the repression of the commodity—and
by the commodity's strange and insistent return.[23]

NOTES

1. *Aelita: Queen of Mars,* directed by Iakov Protazanov (1924; Chatsworth, Calif.: Image Entertainment, 1991), DVD. *Solaris,* directed by Andrei Tarkovsky (1972; Moscow: Ruscico, 2000), DVD. *Kin-dza-dza!,* directed by Georgii Daneliia (1986; Moscow: Ruscico, 2009), DVD. Testifying to the enduring interest of the original film in post-Soviet Russia, in 2013 Daneliia made a new, animated version of *Kin-dza-dza!, Ku! Kin-dza-dza,* directed by Georgii Daneliia (Moscow: Lizard Cinema Trade, 2013), DVD.

2. The Russian words Bukharin and Preobrazhenskii use for "commodity" and "product" are *tovar* and *produkt,* respectively. N[ikolai] Bukharin and E[vgenii] Preobrazhenskii, *Azbuka kommunizma* [1919] (N.p.: n.p., 1921), 48.

3. Julie Hessler examines peasant market trade and other "gray areas on the margins of socialism" in *A Social History of Soviet Trade: Trade Policy, Retail Practice, and Consumption, 1917–1953* (Princeton, N.J.: Princeton University Press, 2004), 251.

4. Mark Bould and China Miéville, "Preface," in *Red Planets: Marxism and Science Fiction,* ed. Mark Bould and China Miéville (Middletown, Conn.: Wesleyan University Press, 2009), x.

5. Sibelan Forrester and Yvonne Howell discuss this spectrum of "official and dissident potentials" in their introduction to a special 2013 issue of the *Slavic Review* on Soviet and post-Soviet SF. Sibelan Forrester and Yvonne Howell, "Introduction: From *Nauchnaia Fantastika* to Post-Soviet Dystopia," *Slavic Review* 72, no. 2 (2013): 219.

6. Matthias Schwartz traces the emergence of *nauchnaia fantastika* as both a term and a type of literature in "How *Nauchnaia Fantastika* Was Made: The Debates about the Genre of Science Fiction from NEP to High Stalinism," *Slavic Review* 72, no. 2 (2013): 224–46. According to Schwartz, the term *nauchnaia fantastika* was first used by Yevgeny Zamyatin in a 1922 essay about H. G. Wells (233).

7. Samuil Marshak, *"Sodoklad S. Ia. Marshaka o detskoi literature"* [Supplementary paper on children's literature], in *Pervyi vsesoiuznyi's ezd sovetskikh pisatelei 1934: Stenograficheskii otchet* [First All-Union Congress of Soviet Writers 1934: Stenographic report] (Moscow, 1934), 30–31. Cited in ibid., 234.

8. On SF children's literature, see ibid., 242.

9. Among the relatively few exceptions to the suppression of SF cinema in the Stalinist 1930s–40s, Vasilii Zhuravlev's *Kosmicheskii reis* (Cosmic Voyage, Mosfilm, 1936) is especially notable. Set in 1946, this propagandistic children's film deploys groundbreaking special effects in its celebration of Soviet aeronautic achievements still to come.

10. Ian Christie, "Down to Earth: *Aelita* Relocated," in *Inside the Film*

Factory: New Approaches to Russian and Soviet Cinema, ed. Richard Taylor and Ian Christie (London: Routledge, 1991), 101.

11. Roumiana Deltcheva and Eduard Vlasov identify the bust of Socrates and other objects in the library in their article, "Back to the House II: On the Chronotope and Ideological Reinterpretation of Lem's Solaris in Tarkovsky's Film," *Russian Review* 56, no. 4. (1997): 537.

12. Kathleen S. Lewis, "From the Kitchen into Orbit: The Convergence of Human Spaceflight and Khrushchev's Nascent Consumerism," in *Into the Cosmos: Space Exploration and Soviet Culture,* ed. James T. Andrews and Asif A. Siddiqi (Pittsburgh, Penn.: University of Pittsburgh Press, 2011), 217.

13. Susan Reid, "This Is Tomorrow! Becoming a Consumer in the Soviet Sixties," in *The Socialist Sixties: Crossing Borders in the Second World,* ed. Anne E. Gorsuch and Diane P. Koenker (Bloomington: Indiana University Press, 2013), 33.

14. Ibid., 41.

15. Andrey Tarkovsky, *Sculpting in Time: Reflections on the Cinema,* trans. Kitty Hunter-Blair (Austin: University of Texas Press, 1987), 140.

16. Walter Benjamin, *The Arcades Project,* trans. Howard Eiland and Kevin McLaughlin (Cambridge, Mass: The Belknap Press of Harvard University Press, 1999), 204–5.

17. Tarkovsky, *Sculpting in Time,* 121.

18. Georgii Daneliia, "Kin-dza-dza," in *Chito-grito* (Moscow: Eksmo, 2006), 733.

19. Alexander Gerschenkron, "Soviet Policies versus International Cartels," *Slavic Review* 33, no. 1 (1974): 72.

20. Nicholas Galichenko, *Glasnost: Soviet Cinema Responds,* ed. Robert Allington (Austin: University of Texas Press, 1991), 67. *Za spichkami (After Matches),* directed by Leonid Gaidai (1980; Moscow: Krupnyi plan, 2004), DVD.

21. H. G. Wells "The Rediscovery of the Unique," cited in Bould and Miéville, "Introduction," in *Red Planets,* 3.

22. Forrester and Howell, "Introduction," 219.

23. On space exploration and the Soviet cultural imagination, see Andrews and Siddiqi, "Introduction," esp. 2–6.

15 Parodies of Realism at the Margins of Science Fiction

Jang Jun-hwan's *Save the Green Planet* and Sin Sang-ok's *Pulgasari*

TRAVIS WORKMAN

In 1978, the future dictator of North Korea, Kim Jong Il, organized the kidnapping of the director Sin Sang-ok and his ex-wife, actress Ch'oe Ŭn-hŭi.[1] The purpose of this unprecedented act of Cold War cinema politics was to use these famous film artists of South Korea to lift the global status of the North Korean film industry and to make it more entertaining to the domestic audience. After his "reeducation," Sin rebuilt his company, Sin Studios, in the North, and produced many films there. It is perhaps appropriate that Sin's most remembered directorial effort in this project to globalize the North Korean film industry, *Pulgasari* (1985), would be a fantasy monster film that employs conventional images of science fiction, including Godzilla-inspired special effects and human versus monster battle sequences. For an industry fixated on the narration of national history and the "realist" representation of an ideal national society, the spectacle of the monster was to herald North Korea's entrance into global cinema. Despite the presence of the fantastic monster, the diegesis of *Pulgasari* otherwise adheres to a surprising number of the North Korean state's dictates on the narrative and formal representation of national history. In a film industry governed by rigid notions of realism and historical referentiality, Sin was compelled to insert the fantastic and spectacular monster within the conventions of that realism rather than creating the kind of hypothetical future world common to science fiction.

The conventions of North Korea's "subject realism" (*chuch'e sasiljuŭi*) were established firmly in 1973 with the publication of Kim Jong Il's *On the Art of the Cinema*.[2] Sin's interpolation of an out-of-place science fiction element into his kidnapper's version of realism magnifies

the tension between global science fiction film, with its claims to topi-
cal universality and global entertainment value, and the local political
and historical concerns of the Korean film industries. This chapter ex-
amines this kind of partial appropriation of science fiction elements at
the cultural and geographic margins of the science fiction film genre. It
analyzes how *Pulgasari* and a South Korean film, *Save the Green Planet*
(Jang Jun-hwan, 2003), each use science fiction elements out of the
context of the genre in order to parody and to derealize dominant re-
alist conventions. These films do not create internally coherent specu-
lative worlds, but rather speculate about the political and social mean-
ing of the points of intersection between speculation and realism, and
between the fantastic and the mundane. They magnify the cognitive
dissonance between science fiction and realist genres by keeping the
possibilities of both realist referentiality and fantastic, allegorical illu-
sion in constant tension.

In his foundational discussion of literary science fiction, "Estrange-
ment and Cognition," Darko Suvin defines the science fiction genre by
opposing it to both mainstream realistic literature and to fantasy and
supernatural fairy tales.[3] For Suvin the particularity of science fiction
is that it estranges our empirical world by creating related worlds that
are not restricted by our scientific laws or our degree of technologi-
cal development. This estrangement differs from fantasy and fairy
tales, however, because it does not deviate from the empirical world
in order to regress to a prescientific and individual world of fantasy,
but rather to cognize ("to reflect *on* reality"), often in a politically and
socially critical manner. "Estrangement differentiates SF from the
'realistic' literary mainstream extending from the eighteenth century
into the twentieth. Cognition differentiates it not only from myth, but
also from the folk (fairy) tale and the fantasy."[4] Suvin associates the
"'realistic' literary mainstream" with the philosophical-scientific per-
spectives of naturalism and empiricism. Science fiction is a genre of
utopian thought because it constructs internally coherent non-places
that create a cognitive dissonance with the realities that are composed
in mainstream realistic literature (as well as the dominant notions of
the real that this literature helps to maintain). Realistic literature has
both referentiality and plausible narrative causality, and science fiction
is characterized by estrangement and speculation.

The film medium has a number of specificities that complicate Suvin's

understanding of literary science fiction's estrangement of realistic literature. As Roland Barthes argued about the nineteenth-century novel, the "referential illusion" of the "realistic literary mainstream" is created through an illusion of direct accord between the signifier and referent.[5] For film realism, there are a number of medium-specific problems involved with the question of referentiality and the referential illusion, from the camera's indexing of objects by its physical registration of light (Bazin), to the particularly cinematic relation between fictional narrative and formal conventions (Bordwell, MacCabe), to the equal claim to actuality held by the non-narrative spectacles of a "cinema of attractions" (Gunning).[6] All of these ways of understanding referentiality are specific to film and the ideas of realism associated with film. On the side of speculative narratives in film, Brooks Landon has argued convincingly that in contrast to the cognition and seriousness of much science fiction literature, science fiction film is usually more concerned with provoking a visceral response in the viewer through the use of speed, spectacle, special effects, and attractions. In Landon's formulation, compared to science fiction literature, science fiction film gives primacy to images rather than to ideas.[7]

Without working through all of the numerous questions presented by this pairing of the medium specificity of realism in film with that of science fiction in film, a few factors are important for my discussion. What constitutes "realism" in film is determined by narrative, formal, and generic conventions with their specific historical timelines. Therefore, we should take into account the specific realist conventions dominant in a context when reading how science fiction film estranges those conventions. For example, critical realist representations of heroism in 1990s South Korea depended on a certain way of filming the flashback, and North Korea's subject realism depended on the "socialist realist gaze," two factors that are significant for my reading of the parodies of those realisms.[8] In addition, following Landon, film has the capacity to create illusions that provoke an immediate visceral response, regardless of whether or not the fictional world is supposed to be verisimilar to the world of everyday experience. Attractions and spectacles were as central to the referentiality of the earliest films as they are now to the speculative worlds of contemporary science fiction films.[9] Because the film image is always a present illusion, even in its most realistic incarnations, film can give visual shape to cognitive

dissonance through the juxtaposition of realistic and science fiction elements within the same frame. Science fiction literature can employ realist narrative and descriptive devices, but its fictional worlds are less easily rendered into such hybrid illusions.

Save the Green Planet and *Pulgasari* both take advantage of these medium-specific factors within the utopia, or non-place, of cinematic experience. Rather than being primarily concerned with the difference between empirical-naturalist thought and utopian thought, *Save the Green Planet* and *Pulgasari* use science fiction elements to derealize the hegemonic realisms in their respective industries at the level of film narrative and formal conventions. In each case, the derealization of a specific realism occurs through imitation and diversion, or parody. These methods of parody also have their medium specificity. In *Film Parody*, Dan Harries analyzes how parody spoofs the traditional conventions of genre films through the reiteration, inversion, misdirection, literalization, extraneous inclusion, and exaggeration of genre elements (of which extraneous inclusion, reiteration, and literalization are the most significant for the present discussion).[10] Harries borrows from Rick Altman's work on genre to describe how this work of parody can be broken down into its lexical, syntactic, and stylistic effects.[11] Harries recognizes the comedy and potential subversions of parody while also showing how parody can become another self-referential genre, or an anti-canon-as-canon. *Save the Green Planet* and *Pulgasari* are unique as political and social commentaries because they contain, simultaneously, science fiction's cognitive estrangement and parody's methods of imitating generic film language. They try to maintain a balance between science fiction, which can exhaust itself in the pleasures of escapism or in allegorical references to history, and parody, whose irony about the real can become a routinized and generic gesture of comedy.

In their narrative and formal parodies of realism, both films create another possibility for allegorical referentiality compared to that of science fiction. Rather than creating an integrated alternative world that has an analogical and allegorical relation to empirical reality, both films use the specificity of film to continually shift between conventions of realist reference and the allegorical meanings of science fiction. In kidnapping Sin Sang-ok, Kim Jong Il attempted to enliven the North Korean cinema with mass entertainment. But in the case of *Pulgasari,* the desire for a new spectacle became monstrous when

Sin created analogies between the monster and Kim Jong Il's father, Kim Il Sung, within the aesthetic of subject realism. The monster made possible an uncomfortable critique of the aesthetic and political system that subject realism was responsible for maintaining. Through this type of interpenetration of science fiction and realism, both films are able to allegorize history from a new global perspective, but only by engaging with the narratives, forms, and genres of local historical representation.

Save the Green Planet

But let me begin on the other side of the long Cold War in Korea (1945–present), with *Save the Green Planet* and its critique of neoliberal corporate society in South Korea. Science fiction was not traditionally a significant genre in South Korean film. Although there has been a recent growth in the science fiction genre, when *Save the Green Planet* was released in 2003, only a handful of science fiction films had ever been made there, including *Yongary* (1967), *Butterfly* (2001), and *Resurrection of the Little Match Girl* (2002).[12] Perhaps because of the relative newness and marginality of science fiction in South Korean film and fiction, we find that a number of recent films mix science fiction with other genres, such as family melodrama (for example, *The Host*, 2006).[13] In the early twenty-first century, genre became the site of critical reflection on referentiality in a new way, particularly with the new conditions for filmmaking in South Korea, which Kyung Hyun Kim, in *Virtual Hallyu*, has discussed as the death of the historically motivated narratives and forms of 1990s realist films.[14] In this transition to the prevalence of genre films, *Save the Green Planet* held a peculiar position. In its themes of corporate exploitation and its anticapitalist messaging, it references the 1990 films of critical realism; however, it is also highly skeptical of presenting a positive hero who comprehends and responds to unfair social conditions. In this respect, it turns to the crime genre's cyclical concern with the identification and expurgation of criminal pathologies from the social body. Finally, although the possibility of science fiction is present throughout the film, in the last scene the diegesis becomes unquestionably science fiction.

With its quick camera movements, music video–style editing, and genre-bending comedy, *Save the Green Planet* is contemporary to

Hollywood films of the mid-2000s, particularly other science fiction films such as *Eternal Sunshine of the Spotless Mind*.[15] The film draws from a large storehouse of global and local references to film history— 1990s South Korean critical realism, Korean melodrama, Hollywood serial killer films, circus and carnival motifs, and, of course, science fiction. The film portrays a young man, Pyŏng-ku, who kidnaps the chief executive officer (CEO) of Yoojin Chemicals, imprisoning and torturing him in the basement of his rural home. We eventually discover that Pyŏng-ku's father died in an industrial explosion at Yoojin and that his girlfriend and mother were also victimized. The film therefore addresses many of the political concerns of social class prominent in critical realist films of 1990s South Korea. However, we gradually discover that Pyŏng-ku has been kidnapping and torturing other business leaders, trying to get them to confess that they are aliens intent on destroying Earth. The film proceeds to pathologize Pyŏng-ku's resistance to the corporation and becomes a crime drama with an awkward degree of sympathy for its serial killer antagonist and his circus performer sidekick, the young woman Suni. A likeable, hard-boiled detective investigates Pyŏng-ku's compound, but Pyŏng-ku unleashes bees to kill him. The would-be hero of the oppressed working class is criminally insane and can only respond to his various traumatic experiences, recounted in a flashback sequence, with pathological delusions and extreme violence. However, in the final scene, after the CEO escapes Pyŏng-ku's lair by "pretending" he is an alien, he is actually beamed to a spaceship and reveals himself to be an alien leader. Now clad in campy alien garb, and looking out at Earth, he decides along with his fellow aliens to destroy the planet, criticizing human beings for their lack of intelligence and their self-destructive tendencies.

In order to produce the effect of science fiction estrangement, *Save the Green Planet* does not manufacture a completely speculative universe that serves as the condition for action. Rather, estrangement results from the way that the science fiction element, not certainly real within the diegesis until the end of the film, continually disrupts the frame for narrative cause and effect—the alien invasion changes from an allegorical symptom of the injustices of neoliberal South Korean capitalism, to a condemnable psychotic fantasy of a criminal, to, finally, the most important science fiction fact, known only to the seemingly psychotic Pyŏng-ku. Rather than merely mixing genres, it uses

Figure 15.1. Having revealed his alien identity, the CEO of Yoojin Chemicals Kang Man-sik ponders whether or not to destroy Earth while twirling a paper umbrella.

the science fiction element to parody both the claim to political authenticity in critical realist narratives such as Pak Kwang-su's *A Single Spark* and the hard-nosed search for the facts of a crime in a film such as Bong Jun-ho's *Memories of Murder* (2006).[16] In this way, the film is an ironic treatment of the various generic desires that spectators invest in realist film genres.[17] However, because it asks the question of its own genre multiple times during the film, it never rests comfortably in either the allegorical and speculative world of science fiction or in the irony of genre parody.

Save the Green Planet seems at once obligated to acknowledge the end of the viability of the heroic labor activist of critical realism as a convincing characterization of Pyŏng-ku and also to recognize the undeniable viability of crime drama's obsession with criminal behavior as the irresolvable symptom of an irresolvable social decline, another index of what Rob Wilson has called, in relation to Korean revenge dramas, "killer capitalism."[18] However, it also cleverly points out, through the literalization of the science fiction element in the final scene, that the narrative causality and historical referentiality mobilized in both critical realism and the crime drama are the effects of formal and generic conventions rather than reflections of reality. The

film speculates about and renders carnivalesque the point at which genre elements interact with one another in their allegorical tensions. The speculative science fiction turn prevents the film from replaying the older narrative of activist heroism, but it also prevents it from suggesting that subaltern reflections on the neoliberal corporate model of society inevitably reach an incommunicable, solipsistic, and homicidal dead end. It suggests that the generic modes of communicating politics need to be undone at the level of narrative, formal, and generic expectations. Jang's humorous criticism of corporations as a destructive alien force preserves the subversion of its parody because the film explores what is desired in critical realism, crime drama, and science fiction without offering any of these objects definitively.

The generic and narrative uncertainty caused by the insertion of the science fiction element, and the question of its diegetic reality, also disrupts the form of the film. To provide just one example, *Save the Green Planet* parodies, or at least repeats ambiguously, the formal presentation of past traumatic events in critical realism and crime drama. In *A Single Spark*, Pak Kwang-su filmed in color scenes set in the late 1970s depicting the life of the biographer of Chŏn T'ae-il (the heroic labor activist), whereas he filmed in black-and-white the social realist scenes portraying Chŏn T'ae-il's struggles in the textile factory in the late 1960s. One of the last sequences stitches the historical memory of Chŏn's heroism seamlessly with the biographer's subjectivity by dissolving from a black-and-white shot to a color shot, mimicking the way that the writer is bringing the past into the present through his own heroic efforts to write his hero's story. *Memories of Murder* is deeply concerned with national historical memory, because it documents the investigation of the first serial case in South Korea in the 1980s. However, it reworks the 1990s critical realist depictions of police violence under dictatorship, as they appear, for example, in Lee Chang Dong's *Peppermint Candy* (1999). *Memories of Murder* presents police investigation as a new mode of excavating the 1980s social ills and their memory.[19] The typical formal conventions of cinematic crime scene investigations—such as disorienting close-ups of the corpses that cut away to the bustle of the investigative team, or shots that suggest but do not reveal the presence of the killer—structure the film's relation to the violent and traumatic national past.

In the flashback scenes recounting Pyŏng-ku's various traumatic experiences caused by the corporation, *Save the Green Planet* quotes the formal conventions of both realist and crime drama excavation, but filters them through the science fiction element. The scenes of his past flash in a quick sequence as the CEO, having temporarily freed himself, combs through Pyŏng-ku's files. These experiences, including his father's death and his own imprisonment, are framed simultaneously as evidence of the evilness of Yoojin Chemicals and an explanation for Pyŏng-ku's mental illness. In the same scene, however, the CEO flips through Pyŏng-ku's serial killer notebook, in which he has tried to document the alien features of his victims. Rather than the formal techniques providing a coherent frame for historical referentiality, through the homologies created by cutting between the flashbacks of trauma and the alien conspiracy notebooks, *Save the Green Planet* provides a virtual and hybridized framing for the fictional world—it is difficult to know whether to respond with anticapitalist sympathy, fear of criminal pathology, or enthusiasm for humanity's struggle against an alien enemy. This hybrid generic and formal framing of the relation between past and present also increases the difficulty of establishing definitively the causal order of the narrative and its allegorical references to the empirical world.

Despite the disorienting barrage of possible realist or allegorical references to an empirical world, the ending of *Save the Green Planet* settles into a more stable sentimental mode and thus remains problematically invested in a certain melodramatic authenticity. After the aliens' destruction of Earth, the credits of the film roll while a television floating in empty space shows home videos of Pyŏng-ku's childhood, asserting a version of memory that redeems Pyŏng-ku's personal experience above all historical circumstance (even the Apocalypse). Jang allows the home video to serve as a redemption of Pyŏng-ku's suffering, finally establishing a stable perspective from which the viewer can grasp the causality of the narrative and the referentiality of the allegorical political critique. Despite the sentimental individualism of the home video floating in space, the film has added, through its parodies of critical realism and crime drama, layers of cognitive complexity to its science fiction condemnation of corporations as an alien force cynically leading the globe toward an unceremonious end.

Pulgasari

Although science fiction literature gained some popularity in North Korea in the 1950s and 1960s, *Pulgasari* was the first North Korean film to draw explicitly from the science fiction genre. Unlike any other North Korean film, *Pulgasari* is connected to the global circulation and appeal to universality in the science fiction genre. Sin employed science fiction and fantasy elements in a parodic manner similar to Jang Jun-hwan, but the conventions of realism he estranged through science fiction belonged to the other side of the Cold War divide (namely, to socialist realism and subject realism). Similarly to *Save the Green Planet*, the film continually re-poses the question of historical referentiality, although in this case the science fiction element is diegetically real from the beginning of the film.

Pulgasari is more precisely a fantasy film based on a folk fairy tale and set during the twelfth-century peasant rebellions against the Confucian court. However, the image of the monster Pulgasari is based in part on Godzilla, and Sin hired the veteran of Japanese monster films, Satsuma Kenpachirō, as his rubber-suit actor. The narrative of oppression and peasant revolution certainly fits the typical themes of subject realism. A father imprisoned for making metal tools for the peasant rebels constructs a Golem-like figurine out of boiled rice. When the daughter spills her blood on it, the figurine gradually grows into a monster that helps the peasants defeat the landed gentry. The narrative takes another turn, however, when the monster's insatiable and automatic need to accumulate metal endangers the very peasants he has helped to liberate, and the daughter Ami must sacrifice herself to destroy him.

The film is easily read as a thinly veiled allegory for either capitalism or the Korean Workers' Party, which both followed a similar trajectory from liberation to accumulation. Although *Pulgasari* probably avoided censorship because of its antifeudal themes, and the conceivability that the monster represents the contradictions of the capitalist stage of development, it is difficult not to read the film's primary allegorical-historical reference as the Korean Workers' Party and the North Korean state socialist system, particularly in its passage from liberation in the 1940s to accumulation in the subsequent decades.

Pulgasari parodies the conventions of subject realism in both its

narrative and its form. It takes up the science fiction theme of a monster that acts unconsciously and is therefore dangerous despite himself (for example, the monster in *Frankenstein*). Pulgasari emerges among the people and becomes a sublime physical force of revolution, but then unwittingly becomes the agent of accumulation endangering the lives of the peasants. This narrative works against the typical causality and referentiality of a production of subject realism, in which peasant suffering, party-led revolt, and the smooth post-revolutionary construction of socialism are presented as the entirely conscious historical activity of the national subject. Considering the humanism of North Korea's "subject thought" (*chuch'e sasang*), which proclaims that "man is the master of all things," the film's use of an unwitting science fiction monster in the narrative role of the revolutionary subject slyly parodies the master narrative of history as a process of a totalizing human consciousness, and highlights how the human sovereignty of the party or the leader can never govern historical and natural processes in the way imagined in subject realism's "total artwork."[20]

Another way *Pulgasari* parodies realist conventions is through the reiteration and inversion of what Stephanie Hemelryk Donald calls the "socialist realist gaze."[21] In the final scene of *The Fall of Berlin* (USSR, 1949), Stalin steps off of the airplane, and shots of the adoring stares of the Soviet soldiers and citizens visually articulate the leader as the subjective center not only of a popular personality cult but also the entirety of geopolitical history. Bazin discussed this centrality of Stalin in the socialist realist aesthetic as a mummified image of history and the subject of history.[22] Although Kim Il Sung gradually appeared less frequently in North Korean films, characters often look toward the camera with the same kind of adoration and emotional attachment for the leader in countless North Korean films (often when a character is conveying a message from the invisible leader). After the villagers' political victory against the king, Sin positions the camera from the perspective of the monster rather than the leader, filming the villagers looking up at the monster, offering him their metal tools and lamenting his appetite. This analogy created formally between the monster and the leader is only possible in film, and it allowed Sin to throw into question the version of causality and referentiality in which the sovereign leader is shown to govern the trajectory of Universal History. As in *Save the Green Planet*, speculation, estrangement, and cognition

Figure 15.2. Pulgasari takes the place of the human sovereign of subject realism and prepares to consume the metal tools that the peasants have gathered for him.

occur at the interstice between science fiction and realism, at the level of the generic and formal frame for causality and referentiality.

The end of *Pulgasari* resolves these cognitive tensions between genres somewhat differently than *Save the Green Planet*. At the end of the film, the allegorical meaning of the monster is not so easily interpreted as an image of the Great Leader or the Korean Workers' Party in a rubber suit. Before she sacrifices herself to kill the monster and save the village, Ami pleads to it, "Please do not keep eating iron, or someday we humans will have to use you to take over other countries." At this point, *Pulgasari* takes on a much more ecological and materialist connotation, differing both from a nation-centered parody of subject realism and also from the floating television expressing an individualist and sentimental humanism that ends *Save the Green Planet*. In this scene, the allegory of accumulation is expanded, so that the monster no longer seems to refer to the North Korean state as such, but to the process of enclosure and accumulation endemic to modernity. Ami speaks of a perpetual war between humans if the monster, which once embodied the will of the national people, forces the people to turn against other nations. This discussion about the inherent imperialism

of the state, or perhaps the imperialism of the accumulative process in capitalist modernity, re-poses the question of historical referentiality in a much more ambiguous way. Rather than the nihilistic presentation of the impossibility of historical change and the sentimental redemption of individual memory that we find in *Save the Green Planet*, *Pulgasari* presents Ami's sacrifice as a way to preserve the revolution by extinguishing the sovereign power of the revolution and its unconscious and monstrous turn to accumulation.

Conclusion

Both *Save the Green Planet* and *Pulgasari* play out a tension between global science fiction film and local realist styles. They also point to the constructedness of cinematic realisms, estranging not only naturalized views of society and history, but also the generic, formal, and narrative conventions whereby realist film makes its claims to causality and referentiality. These films also show that speculative film is still capable of articulating alternative modes of cognition about politics and history, even though its primary aesthetic is one of spectacle and attraction. This possibility for cognition exists particularly when the relation between the global genre and the local national context is explored with the kind of creative attention to the virtual that Kyung Hyun Kim argues characterizes the artistry and appeal of contemporary Korean film.[23] Both Jang and Sin practiced this virtual fusion of genres and conventions, offering allegorical critiques of the corporation and the party state from perspectives at once global and cognizant of the local fictions about reality.

NOTES

1. Steven Chung recounts this event, its controversies, and its aftermath in detail in "The Split Screen: Sin Sang-ok in North Korea," *North Korea: Toward a Better Understanding,* ed. Sonia Ryang, 85–107 (Lanham, Md.: Lexington Books, 2009).

2. Kim Jong Il, *On the Art of the Cinema* (Pyongyang: Foreign Languages Publishing House, 1989). "Subject realism" refers to the cinematic realism developed in North Korea in tandem with the institution of "subject thought" (*chuch'e sasang*) in the 1960s and 1970s. The genres of subject realism indicate

the degree to which the active formation of national and socialist subjectivity is the primary purpose of this realism: films adapted from the immortal classics; films on the theme of the revolutionary traditions; films on the theme of the socialist reality; films on the theme of the Fatherland Liberation War; films on the theme of intelligence and counterintelligence; films on the theme of national reunification. *Korean Film Art* (Pyongyang: Korean Film Export and Import Corporation, 1985).

3. Darko Suvin, "Estrangement and Cognition," in *Speculations on Speculation: Theories of Science Fiction*, ed. James Gunn and Matthew Candelaria, 23–35 (Oxford: Scarecrow Press, 2005).

4. Suvin, "Estrangement," 27.

5. Roland Barthes, "The Reality Effect," in *The Rustle of Language*, trans. Richard Howard, 141–48 (Berkeley: University of California Press, 1989).

6. *Opening Bazin: Postwar Film Theory and Its Afterlife*, ed. Dudley Andrew (Oxford: Oxford University Press, 2011); David Bordwell, "Classical Hollywood Cinema: Narrational Principles and Procedures," in *Narrative, Apparatus, Ideology: A Film Theory Reader*, 17–34 (New York: Columbia University Press, 1986); Colin MacCabe, "Realism and the Cinema: Notes on Some Brechtian Theses," *Screen* 15, no. 2 (1974): 7–27; Tom Gunning, "Attractions: How They Came into the World," in *The Cinema of Attractions Reloaded*, ed. Wanda Strauven, 31–40 (Amsterdam: Amsterdam University Press, 2007).

7. Brooks Landon, *The Aesthetics of Ambivalence: Rethinking Science Fiction Film in the Age of Electronic (Re)production* (Westport, Conn.: Greenwood Press, 1992), 14–17.

8. Stephanie Hemelryk Donald, *Public Secrets, Public Spaces: Cinema and Civility in China* (Lanham, Md.: Rowman & Littlefield, 2000), 59–67.

9. The essays in *The Cinema of Attractions Reloaded* bring to light this connection between early cinema and contemporary science fiction film.

10. Dan Harries, *Film Parody* (London: British Film Institute, 2000).

11. Rick Altman, *Film/Genre* (London: British Film Institute, 1999).

12. *Yongary: Monster from the Deep*, directed by Kim Ki-dŏk (1967; Beverly Hills, Calif.: MGM, 2007), DVD. *Butterfly* (*Nabi*), directed by Mun Sŭng-uk (2001; P'ap Entŏt'einmŏnt'ŭ Asia, 2002), DVD. *Resurrection of the Little Match Girl* (*Sŏngnyang p'ari ŭi chaerim*), directed by Chang Sŏn-u (2002; Seoul: Tube, 2002), DVD.

13. *The Host* (*Koemul*), directed by Bong Joon-ho (2006; Los Angeles: Magnolia, 2007), DVD.

14. Kyung Hyun Kim, *Virtual Hallyu: Korean Cinema of the Global Era* (Durham, N.C.: Duke University Press, 2001).

15. *Eternal Sunshine of the Spotless Mind*, directed by Michel Gondry (2004; Universal City, Calif.: Universal Pictures, 2004), DVD.

16. *A Single Spark* (*Arŭmdaun chŏngnyŏn Chŏn T'ae-il*), directed by Pak Kwang-su (1995; Lake Oswego, Ore.: Cineline, 2001), DVD. *Memories of Murder,* directed by Bong Joon-ho (2003; Seoul: KOFIC, 2005), DVD. One of the most emblematic critical realist films of 1990s South Korea, *A Single Spark,* portrays an activist writer in the 1980s writing a biography of Chŏn T'ae-il, the historical hero of the labor struggle during the era of the Park Chung Hee dictatorship. After toiling long hours in a tuberculosis-inducing sweatshop and organizing its workers, at the film's climax (the content of which every moviegoer in South Korea knew ahead of time) Chŏn T'ae-il lights himself on fire, with the labor law book in his hand, and runs down the sidewalk yelling "We are not machines. Comply with the labor laws." *Memories of Murder* is set in 1986 and depicts the case of the first serial killer case in South Korea. Historical consciousness and the process of working through the ever-incorporated traumas of Korea's past are generically redefined in terms of the method of police detection—the policemen of the 1980s are no longer the agents of an authoritarian state, as in many 1990s films, but rather are the agents who identify and attempt to interpret the most unsavory symptoms of a late capitalist society that has supposedly lost its ethical bearings.

17. I include crime drama within the spectrum of realist films, while recognizing that this categorization is not entirely transparent beyond my simple distinction between speculative and mundane fictions.

18. Rob Wilson, "Killer Capitalism on the Pacific Rim: Theorizing the Major and Minor Modes of the Korean Global," *boundary 2* 34, no. 1 (2007): 115–33.

19. *Peppermint Candy* (*Pakha sat'ang*), directed by Lee Chang Dong (1999; Seoul: T'aewŏn Entertainment, 2007), DVD.

20. Although the phrase "total artwork" goes back at least to Wagner, I have in mind Boris Groys's use of it in *The Total Art of Stalinism: Avant-Garde, Aesthetic, Dictatorship, and Beyond,* trans. Charles Rougle (London: Verso, 2011).

21. Donald, *Public Secrets,* 59–67.

22. Philip Rosen, "History of Image, Image of History: Subject and Ontology in Bazin," in *Rites of Realism: Essays on Corporeal Cinema,* ed. Ivone Margulies, 42–79 (Durham, N.C.: Duke University Press, 2002).

23. Kim, *Virtual Hallyu,* 8.

16 Media and Messages

Blurred Visions of Nation and Science in *Death Ray on a Coral Island*

NATHANIEL ISAACSON

"Death Ray on a Coral Island" (*Shanhudao shang de siguang*)—archaeologist, historian, and SF writer Tong Enzheng's (1935–97) 1978 short story—delivered readers exactly what the title promised, throwing in a number of other technological marvels and a healthy body count for good measure. First printed in *People's Literature* (*Renmin wenxue*) and awarded the National Prize for Outstanding Short Story (*Quanguo youxiu duanpian xiaoshuo jiang*) in 1978, the exotic locations and techno-scientific wonders were ripe subjects for Zhang Hongmei's 1980 cinematic adaptation of *Death Ray*, the first SF film produced in mainland China (hereafter "Death Ray" for the literary version, *Death Ray* for the film).[1] The story later was produced as a radio drama, spawned numerous print knockoffs as a *lianhuanhua* (children's pocket-comic),[2] recently was reincarnated as a cell phone video game, and now enjoys a vibrant second life on the Internet. Tong's work and its facsimiles and imitations in the Chinese mediascape signaled the revival of a literary genre that had been all but invisible during the Maoist era, bringing critical recognition to a form often dismissed as a subcategory of children's literature.[3]

The coral island, caught between the first and second worlds, serves as a theater for the examination of the relationship among capital, science, technology, and political intrigue. Two character types embody a set of anxieties visible across the various incarnations of Tong's story: (1) Chinese scientists removed from their homeland and their attempts to withdraw from the political sphere, and (2) the amalgamated non-Chinese Other that brings Western neoliberal capitalism and Soviet imperialism together in the form of a sinister corporation. Simultaneously, the story enacts a critique of the relationship between global

capital and scientific inquiry, prefiguring in fictional form Chris Harman's critique of capitalist accumulation in *Zombie Capitalism* (2010), where he argues, "The long boom and the 'golden age' [of American prosperity] . . . were all byproducts of militarized state capitalism. Prosperity rested on the cone of the H-bomb."[4] The Chinese scientists in the story attempt to claim a position of intellectual detachment but are unable to do so. A spectrum of media gives voice to the anxieties engendered by China's unsteady relationship with the world at large and its own past through its pondering of the possibility of "pure science" in the shadow of the atomic bomb. Materially, I argue that the story's reiteration in the popular media, including cinema, is symptomatic not only of the shifting national anxieties that spanned the Maoist era and beyond, but also of the market and legal forces unique to China in the 1980s.

Under Deng Xiaoping's "reform and opening up,"[5] China's post-Mao era heralded a decade of renewed vigor in the popular media. An influx of foreign culture set off a collective reassessment of China's relationship to the outside world and its own past. In this context, Tong Enzheng categorized his own life as "quite common experiences for the public intellectual."[6] His work was profoundly influenced by the ever-shifting political landscape of twentieth-century China and by his especially tenuous role of a scientist-cum-fiction writer under socialism. Tong originally had submitted a draft of the story to *Children's Literature (Shaonian wenyi)* in 1964, but the manuscript was rejected for its sympathetic portrayal of overseas Chinese. During the Cultural Revolution, he sold many of his prized manuscripts as scrap paper, and the story narrowly escaped this fate. In his coda on the history of the story, Tong also noted that his decision to kill off three of the protagonists of the story would have been met with severe criticism during the reign of the Gang of Four. As alliances between the People's Republic of China (PRC), the Soviet Union, and the United States shifted, Tong was pressured to change the antagonists from Americans to Soviets, and after criticizing the deleterious effects of cultural controls on Chinese archaeology during the cultural revolution, his novella *Mysterious Fog in an Ancient Gorge (Guxia miwu, 1960)* was interpreted as a veiled attack on the Chinese Communist Party.[7]

Wang Hui argues that "science" (*kexue*) also was often conflated with "the West," noting that understandings of science were further

clouded by association with classical Chinese terms.[8] "Science" is part of the vocabulary of translated modernity that Lydia Liu refers to as the "translingual practice" of the late Qing Dynasty (1644–1911) through which Chinese loans were used to translate Western science first into Japanese and later back into Chinese. This was a disruptive process through which recirculated Chinese *loan words* for foreign terms were conflated both with a vague sense of Western modernity and with their classical implications.[9] Terms such as *civilization* (*wenming*) were transplanted from Japanese (*bunmei*), their meaning imbricated in the conception of modernity and Westernization. Civilization was associated with the imagination of a single historical trajectory and a universal valuation of cultural worth.

Likewise, prevailing understandings of "modernity" are firmly rooted in a Weberian/Marxist model that privileges the development of European institutions and economic systems as a teleological standard, and these associations carried over when the term was translated first into Japanese and then into Chinese.[10] "Science" (Jp. *Kagaku*, Ch. *Kexue*) connoted much more than the literal meaning of the characters—"categorical knowledge"—and instead was associated with the European Enlightenment's scientific method and a limited field of knowledge production. To be scientific was to be modern and Western. In sum, Chinese intellectuals began to share with their European counterparts the diffusionist notion that the West was the vanguard of evolution and modernity, that civilization was the culmination of Western cultural and scientific achievement on a universal evolutionary scale, and that science was the property of the West to be imported for national salvation. This diffusionist vision of techno-scientific modernity continues almost a hundred years later in the film *Death Ray*, as the protagonist is waylaid in his attempts to ferry his inventions home to the beloved fatherland.

Criticism of the relationship between the emergence of the novel and the will to imperial power has contributed to an exploration of the relationship between science fiction, imperialism, and orientalism. Work by Istvan Csiscery-Ronay Jr. (2003), Patricia Kerslake (2007), and John Rieder (2008) has begun to elucidate the relationships between SF and imperial discourse as one of many genres that paved the way for empire by creating the conditions for its popular imagination.[11] The social and material conditions that led to the emergence of SF in Europe turned late nineteenth-century China from an empire at the center of a vast network

of Asian trade and tribute to a semi-colonial outpost at the margins of the Western world. I have argued that early twentieth-century Chinese SF was characterized by a number of anxieties pertaining to imperial expansion and the encounter with the Other and that many of the metaphors used to express these anxieties later were incorporated into the thematic landscape of the modern Chinese canon.[12] Drawing upon this body of work, I have argued that Chinese SF authors were vexed by the question of what alternative iterations of nationhood and global politics might be, and how these fictions could be transformed into reality. Chief among them was the relationship between science and empire and the question of China's national salvation. In contemporary Chinese SF, memory of the colonial legacy has combined with more recent anxieties engendered by the Cold War (indeed, the "cold" conflict between the USSR and the United States was contested as a series of hot-war episodes in East Asia, in Korea and Vietnam in particular). The visible presence of Western imperialism in Asia continues to inform the writings of SF authors in the post-Mao period.

I contend that the same vexations that plagued early twentieth-century Chinese SF during the waning years of the Qing Dynasty—whether an Orientalist genre could be used to overturn Orientalism, and whether science could be uncoupled from the will to power—continued to manifest in the media landscape of the post-Mao era. Chinese authors were conscious of the contradictions and pitfalls inherent in attempting to use an imperialist genre in the effort to overturn such discourse. This crisis of consciousness in many ways reflects Frantz Fanon (1968; 1952) and W. E. B. DuBois's (1965) description of "double consciousness,"[13] wherein authors and intellectuals saw themselves from the perspective of both the oppressed and the oppressor, desiring an end to imperial expansion while harboring a will to revive China's own imperial mandate. The protagonists in the story "Death Ray on a Coral Island" strive for "pure science," hoping that their research will not be used for violent ends, but are ultimately forced to recognize that political detachment and pacifism are untenable.

The Death Ray

Tong Enzheng's depiction of Cold War–era empire shatters the diametrical opposition of the first and second worlds into a kaleidoscope of contingent geopolitical relations. Anxieties regarding the relationship

between China and the world, and the relationship between peace-loving socialist scientists and the potential applications of their discoveries, are projected onto the ambiguous national origins of the principal characters in the story and in the national and scientific agnosticism that pervades the narrative. Chen Tianhong and Dr. Matthew (Matai boshi, aka Hu Mingli) are beset by a nebulous amalgamation of Sino–Soviet and American-brand state capitalist imperialism. The specter of nuclear annihilation looms large in the story, begging the question of whether science itself can be unmoored from the imperial impulse. Almost all versions of the story end in the shadow of the bomb. Another familiar cinematic turn is the insertion of Professor Zhao's daughter Mona, who is Chen Tianhong's fiancée.[14] Mona rescues Chen Tianhong from the coral island at the end of the film, and the two escape just in the nick of time, watching over their shoulders as a mushroom cloud erupts over the surface of the ocean in a shot-reverse-shot sequence. The actress, Ma Junqin, was featured prominently on film posters for the movie, emphasizing the romantic aspect of the imperial confrontation that the SF narrative promised to offer.

Dr. Matthew imagines the laser beam's practical application in engineering and mining as a laser beam (*jiguang*) and a tool (*gongju*) for the betterment of nation and society; his corporate sponsors at the Venus Corporation see a death ray (*siguang*) meant for the expansion of empire. This ambivalence is recapitulated with Dr. Matthew's lightning-discharge-inducing device, which Admiral Shapunov has renamed the "death flame" (*sishen de huoyan*). The blurred boundaries between right and wrong, as well as the possibility of pure science unfettered by ideological considerations, are also cathected as suspicion of the means and ends of state capital.

An emerging anxiety in contemporary Chinese SF is the relationship between science and modern transactions of global capital. Financial instruments—contracts and patents—are objects of suspicion and danger: tools that facilitate acquisition of both the means of production and the means of destruction.[15] During Dr. Zhao and his team's celebration of their successful test of the high-tension atomic battery, Dr. Zhao rebuffs the contractual advances of Brashius, representing the Lovell Corporation (*Luofei'er gongsi*), then receives a phone call from the Warner Company (*Huana gongsi*), likewise seeking to purchase his patent, and immediately after has to rebuff Brashius a sec-

ond time. Twice, we see Dr. Matthew sign his rights away in contracts, only to be duped by the corporations he has agreed to work with. Only on the third occasion, when Brashius offers to renew his contract and his tenure on the coral island, does he finally refuse. Joseph Luo voices the neoliberal stance, quipping, "Dr. Matthew, you musn't be angry. Science is a commodity. We have no responsibility for how the customers use what they buy."[16] The complex relationship among science, technology, morality, and politics is further muddied by the imperatives of global capital.

When Chen returns to mainland China in the post-Mao era as a foreign-born and -trained intellectual, the questions of what struggles he is going home to face and how his opinions of science, nation, and political rectitude will weather the storm remain unanswered. China is an unseen and unproven socialist utopia, while the outside world is murky and perilous political territory. The characters in the story embody a morally ambiguous world, torn between the various imperatives of science, nation, peace, and the global economy.

The World

A history of campaigns against political heterodoxy in art and censorial barriers to earlier publication of this story and others offers one ready explanation for the political ambiguity of *Death Ray*, but these ambiguities are symptomatic of more than artistic caution as a means of avoiding censure. Chen Tianhong's anxious return to the fatherland occurs at the moment of China's entry into the global financial system. The literary and film versions of *Death Ray* come immediately before and after the Sino–Vietnamese war of early 1979, a moment that Wang Hui argues was "symptomatic of China's entry into the American-led economic order. . . . The war also demonstrates the relationship between marketization and violence."[17]

China, Chen's utopian safe harbor of pacifism, ideological purity, and resistance to capitalist incursion, is almost entirely effaced.[18] Chen Tianhong's identity is explicitly named for the first time in English when he washes ashore on the coral island, identifying himself as a "Chinese narrowly escaped from death," the translation of this phrase appearing in subtitles. The scientists have cast off most contemporary signs of "Chineseness." Not only is it the case that markers of Chinese

nationality "operat[e] as a territorializing power highly effective in marginalizing the other, that shapes the meaning of Chineseness here as a curse, as something to get used to,"[19] but these essentializing features are burdens to be cast off in order to join the global scientific community. The film and *lianhuanhua* (children's pocket comic) consistently feature Tianhong and his cohorts wearing lab coats and Western-style suits rather than Mao jackets, hosting Western-style banquets, and drinking coffee and milk. The characters instead refer to "the fatherland" (*zuguo*) rather than "China" (*Zhongguo*). Tianhong and Mona intone the phrase with gazes of anticipatory adulation and bated breath and mirror the heroes of Mao-era socialist-realist cinema.

A flashback sequence features the young Mona celebrating Christmas—the most quintessentially capitalist and Christian of holidays. The only identifiable song, hummed by Mona and her mother and played extra-diegetically on a keyboard, is the Christmas carol "Silent Night." Dr. Zhao's private plane embodies a cosmopolitan, transnational citizenship actualized through freedom of movement about the globe. All of these material trappings would have been a rare sight in China during the late 1970s, where average annual income was somewhere around $200US. These depictions offer their audience the sense of exoticism and wonder that is part and parcel of the visual pleasure of SF, but they also express a sense of uneasiness about China's place in the world. Science is portrayed as something that is in many respects foreign—although scientific research and technological advances are achieved by Chinese people, they are achieved outside of mainland China and must be brought home to the "fatherland."

Vaguely located somewhere in the South Pacific, the "xx Archipelago" and "X Port" (named only in the literary version) hint at but never name real geographical places. The film is set on a tropical island, and scenes inside Dr. Matthew's lab reveal an undersea house of wonders, but the exact location is never named. Mona learns of Chen Tianhong's crash through a news report that says his plane has been shot down "in the airspace over the waters of the ASC," but no more specifics are given. Stock footage used in the film features scenery from the United States—a Black Angus steakhouse and a Perkins restaurant appear in one shot—but the location of Professor Zhao's lab is never named specifically. Shots of various characters driving cars and stock footage of traffic scenes show vehicles with steering wheels on both sides of the

car. Such visual inconsistencies point to sloppy continuity editing, but they also contribute to a pervasive narrative vagueness.

In the literary version, it is hinted that the ASC is both an expanding military empire somewhere in Northern Europe and a capitalist empire in North America. When Tianhong's plane is hit by the mysterious burst of ball lightning, he remarks that even high up above the surface of the Earth, "the bear's paw could still stretch out to seize me,"[20] and upon meeting Admiral Shapunov, he describes him as resembling a polar bear. The filmic Shapunov has bleached blond hair and bushy eyebrows, and is accompanied by vaguely foreign, mustachioed sailors. Though the world map of "Death Ray" blurs the borders between states, it does not posit the replacement of the nation with a supranational logic of global capital. Instead, the new global configuration provides a new means of imperial expansion.

The dangers of the outside world are figured as nefarious corporations and plotting governments whose thinly veiled influence reaches out across the globe, and as morally ambivalent individual actors. A loyal core of patriotic scientists are pitted against a nebulous foreign enemy that threatens to turn their humanitarian inventions into weapons of mass destruction, but they are also pitted against ambiguously Chinese sell-outs to foreign powers. Though Professor Zhao and Tianhong's allegiance to China (though he has never been there) is obsessively reasserted, this patriotism does not extend to Joseph Luo and George Zuo. Although Tong himself acknowledged that he made a conscious decision to depict overseas Chinese scientists in a morally ambivalent light, it is apparent that those who reinterpreted his work found the issue even more vexing.

This ambiguity is captured most saliently in the visual representation of overseas Chinese scientist and "playboy" (*huahua gongzi*) Joseph Luo. From the short story to the film and then the *lianhuanhua* iterations of the story, we see a gradual transformation of Joseph from overseas Chinese to long-haired Caucasian. While he appears as a black-haired Chinese in the film, two of the *lianhuanhua* depict him as a man with flowing blond hair. Figures 16.1 and 16.2 depict Joseph Luo at the moment that he reveals his neoliberalism. In Figure 16.1, Joseph is clearly of Chinese descent, and his duplicity is communicated through his snide expression as the camera angle over Dr. Matthew's shoulder establishes his downward gaze upon his hapless

Figure 16.1. Joseph Luo talks to Dr. Matthew.

mentor. Figure 16.2 makes striking use of the visual language of socialist realism: Dr. Matthew, just to the left of the center of the frame, is drawn with bold, angular lines and stands solemnly erect, nearly a head taller than the three villains who are crowded together. Joseph Luo hides behind Brashius and Shapunov, flowing blond hair cascading over his hunched shoulders.

Ambivalence over national origins extends to the protagonists as well. Dr. Matthew's Japanese upbringing undoes a familiar trope of Chinese cinema since the late 1930s—the portrayal of Japan as a voracious military aggressor. One *lianhuanhua* version of the narrative illustrated by Luo Pan depicts a Japanese man clad in *tabi,* a World War II army uniform, and round-rimmed glasses, lecturing a group of children, one of whom is wearing a Sun Yat-sen suit. The group is standing on a hillside surveying the devastated ruins of Hiroshima.

62。马太把布莱恩等人迎进书房，六个水兵毫无表情地站在门外。布莱恩指着军官向马太介绍说："这位是海军上校沙布诺夫。"马太只淡淡地请他们坐。

Figure 16.2. L-R: Dr. Matthew, Joseph Luo, Brashius (aka Bryan), and Admiral Shapunov are introduced to one another. .

The image of Japan as the victim, rather than the perpetrator of aggression during World War II, is strikingly rare in Chinese cinema, and state-controlled media continue to rely on the depiction of Japan as an unapologetically malevolent aggressor in the interest of perpetuating a national narrative of victimhood.

While engaging various levels of specificity regarding the geopolitical location of the story, all versions of the narrative share a vexatious ambiguity about the world. These entities are part of the "*decentered and deterritorializing* apparatus of rule that progressively incorporates the entire global realm within its open, expanding frontiers. . . . The distinct national colors of the imperialist map of the world have merged and blended in the imperial global rainbow."[21] This merging and blending is especially apparent in the innuendo-laden descriptions of nation-states and individuals. The various versions of Tong's

core narrative obfuscate the difference between the bear's paw of second-world Soviet socialist imperialism and the invisible hand of first-world Western European neoliberal capitalism.

This is not to say that ambiguity pervades all levels and all iterations of the story. Zhang Hongmei's film makes use of a set of stylistic norms that are familiar elements of the classical Hollywood style. First, the film is a clear instantiation of what David Bordwell refers to as "an excessively obvious cinema."[22] What is visually obvious is emphasized with redundant dialogue and repetition. The nefariousness of global capital and financial instruments mentioned above is conveyed in a familiar cinematic language. They speak in brassy, nasal, vaguely foreign accents, hair dyed odd shades of blond. They dispatch henchmen via videophone, threatening them with personal consequences for any possible mistake. And, of course, they smoke, clasping their cigarettes fiendishly.[23] The camera captures all of this at the oblique angles familiar both to socialist-realist cinema and to the stylistic devices of Hollywood cinema: the scientists are well lit and stand upright, often upstaging and appearing larger than their antagonists who are veiled in shadow.

Death Ray's "Media Mix"

The Deng Xiaoping era ended nearly three decades of Chinese isolation from the rest of the world, and audiences were hungry for anything other than the stale imagery of socialist realism and "revolutionary romanticism."[24] *Death Ray* offered tropical islands, laboratories outfitted with state-of-the-art technologies, and private planes, elements all but invisible in the circumscribed mediascape of the Mao era, prompting many Chinese critics to posit that the story became a multimedia craze due to the popular appeal of these exotic locations and techno-scientific wonders.[25]

The proliferation of media products mirrors Henry Jenkins's *Convergence Culture* in at least two important ways. Story content flows "across multiple media platforms," and we see the industry's recognition of what Jenkins describes as "the migratory behavior of audiences who will go almost anywhere in search of the kinds of entertainment experiences they want."[26] Drawing upon Jenkins's work, Mark Stein-

Figure 16.3. Mona and Chen Tianhong look back at the mushroom cloud.

berg has described the synergistic function of a sophisticated network of production and distribution centered on a franchised character image that emerged in postwar Japan. Japanese consumers in the 1950s could consume a number of goods centered around the image of Tezuka Osamu's *Tetsuwan Atomu (Astro Boy)*, including television-syndicated anime series, manga, chocolates produced by Meiji Seika that came with stickers featuring the character, and a range of children's toys. This merchandising business model was influenced by the Walt Disney Corporation's aggressive protection of copyright.[27]

Although the various iterations of *Death Ray* attest to its popular appeal, the specific range of consumer products presents a case study in how media convergence functions in the absence of sophisticated marketing plans and copyright protection. Unlike Jenkins's convergence culture, and unlike the "media mix" described by Steinberg, there is little evidence of "cooperation between multiple media industries."[28] China's legal landscape in the early 1980s contrasted sharply with this business and legal model; the State Copyright Bureau (*Guojia banquan ju*) was not established until 1985.[29] To this day, intellectual property laws in the People's Republic of China often are criticized as

perpetuating the Cultural Revolution–era legal atmosphere of "cultural despotism," whose primary purpose is the suppression of unofficial political opinion rather than protecting artists from plagiarism.[30]

The majority of the products were *lianhuanhua* comics, many of which are near-facsimiles of one another or shot-for-shot reinterpretations of the film. These comics were relatively cheap and were clearly aimed at a juvenile audience. China's legal system could not offer exclusive rights to the production of the *Death Ray* image, meaning that a Japanese-style media mix in the vein of Tezuka Osamu's work would have been far too great a risk. These products largely relied on previously existing culture industry apparatuses—state-owned film and publishing—that were beginning to reorient themselves to the consumer market. China in the early 1980s had only begun to see market forces unleashed (the first phase of which was mostly aimed at boosting flagging rural standards of living), and a youth-oriented consumer market would not be a reality for some time, limiting demand to relatively low-cost goods.

Conclusion

Instead of a bipolar encounter between the first and second worlds, "Death Ray" depicts a conflict among China, Greater China, and nebulous imperial powers. The countries, corporations, and individuals with whom Chen Tianhong and Dr. Matthew come into contact are an indistinguishable mass; their only real identity is as enemy and other. The ASC (aka *Moudaguo*, lit. some big nation) presents an amalgamation of the Soviet threat and the intruding hand of global capitalism in a single body. Outside of the labs populated by overseas Chinese is a world bent on turning scientific discoveries into the tools of imperial conquest. Amang, the mute Malaysian servant, rounds out the undistinguished outside world as the Rest of the Rest. Though he is given an identity in the form of an identifiable country of origin and a remotely Chinese-sounding name, he is consigned to a role as manual laborer and cannon fodder for the ASC. Amang completes a triangle of China, the West, and the weak, voiceless nations in need of China's care. Fanon's and Dubois's double consciousness shatters into plural consciousness.

As I have shown, one problem that emerges in the plots of both the film and the story is the concern over the purity of scientific investigation and its uses. Chen Tianhong repeatedly asserts the impossibility of reclusion. The scientists cannot remove themselves from economic or political concerns any more than they can ensure that their inventions will be used to spread peace and prosperity rather than being adopted as weapons of conquest and oppression. National and scientific agnosticism permeate all versions of the narrative, suggesting a world that cannot do without national boundaries and scientific enterprise, but one in which these entities are the highly fraught territory of continual negotiation.

NOTES

1 The script was cowritten by Tong Enzheng and Shen Ji. Although many studios are attempting to increase their SF film output, to this day, *Death Ray on a Coral Island* stands out as one of only a few Chinese SF films ever made, and is even more rare as an SF box office success. For scholars of both literature and cinema, an explanation for the capricious ebb and flow of SF is one of the most vexing questions. Wei Yang's (133–48) thesis that Hong Kong films are polygeneric, subsuming SF semantic elements in the syntax of other genres, applies to mainland cinema as well, but it does not fully explain the paucity of SF cinema in the People's Republic of China (PRC). Certainly, the ways in which we define SF have contributed to the impression that China "doesn't have science fiction," and looking at the genre in new ways can help to resolve this question. See Wei Yang, "Voyage into an Unknown Future: A Genre Analysis of Chinese SF Film in the New Millennium," *Science Fiction Studies* 40, no. 1 (March 2013): 133–47.

Other scholars have argued that spiritual pollution campaigns and budgetary constraints are to blame. Though the former certainly led to a reduction in SF literature and cinema in the 1980s, China is in stark contrast with former socialist states like East Germany and the USSR, both of which had a prodigious SF cinema. Nor does SF necessarily have to be a big-budget affair. *Star Trek* built an entire television franchise around recycling period sets and props from the studios where it was filmed. Because this question is beyond the theoretical scope and word-count constraints of this essay, I leave it to future scholars.

2 For more on the history of *lianhuanhua,* see Xinzhe Cao, "Zhongguo

lianhuanhua chuban jin xi tan" [Chinese pocket-comic publishing then and now], *Tushu yu qingbao* [*Library and Information*] 4 (2002): 56–59.

3 Most of Tong Enzheng's stories were published in children's magazines. Tong's work also appeared in *Kexue wenyi* [*Science Belles-Lettres*], a popular science journal that began circulation in 1979 and has since been renamed *Kehuan shijie* (*Science Fiction World*).

4 Christopher Harman, *Zombie Capitalism: Global Crisis and the Relevance of Marx* (Chicago: Haymarket Books, 2009), 172.

5 Initiated in December 1978 at the third plenum of the 11th Party Congress, Deng's reforms led China into the age of "socialism with Chinese characteristics." This set the stage for the decollectivization of agriculture, allowing an influx of foreign investment and decentralization of the economy. These reforms also encouraged importation of foreign technology and management expertise and incorporation into the global financial system, alongside domestic development and liberalization of the same sectors. Ezra Vogel, *Deng Xiaoping and the Transformation of China* (Cambridge, Mass.: Belknap University Press, 2011), 217–29.

6 Enzheng Tong, "Wo de jingli," in *Tong Enzheng wenji: Wenxue xilie, lai zi xin dalu de xinxi* [My experience, in Tong Enzheng Collection: Literary works, letters from the mainland] (Chongqing: Chongqing chubanshe, 1998), 134–45. For further biographical information on Tong, see Renwei Dong, *Chuanyue 2012: Zhongguo mingjia kehuan pingzhuan* [Breakthrough 2012: Critical biography of famous Chinese SF authors] (Beijing: Renmin youdian chubanshe, 2012), 28–46; and Dingguo Zhou, ed., "Tong Enzheng nianpu," in Tong, *Tong Enzheng wenji*, 160–74.

7 Guanyu Tong, "Shanhudao shang de siguang" [About "Death Ray on a Coral Island"], *Yuwen jiaoxue tongxun* [The communication of Chinese teaching] 3 (1980): 57–58; 57. For a more detailed account of this episode, see Renwei Dong, *Chuanyue 2012,* 30–31; Dong also notes that *Mysterious Fog in an Ancient Gorge* was nearly made into a film in 1961.

8 Hui Wang, "The Fate of 'Mr. Science' in China: The Concept of Science and Its Application in Modern Chinese Thought," *positions: East Asia Cultures Critique* 3, no. 1 (1995): 1–68.

9 Lydia Liu, *Translingual Practice: Literature, National Culture, and Translated Modernity—China, 1900–1937* (Stanford, Calif.: Stanford University Press, 1995), 32–34.

10 Theodore Huters and Marsten Anderson demonstrate that for late Qing authors, "modernism" and "realism" often were understood as equivalent. Modernization meant both casting off the static indigenous tradition that was modernity's other and adoption of realist narrative representation. Understood as the most viable alternative to a failing imperial system, material

modernization and the adoption of realistic narrative modes also were often equated with Westernization. See Anderson, *The Limits of Realism: Chinese Fiction in the Revolutionary Period* (Berkeley: University of California Press, 1990), 27–37; Huters, "Ideologies of Realism in Modern China: The Hard Imperatives of Imported Theory," in *Politics, Ideology, and Literary Discourse in Modern China: Theoretical Interventions and Cultural Critique,* ed. Liu Kang and Tang Xiaobing, 147–72 (Durham, N.C.: Duke University Press, 1993).

11 See Istvan Csicsery-Ronay Jr., "Science Fiction and Empire," *Science Fiction Studies* 30, no. 2 (July 2003): 231–45; Patricia Kerslake, *Science Fiction and Empire* (Liverpool, U.K.: Liverpool University Press, 2007); John Rieder, *Colonialism and the Emergence of Science Fiction* (Middletown, Conn.: Wesleyan University Press, 2008).

12 Nathaniel Isaacson, "Science Fiction for the Nation: *Tales of the Moon Colony* and the Birth of Modern Chinese Fiction," *Science Fiction Studies* 40, no. 1 (March 2013): 34–38.

13 W. E. B. DuBois, *The Souls of Black Folk,* in *Three Negro Classics* (New York: Avon Books, 1965), 207–389; F. Fanon, *The Wretched of the Earth,* trans. C. Farrington (New York: Grove Press, 1968), and *Black Skin, White Masks,* trans. C. L. Markmann (New York: Grove Weidenfeld, 1967). (Original work published 1952.)

14 Mona's story arc inserts what David Bordwell describes as a "double causal structure" with two plotlines: a heterosexual romance playing out alongside the international intrigue. See David Bordwell, *Narration in the Fiction Film* (Madison: University of Wisconsin Press, 1985), 157.

15 I borrow this phrase from Harman's *Zombie Capitalism,* 93–120.

16 This particular line of dialogue appears in the story as well. Enzheng Tong, "Death Ray on a Coral Island," in *Science Fiction from China,* ed. and trans. Dingbo Wu and Patrick Murphy (New York: Praeger, 1989), 118.

17 Hui Wang, "The Year 1989 and the Historical Roots of Neoliberalism in China," in *The End of the Revolution: China and the Limits of Modernity,* ed. and trans. Rebecca Karl (New York: Verso, 2009), 42–43.

18 As Fredric Jameson notes, "It is a mistake to approach Utopias with positive expectations, as though they offered visions of happy worlds, spaces of fulfillment and cooperation. . . . These are however maps and plans to be read negatively, as what is to be accomplished after the demolitions and the removals, and in the absence of all those lesser evils the liberals believed to be inherent in human nature." See Fredric Jameson, *Archaeologies of the Future: The Desire Called Utopia and Other Science Fictions* (New York: Verso, 2005), 12.

19 Ien Ang, "Can One Say No to Chineseness?," *Boundary 2. Modern Chinese Literary and Cultural Studies in the Age of Theory: Reimagining a Field* 25, no. 3 (Autumn 1998): 224–25.

20 Tong, "Death Ray," 102. Quotations of the story are from English translations of the original Chinese. See Tong, "Shanhudao shang de siguang," 41–58. And Tong and Shen Ji, "Shanhu dao shang de siguang: Kexue huanxiang dianying wenxue juben" [Death Ray on a Coral Island: Science Fiction Film-Literature Script) *Kexue wenyi* 1 (1979): 81–110.

21 Michael Hardt and Antonio Negri, *Empire* (Cambridge, Mass.: Harvard University Press, 2000), xii–xiii.

22 Bordwell, "An Excessively Obvious Cinema," in *Classical Hollywood Cinema: Style and Mode of Production to 1960* (New York: Columbia University Press, 1985), 3.

23 Qiu Yuefeng, the actor who portrays Brashius in the film and is often cast as villains, was known for voiceover work in foreign films. He is featured as the voice of Dr. Matthew in the radio drama version of the story. Pang Wanling (Admiral Shapunov) was also known for playing foreign villains. See Sun Xiantao and Li Duoyu, eds., "1980 nian: Di yi bu kehuan gushi pian 'Shanhu dao shang de siguang" (1980: The first science fiction film, "Death Ray on a Coral Island") in *Zhongguo dianying bainian: 1975–2005* [A hundred years of Chinese cinema: 1975–2005], vol. 2, 46–49 (Beijing: Zhongguo guangbo dianshi chubanshe, 2005).

24 For more on the strictures of Maoist Cinema, see Yingjin Zhang, *Chinese National Cinema* (New York: Routledge, 2004), 189–224.

25 Xiantao and Duoyu, "1980 nian," 47.

26 Henry Jenkins, *Convergence Culture: Where Old and New Media Collide* (New York: New York University Press, 2008), 2–3.

27 Mark Steinberg, *Anime's Media Mix: Franchising Toys and Characters in Japan* (Minneapolis: University of Minnesota Press, 2012), 1–102.

28 Quoted in ibid., ix, vii.

29 Shoukang Guo, "Some Opinions on Copyright in the People's Republic of China," *Journal of Chinese Law* 1, no. 1 (1987): 63–68. See also Dong Han, "Can I Own My Own Writings and Sell Them Too? A Brief History of Copyright in China from the Late Qing Era to Mao's China," *Chinese Journal of Communication* 3, no. 3 (September 2010): 329–46.

30 Stephanie Hemelryk Donald et al., *Media in China: Consumption Content and Crisis* (New York: Routlege Curzon, 2002), 12. See also Han, "Can I Own My Own Writings?," 329–46.

Select Filmography

A7–058. Directed by Joshua DuMond. 2013. U.S.

Aelita: Queen of Mars. Directed by Iakov Protazanov. 1924. USSR.

The Aerial. Directed by Esteban Sapir. 2007. Argentina.

The Aerial Anarchists. Directed by Walter R. Booth. 1911. U.K.

The Aerial Submarine. Directed by Walter R. Booth. 1910. U.K.

After Life. Directed by Kore-eda Hirokazu. 1998. Japan.

Air Doll. Directed by Kore-eda Hirokazu. 2009. Japan.

The Airship Destroyer. Directed by Walter R. Booth. 1909. U.K.

Akira. Directed by Otomo Katsuhiro. 1988. Japan.

Alien. Directed by Ridley Scott. 1979. U.S. and U.K.

Alien 3. Directed by David Fincher. 1992. U.S.

Aliens. Directed by James Cameron. 1986. U.S. and U.K.

Alive in Joburg. Directed by Neill Blomkamp. 2005. South Africa.

Alone. Directed by Gianni Galli. 2010.

Alphaville. Directed by Jean-Luc Godard. 1965. France and Italy.

The Animatrix. Directed by Peter Chung, Andrew R. Jones, Kawajiri Yoshiaki, Koike Takeshi, Maeda Mahiro, Morimoto Kôji, and Watanabe Shinichirô. 2003. U.S.

The Arc. Directed by Richard Oswald. 1919. Germany.

Archetype. Directed by Aaron Sims. 2011. U.S.

Armies of the Old World. Directed by Ismail Kemal Ciftcioglu. 2011. Turkey.

Arrowhead: Signal. Directed by Jesse O'Brien. 2012. Australia.

Attack the Block! Directed by Joe Cornish. 2011. U.K.

Avalon. Directed by Oshii Mamoru. 2001. Japan and Poland.

Avatar. Directed by James Cameron. 2009. U.S.

Backdoor—The Movie. Directed by Sudharshan Ashok. Summit Pictures, 2012. India.

Betaville. Directed by Alyce Wittenstein. Subatomic Productions, 1986. U.S.

Beyond Black Mesa. Directed by Brian Curtin. 2011. U.S.

Bicentennial Man. Directed by Chris Columbus. 1999. U.S.

Bio-Zombie. Directed by Wilson Yip. 1998. Hong Kong.

Blade Runner. Directed by Ridley Scott. 1982. U.S.

The Bloodettes. Directed by Jean-Pierre Bekolo. 2005. Cameroon.

The Boy from Mars. Directed by Philippe Parreno. 2005. France.

The Bunker of the Last Gunshots. Directed by Marc Caro and Jean-Pierre Jeunet. 1981. France.

Butterflies of Trip City. Directed by Nika Belianina. 2010. Canada and Russia.

The Cabinet of Dr. Caligari. Directed by Robert Wiene. 1920. Germany.

Cathedral. Directed by Tomasz Bagiński. 2002. Poland.

The Chronicles of Riddick: Dark Fury. Directed by Peter Chung. 2004. U.S.

Chronopolis. Directed by Piotr Kamler. 1982. France.

The City in the Sky. Directed by Giacomo Cimini. 2009. U.K. and Italy.

Code 46. Directed by Michael Winterbottom. 2003. U.K.

The Comet. Directed by Johan Löfstedt. 2004. Sweden.

Condor Crux, The Legend. Directed by Juan Pablo Buscarini and Swan Glecer. 2000. Argentina.

Connected. Directed by Jens Raunkjær Christensen and Jonas Drotner Mouritsen. 2009. Denmark.

The Dark Knight. Directed by Christopher Nolan. 2008. U.S. and U.K.

Dasavatharam. Directed by K. S. Ravikumar. 2008. India.

Dead Snow. Directed by Tommy Wirkola. 2009. Norway.

Death Ray on a Coral Island. Directed by Zhang Hongmei. 1980. China.

The District. Directed by Áron Gauder. 2004. Hungary.

District 9. Directed by Neill Blomkamp. 2009. South Africa, U.S., New Zealand, and Canada.

Doll No. 639. Directed by András Dési and Gábor Móray. 2005. Hungary.

Eater of the Sun. Directed by Thor T. Schneider and Sindri Gretarsson. 2010. Germany.

Electric Earth. Directed by Doug Aikten. 1999. U.S.

Electronic Labyrinth THX 1138 4EB. Directed by George Lucas. 1967. U.S.

Elysium. Directed by Neill Blomkamp. 2013. U.S.

The End of the World. Directed by August Blom. 1916. Denmark.

The Engagement. Directed by Richard Simpson. 2010. Canada.

Enthiran, the Robot. Directed by Shankar. 2010. India.

Estrellas (Stars). Directed by Federico León and Marcos Martínez. 2007. Argentina.

Eternal Sunshine of the Spotless Mind. Directed by Michel Gondry. 2004. U.S.

Exist. Directed by Tyson Wade Johnston. 2011. U.S.

Extinct. Directed by Michael Pohl. 1995. Germany.

Fade. Directed by Eugenio Mira. 2000. Spain.

Fahrenheit 451. Directed by François Truffaut. 1966. U.K.

Faith. Directed by Apichatpong Weerasethakul. 2006. Thailand.

Fantastic Planet. Directed by René Laloux. 1973. France.

The Fifth Element. Directed by Luc Besson. Gaumont, 1997. France.

File under Miscellaneous. Directed by Jeff Barnaby. Prospector Films, 2010. Canada.

Final Fantasy: The Spirits Within. Directed by Sakaguchi Hironobu. 2001. Japan.

F. P. 1 Doesn't Answer. Directed by Karl Hartl. 1932. Germany, U.K., and France.

Galaxy Express 999. Directed by Rintaro. 1979. Japan.

Game Over. Directed by David Winning. 1978. Canada.

Gandahar. Directed by René Laloux. 1988. France.

Gattaca. Directed by Andrew Niccol. 1997. U.S.

The Ghost in the Shell. Directed by Oshii Mamoru. 1995. Japan.

The Ghost in the Shell: Arise. Directed by Kise Kazuchika. 2013. Japan.

The Ghost in the Shell: Innocence. Directed by Oshii Mamoru. 2004. Japan.

The Ghost in the Shell: Stand Alone Complex. 1st Gig. Directed by Kamiyama Kenji. 2002–3. Japan.

The Ghost in the Shell: Stand Alone Complex. 2nd Gig. Directed by Kamiyama Kenji. 2004–5. Japan.

The Ghost in the Shell: Stand Alone Complex: Solid State Society. Directed by Kamiyama Kenji. 2006. Japan.

Go Goa Gone. Directed by Krishna D. K. and Raj Nidimoru. 2013. India.

Godzilla. Directed by Honda Ishirō. 1954. Japan.

Gold. Directed by Karl Hartl. 1934. Germany.

Golem. Directed by Patrick McCue and Tobias Wiesner. 2013. Germany.

Grounded. Directed by Kevin Margo and Barrett Meeker. 2011. U.S.

Gwen, or The Book of Sand. Directed by Jean-François Laguionie. 1985. France.

Halo: Landfall. Directed by Neill Blomkamp. 2007. South Africa.

The Hands of Orlac. Directed by Robert Wiene. 1924. Germany and Austria.

Hellboy II: The Golden Army. Directed by Guillermo del Toro. Universal, 2008. U.S. and Germany.

Hell's Ground. Directed by Omar Khan. 2007. Pakistan.

The Host. Directed by Bong Joon-ho. 2006. South Korea.

I'm a Cyborg, but That's OK. Directed by Park Chan-wook. 2006. South Korea.

Inception. Directed by Christopher Nolan. 2010. U.S. and U.K.

Independence Day. Directed by Roland Emmerich. 1996. U.S.

Interplanetary Revolution. Directed by Zenon Komisarenko, Youry Merkulov, and Nikolai Khodataev. 1924. USSR.

Interstellar. Directed by Christopher Nolan. 2014. U.S. and U.K.

Invasion. Directed by Hugo Santiago. 1969. Argentina.

A Journey That Wasn't. Directed by Pierre Huyghe. 2005. France.

Juan of the Dead. Directed by Alejandro Brugués. 2011. Spain and Cuba.

La Jetée. Directed by Chris Marker. 1962. France.

Just Imagine. Directed by David Butler. 1930. U.S.

Kalai Arasi. Directed by A. Kasilingam. 1963. Tamil.

Kin-dza-dza! Directed by Georgii Daneliaa. 1986. USSR.

King Crab Attack. Directed by Grégoire Sivan. 2009. France.

Koko's Earth Control. Directed by Dave Fleischer. 1928. U.S.

Ku! Kin-dza-dza! Directed by Georgii Daneliaa. 2013. Russia.

Leviathan. Directed by Kelly Richardson. 2011. U.S.

The Man Who Fell to Earth. Directed by Nicolas Roeg. 1976. U.K.

Mariner 9. Directed by Kelly Richardson. 2012. U.K.

The Matrix. Directed by Andy Wachowski and Lana Wachowski. 1999. U.S.

Metal Attraction: Kung Fu Cyborg. Directed by Jeffrey Lau. 2009. Hong Kong and China.

Metropolis. Directed by Fritz Lang. 1927. Germany.

Metropolis. Directed by Rintaro. 2001. Japan.

The Migration. Directed by Sydney Freeland. 2008. U.S.

Minority Report. Directed by Steven Spielberg. 2002. U.S.

Mission to Mars. Directed by Brian De Palma. 2000. U.S.

Moebius. Directed by Gustavo R. Mosquera et al. 1996. Argentina.

Monsters. Directed by Gareth Edwards. 2010. U.S.

Monsters vs. Aliens. Directed by Rob Letterman and Conrad Vernon. 2009. U.S.

Mumbai 2025. Directed by Thomas Jacob. Red Orphanage, 2010. India.

Newmedia. Directed by Julian Cooke and Sebastian Dias. 2011. Argentina.

Night of the Living Dead. Directed by George A. Romero. 1968. U.S.

1945A. Directed by Ryan Nagata. 2010. U.S.

Oblivion. Directed by Joseph Kosinski. 2013. U.S.

One Million Kingdoms. Directed by Pierre Huyghe. 2001. U.S.

Pacific Rim. Directed by Guillermo del Toro. 2013. U.S.

Perspective. Directed by Mehmet Can Kocak. 2011. Turkey.

Planet of the Apes. Directed by Franklin J. Schaffner. 1968. U.S.

Plurality. Directed by Dennis A. Liu. 2012. U.S.

Portal: No Escape. Directed by Daniel Trachtenberg. 2011. U.S.

The Price of Knowledge—The Ballad of the Lost Wanderer. Directed by Anders Muammar. 2007. Sweden.

Primitive. Directed by Apichapong Weerasethakul. 2009. Thailand.

Project Kronos. Directed by Hasraf Dulull. 2013. U.K.

Prometheus. Directed by Ridley Scott. 2012. U.S. and U.K.

Pulgasari. Directed by Sin Sang-ok. 1985. North Korea and Japan.

Pumzi. Directed by Wanuri Kahiu. 2009. Kenya.

Queen of Arts. Directed by A. Kasilingam. 1963. India.

Quietus: To the New World. Directed by Richard Lowry. 2004. U.S.

The Raven. Directed by Ricardo de Montreuil. 2010. U.S.

Reign of Death. Directed by Matthew Savage. 2009. U.K.

The Rift. Directed by Robert Kouba. 2012. U.S. and Switzerland.

RoboCop. Directed by Paul Verhoeven. 1987. U.S.

RoboCop 2. Directed by Irvin Kershner. 1990. U.S.

RoboCop 3. Directed by Fred Dekker. 1993. U.S.

Ruin. Directed by Wes Ball. 2011. U.S.

Save the Green Planet! Directed by Jang Jun-hwan. 2003. South Korea.

A Scanner Darkly. Directed by Richard Linklater. 2006. U.S.

The Schneider Disease. Directed by Javier Chillon. 2008. Spain.

Sentinel. Directed by Francisco Silva. 2012. U.S.

Shaun of the Dead. Directed by Edgar Wright. 2004. U.S.

Sight. Directed by Daniel Lazo and Eran May-Raz. 2012. Israel.

Sky Captain and the World of Tomorrow. Directed by Kerry Conran. 2004. U.S.

Skyline. Directed by Colin Strause and Greg Strause. 2010. U.S.

Slaughterhouse Five. Directed by George Roy Hill. 1972. U.S.

The Sleepwalker. Directed by Fernando Spiner. 1998. Argentina.

Slow Action. Directed by Ben Rivers. 2010. U.K.

Solaris. Directed by Andrei Tarkovsky. 1972. USSR.

Soylent Green. Directed by Richard Fleischer. 1973. U.S.

Star Trek into Darkness. Directed by J. J. Abrams. 2013. U.S.

Star Wars: Episode I—The Phantom Menace. Directed by George Lucas. 1999. U.S.

Star Wars: Episode II—Attack of the Clones. Directed by George Lucas. 2002. U.S.

Star Wars: Episode III—Revenge of the Sith. Directed by George Lucas. 2005. U.S.

Star Wars: Episode IV—A New Hope. Directed by George Lucas. 1977. U.S.

Star Wars Episode V—The Empire Strikes Back. Directed by George Lucas. 1980. U.S.

Star Wars: Episode VI—Return of the Jedi. Directed by George Lucas. 1983. U.S.

Stardust. Directed by Matthew Vaughn. 2007. U.K., U.S., and Iceland.

Steamboy. Directed by Otomo Katsuhiro. 2004. Japan.

Tag 26. Directed by Andreas Samland. 2002. Germany.

Tales of the Black Freighter. Directed by Daniel DelPurgatorio and Mike Smith. 2009. U.S.

Tears of Steel. Directed by Ian Hubert. 2012. Netherlands.

The Terminator. Directed by James Cameron. 1984. U.S.

Terminator 2: Judgment Day. Directed by James Cameron. 1991. U.S.

Tetsuo: The Iron Man. Directed by Tsukamoto Shinya. 1989. Japan.

TH.2058. Directed by Dominique Gonzalez-Foerster. 2008. U.K.

There's Only One Sun. Directed by Wong Kar Wai. 2007. Hong Kong and U.S.

Things to Come. Directed by William Cameron Menzies. 1936. U.K.

The 3rd Letter. Directed by Grzegorz Jonkajtys. 2010. U.S.

Thor: The Dark World. Directed by Alan Taylor. 2013. U.S.

Time Masters. Directed by René Laloux. 1982. France.

The Time Monsters. Directed by Donald F. Glut. 1959. U.S.

Tomorrow Calling. Directed by Tim Leandro. 1993. U.K.

Total Recall. Directed by Paul Verhoeven. 1990. U.S.

Total Recall. Directed by Len Wiseman. 2012. U.S. and Canada.

Transatlantic Tunnel. Directed by Maurice Elvey. 1935. U.K.

Translucent Unicorn. Directed by Robert Kouba. 2010. Switzerland.

A Trip to Mars. Directed by Holger-Madsen. 1918. Denmark.

A Trip to the Moon. Directed by Georges Méliès. 1902. France.

Twelve Monkeys. Directed by Terry Gilliam. 1995. U.S.

20,000 Leagues under the Sea. Directed by Stuart Paton. Williamson Submarine Film, 1916. U.S.

2001: A Space Odyssey. Directed by Stanley Kubrick. MGM, 1968. U.S. and U.K.

2081. Directed by Chandler Tuttle. Moving Picture Institute, 2009. U.S.

Tyrants from Afar. Directed by Arjan Van Meerten. 2004. Netherlands.

Vikram. Directed by Rajasekhar. 1986. India.

Wall-E. Directed by Andrew Stanton. 2008. U.S.

Warm Bodies. Directed by Jonathan Levine. 2013. U.S. and Canada.

Waxworks. Directed by Leo Birinsky and Paul Leni. 1924. Germany.

The World of Tomorrow. Directed by Kerry Conran. 2005. U.S.

World War Z. Directed by Marc Forster. 2013. U.S. and Malta.

Xxit. Directed by Sam Nicholson. 2011. U.S.

Y: The Last Man Rising. Directed by Christian Cardona. 2012. U.S.

Yongary: Monster from the Deep. Directed by Kim Ki-dŏk. 1967. South Korea.

Zombieland. Directed by Ruben Fleischer. 2009. U.S.

Contributors

Michelle Cho is assistant professor of East Asian studies at McGill University.

Steve Choe is associate professor of film studies at the University of Iowa. He is the author of *Afterlives: Allegories of Film and Mortality in Early Weimar Germany.*

Hye Jean Chung is assistant professor of film and cultural studies at Kyung Hee University.

Istvan Csicsery-Ronay Jr. is professor of English at DePauw University. He is the coeditor of *Science Fiction Studies,* founding editor of *Humanimalia,* author of *The Seven Beauties of Science Fiction,* and coeditor of *Robot Ghosts and Wired Dreams: Japanese Science Fiction from Origins to Anime* (Minnesota, 2005).

Jennifer L. Feeley is an independent scholar and translator. She is the translator of *Not Written Words: Selected Poems of Xi Xi.*

Paweł Frelik is associate professor in the Department of American Literature and Culture at Marie Curie-Skłodowska University, Lublin, and at the American Studies Center at the University of Warsaw. He is the editor of *Playing the Universe: Games and Gaming in Science Fiction.*

Everett Hamner is associate professor of English at Western Illinois University.

Nathaniel Isaacson is assistant professor of modern Chinese literature at North Carolina State University.

Jihoon Kim is assistant professor of cinema and media studies at Chung-ang University.

Thomas Lamarre teaches in East Asian studies and communication studies at McGill University. He is the author of several books, including *Uncovering Heian Japan: An Archaeology of Sensation and Inscription, Shadows on the Screen: Tanizaki Jun'ichiro on Cinema and Oriental Aesthetics,* and *The Anime Machine: A Media Theory of Animation* (Minnesota, 2009).

Emily A. Maguire is associate professor of Spanish and Portuguese at Northwestern University. She is the author of *Racial Experiments in Cuban Literature and Ethnography.*

Sharalyn Orbaugh is professor of Asian studies at the University of British Columbia. She is the author of several books, including most recently *Propaganda Performed:* Kamishibai *in Japan's Fifteen Year War.*

Joanna Page holds a senior university lectureship in Latin American cultural studies at Cambridge University. She is the author of *Crisis and Capitalism in Contemporary Argentine Cinema* and *Creativity and Science in Contemporary Argentine Literature: Between Romanticism and Formalism* and coeditor of *Visual Synergies in Fiction and Documentary Film from Latin America.*

Swarnavel Eswaran Pillai is assistant professor in the English and Media and Information departments at Michigan State University. He is director of the film *Migrations of Islam* and author of *Madras Studios: Narrative, Genre, and Ideology in Tamil Cinema.*

Jillian Porter is assistant professor of Russian and affiliate faculty in film and media studies at the University of Oklahoma.

J. P. Telotte is professor of literature, media, and communication at Georgia Institute of Technology. He is the author or editor of several books, including *Science Fiction Film, The Essential Science Fiction Television Reader, The Mouse Machine: Disney and Technology,* and *Science Fiction Film, Television, and Adaptation: Across the Screens.*

Sarah Ann Wells is assistant professor of comparative literature at the University of Wisconsin–Madison.

Travis Workman is assistant professor of Asian languages and literatures at the University of Minnesota.

Index